New Art Around the World

New Art

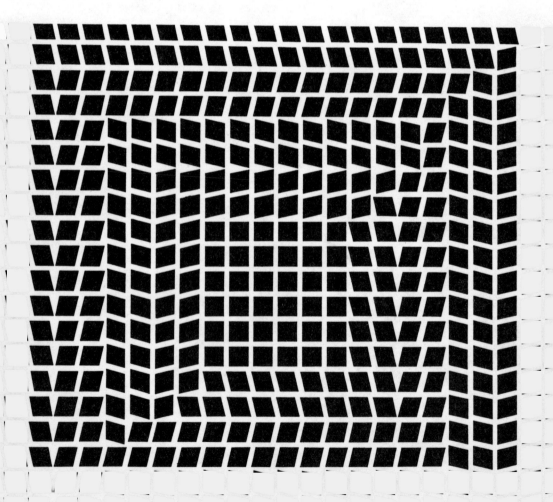

Around the World

PAINTING AND SCULPTURE

The United States / Sam Hunter

France / Alain Jouffroy

Great Britain / Alan Bowness

Italy / Nello Ponente and Maurizio Fagiolo

Spain / Alexandre Cirici-Pellicer

The Netherlands / R. W. D. Oxenaar

Scandinavia and Finland / Pontus K. G. Hultén

Belgium / Jean Dypréau

Japan / Yoshiaki Tono

South America / Jorge Romero Brest

Greece / Dimitris A. Fatouros

Israel / Yona Fischer

Poland / Mieczyslaw Porebski

Czechoslovakia / Jiří Kotalik

Yugoslavia / Zoran Kržišnik

Germany, Austria, and Switzerland / Will Grohmann

Harry N. Abrams, Inc. *Publishers* **New York**

All foreign-language articles (with the exception of *Japan,* which was written in English) translated by HENRY MINS except for:
The Paris International Avant-Garde, translated from French by NORBERT GUTERMAN
and *Israeli Art Today* and *Yugoslavia,* translated from French by MICHAEL BROZEN

Frontispiece: Victor Vasarely *Cassiopée* (detail)

Library of Congress Catalog Card Number: 66 — 29665

Printed and bound in West Germany

Contents

Foreword

Giving a survey of present-day painting and sculpture in Europe, North and South America, and Japan has proved to be a difficult enterprise. At any international show, the jury is faced with the all but unanswerable question of who is to be invited and who is to get the prizes. The number of young artists has become virtually infinite, the concept of art has expanded beyond all measure, and yet any interference by a jury is regarded as untimely. Everything is art, from works in a legitimate tradition to the most daring experiments with light projections or stagily ordered ensembles, and we do not have far to go to the time when mere indications will be given instead of worked-out sketches, indications for a public, whatever its reactions might be.

Not so long ago, any exhibition of modern art referred to Cézanne, to Cubism, or to Klee's universal *Geviert*. People went back to the researches of Freud and Jung, spoke of archaistic structural elements, and looked for possible parallels between what art was saying and what Einstein and Planck were saying in science. New aspects were found of reality, of the artist-world relationship, of the artists' and the world's mutual containment rather than their mutual opposition. But all that is of very limited interest to painters and sculptors today. Mathieu was shocked by Wols and found that he was marking the end to the development since 1880; for young contemporaries, he is a glorious legend, in which his death is as important as his work. They would be just as unwilling to learn from Wols as from Hans Hartung and his "thinking hand," which forms the meaning of his world.

Naturally, the young artists have not ignored the pioneers since World War II; in one way or another, all of them have got a shock from Pollock or Calder, Dubuffet or Moore, and through them have come to fundamental experiences and insights, which, however, are not perceptible in the way their works appear. The young people are starting from somewhere else, to some extent the new objects and materials that are forced on them by today's metropolitan consumer world, to some extent the complex structures in which time,

motion, and light are all involved. They are further than ever from *l'art pour l'art*, and the drama comes as it were spontaneously from both starting points, even if it is more concerned with the absurd than with the probable, with positing absolutes than with relationship.

The publisher and editor have tried to find the leading experts on the subject in the various countries and continents, and to bring in the younger generation of art critics. If this has led to great divergences in ideas of what art is, and in scales of judgment, that is rather a gain than a drawback. From it the reader will get all the clearer a picture of the powerful tensions that today endanger creativity and its relationship to its times and society.

The sequence of countries does not have any internal connection, since the authors of each chapter were entirely unconnected, nor does it indicate any ranking by importance. The chapters were printed in the order we received the manuscripts.

<div style="text-align:right">The Editor</div>

Note to the American edition:

The terminology of modern art is very fluid, and often varies according to locality, degree of expertise, and, no doubt, to other factors. Thus, the American term "Action Painting" has been used, more or less well, by writers in other languages; with us, such a term is "Tachism," taken from the French. A particularly vexing term is *informel*, which is a coined word. It does not mean "informal" in contradistinction to "formal"; rather it indicates a kind of art that in its physical creation is seemingly spontaneous, uncontrolled, impetuous, and irregular. Therefore, when the term "Informal" and its variants are used in this volume, they are analogous to the French *informel*.

<div style="text-align:right">The Publisher</div>

American Art since 1945

By Sam Hunter

The past two decades brought an original mode of art to America in Abstract Expressionism, and it developed into a powerfully influential movement; but recently its ascendancy has been challenged by a rising younger generation of new abstractionists, New Realist, assemblers, and Pop artists. They now form a loose "antimovement" that shows every sign of becoming a supplanting source of artistic energy and influence. No period of American art has been richer in innovation or generated more heated argument over the validity of new artistic directions. It is generally recognized that Abstract Expressionism, which ruled American art for two decades, has exhausted its collective impulse as a unified movement, making way for change and the new images. But, if it has lost its force as the prevailling, canonistic style, a few individuals within it are more masterful than ever before. The most profound expressions in American art perhaps still flow from the pioneer Abstract Expressionists, whose individual energies have shown no visible decline. As the critic Harold Rosenberg noted in his important collection of essays, *The Anxious Object*, "Much of the best art of our time is the product of individuals left stranded by movements that have come to a halt and who keep looking back to great days of which each retains a different version."

Whatever the ultimate historical judgment may be of the latest novelties in American art — and there seems little doubt they have won themselves a secure place — perhaps even more critical is the fact that innovation has opened a stylistic and ideological dialogue between generations. The younger artists who arrived after 1960 may seem to subvert the cherished ideals, methods, and even artistic standards of the recent innovating past, but they also issue directly from it, and their work can be placed within an intelligible continuity of taste and change. America now boasts an established tradition in contemporary creation that is active and reactive, that moves our artists in their various directions as the School of Paris once did. It is a tradition of native origin and international consequence, a shared impulse which strongly shapes the outcome of

the individual's struggle with new artistic forms and ideas in Paris, London, Rome, and Tokyo, as well as in New York. The decisive American development of the past two decades has been the creation of a collective and sustained body of invention which works as a generative tradition within the mainstream of European modernism. Contemporary art is irreversibly international, and since World War II American artists have played an increasingly influential role in determining its character and upholding its standards, both by reason of individual discovery and by their new-found solidarity within creative traditions, movements, and countermovements of their own making.

The prevailing tendency of American art over most of the past two decades has been called, interchangeably, Abstract Expressionism, Action Painting, or the New York School. These terms describe a loose association of artists guided by common aims, who emerged in a period after World War II when the School of Paris seemed to be vacant of new ideas and dying of skill. The deceleration of European innovations in the 1940s, and catastrophic political events on the Continent, released new energies among young American artists. For a moment, it might have seemed that the impulse of modernism had been expatriated and driven underground in this country, for the emerging American vanguard drew support and inspiration in its complex beginnings from the presence in New York during the war of a number of Europe's leading artists and intellectuals. Léger, Tanguy, Mondrian, Breton, Ernst, and Matta, among others, maintained warm and influential relationships with many of the younger Americans and shortened the intimidating distance between them and European modernism. Many of these European artists showed at the Art of This Century Gallery of Peggy Guggenheim, and it was there that some of the pioneer American Abstract Expressionists — Pollock, Rothko, Still, Hofmann, Motherwell, and Baziotes — held their first one-man shows between 1943 and 1946.

Jackson Pollock's exhibition of 1943 was the first in the series of new vanguard representations, and it took on the character of a visual manifesto for a new point of view in American art. Pollock had for some time been mistakenly identified with the artistic productions of the European Surrealists exhibited in the same gallery, and his rather narrow and violent early paintings did in fact show relationships to their automatism and symbolism. At the same time, Robert Motherwell was also testing "automatic" painting, and Arshile Gorky worked directly under the influence of Matta and of Miró's abstract Surrealism (colorplate 2). Baziotes, Rothko, Gottlieb, Still, and Newman explored archaic and primitivistic art forms and turned to "myth" for a new

subject matter. Their originality lay in an emphasis on symbolic content, not for historical or nostalgic association but as a way of relating the findings of the unconscious to the act of creation itself. It was some time, however, before fantasy and an intensely personal expressiveness were purged from the new American art and transcended. Discovery was led along new paths of self-exploration and self-obsession, even as a new kind of spatial expression was being elaborated.

In his turgid early style, Pollock wrestled with crude and vital fantasies derived from the imagery of Picasso's *Guernica* and the stock-in-trade of Surrealist monsters, but a free and powerful brush dissolved his content of violence, subtly transforming it into the nonrepresentational "writing" that later became his recognizable trademark. Even his open drip paintings after 1947, however, still echoed the charging energies and conflictng moods of the first paintings. In the labyrinthine coils of his whipped lines some imaginary beast — or an invisible adversary — seemed trapped, and struggling to free itself (colorplate 1). To a lesser degree, Surrealism formed the paintings of Willem de Kooning, who shared with Pollock leadership of the American avant-garde, and became its most influential figure after 1952. De Kooning's first typical "signature" forms, such as the well-known *Pink Angels,* are a condensation of opposing curved pelvic silhouettes, or imaginary anatomies in flattened emblematic form, derivative of Picasso and Miró of the *Hirondelles d'Amour* period in the early 1930s. Their content is essentially fantastic, but it is only a short step in De Kooning's art from such images rooted in the Surrealist imagination to the fragmented and freely registered color shapes of his mature style. After 1948, the fantasies are still there but are subdued and incorporated within a larger presence and to a larger aesthetic purpose (colorplate 3).

The process of sublimating fantasy and violent expressionist accents also brought visible change to the work of other members of the American vanguard in the late 1940s. Rothko, Newman, Gottlieb, and Still abandoned myth and primitivistic content for purely abstract idioms. Painting discovered new resources in elucidating the creative act itself as its primary expressive content. There was a shift in emphasis, then, from what was taking place inside the artist's mind to the developing image that grew under his hand. In the process the artist inevitably became something of a virtuoso performer, inviting his audience to admire his skill in improvisation, his boldness in gambling everything on a brief moment of great intensity.

This was true particularly of Pollock, Hofmann, De Kooning, and other artists associated with them, who gave special importance to speed of execution

and autographic gesture. Their work embodied a new time sense, for it insisted that the painting be experienced urgently as an action and as an immediate, concrete event. The painting thus came to symbolize an incident in the artist's drama of self-definition rather than an object to be perfected, a fantasy to be expressed, or a structure to be made in accordance with any prescribed rules. The term "Action Painting," invented by Harold Rosenberg, has implications of engagement and of liberation from received ideas of "style" that carry beyond the question of athleticism and improvisatory energy to which this epithet has generally been restricted.

The late German modernist Hans Hofmann, whose influence on the American vanguard as a teacher was immense, perhaps anticipated, even if he did not fully realize, the freer modes of Action Painting. As early as 1940, in the innovating painting *Spring*, he explored the technique of dripping and flinging paint on the canvas, a method which Pollock later canonized. In conversation Hofmann has distinguished between traditional concepts of fixed form and the idea of mobile form which serves a process of continuous transformation and spatial movement. In his own work, paint stroke, mark, and drip instantly registered as coherent and intelligible form when they hit the canvas surface (colorplate 4). This, of course, was the generic type of painting that revolutionized American art in the 1940s. First a widening circle of artists, then a small group of critics and connoisseurs, and finally a wider public acquired the capacity of "reading" Action Painting and its related welded-metal sculpture as a new, earnest, and complete aesthetic statement.

The transition in style from various forms of expressionist and romantic realism that dominated the period of the 1930s to the new abstraction was for most of the vanguard artists rather abrupt. Apart from Gorky, Hofmann, and De Kooning, most of the new generation were mature artists who had worked effectively as interpreters of the social scene before their conversion to abstract idioms. It is significant that in the forties and early fifties, representational imagery reappeared in their work with frequency and intensity. Pollock's early anatomical fantasies were restored in his black-and-white paintings as late as 1951, as if he were compelled to repeat his rite of passage from figuration to abstraction in order to prevent any confusion with purist or intellectualized forms of nonobjective art established earlier in the century. A romantic and expressionist bias was erupting within an abstract manner at the same period in Europe in the primitivistic figuration of Dubuffet and in the grotesque inventions of Jorn, Appel, and the CoBrA group. Only the human mask, the human body, or a fantastic bestiary seemed able to deal with

the intensity of feeling that this painting of "extreme situations" took for its principal content.

If there were elements of brutalism and Dadaism in the more savage early paintings of Pollock and De Kooning, other fine artists of their generation were content to seek a classical balance and restraint, within a more limited repertory of means. Bradley Walker Tomlin's system of monumentalized calligraphic signs, muted in color and structurally taut, gave lucid order and shapeliness to the impulsive energies of Action Painting without any disabling loss of freedom or spontaneity. And until his last festive and rather Impressionist works, with their loose color flakes and carefree accents, the mood of his work was one of sober restraint.

Robert Motherwell, surely one of the most fascinating temperaments among the Action Painters, helped set the high and serious intellectual tone of the movement by his critical activities as writer and editor. He, too, worked consciously within a more traditional framework of European taste and sensibility, under the mixed influence of Picasso, Matisse, and Schwitters. Motherwell found an eloquent personal vehicle in the collage and in his stark black-and-white elegies of the late 1940s and early 1950s, dedicated to Spain, which may have been decisive in the formation of Kline's more specialized manner (plate 1). Motherwell's fluent alternation between an amorphous style of Expressionist decontrol and explicit linear structure, his conversion of the abstract painting into an "intimate journal," even as he was expanding its energies to carry monumental form, are typical of the mixed inspiration and experimental audacity of the new abstraction and its persistent romantic accents. In recent years he has enlarged his characteristic image and sharpened its focus in far more terse and concentrated plastic statements. He has perhaps been misunderstood as an intellectual artist whose work comments on the primary innovations of sterner spirits. In fact, Motherwell has emerged as both a master of that monumental scale so characteristic of contemporary expression in America and an incomparable lyricist whose paintings reject comparisons or association. His continuing series of black-and-white elegies is in the highest tradition of contemporary American painting.

The most dramatic evidence that a limited repertory of gesture and a monochrome palette could densely elaborate pictorial structure, however, was to come from Franz Kline, one of the most powerfully concentrated talents in American art. In his first one-man show of 1951 he demonstrated something of De Kooning's vigorous decisiveness within an essentially equivocal expressive language. By drastic simplification of image and by restricting his

palette to black and white, Kline made his brushstroke convey with un-exampled directness the surging moment of creation. Because his great ciphers seemed so immediately the product of bodily action and the movement of his brush, Kline's art seemed to express perfectly the idea of gesture and action in painting as value (plate 2). That such a stark and heroically reduced means could communicate with plastic authority and encompass the most complex visual meanings in the interplay of forms has been one of the enduring revelations of Action Painting.

The diversity of temperament and the range of expression among the emerging Abstract Expressionists dispel the charges so often made by popular journalists that the movement was narrow in its range of artistic personality and specialized in means. It would be difficult to conceive a more violent contrast to Kline's declamatory rhetoric than the quietist and searching mood of Philip Guston's painting. An effective romantic traditionalist in the late 1940s, Guston experienced a change of style around 1950 that was very much in the pattern of many leading artists of his generation who found for them-selves an unsuspected originality in the new style. He brought to abstract painting striking attenuations of form, a compensating richness of texture that bound structure to the palpable density of the pigmented surface, and qualities of probing intellect. His tortuous, slow-moving brushstroke suspended and visibly prolonged the action gesture, extracting from it a fresh repertory of subgestures and meanings. Hesitations and doubts were recorded in the motor activity of painting and allowed to stand as expressive signs of an evolving drama of chaos and order, disquiet and calm. The coagulant signs of worked surface left in paint could be read, reductively, as a process of forming with color-matter, or legitimately enriched with highly charged existential mean-ings. Guston's intensely single-minded vision, his reliance on a severely limited range of paint marks and shapes, compelled an exhaustive scrutiny of form in its palpable reality. The very specificity of his paint detail, although an expressive means rather than an end, nevertheless represented an instinctive personal program, it now seems, to preserve for painting something of its original value as expressive language. There was a noticeable shift in American art during the middle of the 1950s toward concentration, intensity, and intro-spection, perhaps in part to offset the looser rhetorical flourishes and shallow-ness that were becoming increasingly noticeable among the proliferating fol-lowers of Abstract Expressionism.

James Brooks is another of the greatly endowed second wave of major Abstract Expressionist artists who reached a mature style around 1950. He

absorbed the innovations of Pollock and De Kooning into a personal manner but broadened and smoothed out something of their expressive individuality in a more consonant and representative art of unerring formal harmony. An inward note of imperturbable felicity rings as true in his painting, of whatever period, as it does with such noble calm in the art of Braque. Brooks is a painter whose emotions find their deepest expression in an impeccable sense of proportion and in an appreciation of measured quantities of tone, line, and color value. Even when his forms in recent years became more provisional, his attack blunter, and his colors muddied, these intensified conditions of difficulty he set himself only made his powers of formal resolution more immediately apparent. Like so many of the artists of his generation, Brooks is driven to work at the undefined margins of current styles to escape his own formulations and the dangers of mannerism. In recent years he has moved away from the activism of surface and virtuoso brushwork of the conventional Action Painting style which he helped to establish, and identified himself with the new and more impersonal currents that utilize large unmodulated shapes and closely valued color contrast over uniform areas of surface (plate 3).

Conrad Marca-Relli also found a second maturity and creative fulfillment in the early 1950s within the new style of Abstract Expressionism. For most of the past decade he has worked with a combination of toughness and grace, in the electric manner of whipped lines, torn shapes, and smeared color that Pollock, Hofmann, and De Kooning had first released in American art. Using cutout canvas shapes attached to a canvas base with a black glue line that both demarcated and blurred their separate identities, Marca-Relli developed new and dramatic modes of juxtaposition and structure in an original collage idiom. Qualities of the elementary mixed with refinement, and, in an early figurative mode, metaphysical allusion poetically transformed the brute physical fact of his torn and reassembled canvas fragments. His attachment to the figure may have been sanctioned by De Kooning's "Woman" series, but the gravity of his image had more to do with De Chirico's manikins, from whom they borrowed their khaki colors, misarticulated anatomies, and stately presence. After working in white plastic construction and then, in recent years, with sheets of aluminum (plate 4), Marca-Relli has invented a new form of relief-painting in light aluminum sheets that gains a more ordered and precise definition of image within a rigorous formal scheme. These elegant and chaste constructions make obvious contact with hard-edge and geometric abstraction. Despite their Constructivist control, they retain the resolutely hand-

fashioned quality, the refinement of tonal relationship, and the ambiguities of structure and intellectual content of his more spontaneous early manner.

From the late forties to the middle fifties De Kooning was the dominant force in American painting, providing a dictionary of vital pictorial ideas and a point of departure for new explorations. Pollock's liberating energies and formal radicalism gave him the status of cult hero for the young artists, and his untimely death in 1956 expanded his legend. But his direct influence was negligible until the deeper meanings of his style later became apparent. It was De Kooning's technical fluency, his aggressive onslaught on heroic figurative styles and tradition, and his grace within a pictorial environment of violence that directly affected his own and a transitional generation of younger artists. The open De Kooning "image," with its repudiation of "style" and studio professionalism, left room for the refined lyricism of Jack Tworkov, the structured fluencies in paint and collage of Esteban Vicente, and distinct personalizations of his idiom among an emerging crop of brilliant young painters — Larry Rivers, Joan Mitchell, Grace Hartigan, and Alfred Leslie, among others. Their manners were too abrasively individual to be homogenized in a school, in the academic sense, yet sufficiently representative to give De Kooning's brand of Abstract Expressionism the solidarity and authority of a genuine movement. As Harold Rosenberg has noted, with his usual percipience, in *The Anxious Object,* vital art movements release rather than stereotype individual energies: "In the shared current individuality, no longer sought for itself, is heightened Far from constricting the artist's imagination, the movement magnetizes under the motions of his hand insights and feelings from outside the self and perhaps beyond the consciousness."

As Abstract Expressionism gained currency in regional centers, it seemed identified almost exclusively with the physiognomy of the De Kooning painting, whether abstract or figurative, and for a long while the important innovations of another widely divergent group of pioneer abstractionists were sequestered and denied their full impact. The painters Clyfford Still, Mark Rothko, Ad Reinhardt, and Barnett Newman, to be joined by Adolph Gottlieb after his pictograph phase, created new forms of symbolist abstraction which have become as decisive an influence in the 1960s as the De Kooning manner was in the 1950s. Although they openly rejected the methods and aims of Action Painting, there were strong ties between the two groups of artists, quite apart from intimate personal associations.

In the constellation of painters identified with De Kooning and Pollock, Action Painting presented itself as an art of passionate gesture, mobility, and

large liberties. The painting could be understood as the record of an act, for the vital signs of personal involvement and spontaneous invention were left conspicuously visible. The artist's subjective involvement in the creative process was also conveyed by allusions to mythology or to an internalized imagery, and in the case of De Kooning by bold references to traditional figuration and the grand manner. By the late 1940s, however, the charged expressive brushwork of the orthodox Action Painters and their vehement emotional accents had significantly given way to breadth, refinement, and objectivity.

Pollock's open drip paintings canceled pictorial incident and evolving images in a field of uniform accents. As disrupting image fragments or points of psychological stress and violence in paint handling were submerged, the over-all effect of the painting gained in importance. The entire evenly accented painting rectangle achieved a single effect, or totality, and arranged itself in the eye of the beholder as one palpitant, shimmering whole. With this development came an increase in scale, and thereby in impressiveness, with the effect that in addition to operating as an absorbing spectacle of gesture, the painting seemed to expand beyond the limits of the frame, putting the spectator in a total environmental situation. Pollock's great paintings of 1949 and 1950 and De Kooning's monumental works such as *Excavation* and *Attic* of the same period are not to be read merely as gestural display or virtuoso performance; they are too large, profound, and deeply meditated structures for a restricted reading as expressionist outbursts. They represent modes of dealing with an environmental situation, as were Monet's late water landscapes in a more passive and optical manner; their enlarged image and sheer physical extension erase the boundaries between the work of art and the space we occupy.

But the interest in a uniform pictorial field and a monolithic kind of pictorial order were already apparent in the paintings of Still, Rothko, and Newman, whose art disengaged itself from drawing, the destruction of forms, and personal gesture, and stood, in the late 1940s, at the antipodes of energetic Action Painting. Where Pollock and De Kooning achieved spatial envelopment by the acceleration and fragmentation of form and image, these artists gained a potent expansive force by the deceleration of small variegated forms into dominant islands, zones, and boundless fields of intense, homogeneous color. In place of motor activity, illusionistic and optical ambiguities were employed to express qualities of momentariness and changefulness, for such emphatic expressions of order and intellectual control required them to maintain contact with contemporary sensibility.

Some of these significant changes, in a transitional form, can be read clearly

in Adolph Gottlieb's *Duet* (plate 5). There is a split between linear activity, the sign of the hand's aggressive passage, and a more passive mode of visual perception. Action in the sense of free movement is countermanded by a different demand on the receptive faculties and a slower rate of digestion of the painting's components. The bottom half of the painting has the hurried tempo and helter-skelter randomness of Action Painting, but the pair of flat, glowing orange disks above manages an arresting kind of stability. The imagistic powers of the matched disks hold our attention; their color and the background color are so close in value that our eyes can scarcely tolerate their slight differentiation and struggle to resolve the dissonance. Color shifts have taken the place of drawing as the vital "action" of the painting, and turbulent, coiling lines form a recessive, ghostly counterpoint: these lines are mutants of superseded expressionist form in transition from their familiar content of freedom and decontrol to one of geometric stabilization.

Barnett Newman's immense red color field in *Vir Heroicus Sublimis* (colorplate 6) deals with pictorial decorum in an even more radical way. The familiar agitated spatial movement and self-referring signs of Abstract Expressionist painting are eliminated and grandly solemnized by a complex pulsation of high-keyed color over a pictorial field of vast expanse divided by four fine vertical bands. These fragile and oscillating stripes play tricks on the eye and the mind by their alternate compliance and aggression. Brilliantly visible and all but subliminally lost, they produce curious retinal afterimages. Their cunning equivocation quite subverts the concepts of division and geometric partition, as if ideas of uniform space and mechanical analysis in a series were being swallowed by a new intuition of total experience. In this powerful and transfiguring visual drama, which has been aptly characterized as "the abstract sublime," the enormous expanse of red becomes numbing to the ego, as any "oceanic" experience in nature moves us off our ego center; at the same time the experience is mentally rousing, since problems in visual interpretation are posed and require mental alertness. Newman's sources are momentary, despite his insistent geometry, and they also include psychological content. His art, indeed, defines the limitations of intellectual control by analysis, and acknowledges that we are made and remade by each succeeding moment of experience.

The five dividing lines in the painting seem to pass through it from somewhere outside the field. Framing edges act as a camera finder, isolating a part of a larger visual whole. Symbolically and in sheer physical expanse, the painting forms a bridge between ourselves and a total environmental situation. Paradoxically, monumental scale invites an intimate sense of involvement: We

cannot back off from the painting, or ever quite take it in in its entirety; it escapes us even as it envelops, drawing us into its orbit and forcing us to identify with its uncompromising and aggressive chromatic life. These paradoxes and ambiguities deny the Constructivist gridiron order and substitute a more integral vision for mechanical analysis. If Pollock's art may be said to have demythologized Surrealism, Newman's made the doctrinaire absolutism of geometric painting so problematic as to be no longer tenable from the contemporary point of view.

The rigor of form, mechanical handling of surface, and problematic character of Newman's painting seem immediately related to the "antisensibility" painting of a whole school of younger abstract painters today, and to the bright, unmodulated surfaces of a number of Pop artists. Something of the same calculated insensitivity, directed to a higher artistic purpose, was also apparent in the paintings of Clyfford Still, whose preferred forms were organic, or biomorphic, rather than geometric (plate 7). His space-absorbing areas of homogeneous hue, whether bright or somber, his destruction of Cubist structuring and linearity, and his rejection of facility in handling — all have had their considerable impact on the course of American art. In certain areas he was prescient and profoundly influential. Sam Francis's dripped, liquid paint applications (colorplate 7) owed something to the controlled accidents of Pollock's characteristic spatter technique, but when in his early style Francis massed his congested and dribbled kidney shapes in curtains of luminous darkness, relieved by the marginal activity of brilliant touches, his main debt was to Still. As early as the mid-1940s Still had experimented with radical chromatic reductions, pushing color expression close to invisibility by loading his canvas with opaque blacks and purples, and keeping in play only a thin and aberrant fluctuation of bright spectrum colors at the extreme edges of the canvas.

The reduction of chromatic expression to near invisibility has occurred in the 1960s most dramatically in the black canvases of Ad Reinhardt. His segmented compositional grids are so dark and even in emphasis that distinctions of form and color require the most intense scrutiny to be discovered. Yet the almost imperceptible movement the eye is allowed from one Gestalt structure of geometric shapes to another, and the shifts from color to its absence, reconstitute, in quintessential expressive form, ideas of change and stability, activity and quiesence that are at the heart of the most significant contemporary expression. The singlemindedness of Reinhardt's means and the uncompromising severity of his impassive icons and their painstakingly worked surfaces are the most extreme example of purity in contemporary American painting. In their

context of renunciation and austerity, the faint tremors of personal sensibility, as they can be discerned under proper light conditions, register with added force and poignancy (plate 8).

More than any other artist of his generation, Reinhardt has proven prophetic of the "cool" and "minimal" abstract painting of the sixties. His mood of renunciation and denial, his tireless insistence — both in his art and in his inspired "art dogmas" — on a scheme of values perhaps more congenial to the Eastern mind, admiring of vacuity, repetition, refinement and inaction, support and confirm the most radical nonobjective painting of today. The wonder is that Reinhardt was able to adhere strictly and steadfastly to his ascetic principles, to uphold his personal orthodoxy and to continue viewing art in its sacred and essential function against the mood of the times which so strongly favored a drama of personal crisis, existential values, and emotional release. After operating more or less underground in the fifties, his reductionist, symmetrical, standardized, and even academic art emerged to sanction the explorations of a radically objective generation, and served as an antidote to the spontaneity, decontrol, and subjective storm and stress of the Action Painters. His black paintings, since 1952, with their subliminal visibility and uniform design are even less "interesting" or engaging, by way of surface detail or pictorial dynamics, than those of Barnett Newman, whose example has also had a profound impact on the new generation. Reinhardt's statements in negation of expressionist positions and extraneous personal factors in art have given an additional programmatic value to his absolutist orthodoxy. While he has no direct imitators, or a "school," his rejections have made a significant difference in clearing the way for new ventures and innovations.

In an article in *Art News*, "Timeless in Asia," he wrote: "Nowhere in the world has it been clearer than in Asia that anything irrational, momentary, spontaneous, unconscious, primitive, expressionistic, accidental or informal, cannot be called serious art. . . . The forms of art are always preformed and meditated. The creative process is always an academic routine and sacred procedure. Everything is prescribed and proscribed. Only in this way is there no grasping or clinging to anything. Only a standard form can be imageless, only a stereotyped image can be formless, only a formularized art can be formulaless." One might add by way of a qualified objection that while the "crisis" aesthetic of De Kooning and his hyperactive, seething surfaces seem diametrically opposed to Reinhardt's quietism and expressive restraint, the two artists can in fact be related by the radical extremes of their separate positions. Both seem determined to test, respectively, the expressionist and

doctrinaire abstract modes they inherited, and to redefine them in vital contemporary terms — De Kooning by his wide inclusions, and Reinhardt by his sharply restricted pictorial means. On the other hand, at some far point, their contradictions do meet. De Kooning throws away "personality" in the working process through grand and wasteful expenditures of energy, as much as Reinhardt dims and strangles it out of existence by a kind of puritanic self-withdrawal and a suppression of the signs of individual authorship. Both forms of expression, representing the antipodes of current American art at its most mature level, are equally viable, universal, and as applicable to the historic art process as the ancient dualisms of mind and matter, romantic and classic, the rational and the irrational, or — to give the dichotomy a more contemporary resonance — pure and impure.

Perhaps the most intensely personal style constructed on a basis of renunciation and self-transcendence has been that of Mark Rothko, one of the most original of the pioneer abstract artists who emerged in the early 1940s. His thin sheets of veiled color of roughly rectangular conformation strike the same sustained note of even burning intensity that the color fields of Newman and Still achieve, but his surfaces make more concessions to a traditional sensuousness and to poetic sentiment. The edges separating Rothko's sparse color blocks and the distinctions between slablike figure and field are left deliberately hazy to allow room for expansion and for those multiplying internal relationships that generate new metamorphic life within a structure of utmost simplicity (colorplate 14). Rothko's colors run toward intolerable brightness or dark and muffled hues of subliminal refinement; his art is emotional and Impressionistic, responsive to the tremolo of sensibility rather than to concept or program. Within a generally moderate scale that mediates between the intimate easel convention and the monumentality of mural painting, his paintings convey a grandeur and solemn impressiveness unique in American art.

Although his intensely personal idiom seems remote from current modes, Rothko's technique of using paint as a dye, dissolving its paste in thin washes that leave the canvas weave exposed and aesthetically active, profoundly influenced the new directions of abstract painting. Pollock and Hofmann had soaked liquid or thinned paint into unsized canvas, minimizing the pressures of hand, and Helen Frankenthaler in the early 1950s began to work consistently with diluted solutions of soft luminosity. Her development of this technical innovation into a strongly personal idiom (plate 6) is clearly the direct, immediate link to the abstraction of Morris Louis. Rothko, however, had already disassociated his art from the material paint densities and traditions of pig-

ment manipulation followed by the majority of Action Painters, and the weight of his prestige, more than any other's, opened American painting to such new technical and formal possibilities.

By age and origin Morris Louis should be associated with the great innovating generation of Pollock and Rothko, with whom he shares many formal characteristics. But his main impact is on the present moment. A patent anonymity of style and an emphasis on optical dynamics released new energies or confirmed them among a younger group of underivative artists. In his first mature work, in 1954, Louis flowed thin films of plastic pigment on unsized canvas to form overlapped color constellations reminiscent of Action Painting. However, the even consistencies and the transparency of his diaphonous color veils, their slowed velocities and relatively indeterminate flow — defining edges were formed cunningly by the natural process of drying rather than by expressive inflection of the hand — paralyzed the urgent and directed expressiveness of Action Painting. Individual color notes detached themselves with an extraordinary limpidity and distinctness from a swarming melee of color shapes despite their chaotic intermingling and accidentalism. Pollock's spatter-and-splash technique was magnified and played back in slow and disembodied motion, with an extraordinary new emotional reserve. In *While* (1960 — colorplate 9), transparent overlays of color have given way to open and clearly differentiated ribbons of distinct hue and shape. These elegant waving tendrils of brilliance are no longer the servant of an internally motivated expression but set off a chain reaction of objective phenomena that drastically curtail the role of artistic intervention. Paradoxically, color gains a richer role as its energies are liberated from "handwriting," palpable material texture, and emotional accent.

Louis's formal exposition, in effect, shifted from the first to the third person; color was given an autonomous function and treated as a new fact. The mistrust of a personal "handwriting" in painting corresponded to the suspicion, voiced by the French novelist and essayist Nathalie Sarraute, of object-symbols steeped in personality which can no longer be considered reliable facts and thus may deceive us. Like the French novel and films of the New Wave, American art in the 1960s turned away from human psychology to a radically objective view of reality. In the process of releasing new color energies, Louis isolated and codified the gestural liberties of Action Painting, transforming their characteristic function and content within a new iconic form. Impulse and anxiety yielded to a mood of experimental objectivity, renewed respect for ordering intelligence, and personal disengagement. By giving accidentalism a more sym-

metrical configuration, particularly in the centered and closely bunched color stripes of his last years, Louis established within the general Abstract Expressionist aesthetic a new union of impersonality and high style. In their simplicity, sensuous fullness, and ambition, his paintings belong to Abstract Expressionism; their optical dynamics and reserve pointed the way for a new generation.

The great generation of Abstract Expressionists built its new traditions at least in part by testing received pictorial forms and ideas, whether of Cubism, Surrealist automatism, or geometric painting, and pushing them to a point where they reversed themselves into originality and fresh content. Today, a younger generation has worked the same aesthetic strategy on the established reputations of its time and place, testing and adapting to its own purposes the innovations of the Abstract Expressionists. The principal novelties that have come forward in the past decade can generally be classified under new orders of abstraction and new forms of realism, two modes which often converge and augment each other. There has also been a significant cross-fertilization between pictorial and sculptural forms and materials, breaking down the traditional distinctions between the mediums.

One important source of the new abstraction is the color-field painting of Newman, Rothko, and Still, and their sense of the total environmental situation. Joseph Albers provided another precedent for the revived concern with optical and perceptual problems within a rudimentary geometric pictorial organization (plate 9). The schismatic forms of a swiftly changing abstraction are alternately free or meticulously engineered, and its range of effects extends from pure color expression to the virtual exclusion of color, to the end of enforcing literal object qualities rather than the illusionistic properties traditionally given to painting. The New Realism includes assemblage and incorporates objects or their fragments in varying degrees of intensity; one of its most significant variants is Pop Art, which draws on the imagery and techniques of commercial art and popular culture for its content and visual impact.

A natural line of descent for the recent abstract painting can be developed from Rothko, Still, and Newman through Morris Louis to Kenneth Noland, Ellsworth Kelly, Frank Stella, Al Held, Raymond Parker, and Jules Olitski — some of the leading younger painters who seem bound by common methods, although their individual styles may vary greatly. A number of them use emblematic forms, others expanding color fields or color shapes amorphous in character. All are aware of the formal, psychological, or perceptual content of ambiguity in art, and their handling of surface is relatively mechanical com-

pared with the conspicuous intimacies of touch of the older generation; but the terms "mechanical" and "anonymous," which have been used to describe these artists' style, are deceptive and inadequate. Many of the features of abstract painting have had a coincident development among the Pop Artists. Robert Indiana and Roy Lichtenstein, particularly, and Tom Wesselmann and James Rosenquist create forms that are bright, flat, and ambiguous in their expansive powers. All these artists, at either end of the realist and abstract spectrum, take an anti-expressionist, disinvolved, and "cool" view of their artistic means, and the process of the creation is masked rather than exposed. Dadaist and anti-art tendencies also have assumed a new importance in abstract art and Pop Art, not as the agent of personal disorder but to redefine the values of art in the context of the materialism and shifting technologies of modern life.

Kenneth Noland's concentric circles and parallel repeating chevrons contain in a system of some rigor the sensuous brilliance of his saturated color surfaces. His technical method of staining and his color key derive directly from Morris Louis, but the artists otherwise are widely separated both by temperament and pictorial goal. In Morris Louis' floral paintings and color columns, evidence of accident as a fact or natural occurrence beyond the individual's management and control remained residual. Louis let paint have its way with him, up to a point, in the interests of pursuing complex and proliferating sensations, whose individual notes and their intermingling were relished with an almost extravagant symbolist delight. Noland is intellectually more rigorous, a sensationalist operating in a situation of ambivalence who must answer to the pressure for order. His emblematic signs create a remorselessly circumscribed yet ambiguous situation that keeps our attention intensely occupied in a problematic dualism of structure and sensuous elaboration. Louis's art is primarily lyrical, despite its color density and condensed form; Noland's art deals with lyrical sensations in the context of a stressed formality. He insists that we stay hypnotically within the repeating circles and angles of his painting, and excludes associational subtleties. His formal explicitness is relieved, however, by the soft luminosities of thinned plastic pigments, so that an alternating current is established between focus and dispersion, between concentration within his emblem form and the resonating expansion of color forms to the limits of their field. The use of thinned pigment is another variation on modes of dealing with the problem of movement on the flat modern painting surface. As paint sinks into the canvas weave more readily, its color brilliance must be pitched higher to draw it forward and restore a lively oscillation in depth (colorplate 10).

Ellsworth Kelly's flat, swelling color shapes also obey a rigorous objective

rule. They are scrupulously clean of detail and surface irregularity that would betray the individual hand; the result is not mechanism or nihilism — the same applies to Noland — but a *new* kind of sensuousness, no matter how it may seem to frustrate traditional understanding of that term. The sensuous reserve of both Noland and Kelly is a defense against the rhetoric of personal engagement of Abstract Expressionism, a campaign for them long ago concluded and no longer compelling. In Kelly's *Blue-White* (colorplate 8), figure and field themselves become tangible realities and simple facts, owing to their sharp definition and contrast. Yet they are ridden by ambiguity and curious tensions: their vast expanse is balanced at fine tapering points; curved edges flatten as they begin to bulge, absorb each other as they establish their separate identities. The painting is a feat of equilibrium, of force met with counterforce, to the end of creating many levels of arrested action and movement. The interplay of legibility and confusion, visibility of the fragmented shape and its absorption in the total visual field, as well as the imposing scale of the work, derive directly from Abstract Expressionism. Indeed, the apparent elements of control — machined edge, flat color, saturated surface — are precisely those that express in a fresh, contemporary way the problem of individual freedom so integral to Abstract Expressionism, for the painting is conceived as a living and unfinished situation, involved like ourselves in a ceaseless process of movement, development, and change. Noland's concentric circles or parallel angled bars of color also show an appreciation of self-renewing images whose geometric stability is only as important as their capacity to continue the painting's action indefinitely.

New experiments in activating closely valued color areas of high brilliancy or repeating geometric patterns that the retina cannot tolerate and seeks to merge and mitigate by making more comfortable alternate configurations dominate the expanding international tendency of optical abstraction. The European master Victor Vasarely and the American Joseph Albers have pioneered in this mode, which stems essentially from the formal canon of the Bauhaus, from its assault on sensuousness and its devotion to anonymous authorship and scientific discipline. An entirely contemporary emphasis on visual and psychological dynamics, however, has given optical abstraction a striking originality and relevance to contemporary concerns. The mode duplicates on more impersonal levels the obsession with identity that in so different a manner characterized Abstract Expressionism, but reduces that essentially romantic quest for self-definition to a more elementary perceptual and formal problem solving. In the optical manner, symmetry becomes mobile and ambiguous and images split

the eye, inviting and then frustrating the mind's tendency to unify forms in a single, simple pattern. At its best, in the very recent work of Ellsworth Kelly, optical abstraction combines lyricism and violence. Despite an almost programmatic insistence on anonymous authorship, the new painting manages to communicate both an extraordinary formal power and a mysterious psychological resonance of effect as it drives art beyond what may be safely known or predicted about the conflicting pulls of formal and chromatic contrarieties on the senses and the mind. It is an art of geometry and mechanism perhaps, but born of tension and aimed aggressively at its audience; it thrusts upon the spectator equivocal and demanding visual choices that admit of no facile solutions.

The adoption of starkly ruled line and definite means to achieve open and unfinished statements is also apparent in the vibrant optical paintings of Richard Anuszkiewicz (plate 26) and Larry Poons (plate 27), whose resonating afterimages and light halations transgress and energize geometries and color dots set against fields of saturated hue; the relations between fluctuating form and ground is as unresolved in their case as are those in Action Painting. The elements of implied movement and kinetic energy which have become such important factors in optical painting also work literally to create brilliant luminosities and illusionistic figures, which a critic has compared to St. Elmo's fire, in such electronically programed "tangible motion sculptures" by Len Lye as *Fountain* and *Flip and Two Twisters* (plate 28). The energies of contemporary art seem increasingly able to transcend traditional divisions of mediums which formerly stabilized the boundaries between motion and static image or, for that matter, between pictorial illusion and three-dimensional sculptural form.

With more traditional painterly qualities, Raymond Parker's enlarged color masses cast a fresh light on the pictorial problems first raised by Rothko's art. Parker builds his simple, balanced color slabs so that they both subtly fuse and stand apart from each other in estranged solitude, asserting their individual presence (plate 10). They are architectural elements, and subtle actors in a drama that balances solitary identity and association by group or ensemble. That duality is supported, too, by the restrained voluptuousness of a surface which alternately cancels and asserts a personal brushstroke. Parker's ambiguous shapes split our attention between parts and wholes, individual accent and formal stereotype, as a mode of prolonging the painting's action and keeping its developing possibilities open and unresolved. Parker's newest painting disposes shapeless, adhesive color forms in asymetric arrangements that stretch tensely and miraculously toward consonance and uniformity. Jules Olitski

carries the process of reversing the random into order to a far and elegant point of risk-taking, offsetting immense lopsided color shapes of thinned plastic pigment by small bright accents. His art is as reckless in its imbalance as it is circumspect in assigning the exact quantities of color area and intensity required to bring off the considerable feat of achieving a dynamic, plastic equilibrium (plate 11).

Al Held occupies a strongly independent position which combines the reductionism and control of the new abstraction with vestiges of the somatic power, concreteness, and action principle of the previous expressionist generation. His art invests a few bare Euclidian figures with a blunt tremendousness that is a matter of scale, of massive forms which seem as sturdy as construction girders, and of material sensibility. He builds his surfaces up painstakingly over long periods of time, layer by layer, scraping, sanding, and re-covering them with acrylic plastic paint until they stand out in aggressive, sculptured relief. His most recent painting, some 56 feet in length, occupied him almost exclusively for a year; it is a composition of utmost simplicity and evolving subtlety composed in three identical, joined rectangles of circle segment, square, and triangle. The work has an uncanny force, hypnotically communicating both the rigorous formal standards and the obsession of Held's dramatic art.

Perhaps the most seminal painting personality to emerge from the younger abstract generation has been Frank Stella. His repeating, ruled stripes, metallic no-color, and his invention of the shaped canvas have radically challenged the exhausted pictorial conventions and prevailing romantic expressionist sensibilities of the recent past. Stella's art content is kept deliberately low, and his note of monotone is pervasive and insistent, with a severe, astringent formality always in evidence, to a degree which has helped force a fundamental change in artistic outlook. By extinguishing pictorial variety, development, and climax, and thus risking boredom, he tests the public's commitment to the essential and irreducible values of art. His example has been influential in the formation of a new "cool" aesthetic among younger abstract painters and sculptors, and it has led — in conjunction with parallel explorations by Sven Lukin, Charles Hinman, Richard Smith, and others — to a redefinition of the points of contact between pictorial and sculptural media.

George Ortman's seductive painting *The Good Life, or Living by the Rules* (plate 12) is a brilliant demonstration in a minor key of the ingenious modulations of the new geometric and optical abstraction. The title of the painting alludes to order and proportion somewhat playfully and ironically. The actual

construction translates an outlived ideal into viable contemporary experience. Geometric figures take on an enigmatic and magic quality because of their swiftly alternating contexts. Their brilliance of hue and contrast detaches them from the ground of the painting, so that they seem to float free in space, but their afterimage ghosts, echoing their profiles in larger scale, draw them back to the surface. The shapes of the most diversified color forms stand out with the vividness of *trompe l'oeil,* but since they are painted on a plaque of raised relief, this sculptured context cancels their illusionism by its tangible solidity. These modulations in depth and flatness, concreteness and illusionism support a new point of view in contemporary art. The spectator is warned against placing his trust innocently in established pictorial forms or in the simple evidence of perception, and is instead engaged by a circle of riddles in a delightful game of problem solving. The construction looks and works like a child's educational toy but is not so innocent of purpose, for its meaning is educative in the deepest sense: it is a passionate instrument of conversion to a new aesthetic point of view.

The determined ambiguities of the new abstraction act to deny dominance and privilege to any single plastic viewpoint, thus enforcing a greater openness of spirit and a more insistent relativism. These problematic qualities have emerged with even greater vehemence in the controversial areas of assemblage, a new realism, and so-called Pop Art. Somewhere in the background of these new expressions is the figure of Willem de Kooning in the dual role of muse and adversary. Just as Newman and Pollock extended the painting into the environment, either by enlarging its characteristic image or by accelerating its movements, so De Kooning brought another revolutionary insight to contemporary painting in his creation of the "Woman" series, particularly by making a new accommodation with the vernacular imagery of urban life.

His women evolved from a collage method that used commercial illustrations of lipsticked mouths and whole or partial banal images of Marilyn Monroe and other mass-culture female idols. Something of the visual blatancy of the billboard and the impact of commercial culture remained unassimilated in his art, for all its emphatic painterliness. In the same period, Larry Rivers began to reappraise and resume the pictorial cliché in his historically important *George Washington Crossing the Delaware* (1953), a painting inspired by folklore and popular myth. Rivers transformed a scorned and banal theme by expressive handling in the current mode of Action Painting and thus introduced a startling shift in the balance of painting. At the time, his innovation was viewed generally as a brilliant tour de force, for it was difficult to conceive that invention,

in painterly terms, could become a stereotype and that stereotyped Americana would supplant it as an expressive resource. But we see now that Rivers's experiment (colorplate 12) was a genuine novelty and not a gesture of iconoclasm in reverse directed against the exclusive painterly canon of Abstract Expressionism. The visual cliché re-entered American art with a vengeance in the middle 1950s, and a vernacular language drawn from popular sources began to establish itself as an underground movement opposing the subjective preoccupations and the idealism of the period's dominating "high" art.

De Kooning's "impurity" and his inspired raid on the urban environment for imagery and hints of subject matter, his collage technique of lifting transfers of newsprint, and the digressive quality of his vision, with its reliance on external stimuli as well as painterly impulse, sanctioned Rivers's experiments. But Rivers pioneered in introducing recognizable subject matter in far more explicit terms than had De Kooning, when such adulterations of abstraction were considered close to treasonable among the avant-garde. Subject matter of the commonplace, particularly in the realism of his "Berdie" period and his later representations of themes freely transposed from other mediums, from photographic images and trademarks of commercial products, anticipated and then coincided with the development of similar content which was to have more far-reaching influence transmitted through the art of Robert Rauschenberg. Rivers turned Action Painting from the expression of unique personal experience to a method of standardization, in repeating images. This processing and standardization of pictorial imagery suggested the possibility, in turn, of dealing with a whole new repertory of forms and images taken from popular life and from commercial culture.

Rauschenberg painted in the early and middle 1950s with the free brushstroke of De Kooning's Action Painting but began to load his canvases with rags and tatters of cloth, reproductions, comic-strip fragments, and other collage elements of waste and discarded materials of a Dadaist density. His packed, agglutinated surfaces were worked over with paint in the characteristic gestural language of Action Painting, but painterly expressiveness had reduced powers and prerogatives in the context of an artistic structure choked with alien matter. The intensified use of sub-aesthetic materials called into question the hierarchy of distinctions between the fine arts and extra-artistic materials drawn from the urban refuse heap. "Junk art" gathered momentum in the late 1950s and was given added emphasis in the conglomerates of rusting boiler and machine parts of Richard Stankiewicz's sculpture, in the surfaces of splintered wood and plastic of Robert Mallary, and in John Chamberlain's crushed and

shaped auto-body parts. Allan Kaprow, one of the prophets and advocates of literal experience in art, proposed "a quite clear-headed decision to abandon craftmanship and permanence," and "the use of obviously perishable media such as newspaper, string, adhesive tape, growing grass, or real food," so that "no one can mistake the fact that the work will pass into dust or garbage quickly."

The junk materials that Rauschenberg and others incorporated into their work had, of course, a subversive content in glorifying what is destitute, outlawed, and disreputable. Such strategies not only posed questions about the nature of the art object and the integrity of the medium but commented on the social context of city life and mass culture which gave rise to such assimilations. Rauschenberg radically deepened the alliance with the image world of popular culture and with artifacts of daily life by inserting Coke bottles, stuffed animals, rubber tires, and miscellaneous deteriorating debris into the work, and against these intrusions painterly qualities and the fluid formal organization of Abstract Expressionism operated. Unlike the poetic objects of the Surrealists, his debris was not calculated to shock by its incongruity primarily; its associational or fantastic meanings, in fact, were minimized. Junk and artifacts were used in an optimistic matter-of-fact spirit; if social commentary was part of their content, it was on an elementary and unspecific level, referring to nothing more than the life cycle of objects in our culture and their rapid decline into waste as the flow of new goods pushes them aside.

The periodical nature of that culture legitimized Rauschenberg's inventions and assimilations of decaying objects, which were given a new role and active purpose within the developing work of art. Ladders, chairs, and other objects — whole or in part — were attached to paintings without transition other than the passage of paint over them, and thus the dialogue between art and everyday reality was kept open and unresolved. Paint itself was given no position of special privilege but treated as a physical fact among others and as surface cover, thus subverting the gestural handling and spontaneity of Action Painting even as it was imitated or parodied. As Rivers in a sense mechanized De Kooning's fluent graphic notation into an instrument of uniformity and repeatability, so Rauschenberg directly took over Rivers's sensitive scribbles, washes, and erasures, in his own transfer drawings and rubbings particularly, to further empty sensibility of personal content. By a process of depersonalization, the individually inflected language of gesture in drawing and painting became hypertrophied and merely symbolic of a certain class of activity, and objects or mechanical reproductions gained a vivacity, energy, and inventive poten-

tial they had never known. More recently, Rauschenberg has used images taken from illustrated journalism, mechanically registered on canvas by silk-screen reproduction, as a method of further challenging the idea that uniqueness is indispensable to contemporary creation (colorplate 11).

The innovations of Jasper Johns have had an even more far-reaching influence on the radical changes that took place in the 1960s. His historic paintings of flags and targets, first exhibited in 1957, and subsequent maps, rule-and-circle devices, and other subjects created radical new forms of representation from a functional or commonplace imagery. Many of his references elucidated the creative process itself, in a do-it-yourself spirit, breaking down and isolating its elements of illusion and literal fact, the visual and the tactile, and inviting the public to restructure the magical unities of aesthetic experience. Johns's American flags in particular showed new and startling possibilities of image elaboration by making over the devalued currency of visual clichés which have become merely formal and empty of content due to overfamiliarity. The commonplace is an effective instrument of art because we are visually blind to its possible meanings; its content includes the apathy which the spectator brings to it. Any dramatic alterations of a cliché gain an added force from the element of spectator surprise and from its low credibility as a source of fresh experience. As Abstract Expressionism and its cult of unique and privileged experience became commonplace by repetition and dispersion, the commonplace image took on fresh qualities of fantasy and expressive life.

Johns's first characteristic and innovative image was the target. In two separate versions, fragmentary painted casts of body parts and a repeated partial mask of the face were set in a series of boxes over a centered bull's-eye (colorplate 13). The sober formality of his hypnotic bull's-eye and the subdued human associations of his casts created a powerful interplay of thwarted alternatives; human feeling was suspended, in effect, between the waxworks and a severe geometry, the body's cage and a mental prison, and either image system proved curiously opaque and enigmatic. One expected to be able to decode messages from secret regions of the psyche, but they were effaced in "impersonality" in the received and sanctified modern fashion.

The sense of averted and hidden meanings link Johns's constructions to Joseph Cornell's more personal box constructions (plate 14). Cornell's Victorian poesy and riddles echo the preoccupations of another generation, for whom the free associations of Surrealism provided a liberation. Johns belongs to a new age of dissociation of thought and feeling, and his inventions deal more rigorously with the work of art not as an object of sentiment or fantasy but as a

problem in formal structure and meaning. From his constructions have evolved, however, a host of mysterious object ensembles in boxes and containers that invite examination at close quarters and depend on unexpected Dadaist displacements of shape, texture, and function. Often the observer is invited to alter the arrangement or organization of such ensembles, in the spirit of both play and discovery, as for example in the boxes of George Brecht; such games of chance are related to the elementary problem solving of Ortman's abstract construction described earlier, which in turn derived directly from Johns's ambiguous language of signs.

Robert Morris' recent lead plaques (plate 15) with appended wire, metal scrap, measuring rules, or words taken from Marcel Duchamp's notes in *The Green Box* for his *Bride Stripped Bare by Her Bachelors, Even* are an homage both to "chance" and to Johns's leadership in converting impossible substances and surface textures into art. Lucas Samaras' more aggressive boxes are beset and booby-trapped by massed common pins and razor blades, as well as by delicate shells, stones, bits of colored glass, and assorted paraphernalia of sensuous mystery and childhood memory (plate 13). The Surrealists' love of the enigmatic and the occult contributes to the atmosphere of Samaras' construction, but so, too, does the action principle of postwar American art, with its conviction that art and life must be conquered dangerously, each by means of the other. Objects that wound or threaten and coarse yarn in unsubtle primary colors explode his private dream world of exquisite sensation and ingenious calculation. The work of art as a secret refuge of personality or as a nostalgic collection of treasured trophies is transformed by the act of risk-taking at more significant formal and expressive levels.

The mixed sculptural and drawing modes, the interplay of literal object and pictorial illusion in the lifesize manikins and *tableaux vivants* of Marisol are also very much indebted to Johns. Marisol's brilliant theater explicitly makes use of autobiography; self-portraits and fantasies enter freely into the work and are a major feature of it. The artist is her own hero, but she emerges in fiercely alienated form in arbitrary or hallucinated images strangely dissociated from feeling. To be able to view oneself as a spirit object or as a kind of fantastic human furniture is the far-out point of impersonality of Marisol's weird and powerful sculpture. Apart from herself, American folklore and the hipster world are the principal targets of Marisol's magical transformations and very considerable formal ingenuity (plate 16).

Johns's art has not only brought him into contact by inference and representation with the world of things but actually converts whole objects into artful

facsimiles. His beer containers and Savarin coffee can with paint brushes are painted casts in bronze of actual objects. They differ in intention and impact from the readymades of Duchamp, who has been an important confirmation, rather than a source, of Johns's imagery and irony. By designating a bicycle wheel or a bottle dryer a work of art, Duchamp expressed the artist's sovereign prerogative to make art fit his own arbitrary definitions, and also used commonplace objects to launch an attack on the pretensions of museum culture. Johns concerns himself to a much greater degree with the old romantic game of illusionism. In contemporary terms, his art acknowledges in a manner different from Duchamp's the distinction between the work of art as a unique creation and its current devaluations by reproduction and mass culture. Individuality of touch and "fine" handling remain a marginal and furtive activity in Johns's sculpture "combines"; the facsimile object enters the context of art by reason of its expressive and artful painted surfaces, in which we recognize the operation of traditional sensibility.

Jim Dine occupies a unique position among the artists emerging after 1960 who have been associated loosely, and in his case erroneously, with Pop Art. His paintings with object attachments and his environments have an abrupt, seizing power that rebukes the indirection and muted poetic sentiment of his first mentor, Johns. Dine extends the paradoxical play between literal experience and illusionistic representation by regenerating, with a rivaling skill, the painterly direction of Action Painting, then assimilating it to a wide repertory of objects rich in human association of personal use or admired strength (colorplate 15). His household furniture, portions of room environments, bathroom cabinets, tools, and, most recently, palettes and robes are meant to be enjoyed for their expressive power within the formal scheme of his constructions, and are not underscored for their scandalous potential. They do strike an overt aggressive note (an ax plunged in a plank, a saw bisecting a blue field of paint) and release sexual fantasy. His unvarnished directness and mechanical resourcefulness are in the American grain, more related in temper to David Smith than to Johns, and thus free of the hermeticism that is one of the liabilities of Johns's style for many of his followers. Dine's purposeful unsubtlety has been characteristic of the mode of realism in the past whenever a preceding style tended to become ritualized or confined by a particular individual sensibility. His almost programmatic "brutalism" is, however, only one note in a virtuoso range of effects that includes an exquisitely controlled draftsmanship, powerfully expressive color, and the skilled mastery of large expanses of evenly accented surface, as the occasion may demand.

Claes Oldenburg is another artist who occupies a special position by reason of his inventive re-creations and transformations of the object. His wide-ranging interests and energies make him one of the most important innovators of the 1960s. He was educated to Abstract Expressionism but broke with that movement around 1959, opening paths to a variety of new expressions, including Pop Art. He originated (with Allan Kaprow, Jim Dine, and Robert Whitman) the "happening," which extended Action Painting into a form of spontaneous, expressionist theater, but he is best known for the gigantic ersatz food in painted canvas and plaster which he evolved after 1960. The surfaces of these bloated, dropsical facsimiles of the lunch and drugstore counter were freely handled in the splatter-and-splash technique of Action Painting, but the reference to their real-life models was inescapable. A repeated emphasis on comestibles seemed rather innocently to draw on the preoccupation of advertising with the infantile oral obsessions of Americans, and Oldenburg's subject matter became the basis of similar themes handled in the more conventional terms of easel painting by Wayne Thiebaud (plate 18) and others. Oldenburg also created a series of free translations of commerical trademarks, among them Seven-Up, in vast enlargement. His themes were the consumer commonplaces of standard brands, but his handling was deliberately chaotic and low in legibility, like Action Painting.

The cult of literal experience that appeared with Rauschenberg's objects became in Oldenburg's hands less diffuse, and focused on sets of objects with greater symbolic depth and meaning. The American food package, by its ubiquitousness and derived associations in the context of advertising, has become a symbol of insatiable craving for gratification. But a synthetic ugliness and anonymity stifle its suggestions. As Oldenburg's formal powers in his very original style zestfully expanded, so did the actual size of his inventions — to the point of farcical exaggeration. His giant hamburgers transformed food into a dream object so outrageous in scale as to seem comical. The aggrandizing impulse of Abstract Expressionism appeared to have run amuck at the lunch counter. Oldenburg's fabrications coincided with Robert Mallary's brilliant abstract reconstructions of clothes and splintered wood slats in grotesque falling attitudes that stood halfway between Kline's calligraphy and the slapstick antics and pratfalls of vaudeville comics. Plastic improvisation and personification augmented each other in a rhetoric so inflated that it reversed itself finally into stage farce.

In recent years, Oldenburg's objects have been renovated and "improved" on man-made nature. A new series of soft telephones (plate 17), toasters, and

typewriters looks freshly manufactured, slick, and grossly opulent instead of overripe or decayed. The object is mechanical, something to be consumed by use rather than assimilated physiologically. It enters the new context of art in a virginal state before it has been caught up in the consumer cycle from use to junk. But these creations are as outrageous as ever, in both their immensity and their contradiction of the normal properties of the things they dissemble. We identify telephones by their hard and metallic qualities, but Oldenburg's are collapsed and baggy shells, all epidermis and no working parts. They seem on the threshold of animistic and magical life but can never quite slip their utilitarian identity, and this fine nuance is their whole point. In fact, like a deflated football, they are objects without a function. By taking them through such a poetic metamorphosis and thus making them useless, Oldenburg associates his telephones, typewriters, and appliances with the art object, which is by definition gratuitous. His dummies and substitute objects create a rich play of shifting identities that enters the very fabric of the art object itself.

The dehumanizing impact of our surroundings supports the uncanny and very moving sculpture of George Segal. It is an art that defies conventional distinctions between sculpture and painting, object and environment, plastic elaboration and poetic sentiment. His human images often seem a vulgar intrusion on a fictional and manufactured reality that takes no heed of man and has no place for him. Segal's ghostly human replicas are pieced together from molds of friends who have been patient enough to leave their impressions in plaster. The surfaces of the forms are freely manipulated, shaped, and expanded by hand in quick-drying plaster, with something of the amorphousness of a Reuben Nakian sculpture. These stolid and insensible dream figures dwell in the lonely limbo created by the bright chrome-and-neon vacancies of a public world of gas stations, cleaning establishments, and mass-transportation vehicles, or occupy the privacy of a home where they tend themselves blindly and absorbedly as animals do, and wait impassively for some external stimulus to move them off dead center (plate 19). The subtly modulated surfaces of Segal's plaster robots are, like Oldenburg's fabrications, quite literally shells. They make no explicit social commentary, and their "message" is their theatrical presence and illusion in an environmental situation. Humanly anesthetized and virtually unmotivated, they simply exist as objects exist. Their most vivid identity and energies are aesthetic; since they are denied the energy of action, they can serve the gratuitous life of the work of art, just as Oldenburg's dispossessed and stateless objects do.

The acute sense of alienation at the heart of George Segal's environmental sculpture has produced other variations on the human figure in the context of contemporary life of poetic intensity and power. Richard Lindner's art translates the theatrical and gaudy parade of the New York street into an intense drama, compulsive in its imagery and patterning. His fantastic realism is balanced by a heightening of abstract design. In *One Way* (plate 20), traffic lights and a striped safety barrier make a formal display of such distracting brilliance that they take on a symbolic function, creating a Disneyland setting for a dreamlike New York scene. The policeman, a brutalized representative of law and order, sets off a lady of the night in fetishistic boots. Perverse and erotic imagery of this genre has broken to the surface in much recent American art with sharp explicitness, just as it has in literature; such content acts as a subversive element and is sanctioned by the insistent prurience of so much commercial advertising which reduces modern man and woman to their sexual identity alone. What was once forbidden subject matter has now become a commonplace which some artists do not choose to ignore or idealize but adapt to their own valid expressive purposes. The difference between Lindner's vicious females and the mechanized sex idols of the mass media is one of formal intensity and emotional catharsis. He carries the routine process of depersonalization of the female to one plausible conclusion, creating a terrifying Freudian maenad who rivals the decadence and animal brutality of George Grosz's Berlin-period prostitutes. Yet Lindner's fantastic creatures are puppets in an aesthetic game whose ground rules have been established by the innovations of a variety of forms of contemporary abstract painting and Pop Art, which they echo and extend.

In the 1960s the increasing rate of technological change and the proliferation of mass communications converged with the diminishing momentum of the Abstract Expressionist movement to bring a fresh kind of American art and a sharper social awareness of the mounting crisis in ideas of individual identity. This crisis had a particular meaning for American artists, even if it has not been systematically articulated by them, for Americans have been subjected more intensively to patterns of voluntary collectivization and conformity, whose symbol is the organization man and whose fetishes are statistics about group behavior and an irrational worship of possessions. One writer has put it that the social center of gravity is shifting and no longer lies in the individual but in the relations between things. The individual's range and power of expression have been further threatened by the stupefying power of mass communications, which make banality a major industry. Never before

has the real world been to a comparable extent reproduced, duplicated, and anticipated by fictions. The acceleration of mass-media impact and its invasion of private areas of experience directly precipitated those new forms of expression known as Pop Art.

The Pop artists take their imagery directly and often quite literally from the billboard, the supermarket, the comic strip, road signs, television, movies, and other popular sources. The public dreams through the mass media, and the Pop artist re-creates mass-man's fantasies and euphoric reality substitutes, exploiting both their associational content and their formal potential in terms of the flat design and condensed sign language modern art requires. The imitative forms and content of Pop Art are the subject of heated dispute among artists of the older generation, especially because it has been charged that they do not expand sufficiently on their visual sources and, therefore, confirm all the mechanical and anti-individualistic tendencies in American life and culture to which the Abstract Expressionists, by contrast, proposed a loud dissent. Since Pop Art is generally too "cool" to be subversive of the established order — a rule to which the explicit eroticism of Tom Wesselman's "Great American Nude" series is the exception — it has also been criticized, not without wit, as the neo-Dada of the age of affluence. The older avant-garde audience, feeling its values threatened, preferred a restricted view of Pop Art as an entertainment. The emergence, however, of a number of strongly individual artistic personalities and their shared patterns of development have made it impossible to ignore this artistic phenomenon or to set arbitrary limits on its expressive possibilities or future growth.

Pop Art made its dramatic public debut in 1962 with the exhibitions of Roy Lichtenstein, James Rosenquist, Andy Warhol, Tom Wesselman, and Robert Indiana. An offending shock was experienced by many artists of advanced tendency and most critics from an imagery that scarcely seemed to transform its sources in the comic strip (Lichtenstein), the billboard (Rosenquist), repeated or isolated commercial brand symbols (Warhol), and montage in strong relief of food products (Wesselmann — plate 21). The more obviously aesthetic intention of Robert Indiana's lettered signs and directional symbols was found only slightly more acceptable, since he, too, took over explicit routine commercial or industrial imagery and presentational techniques. Image banality was matched, in provocation, by the apparent indifference of Pop artists to individualized handling and their uncritical enthusiasm for the bald visual stereotypes of commercial illustration. Mechanical image registration in current styles or commercial art ran strongly counter to the accumulated

store of knowledge, craft, and painterly expressiveness built up by a previous generation. America was prepared for expressionistic rawness in art, but slickness seemed intolerable and meretricious.

With the passage of time, however, it has become clear that the Pop artists are within the bounds of contemporary traditions and can be related particularly to current modes of hard-edge and optical abstraction. Most significantly, their interest in the mass media can now be understood as selective and discriminating. Communications media are regarded as dynamic processes and environments rich in artistic metaphors and meanings rather than as a source of techniques to be slavishly imitated. By monumentally dilating a detail, Rosenquist discovers iconic possibilities in a fragment and creates confusing alternative readings of his compartmented paintings that relate to the ambiguous legibility of contemporary abstraction (plate 23). Lichtenstein slows down the cartoon image by enlargement (colorplate 16), and, by including the Ben Day screen dots conspicuously as part of his configural form, he compels our attention to medium and process as his primary content. Another kind of distance was achieved by Lichtenstein in his choice of somewhat out-of-date comics for his subjects. Modern existence accelerates the movement of time and makes us more sharply aware of changing styles, events, and the obsessional fashions of public life; such intuitions are at the heart of much Pop Art. For a time sense more immediate and telescoped, the fashions of a few years past might seem like those of remote antiquity. The communications media have become a collective vehicle of instant history-making, contracting time and space into a blurry, continuous, and immediate present.

Warhol's repeating images of car crashes (plate 22), movie stars, or soup cans are snatched from the march of news events, the waxing and waning celebrity pageant, or the life cycle of processed articles and food; the iconic gravity of his forms counters the accelerated transience of the ephemera that are fixed and symbolized. More recently, he has constructed food and soap cartons of painted wood, stacked to imitate a supermarket storeroom. These objects hang on a nuance of contradiction between the actual and its simulations and on the artist's fine calculation of his audience's different responses to each. Warhol destroys the functional and visual credibility of a package whose legend and image we know by heart but refuse to accept in the context of imitation. The original, misrepresented reality and its wooden painted dummy both float in our minds for a moment, in a kind of free-fall state without normal attachment. This is another way, and an ingenious and effective one, of elucidating in public the rudimentary alienations of the artistic process and

inviting audience participation. As the Impressionists mixed colors on the retina of the beholder's eye for greater immediacy, so Warhol mixes a known detergent or food package and its invented facsimile in the mind, liberating a prepared image from the context of life into the context of art.

Robert Indiana's lettering and signs (plate 24) are organized in more traditional pictorial terms but play on dual sets of responses to verbal and visual information. Their vivid optical dissonances and emblematic forms scintillate, dazzle, scramble, and unscramble color structures in a manner of abstraction that can be linked to an honorable paternity in Newman and Albers and is even more directly related to the work of Kelly. Lichtenstein's recent parodies on Picasso's style, as well as his comic strips and abstract sunsets, energetically combine an intense aestheticism with the mechanical kind of sensibility he has now established as viable for art. The monumentality, formal power, and essential simplicity of Pop Art link it directly to the ambitious forms of contemporary abstraction rather than to an anecdotal or illustrative genre.

Of great interest is the character of the Pop artist's media sources. The television screen, the advertising blowup, the blurred wirephoto, the comic strip — all provide images relatively crude and low in definition, whose character as media is therefore constantly present. Marshall McLuhan, a brilliant analyst of the revolutionary impact on human perceptions of mass communications, has noted that the different kinds of such "low-grade" imagery (low in content and information) "share a participational and do-it-yourself character." The imagery and conventions that Pop Art draws on are dynamic, coarse, and unfinished, despite their mechanically processed look; they require audience activity and fill-in and constantly recall us to their own character as an expressive process. Somewhere in the background of Pop Art is also the sense that the tendency of mass media toward repeatability and uniformity compromises the idea of the "original," and that art must take account of this pervasive change. A sociologist has suggested that the "original" has acquired a technical or esoteric status as mere prototype or matrix from which copies can be reproduced. A public that cheerfully accepts Van Gogh's *Sunflowers* in reproduction may be quite unprepared for the demands on individual response required by its obscure and scarcely known original. The printing revolution and the more recent flood of pictorial reproductions helped dispel the notion that uniqueness was indispensable to art, and created, along with other elements of urban mass culture, an alternative "low" popular tradition to high art. The Pop artists, however, do not passively repeat the form and content of mass media but select certain significant aspects and

transform them. The color surfaces of Rothko, Still, and Newman, and their perceptual ambiguities, the "environmental" emphasis of so much current art, beginning with De Kooning and given greater emphasis by Rauschenberg, Johns, and Oldenburg and their standardization of individual handling, have prepared the way for the assimilation of the homogenized forms of popular art. Another fascinating and entirely native precedent has existed in American art for some time, anticipating the incorporation of visual clichés and lettering in an emblematic subject matter of standardization: the lively, brash vernacular style of Stuart Davis (plate 25).

Pop Art, of course, could not have arisen without other, more immediate and compelling precedents such as the paintings of Stuart Davis, some of which have been described earlier in this essay. Pop Art priorities actually must be given to England, where commercial art imagery and techniques, juxtaposed with more traditional handling, appeared in the prints of Eduardo Paolozzi and the painting of Richard Hamilton in the mid-fifties. In America the use of banal and repeated imagery, which began with Larry Rivers' reappraisal of the visual clichés of American folklore, received a refreshing new impulse from Alex Katz and from other even more literal lyricists of the commonplace. In the late fifties Katz made life-size cutouts in mild commercial colors, with an almost childlike simplicity of definition, for Kenneth Koch's play, *George Washington Crossing the Delaware*, which was in turn inspired by the Rivers painting of the same name. Katz's paintings since have been mainly portraits, schematic but immediately recognizable enlargements of friends and well-known art-world figures; or large, staged compositions of persons frozen in a social activity and arranged in deliberately stilted groupings. His reductive but strongly personal, and even poetic, pictorial style combines the elementary visualizations of the commercial billboard with a definable native idealism, suggesting something of the matter-of-factness and moral innocence of Winslow Homer's early children and croquet subjects. His art is essentially modest, direct, classic, but also ambiguous in its visual blatancies and solemn ceremonial mood. The photograph, with its low-key, flattened, often insipid reality, provided a point of departure for his pictorial style and has served other current realists whose content is also essentially ambiguous — among them, in their very different manners, Wynn Chamberlain and Howard Kanovitz.

The postwar period produced a number of major American sculptors whose innovations are intimately associated with those of the Abstract Expressionists. Sculpture has shared with painting its seminal insights, but in the early 1960s

the revolutionary changes in sculptural idioms seemed even more dramatic since they involved radical redefinition of the nature of the medium itself. Assemblage, "junk sculpture," and new types of formal structuring that profit from visual ambiguity and magical association have created fresh artistic alignments that blur traditional distinctions between painter and sculptor. The ideas treated by painting and sculpture now seem surprisingly interdependent, as they were in the Baroque age, another period marked by an extraordinary surge of energy and fertile invention that often transgressed the integrity of artistic media or brought them into a new synthesis.

Shortly after the war, an idiom of fluid metal construction emerged as the most powerful tendency in advanced American sculpture. Freely adapting from Surrealism its addiction to accident, the welder-sculptors built open forms in a variety of welding techniques that combined improvisation, concreteness, and the formal ideals of modern Constructivist tradition. Many of the first ventures in this mode were fantasy-ridden and aggressive in handling, despite an overriding concern with the expressive potential of medium. The new work was not all exasperation and strident feeling, however, and admitted many variations in mood from dramatic emotionalism to quietism. Ibram Lassaw's first metal sculptures in his mature style of the early 1950s were intricate cage constructions and delicately fused continuous grids in three dimensions whose uniform accents created an atmosphere of luminous serenity. David Smith worked in a coarser, more capacious idiom that multiplied allusions to fantastic anatomies, personal mythologies of predatory birds and fleeing specters, and "found objects" of machine parts. His romantic rhetoric was kept within bounds by a mastery of lucid Constructivist form.

Seymour Lipton established a dramatic relationship between the organic forms of nature, which dramatized the life processes, and the revealed dynamics of the creative act itself, in an idiom mixing expressionist fervor and formal control. Herbert Ferber's imagery was thorny and barbed but spatially liberated; David Hare's hybrid forms made overt references to Dadaist discontinuities and to the pull of primitive cultures. Theodore Roszak invented a language of potent new sculptural symbols analogous to clutching tree roots or bone and skeletal structure, and his dramatic images of aggression gained a special harshness and durability in welded steel. Like the Abstract Expressionist painters, these sculptors were impelled by an ambivalent sense of forging bold and urgent personal images within the main line of European modernism. For a younger generation that followed them, it was their brutalism, their "unfinished" images, and their technical *laissez faire* in defiance of traditional

sculpture methods that proved most liberating. The accents of a personal romanticism and the idea of the artist as his own hero, whose ideals and passions might enlist one's sympathies, no longer seemed applicable to their own situation, however.

One of the pioneer figures in sculpture who had a more direct bearing and influence on the work of the new sculpture generation was Reuben Nakian. Like so many American avant-garde artists, he had been a technically accomplished traditionalist until the early 1940s and then experienced a revolution in style. Later in that decade, he began to improvise freely in plaster, developing mythological subjects (recognizable themes of seduction in baroque and twisting diagonals) which were gouged, pressed, and kneaded until they functioned as loose, amorphous abstract forms. Then, in 1953, he experimented with burlap stretched on chicken wire, dipped in glue and quick-setting plaster. His forms were close in spirit to De Kooning's, and their impermanence of surface, casualness of technique, and materials seem now to have anticipated the glued-paper constructions of Oldenburg. Before the "object" could become sculptural, sculpture had to identify with the object, and by 1960 Nakian's thin plaster shells seemed to resemble casual assortments and bundles of stiffened rags. Such inventions (plate 31), later cast in bronze, represented a major departure from the direct metal techniques and the alternately linear or cubistic structural forms of the leading sculptors of his generation. In the art of De Kooning, too, a similar reversal was experienced as the wall of paint he erected became so literal in its material densities that it denied space its transforming function and took on the quality of an inert object mass.

In recent years the enlargement of their characteristic image in the work of the pioneer welder-sculptors coincides with changes that have taken place in painting. By the late 1950s, David Smith's "Tank Totems," monolithic forgings, and "Agricola" series reduced drastically the loaded allegorical content of his work in favor of stricter and more economical forms. The process of reduction continued in the 1960s as he created even starker linear silhouettes and cubic masses of stainless steel of imposing monumentality (plate 29). His last work was classic in its lucidity and severely nonpersonal: insubordinate energies operate in the matter of scale and collide with a restricted range of decisions as to balance and size of component masses and the play of light achieved by the mechanical brushing of surface. His renewed passion for a simple but ambiguous geometric order coincided with the interests and pre-occupations of a younger generation of painters, to whom Smith felt related.

Smith is generally acknowledged to have been the most potent and energetic

inventor of his sculpture generation. His direct influence is no more evident than Pollock's, however, perhaps because he, too, created such an intensely personal style that it was finally inimitable. Only the late Wilfrid Zogbaum was able to use Smith's open linear forms and combine machine castoffs and freely created shapes without penalty of derivativeness (plate 32). His own temperament was reserved rather than explosive and tended toward refinement of structure. In his last work he used mild incongruities of juxtaposition, setting beach stones washed smooth by the sea against an elegant network of steel tubing to create a different atmosphere of style. By introducing natural objects and surface color within a rigorous formal environment, he gained a symbolic intensity rather like the gravely immobile unrelated objects that are unified by the insistent geometries of De Chirico's metaphysical still lifes.

The new tropism toward aggrandizement of scale has marked the most recent work of Alexander Calder, perhaps America's most distinguished modern sculptor. Until the 1960s Calder had seemed to be moving, with no diminution of invention or ingenuity, along the established paths he laid out for himself in Paris some thirty years before. In recent years, his stabiles have expanded in size and become environmental; they can be walked through and under and, ideally, should be experienced as part of the landscape (plate 30). The enlargement of their swelling curved black shapes, and even of their welding seams and rivets, gives them an intensified presence and power, making them intelligible in the context of contemporary variations on the geometric and biomorphic traditions of shape construction of such hard-edge painters as Ellsworth Kelly.

A comparable process of concentration and expansion has also taken place in the work of Seymour Lipton and Ibram Lassaw. In his recent *Defender* (plate 33) and *Manuscript,* Lipton's affinities with painting modes have become more pronounced, if still underivative, and serve to augment the force of his style. The shallow curved plane of *Defender,* with its undetailed expanse of ridged and shimmering metal encrustation, must be linked to the homogeneous, scarcely modulated color surfaces of Rothko, Newman, and Gottlieb. Surface becomes echo and amplification for a frozen turbulence of tangled bladelike forms whose dynamic action is reminiscent of the calligraphic clusters of a typical Gottlieb *Burst.* An impersonal ideal of formal control subdues expressionist action. But, if there are echoes in Lipton of painting innovations, his own dedicated search for a heroically reduced and elemental image throughout a long and distinguished career, his inveterate symbol-making and essential simplicity of design have also affected today's pictorial

tendencies. His work leaves no doubt that its impact is primarily sculptural, however, no matter how weightless his metal shells or how seductive their gleaming surfaces. Brilliant textural detail is displaced by tough emblems of structure, and freedom bends to formal rigor. One distinguishing feature of sculpture among the pioneering older generation is a certain compactness of statement. Everything must be taken in at a glance and fit into a single well-knit pattern. Lipton's great strength is this breadth and power of generalization, a power that belongs to the realm of sculpture essentially.

Ibram Lassaw's elegant attenuations of the early and middle 1950s have given way to denser, more coarsely wrought and massive clusters of form, enriched in color by the use of various metal alloys and by chemical treatment. *Equinox* and *Cythera* (plate 34) are full-bodied in their turbid and clotted forms, which multiply by accretion like a coral growth, and manage a mineral and crystalline brilliance despite their amorphous qualities. While form is more substantial and expressionist in its agitated rhythms, these structures retain a certain tenuousness. Their mineral durability is counteracted by the evocation of transience, impending change, and metamorphosis — that intuition of the momentary which contemporary sculpture shares with painting as one of its principal insights.

Lassaw's expanded style bears a curious relationship to Philip Guston's recent work, in which uncertain shapes emerge slowly from a dense pictorial matter and tremble on the verge of animistic life. Multifooted creatures, heads lolling in shaggy paint landscapes, cloudy and cumbersome shapes, heavily adrift in medium are Guston's new cast of personae, evocative of the dark underside of creation (colorplate 5). By working within a vital chaos of dissimilar and disjunctive shapes, he keeps the process of realization in a state of potency, open to change and revision. A sharper focus would defeat the many-tentacled growth of form and commit the artist to more facile levels of intelligibility and definition. The very opacity of meanings and the textural density of means make other, more familiar externalizations of form seem a violation of our sense of complex reality in the name of conceptualizing. No matter how apparently impenetrable the enriched materialism of this art, it has an indisputable poetry and achieves the fullness of existence. The slow-blooming interior landscapes of Lassaw and Guston seem like messages from another world and another period in time.

Paradoxically, however, such a radical "destructuring" of artistic language at sheer material levels opened painting and sculpture to the shapeless debris and litter of the real world and made possible the reconstitution of outlawed

object fragments within the work of art. Shapeless and gross paint and molten metal, all that is most heterogeneous and embryonic, have been converted into a pure poetic ore by Lassaw and Guston. These important transformations of brute matter serve expressions otherwise quite alien to their intention and strongly individualistic orientation. The general movement in sculpture today is away from personal accent and technical consistency of medium. Sculpture has instead become radically nonpersonal, moving outward toward the environment; most significantly, it has further broken down traditional distinctions between the illusions of pictorial space and three-dimensional construction. The result has been a new and evolving definition of sculptural means, a convergence of primarily visual effects with the literal presentation of a wide range of objects and materials.

Foremost among the "environmental" sculptors is Louise Nevelson. Her work represents a sharp departure from the methods of the welder-sculptors with whom she is otherwise identified by age and achievement. Nevelson's "walls" (plate 35) assemble commonplace objects in stacked and joined boxes and crates; newel posts, finials, parts of balustrades, slats of chairs and barrels, bowling pins, and rough-cut wood blocks, sprayed in uniform colors of white, black, or gold, are some of the components set in the shallow recesses of her additive cubistic constructions. With all their intricacy and ingenuity of formal relation, their dazzling variations of shape and identity, the walls achieve both a powerfully unified impact and liberating possibilities of expansion. They operate forcefully upon the environment and the spectator. These rigorously formalized structures also have the air of being a collection of treasured trophies; both Cornell's mysterious boxes and Johns's target constructions stand in a direct relationship to them.

Nevelson's elegance of form and workmanship is offset by the sense, at first glance, that her walls have been contrived from manufactured objects of no special personal intensity or expressiveness. The process of formalization is enforced by the very selection of objects, for their banality has already moved them closer to purification and muted their poetry of association. The effects of weathering and aging and marks of human use do persist, to a degree, and surround the object-fragments with an aura of prized and privileged status. The fact that discarded objects, taken out of the stream of life and use, are assembled with such lucid precision creates a subtle interplay between personal identification and the overriding considerations of form and design. Their repeating, only slightly varied structures within the larger whole suggest mental effort, despite their formal elegance, as if some problem had to

be continually restated and did not admit of final solution. Nevelson's ensembles function finally with the metaphysical ambiguity of a De Chirico still life, in which geometric style is a source of mystery rather than of clarity and precision.

A more conspicuous formality with ambiguous psychological overtones has also been a noticeable feature of the new sculpture of a younger generation, in addition to the use of junk materials and interaction with the environment. Edward Higgins's humanoid forms in welded steel and smooth white plaster (plate 36) balance a rigorous Constructivism against soft curves and sensuous surfaces whose blandness disguises the organic vulnerability of his shapes. Sexual identity and a rudimentary animism are both implied and denied; the impression persists of flesh imprisoned in metal, no matter how mechanical or imperturbable his surfaces and technical methods. The sculpture works its essentially magical effects on structural, optical, and psychological levels. It is immaculate and yet totemistic in the semi-Surrealist provocations of its formal embellishments. Limited in permissible meanings to their constructed aspect, Gabriel Kohn's laminated and meticulously crafted wooden forms belong to the new objective tendency. Their ranked and symmetrical orders of form and their hard definition also radiate toward more personal metaphors, since they communicate the sense that they are the produce of a mood of tension rather than of some doctrinaire program.

Lee Bontecou's savage constructions of canvas, metal, and wire regularize and codify within a highly personal system of form the tears, bulges, erosions, and accretions of the waste materials of assemblage and junk sculpture. Strong elements of fantasy are brought to terms with Constructivist genre and the emblem form. The aggression of her images (jagged teeth, suggesting mouths; sealed-off or grated apertures, suggesting mystery and frustration) and their coarse textures of surface have an irrational intensity about them (plate 38). They lend themselves, one supposes, to Freudian allusions, but whatever their interpretation at psychological levels, these mesmeric constructions put a strange hex on the rational, Constructivist ethic; they define a new kind of borderline formality of great expressive density. Bontecou's assemblages use obtrusively inelegant materials and junk components with a surgical precision but are also intensely primitivistic. They move away from the wall and expand in scale as their relief elements are emphasized, dramatizing themselves environmentally as well by their sculptural presence; their pictorialism of surface detail, texture, and incident supports that environmental versatility.

The first among the new generation of sculptors to use urban discards and

metal scrap with personal creative intensity in assemblages of welded metals and found machine parts was Richard Stankiewicz (plate 37). His experiments coincide in time with those of Rauschenberg, and his discovery of the imagistic possibilities of smashed typewriters, beat-up and battered metal scrap, rusting boiler parts, and mechanical equipment sanctioned Bontecou's mechanized fetishes and make the more obscure, if more elegant and polished, animism of Higgins comprehensible. In the background of Stankiewicz's art is a parenthood that includes the metal sculpture of Picasso, Julio Gonzales, David Smith, and the machine fantasies of Picabia. For Stankiewicz, however, the machine is simply an object with a history of use and deterioration and neither a symbol of hope for human betterment nor an impertinent reminder of the destruction of human values. His technical innovations and caricatural energies are directly related to Jean Tinguely's brilliant kinetic animations and deflations of the machine.

John Chamberlain is also known as a junk sculptor, but his art has now moved toward greater uniformity in image formation and technical consistency. He improvises freely and boldly with discards of auto-body parts, taking advantage of their coloristic and formal possibilities. Their context is purely formal, on one level, but they also function as objects of criticism of the prescribed limits and unities of the sculpture medium. His recent work has changed from scarred and battered surfaces to renovated auto fenders glistening with a fresh coat of factory paint (plate 39); the effect of the newly manufactured and synthetic associates these forms with the artifacts of Claes Oldenburg. In his first phase Chamberlain crossed sculpture with a painterly rhetoric derived from De Kooning's inspired mixture of chromatic vulgarity and richness. He never allowed the observer to forget that he was bending sheets of a real automobile chassis; his art was thus "environmental" and its source inescapably the urban litter heap. He has now moved from a preoccupation with destitute objects in junk form to a new opulence that rivals the artificial brilliance of manufactured products in more controlled and homogeneous form.

An alternation between literal object materials and reliance on illusionistic effects peculiar to painting also characterizes the work of three other gifted sculptors: George Sugarman, Mark de Suvero, and Peter Agostini. Sugarman extends brilliantly painted colorful jigsaw ensembles of wooden forms into the environment, laterally along the floor or vertically into space, so that our accustomed points of reference to pedestal sculpture are disoriented. His bright, flat commercial paints and mechanical intricacies of shape relate his forms

to artifacts and, perhaps, to educational toys which test rudimentary abilities of the child to connect and relate parts to whole configurations. Such associations of play and function, however, are incorporated in a larger presence which gains its force by immoderate scale and insubordinate linear and structural energies. De Suvero creates hulking open forms in rough-hewn planks, beams, and steel rods that balance precariously in asymmetric compositions (plate 40). His objects are brute and untransformed, inserted into daring systems of difficult equilibrium with minimal alterations in their original shape or surface; they expand in monumental scale, and their effect is architectural. Agostini works in quick-setting plaster, from casts of light and buoyant objects that occupy space without exerting much weight: balloons, tires, umbrellas, pillows, and crumpled rags (plate 41). The element of weight has been denied its characteristic association with sculptural volume, just as in a vacuum gravity will have no more meaning for a descending cannon ball than for a feather. But weightiness is converted, energetically, into spatial extension. Agostini's methods of casting require the instant decision-making of Action Painting. The dual identities of his shapes as sculptural forms and replicas of ready-made objects and their chalky appearance relate them to Oldenburg's "ghosts," which duplicate in coarse, whitened canvas his black and shiny plastic artifacts, and to Segal's phantomic humanity.

Sculpture today has pushed a relentless process of testing its own established values and expressive means to a point where even the modernist tradition's distinctions between illusionism and tangible concreteness are rapidly shrinking. Painting has drawn closer to sculpture through the assemblage, and in another specialized mode it has given a more literal accounting of the painted surface as an object without becoming an outright freestanding, or necessarily sculptural form. There has emerged recently an original tendency of shaping the canvas surface to accommodate formal exposition at the expense of traditional assumptions about the rectangular format and frame. A group of young painters now works effectively in irregular geometric and organic shapes that extend laterally, or in billowing depth, beyond the conventional frame without surrendering the effect of continuous surface on one plane. Frank Stella's parallelogram shape (plate 42) was dictated by the formal energies of his lines, which move unencumbered into the environment of the room where the painting hangs. Yet the simplicity of his configuration, its even accents, repetition of pattern, and minimal illusion in depth keep his painting in touch with its structural and physical character as a construction of stretched canvas. The physical integrity and emphatic bulk of the canvas

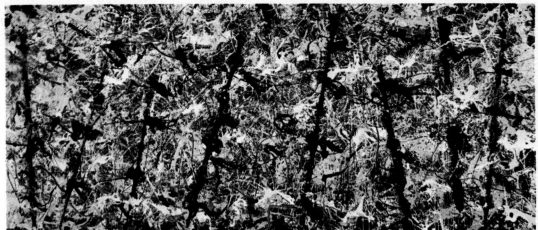

1 Jackson Pollock 1953

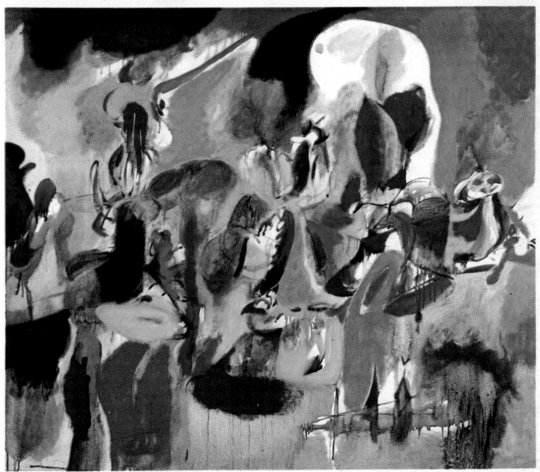

2 Arshile Gorky 1944

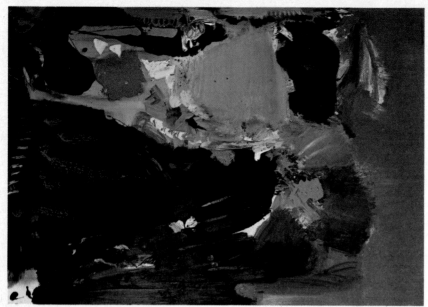

4 Hans Hofmann 1961

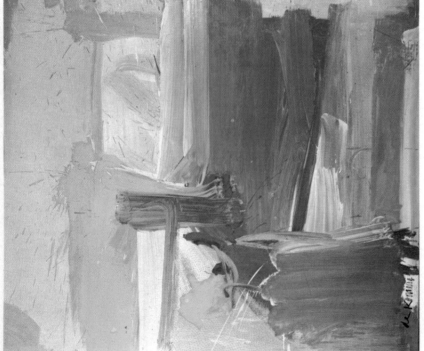

3 Willem de Kooning 1961

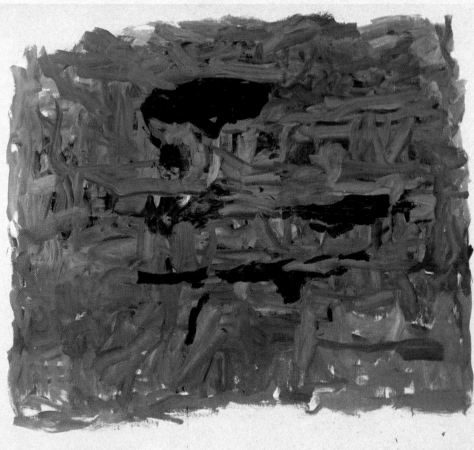

5 Philip Guston 1964

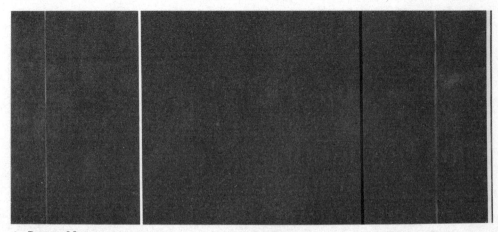

6 Barnett Newman 1951

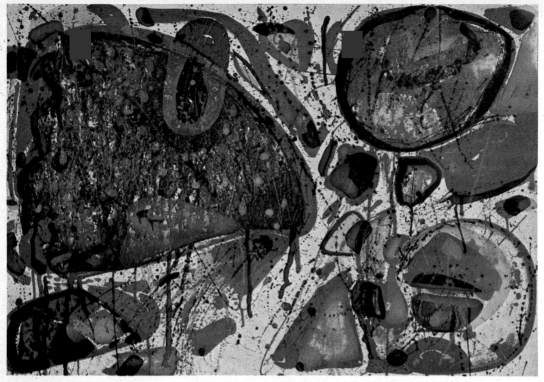

7 Sam Francis 1963

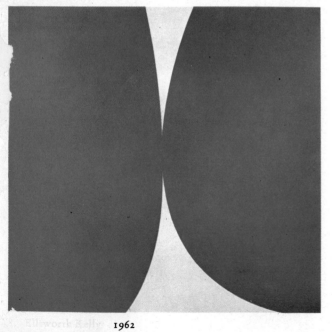

Ellsworth Kelly 1962

9 Morris Louis 1960

10 Kenneth Noland 1964

12 Larry Rivers 1963

11 Robert Rauschenberg 1963

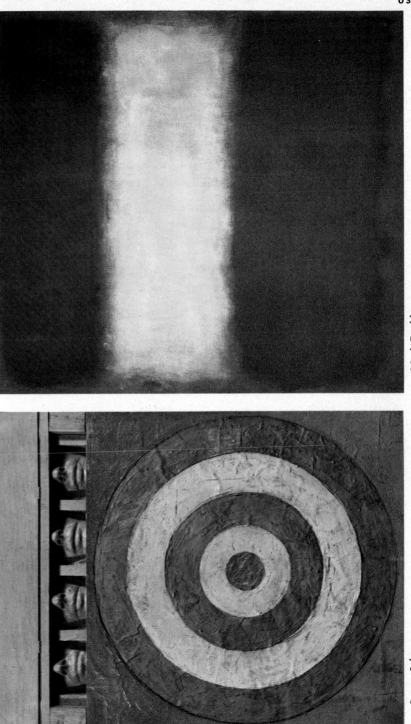

14 Mark Rothko 1957

13 Jasper Johns 1955

15 Jim Dine 1963

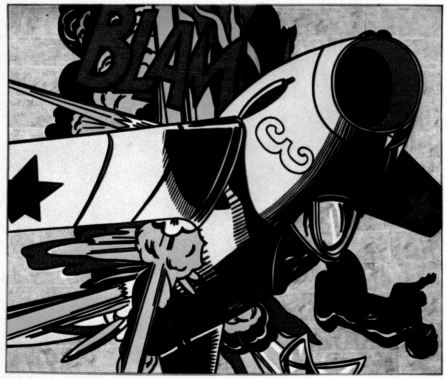

16 Roy Lichtenstein 1962

have replaced the rectangular format and delimiting frame as the elements of control regulating the painting's illusionistic projection.

Sven Lukin, Richard Smith (an Englishman who has been spending so much working time in New York that he is by now identified with American painters), Neil Williams, Charles Hinman, and Larry Zox are some of the many other gifted younger artists who are impelled to work in shaped canvas and to treat the painting as an object as well as pictorial illusion by calling attention to its physical support. Behind these ventures is the same spirit of testing basic definitions of art, its materials and expressive language, and its conceptual superstructure implicit in the alternating identities of Jasper Johns's signs and object attachments. The color-field paintings of Newman and Rothko, the absence of color in Reinhardt, and the rigorous emblematic art of Noland have all had a formative influence on the evolution of the new forms of these younger artists. As painting exhausted some of its illusionistic conventions, it seemed inevitable that the artist would be driven to reappraise its rudimentary structure as an object, which in turn suited the antirhetorical and radically objective mood of the new generation.

The same fundamentalist moods have created a new expressive limbo for avant-garde sculptors in which painting, sculptural effects, architecture, and engineering converge, often paradoxically, in a more total aesthetic experience. "Minimal" or "ABC" art, in the apt phrases coined by the alert and penetrating critic Barbara Rose, describes not only the shaped canvas, monochrome or color-field painting, and a simplified, "cool" geometric painting, but also a new severely structurist art which has given contemporary sculpture fresh meaning. The exhibition "Primary Structures," organized by Kynaston McShine at New York's Jewish Museum in the spring of 1966, demonstrated the common sensibility most brilliantly, and carried the weight of a visual manifesto for a new aesthetic viewpoint. Donald Judd's standardized, repeating aluminum-sheathed cubes; Robert Morris' identical L-shaped volumes in gray plywood; and even Ronald Bladen's more heroic and personal drama of tilting, thrice-repeated, three-dimensional rectangles in plywood and metal — all these works were the enigmatic ciphers of drastic and exhilarating artistic change. The suppression of evidence of individual authorship (to the point where forms were manufactured industrially according to the artist's specifications), the addiction to architectural scale, and the irony of the implacable, almost stupefying formal monotony created a mixed effect of aggression, directed at the spectator, and hermeticism. The impression of dumb, nearly inexpressive eloquence and outsize geometric shapes exceeding

their spatial function invoked the ironic spirit of Duchamp and carried implications of social criticism. It was somewhat as if the bland, manageable, and good design concepts of the Bauhaus had gotten out of hand and extended a small-scale, intimate, formal principle into an environmental art calculated to overpower and subdue the spectator.

Certainly, however, there is plentiful evidence that this structural and anonymous art engages many of the most forceful and subtle new talents in America, and has opened up exciting new possibilities of invention — ranging from the lunging spatial power and giantism of Grovesnor's immense cantilevered girders to the almost precious refinement of Bell's intimate, alternately opaque and transparent glass cubes. Like any genuine new tendency, the structurist art has discovered its own set of precedents, if not direct inspiration, in the classical simplicities of the architect-sculptor Tony Samith, in the last monumental geometries of David Smith, and in the polychrome structures of the Englishman Anthony Caro. The American structural aesthetic has its parallel in the constructions of a new and gifted generation of English sculptors who work in polychrome metal and plastic, often on an architectural scale, and among whom Philip King and William Tucker are perhaps outstanding.

The extraordinary responsiveness of sculpture and painting to each other, and the instant translation of conventions from one medium into the other, speak for the solidarity and unifying power of the aesthetic motives that underlie contemporary art. The interchangeableness of expressive forms and a whole imagery is certainly one of the striking new conditions of contemporary creation, along with such other critical concerns as the newly ambiguous forms of artistic order, the shifting identities of objects and their representation, and the sense of the work of art as part of a total environmental situation. The different experiences of painting and sculpture are today often confused and blurred in the process of reappraisal and redefinition. As the gap between them visibly narrows, their irreducible differences also become more apparent, however. The most serious contemporary painters and sculptors work increasingly and productively in that narrow gap.

The Paris International Avant-Garde

By Alain Jouffroy

*"J'appelle poésie aujourd'hui connaissance
de ce destin interne et dynamique de la pensée"*
Antonin Artaud

("I call today's poetry the consciousness
of the inner and dynamic destiny of thought")

The real avant-garde in France is not national in character. This is its originality and newness as compared with all nineteenth century art movements.

Since 1900, when Picasso came to Paris, artists from all over the world have been going there to give free rein to their genius or to develop further experiments begun elsewhere. Despite such major exceptions as the works of Klee and Schwitters, the principal innovations in painting and sculpture over the past sixty years (except for Futurism and Expressionism) have had Paris as their home base or springboard — Fauvism, Cubism, Dadaism, Surrealism. The various abstractionist aesthetics had roots there: Mondrian worked in Paris from 1918 to 1939, Kandinsky died in Paris in 1944. The New York School, which had become autonomous by 1960, was launched under the stimulus of refugee Surrealist painters — Marcel Duchamp, Max Ernst, André Masson, Sebastian Matta — who during World War II strongly encouraged American artists to emerge from their spiritual isolation, not to say torpor.

In *Souvenirs Souvenirs*, Henry Miller recounts the joy felt by the New York art world when Paris fell in 1940: according to Miller, they hoped to salvage permanently, at the cost of "millions of dollars," the best paintings of the Parisian avant-garde who sought refuge in New York. But, the moment the war ended, Max Ernst, Masson, Léger, Matta, Chagall, and Hélion returned to Europe: a cruel deception that wounded the pride of a great number of Americans and increased their chauvinism tenfold, if not a hundred-fold: we can still verify it today. The only one who remained faithful to New York, Marcel Duchamp, encouraged through his ideas the decline of Abstract

Expressionism and the birth of Pop. For that matter, it is vain to place in opposition, as has often been done, the New York School and the School of Paris as such: both these schools are dead, and the spirit of avant-garde today no longer belongs to any one country. Communication is too easy and too fast between the different cities of the world for any one of them to be able to pretend to hold the monopoly on novelty. In truth, New York and Paris have become the complementary extension of each other. The increasingly frequent exchanges, even the rivalry, between them have helped the interpenetration of ideas; it would also be as vain to deny the continually anticipatory role of the experiments conducted in Paris as to minimize the influence that America since Pollock has exercised in the entire world. As French intellectuals, we feel ourselves to be, like Bakunin, "patriotic and international at the same time," for "the Mother Country represents the incontestable and sacred right of every man, of every group of men — associations, communes, regions, nations — to live, feel, think, want, and act in their own manner." In the eyes of a European artist looking at the future and not at the past, however, the division into national compartments is out of date and ill — fated, and its survival is a spiritual anachronism, for, as Bakunin says, "if the people or the individual exist in a certain way and cannot exist in another, one can by no means thereby deduce that they must have the right, or that it must be useful to them, for the former to consider their nationality, the latter his individuality, as the exclusive principles with which they must occupy themselves eternally."

Nor can the international character of the contemporary avant-garde be disguised: it was from the Russia of Kandinsky, Malevich, and Mayakovsky, from the Germany of the Blaue Reiter and the Bauhaus, from the Italy of the Futurists, from the Spain of Picasso and Miró that the currents of renewal converged in Surrealism. Its influence has grown enormously throughout the world over the past forty years, but the international spirit of the avant-garde was best crystallized in Paris and has survived longest there. Picasso, De Chirico, Brancusi, Chagall, Ernst, Duchamp, Picabia, Giacometti, Hartung, Mondrian, Kandinsky, Calder, Miró, Gonzales, Dali, and many others made the French capital the world center of the arts. Guillaume Apollinaire's prophetic and creative role and André Breton's farsighted struggle in defense of the avant-garde spirit helped pave the way for awareness of the new values these artists have affirmed.

Today, the situation looks vastly different. Modern art has circled the globe — only the Bamboo Curtain of China still stands as a bulwark against it. Since

the end of World War II, the international avant-garde has produced flourishing new artistic schools in nearly every country of the world. This has not robbed Paris of its magnetic attraction, however. Contrary to what is too often claimed, New York has not taken its place. The *international* spirit is still tainted by nationalist conceptions and attitudes.

The very great number of young foreign artists who have settled in Paris over the past twenty years, despite all sorts of moral and material obstacles (which, of course, are not new — remember how long it took before the genius of a Max Ernst was recognized there), is ample evidence of the international character of artistic activity in Paris.

The considerable publicity from which young American artists have been benefiting recently may not have its equivalent in Europe. But the day is coming when commercial prestige will no longer confuse people concerning the real importance of creative arts. Ultimately, the revolutionary intelligence of the creator is the only thing that matters. Works of art no longer need labels of nationality; the profusion of dollars on one side of the Atlantic does not affect the process whereby ideas and forms become universalized.

That is why, discussing avant-garde activities in France over the past five years, I shall not commit the flagrant injustice of setting up nationalist compartments around the artists who have taken part in them. One aspect of the genius of this avant-garde consists in ignoring such categories, in *not* setting Calder against Fautrier, César against Sam Francis, Hartung against Soulages, Miró against Masson, Dubuffet against Matta, Vasarely against Dewasne, Henri Michaux against Wols. These artists enjoy an immense advantage over those who are content with their national or regional surroundings: they acquire a cosmopolitan perspective far broader than the individual mind can normally reach.

Marcel Duchamp, who has long divided his time between New York and Paris, has been the very model for this internationalization of ideas and artistic creation. His influence extends the world over and is nowhere held back by local considerations. His presence in New York assures the American avant-garde its internationalist outlook. In the meantime, it has fallen upon the young European artists, especially those living and working in Paris — some of whom have come there from the Americas and some from as far away as Japan — to continue the liberating work of the earlier creators of the twentieth century.

Since 1945, art movements in Paris have followed one another at a rapid pace. After the spectacular rediscovery of Picasso come a period of geometric

abstraction; then came Tachism and lyrical abstraction, followed by researches into calligraphy and signs and symbols. Surrealism, hitherto kept at a distance by critics more intent on formal aesthetics than on subject matter, has since 1954 made itself felt throughout the world as the greatest movement of spiritual emancipation. Finally came the New Realism and a revolution in our whole way of seeing.

The painters who exerted most influence between 1945 and 1960 are, of course, at the origin of these various tendencies. The so-called geometricians can be traced back to Mondrian, Kandinsky, and Herbin; the Tachists to Kandinsky, Wols, and Michaux; those who invent new morphologies to express man's situation in the world to Wifredo Lam, Matta, and Victor Brauner; and those haunted by the world of objects to Duchamp, Picabia, and Schwitters. For the past five years, it has been obvious that the work of the three last artists has at last spectacularly come into its own. Their influence today dwarfs — and sometimes contradicts — that exerted by the traditional School of Paris. Duchamp's readymades, Schwitters' Merz and Merzbau, Picabia's collages, and the objects of Man Ray and Miró have exerted about equal influence on the new generation on both sides of the Atlantic (a fact that should in itself put an end to rival claims of superiority).

Rauschenberg and Tinguely, Jasper Johns and Yves Klein, Roy Lichtenstein and Raymond Hains, Chamberlain and Takis, Claes Oldenburg and Daniel Spoerri are all in the same position with respect to their elders: each has assimilated in his own fashion the revolutionary teachings of Duchamp, Picabia, and Schwitters and has found a personal idiom in which we recognize the marks of authenticity. It is not possible to favor some at the expense of others without falsifying historical data. The publicity success of Pop Art changes nothing here. Similarly, the indirect influence Matta has exerted over a period of fifteen years — a determining influence on many Italian and American painters — is reflected in Rauschenberg's open realism as well as in that of Ferró: ideas make their way simultaneously in all parts of the world, wherever a scattering of intelligence is to be found. The masks of aesthetics only disguise the singularity of certain developments to fools. Sooner or later, this will be understood.

As early as 1956, when some of the best abstract painters were enjoying well-deserved success — Hartung and Soulages, on the one hand, Riopelle and Sam Francis on the other — Matta, back in Paris after several years in Rome, implanted in the minds of many young painters (Peverelli, Petlin, Hultberg, Adami, and Recalcati, for example) the idea that the rhythms, the lines of

force, the specific terrors and marvels of a new, hallucinatory consciousness of the world had to be reintegrated within the imaginary space. In this way he sought to broaden the horizons of Surrealism and to measure super-reality at the level of everyday life. The impact of Pollock's work, whose advent Wols (as well as Masson and Hartung) had discreetly anticipated, seemed at that time to go counter to this development.

By devoting some of his most important large paintings to political events, Matta anticipated by several years the total reversal in optics, which has since led painters to wonder again about the interplay between the figure and its image, the object and its reproduction. A painting Matta dedicated to the Rosenbergs in 1951, *Les Roses Sont Belles* ("The Roses Are Lovely" — color-plate 17), is the earliest example of an "event painting," the kind Rauschenberg was later to exemplify with the silkscreen pictures dedicated to President Kennedy. To be sure, Matta was criticizing everyday life, whereas Rauschenberg was celebrating it. But the unity of their interests cannot be entirely concealed by differences in their aesthetic and moral formulas. The one condemns what the other seems to accept or approve; reality is evoked by different means, but in both cases it serves as the artist's direct inspiration.

Since 1956, it has been possible to detect a certain weariness in the inspiration of most abstract painters. Riopelle, Francis, Mathieu, and Soulages were equally unsuccessful in renewing themselves. In the United States, too, abstract painting was lapsing into repetitiveness and stereotype. True, Franz Kline, Clyfford Still, and Mark Rothko varied some of their characteristic plastic elements from picture to picture, but they never achieved a renewal of structure, which would have enabled them to become truly great painters. De Kooning alone — like Pollock in his last years — was able to do this by emphatically reintroducing the figure.

In France, Jean Fautrier and Jean Dubuffet cleverly kept their art ambiguous. Fautrier's "Otages" (Hostages) are cries of anguish that owe nothing to Expressionism, and his "Nus" (Nudes) occasionally have the nostalgic intensity of an unidentifiable memory. His paintings are in a subtle way both testimonies and works of pure art. Paulhan was right when he detected a kind of insolence in them. "It is as though he were encased in rage and contempt," he wrote. "He seems to be trying to revenge himself upon us, upon the whole world."

Thanks to his intelligence and incontestable virtuosity, Dubuffet long dominated the international scene in painting, and it would be unfair to deny that he is playing the clown when he ironizes modern life: we must keep in

mind that his style and manners derive from paintings displayed at country fairs — from a certain naïve, popular art. Yet some of his best finds have been assemblages of heterogeneous materials, from scrap metal to butterfly wings, and these have made their contribution to the rediscovery of a poetry inherent in the object (colorplate 21).

Dubuffet's twenty-year fascination with paintings by mental patients, and with all that he calls Art Brut, prefigured the anti-aesthetic, anticultural attitude which is today common among avant-garde artists both in New York and in Paris. It is as though Dubuffet's purpose all along had been to display the richness of invention and power of direct evocation to be achieved when the painter turns his back on established culture and every aesthetic accepted by the schools or by "good taste." It must be kept in mind that *naïfs* and mental patients have been the true creators of that popular art which is transformed into Pop Art only when an alert and informed intelligence practices it. I think Dubuffet's art could readily be interpreted as the first coming to aesthetic awareness of noncultural forms of expression such as the young in Paris and New York are today pursuing and which, needless to say, they will never achieve. Being men of knowledge and talent, they cannot hope to return voluntarily to the naïveté that precedes art.

What has led painters to become aware once again of the need for meaning (figurative or nonfigurative) — apart from Picasso, who always opposed the idea of nonfigurative painting — is the example of the Surrealist painters, who, as Marcel Duchamp once observed, most often appealed to the "gray matter," not just to the "retina."

Daniel-Henry Kahnweiler has justly rejected the hedonistic principle of "aesthetic pleasure." A painting can deeply affect the viewer only to the extent that it modifies his perception, unsettles his ideas about art and the world. The pleasure one feels at the unsettling, which is essentially masochistic, in no way constitutes the work's ultimate justification. On the contrary, aesthetic pleasure tends to devalue, gradually to corrode the significance of all art. Since Van Gogh, Western art has been allied with anguish, with the feeling of danger, with the sense of risk. The various dogmas of abstractionism, whether geometric or Tachist (the latter more diffuse than the former), attempted to bolster or prop up the tottering edifice of an aesthetics wholly based on retinal pleasure. This may account for the rapidity with which every formula of abstract painting has been stricken with sclerosis.

On the other hand, Surrealism, which cast a great deal of light on the unconscious foundations of artistic creation, favored technical innovation:

Ernst's collages, frottages, and drippings, Dominguez's decalcomanias, Dali's symbolically functioning objects, Matta's psychological morphologies, Lam's totemic re-creation (plate 44), Duchamp's readymades and "assisted" readymades, the automatic writing and drawing of Miró. Their diversity has permitted an astonishing development in all domains. If abstract painting — which in its late lyric tendencies was coming closer to Surrealism — finally got caught up in contradiction, and if a large number of abstract painters have sought refuge in semifigurative art, the influence of Surrealism has something to do with it.

Pollock's explosive art enabled many painters to gauge the scope of gestural automatism: it would be impossible to go beyond it, just as it is impossible in poetry to go beyond the shriek. The roads traveled down to the moment of this eruption could only, pursued further, lead into the desert. The disintegration of abstract painting is bound up with its absence of subject matter. Only Hartung and Soulages succeeded for long in endowing their signs with the power of negation, of refusal. Their paintings rise before us like barricades on which the existent crucifies itself. But how are we to believe that a painter can indefinitely keep on crucifying himself in his work? The opening on the impossible to which every man aspires requires the conversion of negation into affirmation: neither Hartung nor Soulages has been able to make this step. To be sure, their paintings have become less aggressive these past three or four years. Hartung's signs are turning into luminous heads of hair (colorplate 19), Soulages's barricades and stormy conflagrations into elegant variations (plate 45), but their search for the "yes" condemns them to a fatal lowering of intensity.

Modern art has often, and wrongly, been accused of a uniform tendency toward abstraction. For example, not enough attention has been paid to the course of Jean Hélion's development (plate 47). The first major abstract painter to switch to figuration during World War II, as early as 1948 Hélion become aware of the change in pictorial optics we have been witnessing for the past five years; and it would be a mistake to interpret this change as a regression, a resurgence of academism. In works dating from about 1951 — such as his series, "Mannequineries" and "Nus et les Pains" — you can find an exact prefiguration of Pop Art. Recently, he has been steering a course toward a sort of Expressionism of happiness — which is prefiguring what?

This about-face was started by Pollock before his death and continued by De Kooning, but in a furious manner, as if, for these painters, the figure represented only a desperate solution. With Jean Hélion — the *Hommes à Chapeaux* ("Men in Hats") and the *Amoureux sous un Parapluie* ("Lovers

65

Under an Umbrella") of 1945, then, starting in 1950, the "Mannequineries," which prefigure Pop Art, the "Bums" on the sidewalk, the "Gutters," the "Readers" of newspapers in public parks — all the cinematic personages of the city were projected anew onto the imaginary space that they had deserted since Fernand Léger. For his part, Giacometti tried to make the presence of man reappear on a horizon that had become inaccessible, for he no longer disassociated himself from time. Hence the reversal in painting that we have been witnessing since 1959 was foreseen, predicted, and realized fifteen years earlier by Jean Hélion and Alberto Giacometti.

Henri Michaux (plate 18), whose exceptional lucidity and importance are only beginning to be recognized, wrote in 1946: "Draw without any special intention, scribble mechanically, almost always faces will appear on the paper It is not in the mirror that one should look at oneself. Mankind, look at yourselves on the paper." Abstraction is the product of deliberate censorship, and abstract art implies a sequestration of emotional realities which cannot be locked up without eventually bursting their prison. When Michaux paints crowds of "bewildering migrations," when he draws with extraordinary meticulousness the interlacings of a mescaline vision, he goes far beyond abstract painting: he is in the domain of experienced hallucination. All that he shows us is real; the "space" of his ink blots refers to that mental reality that is itself the basement of the world.

The abstract painters have longed to link their images to life: their only way of entering the realm of meaning consists of charging the forms — or the colors, the spots, the signs, and their connection — with symbolic intentions, in which one can recognize the reflection — on the mental level — of events, perceptions, and real beings. A few such painters have arrived: Jean Dewasne, Bernard Saby, Jean Degottex, Duvillier, and, more recently, Serge Rezvani have achieved the *tour de force* of linking abstract images to the hallucinatory reality of a vision, which makes their work something more than an aesthetic show. From the poetic viewpoint, their painting is figurative — colors and forms are organized, the elements are ordered in a communicable way. The order or disorder of thoughts and feelings is presented as an equation, and we recognize the organic reality — the heart, the lungs — in all of Rezvani's red paintings on black grounds, just as we recognize the need for madness and merriment — a sort of "mental theater" — in Dewasne's "oleo-glycerophthalic" paintings.

For the past five years, the "subject" has been the most burning question among all artists of the new generation. What is the new subject of art, or,

rather, what are its new subjects? We must not fail to recall how the Cubists began to take a fresh look at advertising posters, newspapers, cigarette packages, the labels on wine bottles. Even before the Dadaists, they were incorporating words and song titles in their pictorial compositions. This showed that they were on speaking terms with the everyday thought of their epoch, as were all the great painters before them — only by means never used before. No art — save perhaps naïve and mystic art — is possible without this dialogue with contemporary thought. Even the austere Mondrian tried to attune himself to the new rhythms of jazz and architecture that were altering the order of the world around him. Tachism and Abstract Expressionism made such an attuning impossible. The painters who committed themselves to these two directions found themselves eventually exhausted, at a dead end, with but one way out of their predicament: an about-face in which the world and thought were reintroduced.

Matta came to understand this as early as 1944. After his "Psychological Morphologies" (1938) and paintings of cosmic and intra-atomic spaces, he introduced figures of a psychological life during his New York period, beginning with his *Vitreur* of 1944. Victor Brauner was never wholly cut off from this development either, and André Masson, for all his fascination with lyrical effusion, brings it to mind in all his work. His paintings sum up and often reconcile the contradictions artists of our time have experienced. His work serves as a bridge between Wols and Matta, a desperately held link between the shrieking phantasms of desire and a paradise separated from the imagination. As he writes, "Why should we let ourselves be caught in the aesthetic dilemma of figuration/abstraction? Figuration, narrowly conceived, is never free enough; abstraction, in the strict sense, is never expressive enough." His *Fin de l'Eté* (colorplate 20) is one of the rare examples of painting today that make evident — without being formally Futuristic — the dynamism of the universe.

Fautrier, on the other hand, has not managed to carry his ambiguous venture into nonformal art beyond the traditional boundaries of French painting — the landscape, the nude, and the still life. Hartung has become too exclusively attached to calligraphic vehemence, and Mathieu has merely speeded up its pace and thickened its line. Soulages, as Jean Cassou suggests, has never really escaped from the close-up of the "flattened-out Piranesian prison" which he invented. Riopelle's spectral pulverization of colors has not led him to the object, by means of which he might have been able to go beyond himself. Sam Francis is still gliding around in that engineless plane he has been piloting now for

fifteen years through smoke and flames of uncertain origin. As Georges Duthuit, Riopelle's and Francis's first great champion, explicitly acknowledged in *Le Feu des Signes,* all these painters went wide of the target which "the subject" is for the painter. Their real merit is to have come as close as they have, asymptotically, without hitting it.

Since 1945, the great avant-garde painters — Surrealists or not — have all been figurative, although not all of them painted figures. The example of Picasso is the most glaring proof. One of the most important paintings since 1945 is his *Massacre in Korea,* in which formal invention and bareness of line and color are bound up with a frenzy that perhaps constitutes the secret point of departure for all aesthetic explorations. Matta is one of the few who grasped this lesson, in paintings such as *Rosenbelles, The Question, Djamila Boupasha,* and his triptych on Fidel Castro's revolution.

Small wonder that the French abstract painters held in such high regard immediately after 1945 — Bazaine, Manessier, Singier, Schneider, Estève, and Poliakoff (plate 46) — have deservedly gone into eclipse. However great their gifts as colorists, their technical skills, their sense of composition, their possible knowledge of the golden mean, and the refinement of their culture, none of them succeeded in creating a mental vision of the world, and hence a new conception of painting. They have been and will remain minor masters. They are solely concerned with ornamentation and display. Jean Bazaine, the most intelligent among them, was unable to go beyond a Neo-Impressionism of movement, where a snowfall at best suggests the disappearance of mankind. On their immediate fringe only Pierre Tal-Coat has reached profundity; with a poet's intuition he has known how to find the accents of panic fear to which the perception of a flame, a movement of branches, a shadow on a rock, are originally linked.

To repeat, Matta, Hans Bellmer, and Michaux have gone much further. Their works attest a real deepening of insight. The world and its phantoms, fulgurations, obscurities, and dangers are for them things to be located, exorcised, captured, and set down. For Victor Brauner, who created his own personal symbolic language, the most bizarre formal inventions clarify the mental life and reflect the archetypical structure of the collective unconscious. For Bellmer, whose explorations are confined to eroticism, woman becomes the heart of all vision (plate 48), the incandescent core of all phantasms. The invention of a new morphology has been the common denominator in the researches of all these artists who today rise high above the crisis afflicting the abstract painters.

The change in optics has been in effect since 1954. That year, the capital

importance of Max Ernst in the development of painting was for the first time internationally recognized, and new light was thrown on the influence of Surrealism on the contemporary sensibility. Since that date, however, Ernst has followed an exactly opposite path: his most recent works (plate 43) are paradoxical tributes to pure painting. Matta's explorations of materials have for the moment similarly veered from his "open realism." Miró has tardily been espousing a kind of Neo-Tachism, in which his signs lose some of their clarity and poetic precision. A few young Surrealist painters, for example Hantaï, actually shifted to lyric abstraction.

André Breton, who had hitherto steered shy of abstraction, has been favoring a return to Kandinsky's "dramatic" period, and directly or indirectly has come to the support of young painters primarily concerned with the lyrical, evocative powers of the blot and the gesture — artists like Duvillier, who is obsessed with the motion of the sea and the sky, and Marcelle Loubtchansky, in whose space all forms tend to liquefy in a molten mass. On this path Jean Degottex has found his *satori* and his grace (plate 50), Duvillier his blue light, crossed with lightning flashes of energy that make thought the illumination of the world.

The spirit of Surrealism has changed since 1924. The painters who are today renewing the powers of Surrealism are unaffiliated with the movement, strangely enough, and it would be futile for any young painter to repeat, without changing their meanings, the experiences and discoveries of his elders.

Abstract painters such as Bernard Dufour, Yves Klein, and Bernard Réquichot have all, through following different roads, reached the conclusion that the problem of representation has to be reconsidered. They prefigured the present reversal of optics: Dufour's romantic paintings inspired by Venice, Klein's "Anthropométries" reintroducing images of the human body after his monochromatic period, and Réquichot's "Papiers Choisis," made up of bits of color photographs — all heralded the conversion of abstraction into "something else." Dufour, Klein, and Réquichot discovered meaning and brilliance in the presence of beings and objects in space. At the same time, none of these painters has been content to go back to realism.

It is obvious, for example, that when Klein (colorplate 22) invested his "imprint" paintings (the "Anthropométries") with the magical character of ceremony, he realized, consciously or unconsciously, that painting was in the process of changing its sign and it course. The nude women covered with blue paint and then "printed" on the white canvas took the viewer back to Plato's cave. For the first time, neither speed of execution not its virtuosity served as

pretext for a painter's ritual ceremony but constituted the very meaning of the work and the nature of the event that his execution "from a distance" invested it with. Thus, as early as 1959, it was possible in Paris to foresee the direction the avant-garde was taking, and the emergence of Pop Art two years later in New York was made possible only by the explorations that had already been carried on in Europe in the current and countercurrent of abstract art.

At the same time, Raymond Hains, Jacques de la Villeglé, François Dufrêne, Arman, Spoerri, and César were remagnetizing real objects by a variety of means: "accumulation" (Arman), "trap painting" (Spoerri), "decollage" (Hains, Villeglé, and Dufrêne), and "compression" (César).

In 1959, immediate success of such works among the Paris avant-garde made it possible for the critic Pierre Restany to group them together under the label of "New Realism." The label has been contested and remains contestable, like so many other labels applied to works of art, but it has the merit of pointing up the break with abstraction of which then Restany was himself one of the most diligent defenders. Actually (I hope Restany and André Breton will forgive me), wouldn't "New Surrealism" be a better label?

On a new basis, these painters reopened the issue of the relationship between man and the world; on a new basis, they linked Duchamp's readymades and the Surrealists' found objects with today's reality; on a new basis, they explicitly related the work to its creator's daily behavior, as Breton had done long before and Robert Lebel after him (in *Chantage de la Beauté*). What set them apart from the orthodox Surrealists and kept them from thinking of themselves as Surrealists was their belief that they chose the objects included in the composition of their work, that their attitude toward them was aesthetic, and that they did not postulate moral values. In reality, choice as well as judgment are products of unconscious activity. Moreover, the determining part played by chance in Spoerri's trap paintings, where real-life situations are literally caught in glue, proves that they were not as far from Surrealism as they supposed. It may be said that the Breton of *Nadja* and the Aragon of *Le Paysan de Paris* were in love with reality, too; in their eyes the surreal was never set off as a thing apart from the most ordinary everyday life. Today we have discovered that the surreal is thought itself.

In 1958, when Klein, at Robert Godet's studio, decided to use living paint brushes for his "Anthropométries," in which the blue imprint of a woman's naked body, singly or multiplied on white canvas, signified what he had to say about "the resurrection of the body" and the dematerialization of the spirit,

he produced an interpretation of life and thought less insane than Dali's "paranoiac-critical method." When Hains and Villeglé in 1949 chose to express themselves through posters ripped off Paris signboards and when Dufrêne in 1957 began to work similarly with the backs of posters, their choices were based on the play of formal balance between figures and lettering or on the expressive vehemence of the tears themselves. But so doing they extended, within the perspectives of an "aesthetics at the zero degree," the proposition formulated by Marcel Duchamp in 1913 in the guise of *Bicycle Wheel*.

There are great differences, just as there are between a "combine-painting" by Rauschenberg and a composition by Schwitters, between a painting inspired by a blown-up comic strip by Lichtenstein and Fernand Léger's *Joconde aux Clés*. The main difference lies in the spiritual distance introduced by the processes themselves. These forays beyond the boundaries of art, by artists who separate art from life, exist within the perspective of Surrealist extremism. Surrealism was never actually confined within a single aesthetic: for the past forty years, it has been reborn from the ashes of each successive death as different formulas were discovered by each of the great Surrealist painters. Today, its influence has become so inextricably mingled with influences from Dadaism, abstraction, and a certain realism that it is no longer possible to recognize it in its original form in the works of young artists. But its wide-ranging spirit remains very much present, lurking in the shadows. The deep and passionate break with older theories and ways of feeling accomplished by the young painters reflects the need for a revolution in thinking, a need which the adventure of art continually rekindles.

It is wrong to give this revolution a name. "New Realism," "Neo-Dadaism," and "Pop Art" are signboards along the road, but it is only the persons actually moving on the road who can name the voyage, not the signboards. In the perspectives now opening for "the image of the future," the creators will be free to explore every line and move in every direction. To become aware of the possibilities latent in such freedom, they have had to disobey the academicizations that ceaselessly spring up in modern art.

Two young painters have played a part in this journey into the unknown since 1959 — Martial Raysse and Jean-Jacques Lebel. The former's *Objet Publicitaire de Prisunic* uses "ugly" neon and plastic materials which he yet endows with paradoxical beauty. The latter has made use of photos from pornographic magazines and cuttings from political newspapers. But whereas Raysse has discovered something fresh, wonderful, and modern, Lebel still wavers between various attitudes and nostalgias.

Martial Raysse is doubtless the only painter today who is in love with the real world: with the objects from a woman's dressing table, which he knows how to set on mirrors; with neon advertising signs, from which he draws surprising ironic or lyric effects; with all the décor of daily urban life. Adhering with ease to the contemporary celebration of woman by fashion and movies, he goes so far as to project color films on his paintings — on the theme of *Suzanne et les Vieillards* ("Susanna and the Elders"), for example — and a large part of his work may be considered a message of luxury and pleasure whose modernity of accent and whose violence can escape no one. Hence he frees himself from the anguish that too often makes painters circle the abyss. The aniline colors that he uses with a rare lyrically evocative strength, the placing on the canvas of the paintings (in which he often incorporates actual ornaments), make evident a comprehension of the world at once mental and sensual. He brings love to the height of its conspicuousness (colorplate 25).

Jean-Jacques Lebel, on the other hand, willfully confuses invention and the known symbol, art and polemic. One cannot decide if his poetic manner occurs through external manifestations of the avant-garde, of which he would be the promoter, or through internalization and individual experimentation. Torn between the need of collective provocation that finds its application in happenings and the need to overtake a secret truth through hallucinatory experience, he does not always know how to describe in his painting (where he often juxtaposes photographic collage, drawing, Action Painting, sexual symbols, and decalcomania) the truth and the tension of inner experience that he invokes (plate 49). Since 1959, the intensity of his plastic works has increased and decreased in turn, and the influences are not always assimilated; with him, thought is often confused with the statement of intentions. But his role of conveyor belt, in that irrational machine that is the avant-garde, should never be underestimated: the Festivals of Free Expression that he has organized in Paris since 1964 constitute an international crossroads where life surges even out of chaos. In the manner of the potlatch of the North American Indians, an irrepressible need to squander is manifested during these festivals. But one can wonder if the expenditure of a volatilized energy before a complacent or restless public is harmful to the concentration on a rite that makes no sense except in the context of the psychic life. The poetic means put to work in happenings are, alas, too threadbare, their false music-hall character too near that of the Quat'z Arts Ball and the bourgeois evenings of *La Règle du Jeu*, to have the pretension to be a way of revolutionary actions. No happening, no matter how uninhibited, can exercise the uninterrupted power of upheaval

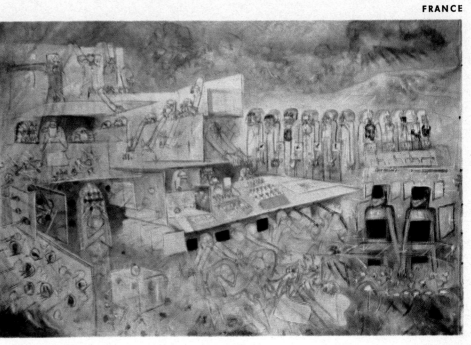

17 Matta 1951

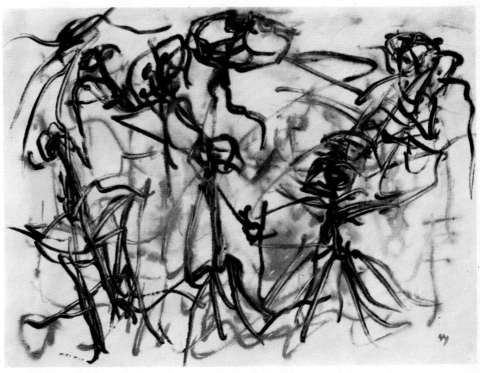

18 Henri Michaux 1960

19 Hans Hartung 1965

20 André Masson 1955

21 Jean Dubuffet 1963

22 Yves Klein 1960

23 François Arnal 1963

rd Réquichot 1961

29 Gudmundur Ferró 1963

30 Victor Brauner 1964

25 Martial Raysse 1964

26 Jorge Piqueras 1965

27 Horst Egon Kalinowski 1958

28 Raymond Hains 1958

31 Fernandez Arman 1963

32 César (Baldaccini) 1961

33 Victor Vasarely 1964

34 Jean Dewasne 1962

that some ideas or certain works of art contain, and it is this that separates happenings from the "inner and dynamic destiny of thought."

Since 1959, Takis (plate 53) has integrated in his sculpture the force of magnets and electromagnets. In homage to man's antigravitational desire, he bluntly essays the impossible: the suspension in the void of elements that communicate only through the invisible force of energy. A marvelous example of Utopia. In his most recent "Télé-sculptures," it is the vibration of light supplied by a mercury lamp that constitutes the vibratory center of the work: all idea of aesthetic is thus reduced to zero by the omnipotence of the intention. With Takis's "Télé-sculptures" and *Télé-lumière*, the readymade is charged with an intensity that Duchamp denied, and still denies, in his *Bicycle Wheel* and *Bottle Rack:* that of anticipation, of dreams beyond attained limits. Takis implicitly refuses the nostalgia included in the art of the vacant lot and prospects in that secret, almost forbidden, but fascinating and doubtless richly surprising realm that still separates art from science, the studio from the laboratory. He *explains* nothing; he *is,* he *shows,* he *stages.*

Marcel Duchamp, with his readymades, was the first to seek to dynamite the dogma of self-expression; he chose among the things people look at casually, never considering their beauty or possible meaning. He also fought against what he felt was still too aesthetic in the early Cubist collages. But it was inevitable that his readymades should eventually be reincorporated into art.

After Duchamp, in 1934, at the Château de Boisgeloup, Picasso executed imprints of objects, but he did not realize their importance until 1944, when he began to make plaster casts of cardboard boxes, oranges, the bark of trees, and torn strips of paper. On May 5, 1944, in Brassaï's presence he said to an editor who hesitated to publish some photographic reproductions of these imprints: "But yes, yes, they are on the contrary very important. And I ab-so-lute-ly insist that they be included in your book." Once again, Picasso gave proof of his prophetic powers, for the imprint is one means of going beyond the readymade and its projection in the realm of ideas. Imprints are to readymades and collages what the mirror images are to true images: a reflection, a transformation, a transition from the real to the ideal. Thus it is to Picasso that the executors of imprints and silkscreen works are indebted. With the imprint, whose remote origin may be sought in prehistoric finger paintings — especially those wall paintings covered with negative prints of hands in a cave at Kap Abba in Darembang, New Guinea — the artist takes possession of the world in a sovereign manner. Painters who reintroduce images or forms of reality by the imprint technique and its mechanical variants no doubt obey anti-aesthetic

promptings, but by the same token they are trying to boaden the field of artistic exploration as a whole, to endow a part of reality with a sacred character. In other words, they refuse to separate art from life. The birth of the New Realism in 1960 thus marks the consummation of an underlying avant-garde current. Today, one begins to perceive that before a work of art, one finds oneself simultaneously in the mental and in the physical, beyond the dualistic categories of reason.

The collages of Bernard Réquichot (which from 1956 on he called "Papiers Choisis") bring back, in an abstract context, figurative elements borrowed from magazine illustrations. From 1957 until his suicide in 1961, such elements, occasionally repeated dozens of times in the same work, create true fugues of figures of the giddiest inspiration (colorplate 24).

The lesson to be learned from Réquichot's and Klein's work was understood by François Arnal. His "Matrix Paintings" of 1962, "Inexactitudes" and "Suggestions" of 1963 (colorplate 23), and more recent "Analogies" and "Juxtaposed Saturations" propound a new vocabulary of forms, in which imprint, repetition, and transformation of the same elements have gradually led him to the projection (in the negative) of real objects. Thanks to men like Arnal, who is thus continuing Klein's interrupted work, so-called abstract painting — far from risking detachment from life — can become again a truly continuous creative adventure. We shall soon discover in it the structures of a particular perception of the world, one in which man for the first time frees himself from the arbitrary separation of that which is seen from that which is thought.

The idea of changing the painting into a sort of Veronica's veil, in which reality comes through in faint outline — an idea that justifies the silkscreen pictures of Warhol and Rauschenberg in New York and endows Piquera's paintings (colorplate 26) and François Dufrêne's "poster backs" with their most secret meanings — was a natural perfection of the imprint (hand and finger marks, footprints) which made it possible.

Since 1959, imprints have played the part of an element of language in Piquera's abstract paintings. They articulate themselves as a "sign" on an ensemble of materials and colors. They annul the factitious character of contours and impose themselves as the unity of the thought projected by picture. Any sort of drawing can lead back to academicism, and it is to avoid this danger that painters as diverse as Klein, Arnal, and Piqueras, working independently but with similar antennae waving, have found a way out of this direction.

Before he embarked on the accumulation of objects, breaking them up and

scrupulously fixing the pieces on the patterns in which they fall (colorplate 31), Arman executed in 1958 and 1959 (after his first series of "Cachets" in 1956 and 1957) a series of paintings titled "Allures d'Objets." These works showed imprints of objects the artist had covered with paint and pressed hard against the canvas. Along with Dufrêne, Arman was without doubt the originator of the intellectualization of the imprint. His "Accumulations," "Colères," and "Coupes" are the exact symbols of a world in which the number finally destroys the idea of identity.

In 1957, François Dufrêne made a major poetic discovery which has been discussed ever since. His "Dessous d'Affiches" (the backs or undersides of advertising posters) are a sort of nonformal painting in colored papers (plate 52). He obtains them by tearing down posters from signboards and then meticulously rubbing the backs of them until he has obtained effects not unlike those many abstract painters have achieved by projections of matter and by scratchings ("grattages"). Often letters come through in the manner of a watermark; less often figures are superimposed; always there are traces of the masonry or boards on which the sign had been pasted. Legible forms are integrated with the material tissue of illegibility. The *dessous d'affiches*, phantoms of the collective life of the streets, may be among the best latent expressions of a Pop Art. In them we recognize — ironically reconciled by the contingent facts of placarding, advertising, paste, and weather — the aesthetic preoccupations of abstract painting, the myths of public opinion and the collective unconscious, and the very texture of banality. Dufrêne's irony (which is antiformal, anti-advertising, antiserious) saves him from lapsing into the fault of systematically glorifying "the images of the day," of which the American Pop painters are the self-styled champions.

Unlike Raymond Hains — who prefers ripped-down posters as he finds them, as they appear to anyone in the street, and who with something like awe discovers in them traces of a "poetry composed by everyone" — Dufrêne deliberately brings values and colors into play. He is not content just to cut out bits from posters sometimes fifteen yards long, to select them, paste them to the canvas, and than sign them; he goes on to decipher the meaning of the palimpsests formed by the accumulation of posters pasted one on the other. His work may be regarded as equivalent to that of semi-automatic painters who try to define figures or symbols in the colors — matter or spots — they have previously thrown at the canvas. Lettering in such works often takes on a new, plastic value, and it is to be regretted that actual figures are most often eliminated. But the result obtained, even when it suggests elaborate abstract

paintings, does not fall within the perspectives of abstract art so much as those of a new way of perceiving the world in which the "I" is no longer the romantic despot, and in which man, freed of all moralistic inhibitions, is at one with his environment.

Hain's attitude to art is yet more radical. A photographer, he at first tried to create "imaginary spaces" by mechanical means, through optical effects. Then, with the aid of "fluted glasses," he went on to transfigure photographed objects and even handwriting (in this way he "pulverized" Camille Bryen's poem *Hépérile*). But as early as 1949, he made a collection of torn posters picked up in the course of walking around Paris. By chance juxtapositions the poster series, called "La France Déchirée," unveils the psychological, political, and social chaos of French society. By bringing out unintentional ambiguities in some of the poster captions, he puts them to polemic use. One caption, for example, "Is This Renewal?" becomes an insolent question addressed to the avant-garde, not just to De Gaulle or the intellectual left. This series is admirable for being in no sense aesthetic. It never submits itself completely to the formal concerns of abstract painters save by the fact that the posters are torn — noncultural equivalent to the gesture in Action Painting. This art, "composed by everyone," consists of distorting actual examples of news and advertising. The big torn posters on metal panels which Hains executed after these present us with sumptuous shreds of a world of advertising annihilated by wear and tear, irony and anger. These works (like Dufrêne's) express an intention that might be called anti-Pop — although they antedate by fifteen years the advent of an art largely founded on advertising, propagated by advertising, and itself increasingly identical with advertising. Hains contests the untouchability or sacrosanct character of the material he works with. In any case he does not genuflect before the modern divinities of comfort, optimism, and mass consumption. His attitude remains critical, lucid, questioning; it helps express the postulates of a revolutionary artist (colorplate 28).

Jacques de la Villeglé chooses posters in which the arrangement and rhythm of the letters, their transformation and mutual contamination, play the most important role. Of the three French *affichistes*, he is no doubt the most lyrical, the nearest to an aesthete. He has a real love for plastic beauty, present or future (plate 51).

Inasmuch as Mimmo Rotella in Rome has been following a similar path since 1951, without knowing Hains and Villeglé, it is not too much to speak of a European movement. Its importance will not escape historians, for it draws up a kind of critical balance sheet between nonformal art, automatic

and gestural painting, carries further the use of lettering by the Cubists and by Schwitters, and reinterprets Duchamp's readymades by carrying their demonstrative power to the extreme. Poetry of the street, archaeology of the collective unconscious, the arcana of chance — Hains, Villeglé, and Dufrêne have anticipated the unfurling of the avant-garde to the very border line of reality and nonart. Their role cannot be ignored without falsifying the history of contemporary avant-garde.

Andy Warhol's paintings, which reproduce consumer products in the advertising style (cans of Campbell's soup, for example), are a continuation of the work of the French *affichistes:* these torn-off can labels, which often come unstuck, are an echo, fifteen years later, of Hains's ripped-off posters. Rauschenberg has incorporated fragments of torn posters in his combine-paintings (such as *Double Feature,* 1959). Although his approach is more faithful to Schwitters' Merz compositions and even to the Cubist collages, he shows the same concern as the *affichistes* for bringing the objects and symbols of contemporary reality directly into art and the same intention of making image and idea coincide. French *affichistes* have taken a more radical attitude, for they are unambiguously situated on the frontier where art and nonart, artifice and life, are at once tangential and distinct. When Rauschenberg integrated the object itself (as in *The Bed,* 1955), he moved ahead of the artists of the new European generation, and in this respect he is incontestably, with Jasper Johns, one of the great creative spirits of the present international avant-garde and, as such, superior to all his New York successors. (In Europe, two important exceptions must be noted in connection with the introduction of the object into the work: Christian d'Orgeix, who practiced it as early as 1951, and Horst-Egon Kalinowski, around 1956. Both artists are involved in something of the same secretive approach as Joseph Cornell. They have escaped for all time to a more "intimist" vision of reality.)

The integration of objects in art was carried to its extreme consequences in 1959, when Daniel Spoerri decided to trap reality just as it was, without any aesthetic modification, as on flypaper (plate 54). His "Tableaux-Pièges" ("trap paintings") are the products of an extremism matched only by Arman's that same year. Spoerri gives us assemblages of actual objects as works of art. When I discovered them in 1960, I become aware of the "revolution in seeing" for which modern art has been groping since 1910. It is not works of art that reflect changes in historic, economic, and social reality, but reality that is subjected to the repercussions of artistic revolutions. Thought precedes and misleads history, and we have lost the capacity for seeing and interpreting

reality as a whole with the same eyes: by projecting upon objects his obsessions and ideas, the artist effects an essential, indelible modification of them. Not that the still life makes life stand still, but how can we fail to connect a revolutionary poetry with all the objects surrounding us? How can we fail to find the latent meanings that the mechanisms of thought hold? The school of looking is not that of those who look. It is, rather, an introduction to the mental revolution.

In directing his attention to the world of machines, Jean Tinguely plays a role in sculpture comparable to Matta's in painting. Just as Matta does not confine himself, in the interpretation suggested by his forms, to a survey of technology, so Tinguely invents machines which in their functioning suggest nonmechanical, psychic and interpsychic, meanings. Their movements, vehemence, and general oddity do not express any mere love-hate attitude to machinery (plate 55).

In his works prior to 1959, Tinguely did not conceal his fascination with a certain aesthetic inherited from Mondrian and Malevich, in which movement brings out the inhuman beauty that was Jean Arp's acknowledged ideal. Once movement is introduced into sculpture, the changing position of the elements produces accidental effects that can often be disconcerting. Moreover, because of the growth and spread of Abstract Expressionism, then triumphant both in the United States and in Europe, one could not help concluding that nonformal art was confounding itself with a dumb rage. It was necessary to infer that the geometrical art which had preceded nonformal art in postwar France — most notably in the masterful compositions of Dewasne and Herbin — would have greater staying power against the unconscious desire for change then being felt by all young artists.

Tinguely's first "drawing machines" introduced the problems of gestural automatism into sculptures: the humor of a Duchamp and a Dali was succeeded by the rule of cruel, lucid irony. Tinguely's machines are equipped with moving, jointed "arms" that literally draw "abstract" works: jerkily, they set down parallel rhythms, accents, or dots on rolls of paper sometimes several yards long, "temperature charts" of the crisis that now set one and another of the artistic avant-gardes against each other.

The machine titled *Metamatic 17* (acquired by the Moderna Museet of Stockholm) is automotive (on wheels), sonorous (it emits sounds), odorous (it produces smells), and altogether spectacular. It can produce up to a thousand drawings in an hour. Moreover, when it upsets it rights itself, aping the frantic machinery of contemporary artistic production, which the market up-

sets and rights in turn, obeying laws that are very simple yet bewildering. Tinguely produced seventeen "drawing machines" in 1959, and with them played a demystifying role against the proliferation of Abstract Expressionist paintings and against the complaisant doctrine corresponding to them.

In Europe, more clearly and with a more violent break than Rauschenberg made in New York — where diplomacy and careful behavior are the result of cold calculation — Tinguely, along with Klein, Arman, Réquichot, and a few others, determined the abrupt shift in orientation of the avant-garde. His action had immediate repercussions. On March 17, 1960, with his ironic and sumptuous *Homage to New York* — an enormous self-destructive machine named Lucifer which he built and set up in the garden of the Museum of Modern Art in New York in five and a half weeks — Tinguely realized the most inventive and conclusive of all happenings, eclipsing all those laboriously "improvised" ever since. Of no commercial value, it cost its creator $1,500 and was reduced to dust when it had destroyed itself in the museum garden in twenty-eight minutes. France at the time was going through the blackest days of the Algerian drama, and this machine was a sort of act of political terrorism in reverse, with implosion taking the place of explosion. A great dream was condensed in it, and the occult decisive happening of which it is the symbol, has left enigmatic traces in our minds.

Homage to New York, or *Suicide Machine* — through which "something is happening, something is shooting" — incarnates the cutting ambiguousness with which all the boldest creative ventures are conceived today. Self-destructive homage, vociferating and no longer unhappy readymade, autodestruction that implies permanent suicide, exemplary, unrepeatable — with these Tinguely has given an unforgettable poetry lesson, at the most appropriate time and place. Historians will one day appreciate this — and right-wing historians ahead of the rest. A few of us already understand why this event is so important, and why the *Homage to New York* of 1960 had greater repercussions even than the drawing machines of 1959. Marcel Duchamp counts among the few, as he draws a parallel between Rauschenberg and Tinguely, even though they are divergent.

"I felt embarrassed to paint a likeness of an object," said Nicolas de Staël, "because, relevant to one object, one single object, I was embarrassed by the infinite multitude of other coexistent objects." Tinguely, Arman, and Spoerri have surmounted this embarrassment, which was acknowledged by one of Europe's last great abstract painters at a time when he was beginning to free himself from abstractionism. The very multiplicity of existing objects led them

to invent the art of multiplication and accumulation. Just when everyone was persuaded it had been banished forever from the field of artistic expression, the tabooed object once again become the axis of contemplation and reflection. Resurrected from collage and related techniques (decollage, imprint, transfer, silkscreen), it triumphantly re-entered the stage of contemporary art, so much so that today it seems to serve as a mask for the man who paints, the man who co-ordinates his visions and articulates them in accordance with a self-invented syntax.

Ferró, an Icelandic painter who has been working in Paris for seven years, creates works of real complexity, in which the worlds of machinery, biology, advertising, and modern news media are reflected in paintings of great breadth, comparable to Matta's large works and Rauschenberg's earliest combine-paintings. Ferró sums up and resolves contradictions scattered through the works of a number of painters, and I should not be surprised if someone discovers one day that his work supplies one of the closest fitting keys to the comprehension of the contradictions in today's thought. A tireless worker, he has executed hundreds of photomontages (which he does not exhibit, because he looks upon them merely as starting points for his paintings) in which figures nearly always coexist with mechanical objects and advertising images. The hybrid figures of his invention bring to mind those of Hieronymus Bosch, for they, too, destroy the preoccupations and knowledge of quite a number of contemporary specialists.

In his paintings, the idea springs from the single encounter of faces whose selection is never deliberately associated with any traditional symbolism. Ferró's subjects are not premeditated: he shuffles them like a deck of cards, like a film cutter to whom the director has given a free hand. In his portrait of Mayakovski, it is purely by chance that he uses the image of an elephant crushing a child under its monstrous foot. The gigantism of Mayakovski's inspiration does nonetheless inspire him. (His early photomontages and collages also bring to mind those Alexander Rodchenko executed in 1923 as illustrations for Mayakovski's *About That.* See Aragon, *Les Collages.)* Never quoting, he draws upon Russian Futurist posters, as though with icy irony he were reminding us that Pop Art is not so new as it pretends. Similarly, when he copied the plans of jet or turbine motors, it was to show the poverty of certain pictorial affectations: the formal inventions of technicians often seem to him more deserving than those of artists.

Ferró's mania for gathering and classifying enormous quantities of documents makes for pictures that teem — he considers it a victory when he has in-

corporated five or ten thousand elements in a single work. When multiplicity is carried this far, we can only admire the energy with which it has been mastered. Any notion of reducing it all to a single theme is alien to Ferró. Whatever he happens to glimpse in magazines, photographs, films, posters, book illustrations, and all sorts of diagrams must find a place in his art. He wants to devour the world. Such an ambition may condemn him never to produce a single "masterpiece," but it will enable him to produce a body of work impressive in its quantity and variety (colorplate 29). Whether he titles it *La Tarte de la Révolution, Foodscape,* or *Rat-cistes* (a pun on rats and racists), each painting involves the same method of gathering and juxtaposing heterogeneous elements. The famous meeting between a sewing machine and an umbrella on an operating table — which inspired such diverse geniuses as René Magritte, Ernst, and Dali — becomes, in Ferró's work, a jostling together of every technique and civilization.

Who is hiding behind these multitudes? It is as though the painter were voluntarily surrounding himself with a universe that negates him. The unconscious, the expression, the individual message — all give way to the awesome omnipresence of things. The palace of the ego has been destroyed, and on its ruins a "library of Babel" has been built, which is not to be deciphered entirely by any single individual. To collectivization Ferró opposes the multiplicity enclosed in vision, the teeming swallowed by memory; to the well-planned world of the scientist, the chaos of arbitrary assemblage; to reason, the flood, the invading cancer of infinite multiplication. In this compensatory operation, which perhaps sums up his work, the individual becomes an instrument of revenge. It is as though someone were sneering in the background of these décors, someone who will never let slip his secret, never let himself go, save perhaps to break down entirely in the end, like a track champion who has run his race; someone who is trying to conceal his own identity behind an iron mask: Ferró, *masque de fer.*

Painting did not always satisfy a need for the radical transformation of reality. A painter like Daniel Pommereulle was led to painting objects and to placing them in a setting, as would have been done by a film director if he had the free genius of Jean-Luc Godard. In a secretiveness similar to that in which Raymond Hains worked until 1959, Pommereulle tries to arouse new rapports between the viewer and the thing viewed: he sees the structures of his thought in a garden table, in balls of wool or barbed wire. To reveal their significance he covers them in colors, in which a particular mauve plays a misleading role (plate 57). He paints the table in cerulian blue; chooses a violet

wool; paints the ball of wire a light blue; covers the inside of a large, lidless, flat box with a layer of cotton wool, which he illuminates with a bluish bulb under a 1925 lamp shade in the shape of a rose; or even, in *Ces Victoires* ("Those Victories"), composes a solemn homage to an absent Authority: a white painting, of which only the edge is coated in colors, next to a white curtain that floats behind a tricolor bust of Beethoven. After Arman's, this experimentation, and that of Tetsumi Kudo, seems to me the most adventurous since Duchamp's readymades, for it dips symbolic allusions, metaphysical meanings, the hallucinatory power of traditional painting, from Bosch to De Chirico, into the world of objects. One is willingly led astray into a world without landmarks, a world of free-floating thought.

Jean-Pierre Raynaud, a young painter, has for a short while been following an almost parallel course (plate 58). Tetsumi Kudo, a Japanese painter now living in Paris, also invents veritable traps for the viewer: white boxes, black placards, and cubes in the shape of giant dice, his works imprison sexuality, birth, and death in a new kind of reliquary (plate 56).

Horst-Egon Kalinowski, with his "Reliquaires" ("Reliquaries" — 1957-58), then with his objects in metal, in wood, and in leather, has doubtless contributed to Europe's direction down the road that hurls the spirit into the inner life of the objects surrounding us (colorplate 27). Among all the artists of the Parisian avant-garde, Kalinowski, Kudo, Pommereulle, and Raynaud are the "object-ists" of a new consciousness in art, for their work is unlimited in its forms and its meanings in the customary field of aesthetic systemizations. A bright light shines under their door, by which all of reality can identify itself with the mental.

Artists have become ever more helplessly acquiescent in the social recognition of their talent, and about all they can do in the face of it is to make their work ever more impenetrable for the majority of the spectators. The world echoes its inaccessible totality in each of its parts. Everything is thrown at us in a lump every second of the day. Man can no longer breathe. He retaliates by creating an imaginary world that is uninhabitable except by all-devouring thought, which encompasses everything.

Victor Brauner has shown in all his work that a painter can materialize his own personal mythology. Every figure born of his imagination is connected with a private phantasm, with an acknowledged desire for freedom or omnipotence: Brauner is the multiple figure that governs his art. But such an obvious — even if refracted in innumerable facets — egotism does not account for the magnetism of his paintings. It is perhaps starting with Brauner that

the individual, in painting, has shown, once and for all, how he disintegrates under the blows of his inner contradictions.

Although, since the period of *Rétractés* (1951), Brauner has gradually regained a kind of aesthetic serenity, and although his works have in a sense been dispelling the anxiety-ridden entities that long populated them, giving way to the grace and freedom of a brilliant improviser, his painting has stayed in touch with the domain of the sacred (colorplate 30). Does this imply that the archetypes dwelling in the individual unconscious are the last survivals of hieratic dramas? At all events, it is interesting to note that the individual, when he expresses himself in archetypal language, now plays the part of the hierophant: he presides over new Eleusinian mysteries invented by the mind to discover the hidden meaning of things. Free from all dogmatism, Phillip Martin is following the same path, but in a mental sphere from which the ego has completely disappeared (plate 61).

After he had made his escape from abstractionism, Bernard Dufour painted apparitions of women in an atmosphere of palaces, forests, and mysterious pools. In 1961, he attacked the problem of the mirror image, set against both the image of a landscape seen through a window from a dark room and the image of the painting itself. The result is almost classical, although it suggests Munch rather than Moreau. Dufour may be likened to a postwar Soutine without the gasping violence or a Modigliani without the enigmatic muteness. Like both these painters, Dufour deliberately seems to contradict the "Cubism" that preceded him — in his case, abstract painting. If it is not quite despair, his works still have an underlying melancholy, an attraction toward the abyss, a need for the artist to lose himself — in a glance or in a road glimpsed when leaving a wood at twilight. Dufour moves like a sleepwalker toward an improbable painting — that of a collective dream in which every individual will recognize himself in all the others (plate 59).

The painting of Jacques Monory, which has a more modern, urban quality — it has obviously been stimulated by the provocation of Pop Art — nonetheless shares a smiliar nostalgia. There are, however, great differences. Where Dufour sees his images emerging out of mists, Monory (like Ferró) takes them from the color pages of magazines. Where dreams lead Dufour far beyond the will to communicate, Monory's dream has a spectacular, if not cinematic, quality which intensifies or compels communication. The image of a revolver served first to liberate him from the anguish in which a "tunnel of abstract painting" had trapped him for many years. In 1955, however, he began to paint furniture and strange machines. In these works, the presence of the

object evoked a questioning of everyday matters, and for the past three years he has kept going back to this earlier manner (plate 60). In the lives of young painters, changes come abruptly — a meeting, a chance incident, a book, an unusual film may, at any instant, change their whole outlook. Monory long suffered from solitude and from his inability to arouse direct echoes through his painting. Before the war, thanks to the friendship of the poets, the Surrealist painters withstood the contempt with which they were treated. Today, poets prefer painters of an earlier generation: Jean Genet likes Giacometti and Leonor Fini, Yves Bonnefoy likes Fini and Balthus, and André du Bouchet likes Hélion. (Has anyone noticed how often poets prefer figurative painters? I, myself, have always felt closest to those who do not set up a wall between their hallucinatory life and their real life. Monory is one of them.)

Most art critics make the serious mistake of praising their favorite painters, and totally ignoring the others. On closer examination of the artists' works, however, we come to like them for hitherto unsuspected reasons.

I would have perforce to omit Dewasne, Vasarely, Agam (plate 62), and Soto from this hasty study of the evolution of art in Paris since 1959; it would be vain to deny that their experimentation has continued to grow more profound. For the last several years, the work of each of them has increased its resonance and today has echoes in New York. Each time that one finds himself in the presence of a painting by Jean Dewasne, one is arrested by a physical presence that extends Mondrian's philosophical vision into the perspective of delirium: that of an exacerbated sensitivity that turns away from nostalgia to affirm a violent and systematic love of modern life (colorplate 34). But what is modern life? According to Piqueras, a compartmentalization of contradictions. According to Dewasne, "a humanity of prodigious possibilities." According to Matta, "a voyage of being." According to Arman, an accumulation of objects. According to Ferró, a caroming of all the techniques. According to Yves Klein, the immensity of the eternal blue space.

Vasarely's work, which, like that of Agam and Soto, is based on increasingly subtle optical games, requires the viewer's co-operation; each of his paintings is a trap where our attention is insidiously won in such a way that we no longer know why the painter appeals to us. Thus Vasarely establishes an art of retinal vision subordinated to thought, in which, at its extreme, we are unable to decide if the optical illusions annul thought or if it is our thought that, at the heart of these illusions, creates an inhuman void (colorplate 33). If one lingered over Vasarely's work, one might decipher the figure of a man: the psychological

background pre-exists. Like Dewasne, but with less extensive violence and above all with less lyric freedom, Vasarely seeks to prove that art can agree with the modern world, can glorify it without illustrating it. These painters alone structure the feelings of danger and catastrophe to which a large number of contemporary painters abandon themselves in chaos.

The more discordant notes a score contains, the better it is. Painting is always in danger of being charmed by two narcotics: systematic praise and smug indifference. This is why it is so important to defend all the eccentrics who keep modern art from being as routine as unanimous acceptance would make it. We must scorn the multitude. Speaking about Degas, Paul Valéry said: "He feared the death of the individual." Today, the only remaining individual — even if his art denies it — is the painter, the poet. His disobedience, apparently, supplies our only glimmer of light.

For this reason, we must demand more and more from our painters and poets: nothing is worse for them than too much applause. The trial Paris is going through at present, scorned as it is for both good and bad reasons, will most probably prove a good thing for an artist's personality and character. Excessive brouhaha, abundance, euphoria, and depression make ideas go flat. And without ideas, painting would soon be indistinguishable from the purely decorative function to which some would like to reduce it. After Braque, Matisse, Brancusi, and many of the great founders of modern art, it will be Picasso's turn to die. The artists who are in their thirties today will find themselves confronted by finished monuments, which they will have to tunnel beneath — or blast away — to go beyond. Now is the time for them to show some life and passion. For it will be necessary to discover many more talents than the ones I have mentioned here. I have not spoken of Arroyo, Recalcati, and Aillaud, all of whom show painterly qualities. Arroyo came from Spain six years ago, Recalcati from Italy two years ago; Aillaud is French. Arroyo's satires on Spanish and French painting and myths have a dark quality under their gaiety, a vigorous insolence, and amazing sense of showmanship (plate 63). Recalcati reinvented figures in space: going beyond Klein's "Anthropométries," he reconstructs the big-city scene (plate 64). A woman, Myriam Bat-Yosef, surprises with the objects that she re-covers entirely with intertwined paintings, in which poetry encroaches upon banality (plate 65).

Bona, always surrounded by poets, began in the footsteps of De Chirico and Max Ernst. Since 1959 she has composed collages or painting-collages of great originality. She uses cloth and ticking, mattresses and pillows, which through her poetic fantasy she transforms into totemic forms, sundered couples, night

scenes, and rituals of death and sex. Night, blood, love, violence, all are turned into lyric symbols of her striving toward a Sacrum. Her women appear to have a twofold task: to find an erotic liturgy and to continue the ancient mysteries (plate 67).

After Niki de Saint-Phalle had represented the circumstances of daily use in a series of collages dating from 1960, she went the way of violence, but by more spectacular if more external means: she shot paint from a gun onto canvas; blood stains, wounds, rage, and blasphemy: all of which is further confirmed by the consecration of altars ironically dedicated to the OAS (the Algerian Secret Army). The figures she now sculpts are startingly gay and display the same aggressive humor, the same quest for provocation and freedom, and the same charming impetuousness of her "shooting period" (plate 66).

Margarita Russo tries to renew a color-and-form magic. She arrived at this through a series of black-and-white impressions taken from pavements, paintings, tables, and doors — traffic signals in the labyrinth of the modern city. She now uses a kind of tracing material on cut tree trunks, branches, and leaves, so as to be able to associate the image with the most original of all formal creations, that of Nature herself. In her circular paintings she presents as many slices of tree trunks as one would expect to find in the original cellular components of primordial life. Color streams forth magically, and the radiance of the Gothic rose window is brought to mind (plate 68).

The new sculptors are alternately fascinated by the eroticism of the figure and the magic of the object. Formal invention often makes them more solid, more steady than the painters. Philippe Hiquily, who has achieved an original style, began to integrate objects in his sculptures in 1955 (plate 69). César after a few remarkable innovations in the sphere of "assisted readymades," including hydraulically crushed cars and other metallic "compressions" (colorplate 32), seems to have reversed his course and to be looking now for the secret of a monumental nude. One can have confidence in Hiquily, Müller, and Berrocal (plate 70), and Takis still holds surprises for us. These men seem more successful at striking a balance between meaning and formal invention, but César is no doubt only hibernating. Etienne-Martin invents "dwellings" that could be inhabited only by imaginary creatures or gods (plate 72): they materialize a desire to integrate with the universe, and seek the chthonian origins of architecture. Between aggression and eroticism, Robert Müller constructs hybrid shapes in which he concentrates defensive and alienated anxieties (plate 71).

Serge Rezvani and Bernard Saby, abstract artists whose works are not dictated by any external stimulus, are closer to the masters of the first half of

the twentieth century than are the overrated Bazaines and Manessiers whose merits were so exaggerated for so long. Saby is a visionary as Mathieu never was. He knows how to express the infinitely great in the infinitely small (plate 73). Rezvani, who fled Paris to shut himself up in a house in the woods, who daily fights against darkness and questions the fire that devours him, who seeks yet never finds — he is perhaps *the* disturbing painter of today. His death in every brushstroke, he comes to us from beyond the grave, defying the passing of time and the insanity of fashion, content to be on the fringes of things (plate 74).

On the other hand, a man like Hervé Télémaque, born in Haiti and working in Paris, has lived and transcribes in his paintings the adventure of integration with Western art. Wifredo Lam did the same, rediscovering and recharging totemic forms with a new meaning. Télémaque, closer in his sensitivity to the American Pop painters than to Lam or Picasso, at first absorbed Gorky's formal vocabulary, in which elements from comic strips are ordered to the extent that they work out a veritable code of seduction and provocation (plate 75). It is evident that this painter, respectful of the styles of contemporary expression but concerned with renewal, places them at the service of his personal intentions, where one often recognizes the uncertainty of a man who seeks to satisfy two complementary needs: the need to please and the need to shock, the need of unity and the need of separation. It is not without importance that the first Negro painter of this generation who came to express, according to new forms, the psychological and social truths that too often tend to be excluded from painting was able to establish his work in Paris. The need of integration felt by Télémaque and the need of remoteness felt by Rezvani indicate the two contradictory behavioral components of the contemporary artist in Europe.

The newspapers lie. The art magazines lie. Painting is a life-and-death matter to a great number of painters. Beset by difficulties, they dig in their heels. Their paintings can be identified by their subjection to one requirement: that they be dictated by vision.

Painting inhabits the sacred domain of free hallucinations. The international avant-garde has just begun to fight. The anxiety of the individual no longer has a single center or a single homeland, and nationalistic art is dead.

As Delacroix said to De la Rochefoucauld, director of the Beaux-Arts, "The whole world can't stop me from seeing things as I see them." Time and again we have it dinned into our ears that all the new generation lacks is a new Picasso. This is false. We need a multiplex, contradictory painting, violent and happy, perhaps even a new kind of historical painting, in which the hero is an

explosive individual. For the generation that emerged in the 1960s, the revolt against uniformity takes precedence over respect for the accomplishments of its elders. Ambition, imagination, and the spiritual freedom of a few individuals will inevitably arouse passions, quarrels, and intrigues. No matter. Ideas change painting by scuttling all norms. The crisis of the European spirit is once again giving birth to Stendhals and Delacroix. They are rebuilding our ways of seeing. Thanks to them we are entering the twenty-first century. The door is open. No one is waiting for us. There are but a few dozen of us who believe that the human spirit is about to accomplish its coming of age.

35 Harold Cohen 1964

36 Bernard Cohen 1964

37 Peter Blake 1965

38 B. Kitaj 1964

39 Antony Donaldson 1964

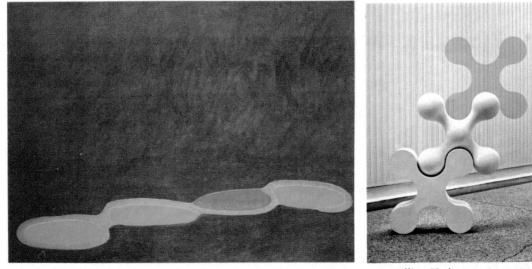

40 John Hoyland 1964

41 William Tucker 1964

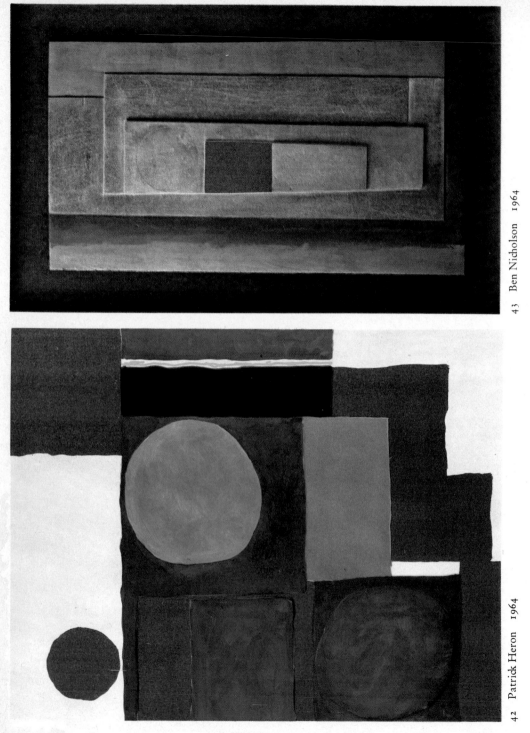

43 Ben Nicholson 1964

42 Patrick Heron 1964

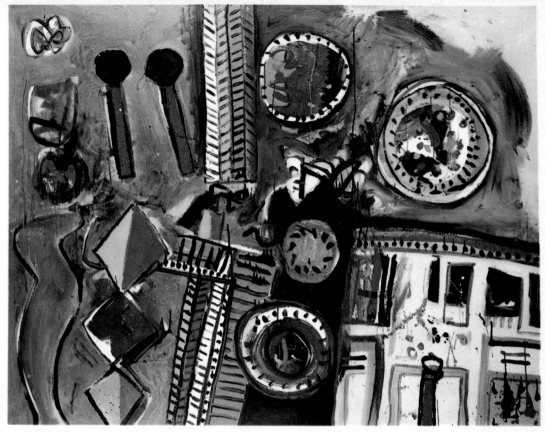

44 Alan Davie 1962

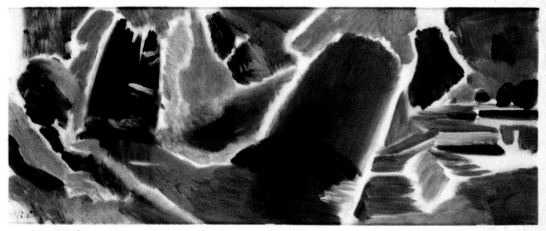

45 Ivon Hitchens 1959

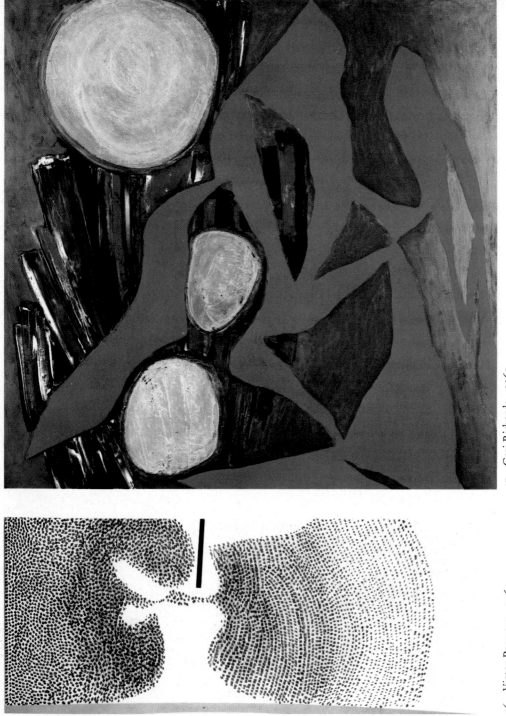

47 Ceri Richards 1961

46 Victor Pasmore 1964

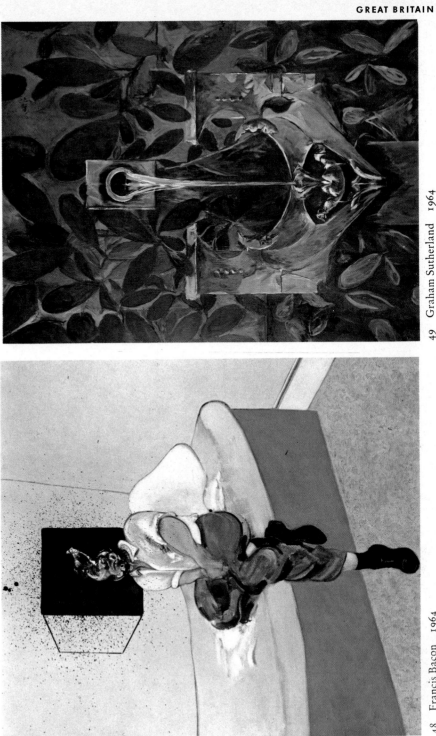

49 Graham Sutherland 1964

48 Francis Bacon 1964

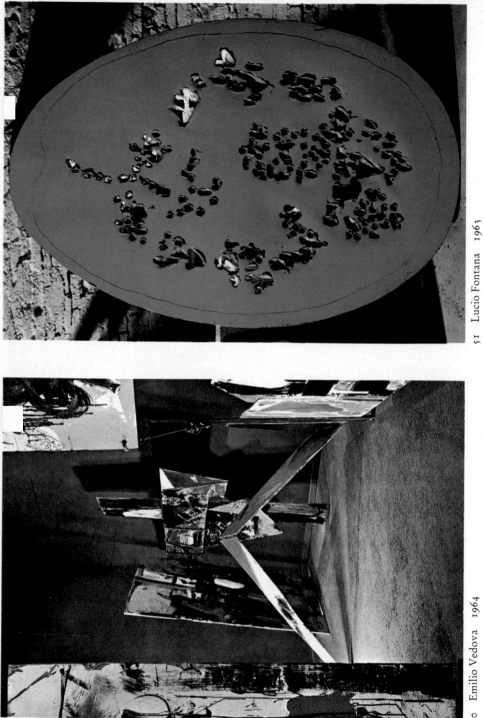

51 Lucio Fontana 1963

50 Emilio Vedova 1964

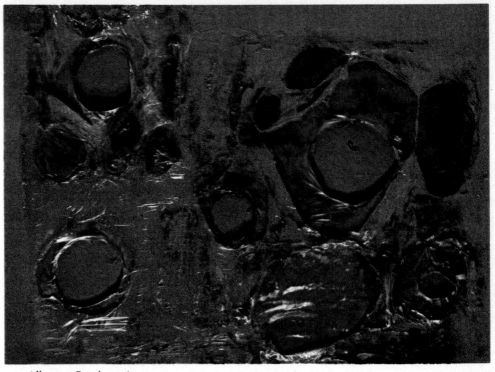

52 Alberto Burri 1962

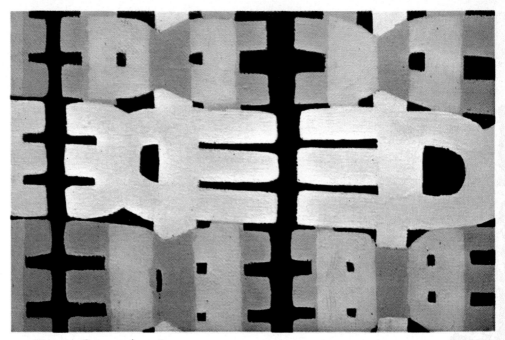

53 Giuseppe Capogrossi 1964

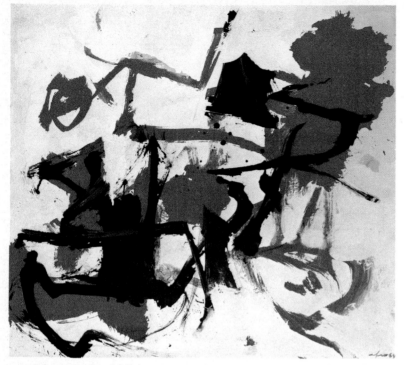

54　Afro (Afro Basaldella)　1964

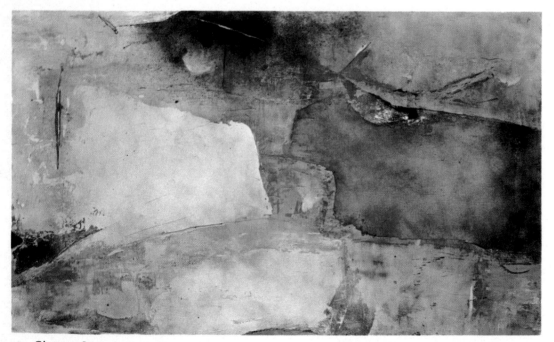

55　Giuseppe Santomaso　1963

British Art Today

By Alan Bowness

If one wishes to understand British art today, there are several preliminary observations that must be made. First, painters and sculptors have been quick to appreciate the internationalization of art that is such an obvious feature today. Second, as in many other respects, British artists are aware of a "special relationship" with the United States, and of a certain unease in their contacts with Europe. Third, they have profited from a social situation that is still in the course of evolution but that establishes a framework for creative artistic activity probably more profitable and equable than that pertaining elsewhere. And fourth, they have been among the first to express the new mood of the 1960s — those qualities that will be seen to distinguish the art of today sharply from that of the immediate postwar years. Before proceeding to a discussion of the painting and sculpture, I should like to take these general points a little further.

First, the internationalization of modern art: It is evident that the dominant position as the capital of modern art held by Paris from the age of Jacques Louis David to that of the Surrealists is now at an end. The fall of France in 1940, the flight to the United States of much of the best artistic talent, and the forced inactivity of the younger generation during the war itself confirmed what would probably have happened anyway. But it is not true that New York has "replaced" Paris, as has sometimes been claimed; for one thing, the basic chauvinism of most New York artists and their associates has prevented this. What has happened is subtly different: the ease of communication between artists and the ease of reproduction and of exhibition of works of art now mean that a total art situation can be shared by painters and sculptors living in different places. There is no longer any need to move anywhere; one must travel, perhaps, and look at the art magazines, certainly, but a common place of residence is not essential.

I would say that this new kind of internationalism has been particularly evident in the relationships between English and American artists in the 1950s

and 1960s (my second general point). Because of the shared language, the literatures of England and America are inextricably interlinked, and the same kind of discussion seems to be carried on whether the writer is an American-born Englishman like Eliot or an English-born American like Auden. Given this precedent in literature, is it surprising that English artists have felt there to be a "special relationship" between themselves and Americans? And there is an obvious ease in personal communication, given the common language, that has almost always been lacking between English and French artists. It is not an accident that there have been no important English-born artists of the School of Paris. The proximity of Paris has always given English artists a mixed sense of inferiority, envy, and even deep-seated antagonism.

On a partly unconscious level, too, there has been an alienation of Continental Europe from English intellectuals. This is in certain respects a consequence of the political and economic unity of the Common Market countries, which include all the major cultural centers of Europe other than London. Without being much concerned with politics, most British painters and sculptors would nevertheless be aware of a certain hostility and lack of understanding felt toward them, in contrast to the far more receptive American audience. Just as French literature no longer has the intellectual prestige it commanded in England until 1940, so French painting and sculpture now totally fail to interest either the artists themselves or, to an admittedly lesser degree, the wider public for modern art in England.

It is impossible to exaggerate this new attitude toward French art and artists. I am not thinking of the older generation, though even here revaluations are constantly in the air, and Bonnard and Matisse (and Mondrian, in so far as he was a Parisian artist) are generally regarded as of greater interest than Picasso and Braque. Of the younger artists, even major figures like Dubuffet and Vasarely get less attention than they merit because of their association with Paris. And a new European artistic development of obvious importance — like the matter painting of Tàpies and Burri, for example — had little effect on English painters and sculptors in comparison with what happened elsewhere.

It is a curious situation, complicated by a certain obtuseness and wish fulfillment on the part of the painters themselves. There is little reason to believe that Americans *need* the English, any more than they need any other European artists. And there is basically more common ground between the English and other American-oriented Europeans, like the Scandinavians, Dutch, and Germans, than the artists have bothered to recognize. They have preferred a self-

imposed isolation, cutting all connections with the Continent and nurturing themselves on a partly idealized view of American painting. As the fortunes of Paris have declined, so has this policy paid off and survived the reality of the American experience as it has been revealed to the artists who have in turn visited the United States. Admiration for certain American artists of course persists, but not the feeling that everthing is ordered better across the Atlantic. It has been equally evident that opportunities exist in the old continent every bit as exciting as in the new: a new confidence is to be found in British art, and this now begins to attract international attention.

If one surveys the art activities of the last five years, one finds this new evidence of outside interest in British art, and especially in the work of younger painters. Leaving aside the valuable but obviously partisan missionary activities of the British Council, there have been mixed British exhibitions in California and Texas (British Art Today, 1962); Minneapolis, Washington, and so forth (London: The New Scene, 1965); Eindhoven (Kompas 2: Contemporary Paintings in London, 1962); Leverkusen (Neue Malerei in England, 1961); Düsseldorf (Britische Malerei der Gegenwart, 1964); and Bochum (Englische Kunst der Gegenwart, 1964). The significant thing about all these exhibitions is that the initiative for them did not come from England: it was the local museum or municipality that requested and in some cases selected the entire exhibition.

What one has then, is a new kind of artistic lineup, a part of the new international pattern of modern art. And London has slowly been winning greater prominence as an international center, where a steadily increasing proportion of the artistic activity is carried on by those who are not native born. There had always been a nucleus of Commonwealth-born artists who gravitated to London; this has been particularly apparent recently because of the Australians who have either settled permanently in London or compromised by adopting dual residence, in their native country and in England. Sidney Nolan is the only one with an international reputation, but the potential of the Australian-British school is obviously considerable, as is confirmed by the diversity of style represented by Arthur Boyd, Charles Blackman, and Brett Whiteley, for example. Other Commonwealth countries have also made their contributions: Dennis Bowen and Avray Wilson from Africa, Sonza and Chandra from India, Richard Lin from Hong Kong, Frank Bowling from the West Indies.

In addition to this, there are the European-born painters who arrived in England as refugees during the Hitler era and have remained to become an intimate part of the English art scene: Josef Herman, Henry Inlander, Peter

Kinley, Paul Feiler, Frank Auerbach, Lucien Freud. In many cases, these artists arrived in Britain as children, and their entire artistic career has been spent here. They are almost totally assimilated, and as English as Rothko and De Kooning are American. The postwar years have brought other permanent or long-term residents: John Ernest and R. B. Kitaj from the United States, Karl Weschke from Germany, Nicholas Georgiadis from Greece, Salvadori and Schettini from Italy. And there are several very promising younger artists still to emerge.

The consequence of all this is that artistic activity in London is far more considerable and more intense than it has ever been before. The contrast with the situation of, say, forty years ago is startling. This brings me to my third general point: the social framework in which the artists work, which is I think a particularly advantageous one. One can only summarize this briefly: the training in the schools is stimulating, and the annual student exhibition, the Young Contemporaries, has the highest standards of its kind in the world. The talented young are watched closely and given appropriate encouragement: part-time teaching posts in the big London art schools bring them together in graduate seminars, as it were, and opportunities to exhibit are rarely lacking at the right moment. There are very wide-awake dealers and public patrons: the representatives of the Tate Gallery, the Arts Council, the British Council, some provincial museums, and the Gulbenkian and Stuyvesant foundations.

Private patronage in England is perhaps comparatively weak, and, partly because of the tax structure, the kind of *nouveau-riche* collector who dominates the American modern-art market hardly exists. In compensation, however, it is proving much harder to gear London to the cycles of fashion in new art that are becoming such an unhappy feature of the New York scene. The pace is tough for the painter or sculptor, as it must be, but fewer spectacular successes and shifts of taste keep it more just and less hysterical.

This is in a way a reflection of the even-textured nature of British society in the sixties. Not that the native obsession with class and social distinctions has disappeared: nothing seems able to destroy these traditional and largely moribund elements of our culture. There is, however, a new mood abroad, and nowhere is this more apparent than in the related fields of design, the arts, and entertainment. Again, this is an immensely complicated situation, and it is impossible to do more here than discuss it very superficially. This is my last general point, however, and it must be appreciated before one can go on to talk about the painting and sculpture, which are to a considerable extent the product and reflection of the society in which they are produced.

Let me begin by pointing the contrast. In the 1940s, Europe was torn by war, and imaginations were possessed with images of destruction, torture, arbitrary annihilation, and the like. Inevitably this colored all the arts of the period, demanding either a cathartic acceptance or a deliberate rejection in favor of an affirmation of positive values. These alternative reactions are represented with extreme clarity by the two outstanding British painters of the mid-twentieth century, Francis Bacon and Ben Nicholson.

In the 1960s, it is impossible to pretend that the world is not a much saner place. One can no longer take up attitudes that were relevant twenty years ago. Not that artists have lost their social consciences; many have in fact been extremely active in such vital questions as nuclear disarmament and radical prejudice. But these are not *immediate* problems for an English artist today, in the sense that poverty and social injustice and fascism once were. He lives in a society of which he has no cause to feel ashamed, a society that approves of him and of which he in general approves. In such circumstances the romantic conception of the artist as outsider becomes increasingly untenable, and a new relationship has to be found that recognizes both the artist's individuality and his integral place in society.

The evidence of this is best seen in the work of English artists of the immediately postwar generation — those born between, say, 1925 and 1930. They grew up during the war and first emerged as individual voices in the early 1950s. In most cases the languages that the voices then spoke were styles current in the 1940s, and they have since proved inadequate. The battered human and animal images of the sculptors derived from Giacometti and Richier: they expressed a particularly anguished appeal for sympathy at their broken and fragmented state.

The young sculptors who used this language at the time — Robert Clatworthy and Elisabeth Frink, for example — have (with some difficulty) had to move on to a greater concern for formal problems. Similarly with the realist or "Social Realist" painters, who began in the wake of Renato Guttuso — and, almost alone among European painters, he, a South Italian, has been able to use the style with conviction. The drab and sordid domestic interiors of Jack Smith and John Bratby and their associates expressed the mood of the moment just as precisely as did the early novels of Kingsley Amis or John Wain, or John Osborne's play *Look Back in Anger*, but this was a sudden outburst that cleared the air in the early 1950s, and to carry on in such a manner was impossible.

There was another protesting realist movement of this kind that raged in

England in the late 1950s, which centered around the former pupils and associates of David Bomberg (1890-1957), a British Expressionist painter of considerable power who won little public recognition during his lifetime. It was Bomberg's isolated position that attracted young painters temperamentally unwilling to jump on the abstract bandwagon, as most of their contemporaries and elders seemed to be doing. In fact, the best artists involved — Leon Kossoff and Frank Auerbach — are probably closer to North European Expressionists like Appel and Jorn than they would recognize, and this may well become clearer as they (particularly Auerbach) develop.

Another painter of this generation, Harold Cohen, leads us conveniently out of this section to a discussion of the painting itself. As befits this Jewish painter — and the Jewish contribution to British painting looks like becoming as significant as it has been to American — Cohen has not shelved what he feels to be the artist's responsibilities, but he has redefined them:

> In this world annihilation hangs over us like a permanent cloud. If ten million of us were destroyed tomorrow, no one man would take responsibility for it having happened.... Is it too fantastic to suggest that the artist, by his insistence upon his right to bear total responsibility for every mark he makes, every image he creates, should be performing a symbolic art, of significance to the society within which it is accomplished?

Given this declaration, one might expect that Cohen's painting would, however abstract, reflect a horror at nuclear destruction by splintered forms, dark tones, murky colors, and so on. In fact, the reverse is true, as *Pandora* (colorplate 35) makes abundantly clear. It is an ebullient painting, light in tone, gay in color, full of rounded organic forms that float freely on the white ground. There is an ordering intelligence at work, but further than this one cannot go: the picture is deliberately devoid of associations, and no useful analogies can be drawn.

Cohen's *Pandora* is individual enough, but it has qualities that mark it out as a product of Britain in the sixties: it belongs generically with the work of younger artists, whom I now want to consider. For I propose opening the discussion of British art today with the youngest generation: painters and sculptors with no history to speak of before the sixties. They therefore exemplify the new mood in a clear and forthright way. This is a confident and uninhibited generation, quick-witted and responsive to challenge. It has made a much

more realistic appraisal of Britain's role in the world than its elders have done, and the outstanding talent seems to be flowing into those areas where standards are international and superlative achievement possible. It is a generation that has quickly drawn international attention to itself, not only as artists but as actors, fashion designers, and the creators and purveyors of pop music.

The first clear indication that something new was happening was given by a little-noticed group exhibition, Situation, that was held at the R. B. A. Galleries in London in September, 1960. "This exhibition is the announcement of the arrival of young, mature artists," wrote the critic Lawrence Alloway at the time (*Arts Review*, September 10, 1960). Alloway was in fact the impresario behind the show. He gave it the subtitle "An Exhibition of British Abstract Painting," but deliberately excluded all the best-known British abstract painters of the day to concentrate on a certain kind of picture for which he invented the term "hard edge." The oldest painter working in this style was William Turnbull, better known perhaps as a sculptor; others were Robyn Denny and Bernard Cohen. Simple, sometimes symmetrical forms and flat planes of saturated color characterized their pictures.

The influence of New York painting (Rothko, Newman, Reinhardt) was obvious, and two of the participants in the Situation show were working in America at the time: Harold Cohen and Richard Smith. The edges of their forms were softer than those of their London colleagues, but their aims and intentions were similar. It was not easy to appreciate Situation painting at the time, and there was little public or critical response. An exception was David Sylvester, who wrote in the *New Statesman:* "For the New York painters who matter, the practice of painting is a process of self-discovery, not the exercise of an idea. For most of the painters of Situation, the practice of art is a form of art criticism."

Looking back, this seems to me to be an exceptionally perceptive comment that illuminates the difference between the older American painters and the younger English ones. It was precisely the rejection of the idea of art as self-discovery in favor not so much of art criticism (a remark that has a somewhat pejorative ring) as of a semantic exploration of art, carried on in a cool, highly intelligent manner. A distinctive new note in painting was decisively struck.

The Situation painters have pursued these interests, and though the appearance of their pictures has changed, the attitude toward them remains constant. Temperamental differences have become manifest within the accepted style, just as happened with Impressionists, Fauves, Cubists, and so forth. The Situation painters' common ground at the time was a rejection of all European con-

temporary painting, including the English artists of a slightly older age group, in favor of certain American exemplars (particularly Barnett Newman). The dialectics of artistic development insured that the landscape-based abstractions of the St. Ives painters would be rejected by the next generation; and the break between artists born before and after 1925 is a real one in British painting.

One can exaggerate the significance of this division, but it is no accident that the oldest of the Situation painters, Henry Mundy, has always stood a little apart from the others. One does not readily find among the younger artists the qualities of a painting like *Grooved* (plate 76): a sensitive awareness of diffused light and veiled color, and the sensation of mysterious objects moving in an enveloping space.

Admittedly the paper collages (plate 77) of Gwyther Irwin share Mundy's delicacy; they also evince a regard for nature unusual among Situation painters, reflecting as they do the surface of rocks and the rhythms of the sea. But the collages represent only one aspect of Irwin's work: his oil paintings show an interest in optical effects that suggests a different kind of artist. Until 1962, however, the prospects for an "op art" were thin and discouraging, and one has doubts about its durability once the novelty has worn off. The most considerable British contribution in this field has been the black-and-white paintings of Bridget Riley, and her work seems to offer more than just visual play (plate 78).

Of more general consequence is the exploration of color, and here another of the original Situation painters, Robyn Denny, has come into his own. Denny is a most subtle and reticent artist who paints symmetrical formal compositions of an austere beauty (plate 79). They are entirely dependent on their proportions and color relationships; this is a classical art, enclosed and stripped bare of outside references. Paul Huxley and John Hoyland pursue similar ends to Denny, but in a more informal context. In their pictures (Hoyland's in colorplate 40) irregular, flat, evenly colored shapes float ambiguously on vast expansive grounds that are painted with sometimes contrasted, sometimes related, colors.

Another strictly abstract painter of the Situation group is Gillian Ayres. Her informal color-space compositions of the early 1960s have hardened and sharpened into decorative explosions of floral elements (plate 80) that spread across the picture surface. This is part of an exploration of curvilinear abstract forms that may also be seen in the paintings of Harold Cohen and even more in those of Bernard Cohen: a new interest in the organic that coincides with the revival of Art Nouveau. Pictures like *Pandora* (colorplate 35) and *Floris* (color-

plate 36) are essentially pictures about communication: in their different ways they are allegories of visual understanding, asking questions about the semantics of art.

The Situation painters were without exception *urban* painters, making no use of landscape, little concerned with nature, and preferring the man-made artificial environment of the big city. Other painters of this generation and younger shared this urban interest in a more explicit form and used it in the creation of a new imagery that, in some cases with justification, found itself labeled Pop. The origins of this particular tendency in England go back at least to the mid-1950s, when the theory of a "fine/pop-art continuum" that would allow the artist to use his experience of the mundane world was discussed by Lawrence Alloway and others in Independent Group seminars at the Institute of Contemporary Arts.

The painter most deeply involved at this time was Richard Hamilton, a friend and disciple of Marcel Duchamp who has consistently tried to come to terms "with life at a banal level without in any way relinquishing a commitment to fine art." Hamilton's paintings are allusive, and he draws upon a world of motorcars, pinups, film stills, television, and advertisements for men's and women's underclothes for references that he mixes in the paintings with quotes from Praxiteles and Renoir and Roy Lichtenstein. There are of course parallels for this in Rauschenberg and other American painters: it represents a breakthrough in subject matter as decisive and far-reaching as Courbet's.

Hamilton's attitude to this material is erudite and sophisticated. He is as much the follower of the Futurists as he is Duchamp's heir: his involvement in the urban environment is total; there are movement and noise in his paintings, and he engineers them as if they were machines of interlocking parts. This is evident from *Glorious Techniculture* (plate 81), which is basically a woman-in-car-in-city picture, for which Hamilton himself has provided (*Architectural Design*, November, 1961) an elaborate catalogue of sources, including the bride inside the cabin, the profile of a rifle, the pump agitator of a Frigidaire washing machine, a cross section of a General Motors engine, and the electrical guitar of Tony Conn, whose name is inscribed in fancy lettering.

Hamilton has always refused to become a full-time "professional" artist, dependent on selling his pictures; he has preferred instead to earn a living from teaching. His remarkable pedagogic activities in Newcastle since 1953 do not concern us here, but one younger painter of unusual distinction, Ian Stephenson, studied with Hamilton and with Victor Pasmore (who also taught at Newcastle between 1954 and 1961). *Sfumato* (plate 82), might be described as an

individual combination of Pasmore's taste and sensitivity with Hamilton's allusive technique. In contrast to the clarity and directness of most contemporary painting, Stephenson's work is suggestive and veiled in the mysterious.

A parallel but independent development to Hamilton's may be seen in the work of Peter Blake. After leaving the Royal College of Art in 1956, Blake won a Leverhulme Research Award to study popular art. He traveled throughout Western Europe, but his final orientation was, not surprisingly, toward the United States. In his *Self-Portrait* of 1961 (plate 83) Blake presents himself as the typical town-bred British teenager of the day. The American-style casual clothes, the collection of badges, the fan magazine that he holds in his hand, are not the attributes we expect from an artist, but they make very clear to us the kind of world in which Blake has chosen to live.

The subject matter of Blake's art is drawn from the everyday images of proletarian urban existence. Naturally and with no hint of patronizing he has taken the visual material familiar to his contemporaries — pictures of pinup girls (*Little Lady Luck* — colorplate 37), pop singers, professional wrestlers; family photographs, holiday postcards, magazines, advertisments of every kind; faces well known from the cinema or television screen — and used them as the raw matter of his art. Sometimes the images are carefully simulated in paint; sometimes they are actually incorporated into the picture as collage elements. It is all very direct and straightforward, done with patience and a loving attention to triviality.

There is often a strong nostalgic sentiment in Blake's art, a remembrance of his own early childhood in his use of thirties images (like that of Shirley Temple), and of his parents' youth in his versions of Edwardian postcards. He has also drawn upon the colorful world of fairground and circus, in such a way that we recall the persistent use of circus iconography in modern art, going back as it does to what is perhaps the first clear example of Pop Art: Seurat's *Cirque,* with its frank adaptation of a Chéret poster.

Other artists, contemporaries of Blake and younger, have made use of this new subject matter in a more allusive way. This can be regarded as neither a rejection of abstraction nor a return to figuration but as a moving on into a new territory for art that has become visible only in the last ten years. It does not replace or invalidate what has gone before.

Painters whose earlier work was unmistakably abstract have been influenced by this more permissive attitude to subject matter. Richard Smith is perhaps the best example. Another Situation painter, he shared Blake's fascination with popular culture, however, but chose the more formal and less literary elements

to incorporate into his art (plate 84). In particular he has used the package as the crucial communication symbol, the means of attracting consumer to product, as valid for art as for advertising. The cigarette packet may take on the enormous size it has on the billboard or cinema screen, and it will probably break with the conventional rectangle of the picture. Like many of the younger painters, Smith has used irregular-shaped canvases, and more significantly has frequently added the third dimension, so that his pictures become brightly colored art objects. Derek Boshier is a younger painter who has made the transition from the literal kind of Pop Art to the abstract variety. His early pictures were figurative and included direct references to packaging and advertisements and also satirical comments on national pretensions and the rivalries of the space race. But after a year in India, Boshier abandoned such subject matter and returned to brightly colored heraldic pictures, with hard and clear abstract forms so dominant that they break away completely from the conventional picture rectangle.

Dissatisfaction with traditional pictorial means is equally clear in the work of another object maker, Joe Tilson, who has frequently used carpentry and lettering in his constructions. Again, communication is a major theme and symbol-making a preoccupation: *Nine Elements* (plate 85) displays the process of translating idea into image. The image may be commonplace — a closeup of an eye on a television screen labeled *Look*, on open mouth with exclamation marks inside called *Vox* — but the Surrealist technique of isolating the mundane, and upsetting the expected scale, usually by gross enlargement, gives Tilson's constructions their compelling quality.

In many members of this new generation, the autobiographical element is strong, as it is with Blake. Allen Jones and David Hockney, for example, are essentially concerned with human relationships, and, more specifically, with their own relations with other people. Love is the explicit subject of many of Jones's paintings (plate 86) and prints, and his most characteristic image is the combined male and female figure, falling or floating in a weightless, trancelike state. The colors are always strong and simple, emotionally charged, but organized with the freedom of the abstract painter.

David Hockney (plate 87) is essentially a graphic artist whose apparent naïveté hides wit and sharp social comment in the tradition of Hogarth. A certain inside knowledge is at times presupposed by the painter, just as it always has been with narrative pictures in the past. And, in the same way, Patrick Caulfield's treatment of banal and familiar images (plate 93) depends upon one already knowing them and appreciating the transformation. Caul-

field is a notable example of a "cool" painter, with a deadpan impersonal technique that admits no indulgence in painterly self-expression. This is perhaps a common characteristic of the youngest generation of British artists. Another example is Antony Donaldson. The subjects of many of his paintings are bikini-clad girls on the beach, but the image is renewed and refreshed by simplifying (and silhouetting) the forms and repeating them to build up flat patterns, using colors like pink and pale blue, totally devoid of erotic connotations (colorplate 39).

An emotional detachment (which does not of course mean that feeling is absent) can also be found in the works of Kitaj. The representative of this new allusive art at its most complex and abstruse is American-born R. B. Kitaj, who studied at the Royal College of Art at the same times as Jones and Hockney. The sources of his paintings (colorplate 38) are often the most recondite imaginable, drawn from the byways of iconographical investigation, social history, literary criticism, and the like. The sources have a fascination in themselves, but one is not required to understand them, and they do not affect the purely aesthetic qualities of Kitaj's work, so that one can say, as Wittgenstein said of Georg Trakl's poetry (in a quotation selected by Kitaj for a catalogue preface): "I don't understand it; but its tone delights me." (The poetic analogy in Kitaj's own case is with early Eliot or Pound, whose work his resembles in many ways.)

Kitaj collaborated with the sculptor Eduardo Paolozzi on a number of works in the early 1960s, and this is an appropriate moment to consider comparable activities in sculpture. These run roughly parallel to the developments in British painting since 1960. Paolozzi was born in 1924, the same year as Hubert Dalwood (a student of Armitage's) and Anthony Caro (a former assistant of Henry Moore's). All three sculptors, to a greater or lesser extent, emerged in the mid-1950s as figurative Expressionists, creating tough and brutal images of undeniable power. They seemed to reject everything that sculptors of the older generation had stood for: craftsmanship, simple good taste, and a tendency to formal abstraction. Like William Turnbull, Paolozzi at first owed much to Giacometti's friendship and encouragement, but neither sculptor could ever accept Giacometti's concentration on a narrow range of figurative images. Instead, both moved steadily toward incrusted totemic sculpture, with a classical and hieratic dignity in Turnbull's case, as *Ulysses* (plate 88) suggests. Turnbull's most recent work is in welded steel, sometimes painted and always of a stark simplicity and complete absence of detail. Brian Wall, though less austere, works on similar lines: both sculptors have that purity and severe

reserved manner that one finds in English painters like Nicholson, Denny, and Bridget Riley.

Paolozzi's art is much less pure and monumental than Turnbull's, and he has been quick to develop the same sort of incongruous imagery that one finds in Hamilton's paintings. The lumbering robotlike figures of 1957-60 are given names like *St. Sebastian, Greek Hero,* and *Electra,* which directly contradict their science-fiction quality. The same contrast is to be found in the surfaces: the sculptures look at first as though they had been dug out of the earth after hundreds of years; on examination one discovers that the texture has been impressed with pieces of modern machinery and children's toys.

All this changed in 1961, when Paolozzi began to make his sculptures out of ready-made brass or aluminum machine parts, as smooth and unambiguous as the forms of hard-edge painting. To begin with, they retained the shape of a monumental monster, but as the forms have become freer and more inventive, so the references have profilerated and become more erudite. *Poem for the Trio MRT* (plate 89) is an homage to the revolutionary Russian artists Vladimir Tatlin, Alexander Rodchenko, and Casimir Malevich, whose white square it incorporates.

The break in Hubert Dalwood's style came earlier: the figure is slowly eroded between 1957 and 1959 until the forms become indisputably abstract. The later sculpture lacks the kind of reference one finds in Paolozzi, but Dalwood is equally concerned with the making of an icon. This is, in Herbert Read's words, "a plastic symbol of the artist's inner sense of numinosity or mystery, or perhaps merely of unknown dimensions of feeling and sensation" *(Concise History of Modern Sculpture,* p. 212). The work that Dalwood made between 1958 and 1962 is like a collection of cult objects designed for use in some mysterious ritual. *Minos* (plate 90) — perhaps a judge of the dead rather than the legendary king of Crete — is one of the culminating pieces of this series, which has certain affinities with the paintings of Alan Davie.

Of all the sculptors mentioned, the clearest break with the figurative Expressionist style of the 1950s may be found in the work of Anthony Caro. In 1959, he visited the United States, and on his return abandoned modeling for the most severely abstract bolted and welded metal sculpture. Working on a large scale to nullify any suggestion of mansize, Caro gave his cumbersome constructions a remarkable feeling of space and lightness. He also began to paint the metal — *Early One Morning* (plate 91) is painted red — and this use of color has been taken up by a very talented group of younger sculptors, most of whom have been taught by Caro at St. Martin's School of Art in London.

Of them, Philip King and William Tucker are the most established. They have much in common: their sculptures always stand on the ground; have clear, sharp outlines and simple shapes; are colored and usually made of processed plastic materials. Tucker's work is more abstract, expecially in its concern for unusual spatial configurations, and it often depends on the repetition of a form (colorplate 41); King — as *Genghis Khan* (plate 92) demonstrates — is interested in the arresting image and is as prepared to allow outside reference into his sculpture as he is to exploit purely optical effects. It has been said that the forms of King's sculpture suggest basic processes — rising, flowing, spreading, and so forth — and this is perhaps also true of the more organic work of Isaac Witkin. Other sculptors of this group tend, like Tucker, to use more impersonal shapes, often flat and sometimes ribbonlike (Tim Scott, David Annesley); these may even be painted in sharply contrasting colors (Michael Bolus). Here sculpture comes close to the shaped or relief painting (*e.g.* Richard Smith or Tilson), and a rigid division between the two exists no longer.

Inevitably the emergence of an extremely vigorous and self-assertive younger generation of painters and sculptors has forced the older artists to the back of the picture. This does not necessarily mean that their work declines in quality or that it is any less progressive: one remembers that Monet and Cézanne were middle-generation artists to Gauguin, Van Gogh, and Seurat and old men to Matisse and Picasso.

The result of the changed situation in England in the last few years has, however, been the paradoxical one of diminishing the apparent stature of what is certainly one of the most versatile and gifted generations of British artists ever. I am thinking now of painters and sculptors born between 1908 and 1920, most of whom first came into prominence during the later 1940s. For the most part, this generation stood for an international view of art that recognized the achievements of the early twentieth-century masters. In this they were reacting against their immediate predecessors, who had in the dark days of the early 1940s turned back to the English Romantic tradition of William Blake and Samuel Palmer for inspiration.

Any rapid generalization of this kind inevitably falsifies, and there are some artists like Keith Vaughan (plate 95) who have their feet in both camps, drawing on this particularly English tradition but at the same time fully aware of the lessons of late Cézanne and the Cubists. Yet a basic contrast does remain, and it can be polarized around two painters, Graham Sutherland and Ben Nicholson. Neither is by temperament a *chef d'école;* this is confirmed by the fact that both of them now live out of England, Nicholson

in the Ticino and Sutherland (most of the time, at least) in the south of France.

Nicholson, however, lived in the Cornish fishing village of St. Ives from 1939 until 1959, and his presence there (and that of his wife Barbara Hepworth and, until 1946, of Naum Gabo) helped make St. Ives the only significant British artistic center outside London. It became an attractive working place for young painters and sculptors, and at one moment was probably more advanced and certainly more internationally minded than London itself. Although they in fact shared little more than a place of residence in common, the younger generation of artists living in Cornwall have often been grouped together as "St. Ives painters": Peter Lanyon, Patrick Heron, Terry Frost, Roger Hilton, Bryan Wynter, and Paul Feiler are the central figures of this loose association; Alan Davie, who summers in west Cornwall, and William Scott have close connections; Victor Pasmore, Adrian Heath, Merlyn Evans, and the sculptor Robert Adams more peripheral ones.

The general importance of the St. Ives painters lies perhaps, in two particular respects: because of the presence of Nicholson, they were in the late 1940s more ready to accept abstraction than most of the London painters were; and ten years later, they were the first group of mature European artists to appreciate the international significance of New York painting. Exhibiting in New York had in certain cases brought them into personal contact with their American contemporaries, and a mutual sympathy and an ease of communication (because of the common language) stimulated the complete reorientation of British painting away from Paris and toward New York.

The St. Ives painters differ so considerably one from another as to make any further discussion of group tendencies impossible. Peter Lanyon was the only native Cornishman, born in St. Ives in 1918, and tragically killed in a gliding accident in 1964. He was essentially a landscape painter in a recognizable English tradition, with close links with older landscape painters like Ivon Hitchens, but through the influence of the abstract art of Nicholson and Gabo (and later of De Kooning and Rothko) he was liberated from the need of depicting a particular place. It was always his own experience of the place — its essence, not its appearance — that he sought to paint. Lanyon was primarily a tonal painter, and this distinguishes his landscapes of the 1950s from De Kooning's, which they superficially resemble and may even have influenced. In the last years of his life, Lanyon had begun to use much brighter and contrasting colors, and his premature death cut short a promising new development.

Patrick Heron (colorplate 42) has always been primarily a colorist, explor-

ing the space- and form-creating properties of color. In simple, abstract compositions, areas of color are juxtaposed to probe qualities of warmth and coolness, weight and lightness, transparency and opacity. In some respects the intention is analogous to that of the Op painters: afterimages are certainly important, but no eye-dazzling effects are exploited, and the final result is a tranquil, poised composition that resolves its contradictions and asymmetries in a classical way.

Terry Frost (plate 97) shares certain qualities with Heron, particularly the concentration on color. But the linear element in Frost's paintings has persisted, a drawn line always playing an important part in any composition; and the image, with its ambiguous hints of figure and landscape and sometimes both, is also usually relevant. The ways in which Frost differs from Heron — in use of line and image — are precisely those in which he comes closest to Hilton. *Desolate Beach* (plate 94) is in some ways a typical St. Ives picture: the title, added after the painting had been conceived and created, summarizes the *mood* of the picture. Shapes of boats and rocks, movement of cloud and water — awareness of every kind of natural phenomena — may underlie such painting, but it exists entirely in its own right, and such information is utilized by the artist as much unconsciously as consciously.

It is precisely this partial dependence on nature that distinguishes this older generation from the younger painters, who have on the whole aggressively rejected it in favor of either a stricter abstraction or an urban-based imagery. It does in fact form a link with the neo-Romanticism of the 1940s, and this is exemplified by Bryan Wynter, another St. Ives painter, whose work explores a sort of *Urwelt* of natural phenomena in a language of images distantly related to Sutherland.

A little apart from the St. Ives painters, but of the same generation, are two Scots-born artists, Alan Davie and William Scott. Though they have many and close connections with their English contemporaries, that they are Celts and not English has its relevance: it has meant, for example, that they have shown a total lack of the response to nature and to landscape so typical of English artists.

Scott (plate 96) is a still-life and figure painter who moves freely between an abstracted image and complete abstraction. His recent work has been on a more monumental scale than before, but the textural richness and the underlying celebration of the virtues of a life of elemental simplicity remain. Alan Davie's work (colorplate 44) has also grown in scale: the color has become dazzlingly brilliant, the patterns richer, and the imagery more clear-cut. The

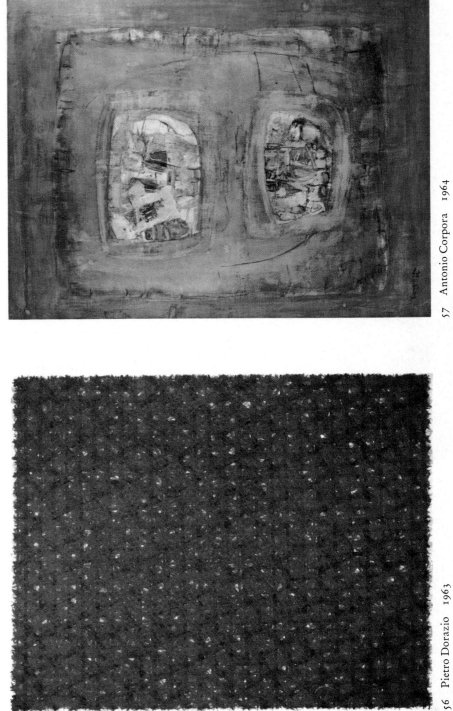

57 Antonio Corpora 1964

56 Pietro Dorazio 1963

59 Achille Perilli 1962

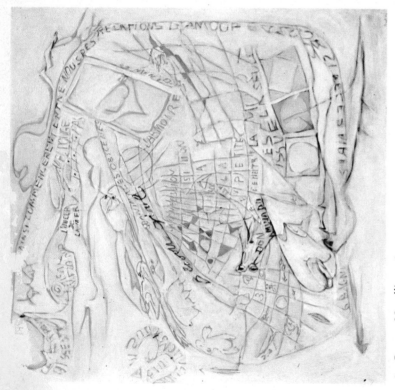

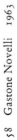

58 Gastone Novelli 1963

61 Leoncillo (Leoncillo Leonardi) 1962

...ao Pomodor. 965

62 Enrico Castellani 1963

63 Mimmo Rotella 1963

65 Lucio del Pezzo 1964

SMALTO SU CARTA 1963

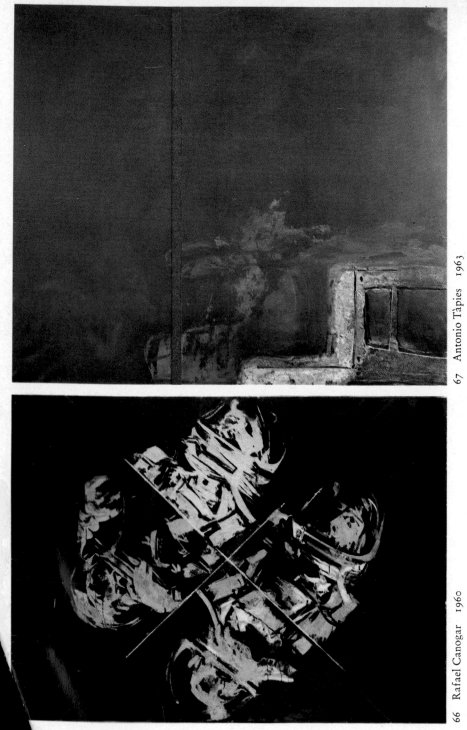

67 Antonio Tàpies 1963

66 Rafael Canogar 1960

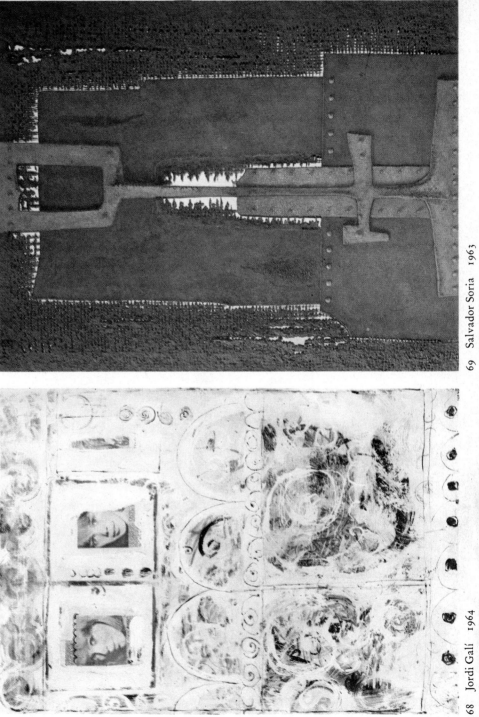

69 Salvador Soria 1963

68 Jordi Galí 1964

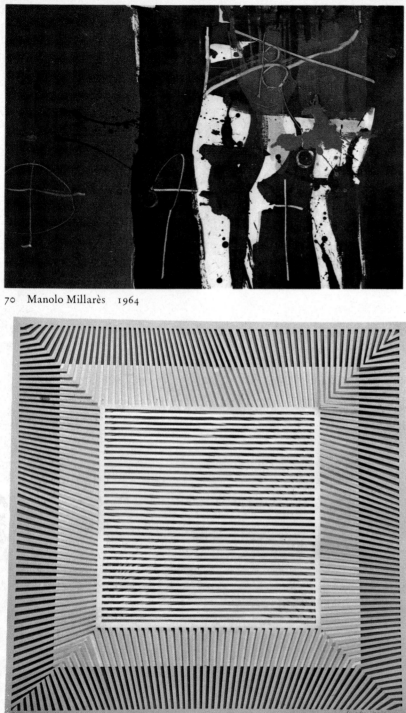

70 Manolo Millarès 1964

Eusebio Sempere 1964

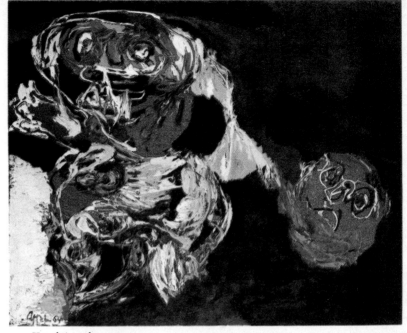

72 Karel Appel 1964

73 Jaap Nanninga 1959

74 Lucebert 1965

75 Jaap Wagemaker 1962

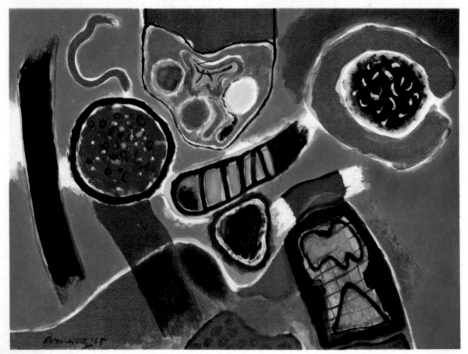

76 Corneille 1965

mood is less violent and depressive than it was in the early 1950s, and Davie's forceful power and confidence are very evident. Again, this indicates no fundamental change: the painting is still a kind of mystical incantation, a search for enlightenment through the medium of art.

A third Celt who has come into greater prominence in the 1960s is the Welsh painter Ceri Richards. His series of paintings after Debussy's piano music, of which *La Cathédrale Engloutie* (colorplate 47) forms the largest group, show the typically allusive, evocative character of his work. A prominent member of the English Surrealists in the 1930s, Richards has remained faithful to certain key Surrealist practices and beliefs — his use of collage construction, for example, in which the objects are chosen not only for their abstract picture-making qualities but also for their poetic associations. Another important part of Richards' art has been concerned with images of procreation and growth, sometimes organic, sometimes frankly sexual. In this respect, too, there are closer connections between Richards and Scott and Davie than with most of the native English painters.

This is made very clear if one compares Ceri Richards' work with that of Victor Pasmore (colorplate 46). Pasmore's long career encompasses many shifts of emphasis, but they constitute a perfectly logical and consistent progression, as the 1965 Tate Gallery retrospective showed. To understand the development of modern art, Pasmore has needed to do it all himself: thus every major modern movement on the more classical side (Cézanne, Seurat, Cubism, Mondrian's abstraction, Constructivism) has both impinged upon his art and been commented upon by Pasmore. He has now for some time, however, been out in front and on his own.

One can make a rough division in Pasmore's art between painting and construction. At one moment in the mid-1950s, Pasmore seemed to be on the point of abandoning painting altogether as an artistic dead end; but he has returned to explore simple formal and color relationships, which are now growing progressively more subtle and complicated. Pasmore's constructions, on the other hand, are part of a very lively exploration of this art form that has been going on in England in the last decade. The classical, mathematical discipline of the relief construction offers a framework for a rigorous rethinking of certain aspects of art that has appealed to the English temperament. Here art comes into contact with pure science, and the constructions of Anthony Hill confirm his interest in ideas of proportion and the new geometry of topology, with its concern for fixed but fluid relationships and asymmetrical patterns. The relief constructions of Pasmore and Hill — like those of Mary Martin and John

Ernest and the associated work in sculpture of Robert Adams, Kenneth Martin, and Brian Wall — represent an important development on an international level that is easy to overlook.

It seems hardly necessary to write at length about the oldest and best-known contemporary English painters and sculptors. Their work was illustrated and discussed in detail and with profound sympathy and understanding by Herbert Read in *Art Since 1945,* and it is now familiar enough to need little in the way of elucidation or explanation.

By general agreement, the senior British painters remain Nicholson, Bacon, and Sutherland, with the landscape painter Ivon Hitchens (colorplate 45) standing a little in the background, perhaps because the subtle movement and color relationships in his pictures seem to be lost outside the soft English light in which they were conceived. Ben Nicholson's move to Switzerland in 1959 has also affected his color, making it warmer and less acid than in many of the paintings of the St. Ives period (colorplate 43). His reliefs and paintings have become more unified in color and texture, grander and more monumental in composition, even when small in size. They have also tended to a more severe abstraction, although the basic and long-accepted division in Nicholson's work between post-Cubist still lifes and totally abstract compositions holds.

Graham Sutherland continues to paint the occasional and sensational portrait (for example, that of Dr. Adenauer), but his essential preoccupation is with the animal and organic world. The water bubbling out among the leaves in *La Fontaine* (colorplate 49) takes on that uncanny presence that Sutherland somehow gives to the inanimate. By contrast, Francis Bacon is totally occupied with the human situation, drawn obsessionally to the kind of despairing self-destruction that his own *Self-Portrait* (colorplate 48) evinces. Though at times — to me, at least — he oversteps the limits of the absurd, the hallucinatory power of his painting has made it for younger painters in particular a shining beacon among so much weak and superficial abstraction.

As for the sculptors, Henry Moore and Barbara Hepworth seem to have successfully reasserted their prime position over the slightly younger generation who for a time in the 1950s had the center of the picture. For the latter it has been a question of retrenchment, sometimes even *reculer pour mieux sauter.* The changing world situation, and especially the new feeling of confidence and optimism among British artists, has, as we have already seen, made the style and philosophy of a whole group of British sculptors seem irrelevant or at least out of tune. The "geometry of fear," to quote Herbert Read's telling phrase, had become a part of past history, and the artists who had given such

sculpture an edge were faced with problems of readjustment that are still incompletely solved. This does not detract from their stature as artists — both achievement and potential remain considerable — but it is not easy at the moment to write about their work.

Some, like Lynn Chadwick, have recently moved to a more abstract language and new, more anonymous, materials, though *The Watchers* (plate 100) represents the culmination of a line of thought toward a more static and mysterious image. F. E. MacWilliam's work has also become more abstract and highly original in its formal relationships. Bernard Meadows is successfully making the transition from animal to human imagery, still retaining an obsession with maleficent power. Reg Butler has pursued twin interests — the modeled girls of unabashed sensuality (plate 99) and the mysterious box-and-tower constructions that still await their definitive formulation. Of all the sculptors of this age group, Kenneth Armitage has perhaps begun to move forward again with the greatest confidence in the last year or two. Though still figure based, his work has become more abstract and more allusive, making metamorphic transformations within itself, as in *Pandarus* (plate 98).

Moore and Hepworth have been closely associated from the time they were students together in Leeds and London. But that they were subject to certain common influences and have lived in a similar cultural atmosphere should not obscure the essential and considerable differences between their work. These have if anything become even clearer in their recent sculpture.

Barbara Hepworth is a classical artist, choosing to live in a landscape (Cornwall) that has affinities with Greece, and expressing in everything she does an idealistic, humanistic philosophy of life. The monumental dignity and absolute purity of her *Single Form* (plate 101) made it an appropriate memorial for her close friend and admirer Dag Hammarskjöld; and, like much of her recent work, this is in bronze, which remains the sculptor's medium of maximum durability and permanence. At a time when most sculptors have been using materials that permit immediate results, Hepworth has also continued to carve in wood and stone (plate 102), finding the careful slowness of carving appropriate to her temperament. A group of small, often multipart, sculptures in one of the most intractable of stones — black slate — has the same extreme and absolute rightness as Nicholson's white reliefs.

Henry Moore's work encompasses a wider range than Hepworth's; it lacks a classical distillation but implies a Romantic-Expressionist totality of experience that makes it unique in the world of art today. Its orientation is usually human, with a range even within a single work from the personal to the

universal, as in the female reclining figures, of which the *Reclining Mother and Child* of 1960-61 (plate 104) is one of the grandest and most moving. In the last few years, Moore has moved away from the more "public" sculpture of the 1950s, where he seemed to be striving to reconcile the gap that exists between the modern artist and his audience. The climax of this "public sculpture" was the Unesco commission, not only the final reclining figure but also the alternative ideas that Moore later worked up into separate sculptures — the seated figures on steps and benches and against walls.

Since 1960, however, Moore's work has taken on a markedly more private, more philosophical quality. (There is an interesting parallel here between the sculptor and his friend, the composer Benjamin Britten, who followed up the public utterances of the opera *A Midsummer Night's Dream* [1960] and the *War Requiem* [1961] with the far more personal *Cello Symphony* [1963] and chamber opera *Curlew River* [1964].) Moore's forms have at times become strikingly more abstract, as in the *Atom Piece* of 1964 (plate 103), which nevertheless retains strong suggestions of the human and the organic in its part helmet, part skull shape.

From sculpture like this, and the *Locking Piece* and *Archer* of 1965, the evidence would seem to be that Moore is moving into a fresh period in his development, a "late style" comparable in originality of idea with the work of the 1930s, but now vested with a gnomic profundity of utterance that leaves us a little mystified, unable entirely to understand, but nonetheless deeply impressed. The ability of an artist to evolve toward such a late style is perhaps the final test of greatness: it is something that Matisse did achieve and that Picasso has not (and this leaves us with a question about the value of much of Picasso's later work). In Moore's case it seems incontestible now that he is the greatest living sculptor, and one of the great sculptors of all time. Always careful to prevent his own work becoming a too powerful influence on others, Moore has by his example done more than anyone else to help lift the whole standard of artistic activity in England to an international level. His presence among English painters and sculptors is one reason for the unparalleled vitality and burgeoning confidence of English art today.

Italy

By Nello Ponente and Maurizio Fagiolo

The Fronte Nuovo delle Arti ("New Front of the Arts"), which held its first show in 1947, was one of the earliest art movements in postwar Italy. Its members, belonging to different trends, were Antonio Corpora, Giulio Turcato, Pericle Fazzini, Nino Franchina, Renato Birolli, Ennio Morlotti, Renato Guttuso, Giuseppe Pizzinato, Giuseppe Santomaso, Emilio Vedova, and Leoncillo. Their association ended with the 1948 Venice Biennale, in the heat of the battle between abstractionists and neorealists.

In 1952, Birolli, Corpora, Morlotti, Santomaso, Turcato, and Vedova, together with Afro and Mattia Moreni, formed the group of Otto pittori Italiani ("Eight Italian Painters"), presented by Lionello Venturi, who described the movement as "Abstract-Concrete." This trend was discussed in *Art Since 1945*, and will be mentioned only briefly here. Afro tends to reconcile the sense of remembrance and the awareness of existing; in his latest works, his brushstroke becomes broader, his discourse less interior (colorplate 54). Birolli ended his search (he died in 1959) on a lyrical note. Corpora (colorplate 57) accentuates contemplation, merging the colors in zones; his calm is derived from his having finally recaptured *le temps perdu*. Moreni turned to Expressionism, arriving at a painting of gesture. Morlotti spent himself in naturalism. Santomaso experimented with Informalism (colorplate 55). Turcato exhausted his "Oriental" vision of the world. Vedova emphasized the anarchic tendency, arriving at a sort of Informal romanticism. Meanwhile, many Italian artists (including the Eight) contributed to the development of poetic Informalism.

Lucio Fontana (born in Argentina) is a veritable demiurge of modern art in Italy. He pointed out the ways and means to overcome the crisis of rationalism, recognizing the validity of the irrational, so long as it is not cloaked in metaphysics and is capable of conceiving a form and embodying it in a way corresponding to its own impulses and not, as in so much of Surrealism, to external sources. His experiments are manifold. The "Concetti Spaziali" ("Spatial Con-

cepts") begun in 1950 and continuing to the present, show holes and cuts, then become more intricate with the addition of stones and bits of glass, and finally become egg-shaped (colorplate 51). The "Nature" ("Natures"), done since 1959, are large bored or cut terra-cotta spheres (at the outset Fontana was a sculptor). Fontana has wiped out every boundary between one material and another, between plastic and pictorial compositional structures, in a renewed invention that proclaims as its emblem Ovid's *Metamorphoses*.

Alberto Burri soon went beyond the influence of Wols and the Dadaist collages. The series of "Catrami" ("Tars") and "Muffe" ("Molds" — 1949-51) were followed by "Sacchi" ("Sacks" — from 1952 on), in which the poorest of materials become precious by the sudden flaring of color. "Bruciature" ("Burns" — from 1956 on) introduce a new element — fire — which alters the material with its dramatic impact. These were followed by "Legni" ("Woods") and "Ferri" ("Steels" — from 1957 on), and finally "Plastiche" ("Plastics"), in which Burri glorifies a viscous and ambiguous material (colorplate 52). Testing the possibilities of the most diverse materials brings Burri to the awareness of action, that reality which is so important in contemporary art, but his gestures never become the impetuous gesticulation of Action Painting. It is a repeated adventure, in which the means and materials vary but the method remains the same. Perhaps the intention is to show that man, with all his problems, his anxieties, even his melancholy, is the strongest force. He can dominate every material, and remains the "navel of the world" — even when he is desperate.

Other painters who grew up in the Abstract-Concrete movement turned to Informalism (for example, Moreni). The most striking case is Vedova, a painter convinced of the social commitment of the artist, not inclined to contemplation, ready for aggression. His painting is scenographic; the drama is made up of apparitions and sudden explosions, tensions and shocks, showing the fundamental despair of modern man. This is true even though Vedova sees the relationship with mechanical civilization as one of interchange, not subordination. His painting is never allegory; it is presence, participation. In his latest work, "Plurimi" ("Plurals"), he once more invents space, again in a theatrical sense (colorplate 50).

In Milan Emilio Scanavino relies on the monochromatic and on gesture (later coagulated in the so-called sign); Alfredo Chighine takes his stand alongside Hartung. In Bologna Vasco Bendini has a romantic relationship with nature; Sergio Romiti (plate 108) takes into account the lyric lesson of Giorgio Morandi, the solitary genius of twentieth-century Italian art. In Rome we note the balance of Antonio Scordia and the latest manner of Mario Mafai, the

master of the Roman School. Informalism soon became a school, and we cannot mention all its practitioners.

Toti Scialoja has a place apart; he has revised his Informal experiments, calmed down his gestures. Since 1959, he has been presenting his "impressions" of colors and materials, whose rhythmic repetitions add a dimension of time. The past and the present are integrated into an ordered world (which represents the future): Scialoja's future has an ancient heart. By virtue of this stubborn construction of a new relationship between space and time, Scialoja today has gone beyond Informalism (plate 107).

An alternative to Informalism may be seen more than anywhere else in Giuseppe Capogrossi, to whom success came very late. The poetics of the symbol wedded him to Informalism, while his will to *form* was ever ardent. It has been shown that Capogrossi's sign is not a product of the moment but is reached after long research; the free form is born of geometric form: fantasy and liberty within rigor and constriction. There is nothing accidental about the signs and the assemblage of signs: rationality and irrationalism are bound closely together, even the arbitrary is calculated. Capogrossi's experiments with the rhythmic and serial possibilities of painting rival the most advanced music, but he also tests the continuity of space and time (colorplate 53).

Meanwhile, some artists were working along another line, in dialogue with Informalism. This group, Continuità ("Continuity"), was organized in 1961 by Argan. Its members were Consagra, Dorazio, Novelli, Perilli, and Turcato, later joined by Bemporad, Fontana, Arnaldo and Giò Pomodoro, and Tancredi. Argan explained that continuity ("absence or indetermination of limits") signified opposition to the fragmentary quality of Informalism, as well as recovery of history. Accardi, Attardi, Consagra, Dorazio, Sanfilippo, and Turcato also belonged to the Forma ("Form") group in Rome in 1947.

Piero Dorazio still represents an alternative to prevailing trends. His geometry is not confined within a two-dimensional space, reducing color to its psychological essence. The spaces are open, and the color flows through them in every direction, varying and modulating them in a continuous rhythm. Nothing is left to chance. For example, the reliefs he has done since 1951 are not Surrealist found objects but experiments with the constructive possibilities of light. His most recent works, with crossing bands of intense color, represent a development of the chromatic vibration of the splendid pictures that preceded them (colorplate 56).

Achille Perilli began as a disciple of Kandinsky and Magnelli, went on to a capricious form of Informalism, and then, around 1959, returned to figurative

reality. The scenes, taken from memory, from dreams, even from newspaper items, are set down in bands, like comic strips. There is a relationship between the bands that contain drawings and the colored ones, a subtle balance between structure and caprice (colorplate 59). The sign, which seems to be Informal, is essentially new because it becomes a character. His forms are not allegorical or metaphysical; they may be called surreal, perhaps magical, evocations, but with a concreteness in which we recognize the combination of experience and intelligence.

Giulio Turcato rebels against any pattern. He works out structures that are not complex but essential, even when he uses clashing materials. He does not move heaven and earth; he does not pretend, by alleging ideal reasons, to justify any mistake or deviation. Everything takes place on a human level; painting is a normal activity. The simplified space is there to indicate an immediate, circumscribed presence in which, obviously, myths cannot exist.

Other artists of the Forma group have passed through the stage of Informalism while still maintaining a poetics of the sign. Carla Accardi came to the sign around 1955, but in black and white and knotted into an indistinct mass. Then the sign became freer and freer, until its final release in her last canvases, in which we find only two luminescent colors, one for the signs and one for the background (plate 105). The ambiguity between the two planes produces an optical effect ("simultaneous contrast") that causes the sign to be reabsorbed in the whole; it is both protagonist and member of the group. This development is, perhaps, directed at the negative, at the fringed zone created by the various signs: at space. Antonio Sanfilippo tries to attain a reconstruction of the image and space with his signs, even the most minute, without a geometry but according to a human situation and a continuous experience (plate 106).

Coming back to Continuità, we note Gastone Novelli. His narrative (a diary that combines news and memory) is developed without hierarchy: Classical Greece and the cabala have the same dimensions on the milky white of the canvas; the colored patch has the same value as the checkerboard — they are forms first of all (colorplate 58). The signs and the phrases too are forms. Taken from the everyday world, from memory, from symbols, from abstraction, they are brought to clarity by means of the watchful labor of the intelligence. Automatism and rules coexist.

Among the sculptors, we must mention Pietro Consagra and the Pomodoro brothers. For Consagra continuity means opening the work toward a new space (in his works, the title *Colloquio* — "Colloquy" — is not an accident). And yet these sculptures seem to be spread out on a single plane; they seem to

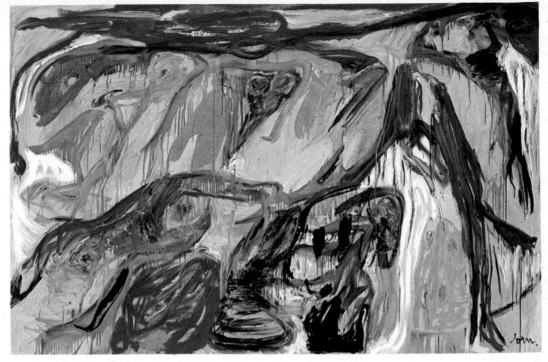

77 Asger Jorn 1963

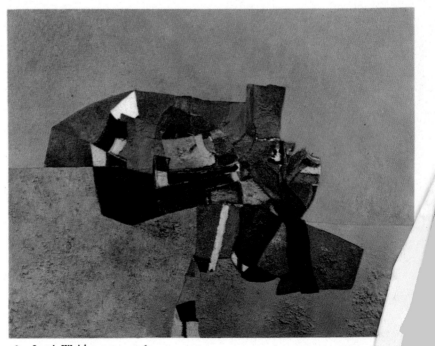

78 Jacob Weidemann 1960

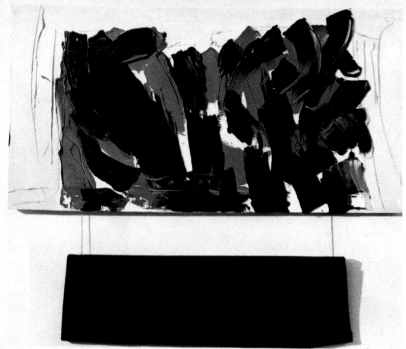

79 Torsten Andersson 1962

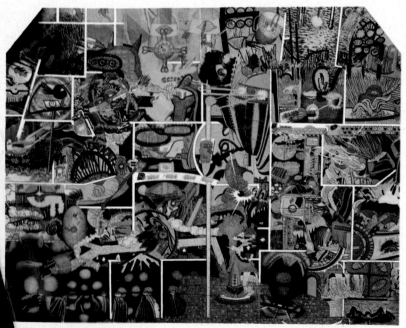

'yvind Fahlström 1964

81 Carl Fredrik Reuterswärd 1960

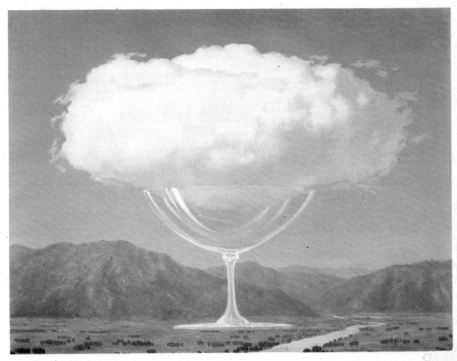

82 René Magritte 1955

83 Maurice Wyckaert 1961

84 Bram Bogart 1964

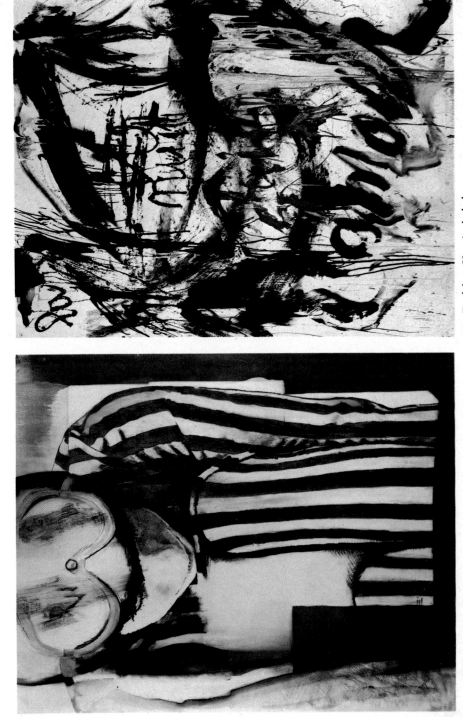

86 Englebert Van Anderlecht 1959

85 Pol Mara 1965

87　Atsuko Tanaka　1962

88　Mokuma Kikuhata　1963

Yoshishige Saito　1960

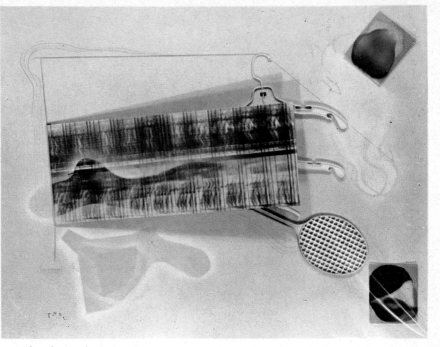

90 Shusaku Arakawa 1964

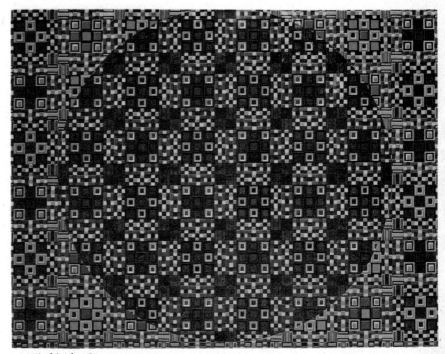

91 Toshinobu Onosato 1964

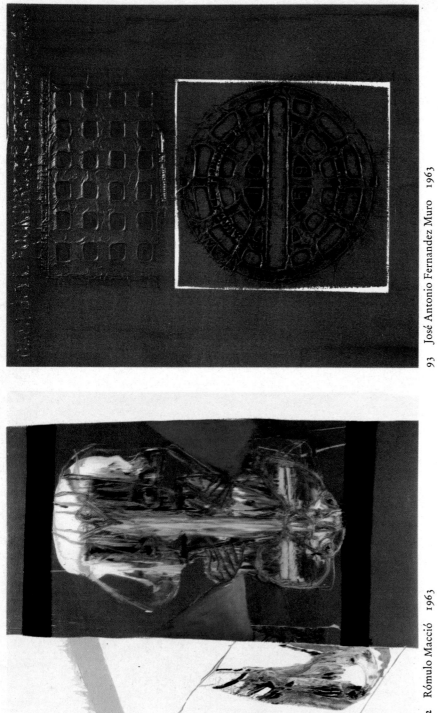

93 José Antonio Fernandez Muro 1963

92 Rómulo Macció 1963

be a series of pictorial bas-reliefs (plate 113), because Consagra seeks to distinguish the space in his work from the space of nature. The monuments of Arnaldo Pomodoro are metal columns, blocks of bronze, wheels, cubes, or compact spheres (colorplate 60). They certainly have reference to our daily lives, to the idols of our society, to technological imperatives, but they are not imitative or conceptual: they are critical. They grow as if by a natural process: the form evolves outward from the nucleus in organic pulsation, with no fixed rules or automatic mechanisms. The irrational is converted into an organic structure. Giò Pomodoro establishes a relationship between surface and space, and hence the three-dimensional element is not blocked, not forced into geometric forms, but is open to other possible movements and non-Euclidean spatial definitions (plate 115). Thus sculpture takes on vital dynamics and becomes an enduring presence.

It is obvious that Dorazio, Perilli, Accardi, Sanfilippo, Novelli, and the Pomodoros will be of decisive importance in post-Informalism.

In 1951, when Informalism was at its height, Enrico Baj founded a "nuclear-art" movement (with Bertini and Dangelo). Then, for several reasons — including the influence of Dubuffet — he changed his attitude and became a severe critic of Informalism. He returned to representational painting, but added a quality of broad humor. The backgrounds are Art Nouveau wallpapers, the characters are made up of objects (for instance, his "Generals" — plate 127) made of medals, bandoleers, epaulets, and so forth. His playfulness never tires. He may well be the only painter (besides Dova) who, starting out as a Surrealist, succeeded in finding his own representational style, free of any literary or pseudo-ideological encumbrance.

Sculpture

The work of the postwar masters continues, but each contributes something different in his development since the 1950s. Many have taken a decisive step forward; others have come to a standstill and hence a retrogression. Thus the sculpture of Giacomo Manzù died out in a pathetic naturalism; Marino Marini, ued his symbolic and totemic images; Fazzini accentuates the classic elegance on the other hand, has deepened his existential investigation; Mirko has contin-
of his forms.

The distance between painting and sculpture has decreased. Are not Burri's "Ferri" and Consagra's "Colloqui" pictorial expressions? Is not Mari's pro-

gramed work, for example, a bridge between sculpture and painting? Sculpture has freed itself from the idea of the statue (which caused Arturo Martini so much anguish), and every artist looks for an autonomous language rather than for content. Some sculptors, such as Mastroianni, Leoncillo, and Colla, succeed in constructing new symbolic presences, but without any metaphysical stuffing, since the humanity of the "personages" is found in the nature of the material. Emphasis is placed on new materials, which are used for their significance as matter, as if for the reconstruction of a new nature.

We must mention first of all the remarkable figure of Lucio Fontana and his "Spatial Concepts" in sculpture, as well as his fresh structures (we think of the neon spatial sculpture for the Ninth Triennale); they are truly stimulating, even for the most advanced artists. Other sculptors educated before the war — Mannucci, Garelli, Mastroianni, Calò, Lardera, Franchina, Leoncillo, and Milani — find a language of their own in Informalism.

Edgardo Mannucci was, along with Burri, among the first of the Informalists. His sculptures are fleshless skeletons, often including luminous materials with carefully polished surfaces (plate 109). His recent works place him among the masters of the decade. Franco Garelli delineates "figures" that are more and more lacerated.

Umberto Mastroianni gives us enormous structures, such as *Battaglia* ("Battle") in the Galleria Nazionale d'Arte Moderna in Rome; they are like geological formations, with a new anthropomorphic sense (plate 110). The form explodes, but at the same time is summed up in a finished vision: multiplicity in unity, confusion in order, protest within a new construction. Implicit in the proposal of new idols is the exploration of a new meaning to be given to the monument.

Aldo Calò tends toward form even when he shatters it (we think of the *Monument to the Liberation of Cuneo* — plate 116); everything takes place within a rational clarity, and the Platonic idea is never lost sight of. Berto Lardera experiments with a rough and "antigraceful" Constructivism.

Umberto Milani goes from the poetics of the sign (also present in his paintings) to a hollowing out of the material. Nino Franchina seems to have a rebirth in Informalism. His baked enamel automobile-metal sheets, done between 1950 and 1954, retain their color; the search for expression becomes an imperious drive; the relationship with space is stressed more and more. His most recent sculptures are slender ethereal apparitions (plate 111).

Leoncillo came to Informalism by way of Expressionism — that of Scipione and Mafai, rather than the American type. Color enters into his ceramics (Leon-

cillo is one of the greatest living ceramists); the material is exalted. As he says, his "feeling for nature" makes him search for a "nature parallel" to, not an imitation of, nature itself. His "Taglie" ("Cuts") and "Mutilazione" ("Mutilations"), in *San Sebastiano* (colorplate 61) in particular (without metaphysics or mysticism), are part of a search for a new order to confer on the formless, certainly going beyond Informalism.

In Bologna, Quinto Ghermandi arrives at the hallucinatory "Eclisse" ("Eclipse") series; Luciano Minguzzi strips the flesh from his naturalistic vision; Roberto Crippa experiments with painting-sculpture.

Ettore Colla, one of the outstanding figures of the last decade, has a place apart. His sculptures, made of machine parts and junk, combined into a new composition, represent a sort of idea of the machine, an anthology of mechanism. They are scraps of war material, fossilized at the instant of the assault, useless objects with the sad heritage of rust. There is a feeling of life rising from the rubble, nothing of the triumph of death. The details and composition are ancient: Colla goes back to strange fetishes and to Oriental civilizations, with a renewed earthy mythological instinct (plate 112).

Francesco Somaini moves between action and reflection, between closed and open space, between centrifugal and centripetal motion. Sangregorio and Lorenzo Guerrini accentuate the weight of the material with primordial violence. Amerigo Tot, a Hungarian by origin, transfers his "totems" into new materials. Alfio Castelli produces significant objects of living nature.

Also beyond Informalism are the hypotheses of Consagra and the Pomodoro brothers, authors of a surpassing dialect.

On the programed trends (but are programed works sculpture?) we shall have more to say later on. Here we note Carmelo Cappello, whose style has been influenced by Max Bill, and the transparent structures of Franco Cannilla.

A number of artists work in an organic idiom. Agenore Fabbri has always been faithful to representation. He has arrived at a region of fantasy, one of his means being the use of strange materials. Alik Cavaliere is today producing facsimiles of plants, trees, and flowers in a decadent tone that owes a great deal to Giacometti's existentialism. Pietro Cascella is a descendant of Surrealism. Trubbiani fuses the worlds of machines and organisms. Off by himself is Andrea Cascella, who starts from a Surrealist position to construct forms, polished or rough, but always divided into regular zones, whose contents are architectural in intent.

Post-Informalism

Going beyond the aesthetics of Informalism, Italian artists mounted a polemical offensive against the preceding decade, as if it were possible to reverse the process of history. The attempt was made to identify Informalism with abstract art and, proclaiming its bankruptcy, to put forth once more a representationalism that in most cases consists of an inward-directed contemplation, and in others of the production of an anthropomorphic image alienated by the pressure of a certain ideology. In any event, having outgrown an aesthetic does not by any means mean a rejection of it, even when taking a critical position toward it.

The present experiments with a new language can hardly ignore the values proposed by Informalism in its day. Today's panorama is rich and suggestive, and new experiments follow close on one another's heels, although as hypotheses rather than as certainties. But are we truly interested in certainties? Or, rather, has it not been certainties, abstract codifications, political and religious aims, dogmas, and imposed ideologies that have in every age blocked experiment and a harmonious relationship with reality? When we hear it said that art should be committed to a party, or should be subservient to some kind of education, whether religious or political, we feel the concept being expressed is one of negation, not affirmation. The didactic aspect that is implicit in every work of art is always autonomous; it increases our experience of the world. Returning to explanatory contents can take place only on condition that they produce an enrichment. Let us take some examples. Pop Art, which appears as a step beyond Action Painting in the United States, gives us an image that is indeed an elaboration of actual, conscious experience and imposed conditioning — comic strips, movies, television — but an elaboration in an autonomous way, a seemingly mundane discourse that in reality changes the time and space planes, reverses them, and constructs them in another dimension. An opposite development are the neo-Constructivist experiments, which aim at discovering a geometrical order; and this geometry is not a given absolute but a spatial hypostasis growing out of the material's possibilities of elaboration.

In reviving the structure of the language, its ideological uncertainty must be replaced by a clearer awareness, and, above all, any metaphysical deviations or involutions must be avoided. Warning must therefore be given that ideology cannot be a oneway street; it cannot consist of a pattern imposed a priori and given as a standard. Ideology and the will to political action are not necessarily the same, especially since we know from experience that the will to political

action can be used as an alibi for the inability to function artistically. Ideology taken as a system of precepts becomes a pseudo-ideology. Therefore, any investigation of the ideological and sociological validity of the various tendencies is legitimate, but it cannot disregard an analysis of the language.

So far as the past is concerned, we know that the dissociation of art from technology, art from politics, and politics from technology was the great break in nineteenth-century culture, and that the main effort of great personalities was bent on curing this cultural condition. Evidently, today the need still exists to bring these various aspects of the human condition to a common denominator. In this respect, from a programmatic point of view, the clearest discussion appears to be conducted by the proponents of the Gestalt trends — clearest, but also more superficial, in that it is more assimilated to a procedure that is technological, not sifted and elaborated in its ideological implications, and hence ending in a stationary state of the lexical structures. On the other hand, the treatment by the various currents of the art of reportage is more tortuous, more uncertain; as far as a definition of commitment is concerned, they show less awareness. Nonetheless, they work out an operative procedure by means of which they arrive at a definition of "another" value and thereby take over the theoretical core of the Informal experiment and tend to impose the immediate presence of an object, "a shortcut between the events of life and the evolution of art" (Calvesi).

It should not be forgotten, however, that these are two parallel inquiries that refer to a single social texture. On the level of artistic labor, it would be historically false to accentuate the contrast between the two types of investigation. In the past, there have also been seemingly contradictory experiments that have coincided, and today there still exist linguistic elements with a common root. And the distances between the various experiments of the present are never too great, except qualitatively — as always, after all.

Neo-Surrealism

Before taking up the two leading trends (programed art and the New Realism), we should like to deal with another trend, which puts itself explicitly outside of history. This extreme form of neofigurative decadence shows ghostly or grotesque images commingled with symbolism, Surrealist metaphysics, and even Guttuso's latest scraps: a set of remnants totally foreign to the logic of the evolution of artistic language, and suspect on the level of the

formal result of persistence of contrasting linguistic strata. The sad conclusion is that it lacks a language of its own. In many quarters the decline of Informalism was anxiously awaited, in order to propose a restoration of old images. Defense of these rearguard positions naturally leads the "Holy Alliance" critics to make a frontal attack on the positions of the avant-garde, identified *tout court* with "fashion."

It is a para-Surrealism that at best goes back to the deformations of Bacon (who at least had the virtue of pointing out such means as the flash and the film montage). We have nothing against the Surrealism of past history, but today's version is muddy and weary, as shown by its inability to set forth a language of its own and by its having to collect its means of expression anywhere and everywhere. The para-Surrealists even smuggle in the developments of Expressionism and Sezessionism. All in all, an indescribable deviation, of which we shall mention only an example or two.

The last gasps of neorealism can be classified as within this trend: Giuseppe Zigaina, for example, a painter of the autumn of romanticism (although he is attempting to bring himself up to date); Ugo Attardi, who was a member of the Forma group; Vespignani, who at present tends toward Surrealism and Pop subjects; Franco Francese, one of the first to study Bacon.

Sergio Vacchi is one of the most applauded exponents. Coming from Informalism, he manifests in his most recent cycles ("Council," "Power," "Adam and Eve") a depressing taste, with heavy Daliesque sexual reference, in which the frenzy is cold, with no true inspiration (plate 117). Gold and silver weigh down these pointless Byzantine canvases. Giannetto Fieschi had said something in the language of Informalism, but today he is in a phase of painful involution: he shuts off ever vaster areas with his sterile intelligence. The meaning of the form does not go beyond late Sezessionism, and the meaning of the subject is on the level of a street song.

Giuseppe Guerreschi today offers academic imitation, a compromise with photography, but without an ounce of the Pop boldness. We mention further Gianfranco Ferroni, Farulli, Calabria, and Alberto Biasi, and, among the young, Antonio Recalcati, a painter who has shown much promise. In Milan, in the orbit of Bacon and Matta (imitated, but in a civilized manner), we find Peverelli, Aldo Bergolli, and Mario Rossello.

A special case is Concetto Pozzati, who started with naturalism, then came to the periphery of Informalism, and in his painting today alternates figures with heavy naturalistic pieces. His organic, inmost inclination always brings him back to neonaturalism (plate 118).

Neo-Concrete and programed art

Let us at this point recall the work of the geometric abstractionists, which still is carried on, a tradition for the young Neo-Concrete artists. For thirty years, Alberto Magnelli has been influencing young Italian artists from his voluntary exile in France. Mario Radice was one of the founders of Italian abstractionism. Mauro Reggiani creates pure, spare abstractions. Luigi Veronesi has made his serene calligraphy more complex in recent years.

Understanding of Neo-Concrete art has been promoted in Italy by MAC (Movimento Arte Concreta) — founded in Milan in 1948 by Gillo Dorfles, Gianni Monnet, Bruno Munari, and Atanasio Soldati — which gained many adherents in all parts of Italy. But its real start, this time an effectual one, was due to the 1960 exhibition of past and present Concrete Art in Zurich, organized by Max Bill. The Monochrome Malerei show (Leverkusen, 1960) also aimed at searching for the "formative elements that make a painting a dynamic structure." Among the Italians were Dorazio, Bordoni, Manzoni, and Castellani. In Italy, too, a Copernican revolution began to be proposed; in Informalism it was the artist who expressed his kinetic activity, while now it is the spectator who has the task of finishing the work. This happens because every work has various possibilities of perception, of variable luminosity, and formal (Gestalt) ambiguity. We encounter once more the "open work" of which Eco has spoken.

The artists of this tendency rely only partly on chance, because every effect is calculated, is programed. At the bottom of the process is what is called "alea" ("hazard") in music.

The problem of the relationship of the artist to science is posed openly. The problem, as Lewis Mumford has said, remains that of reconciling Prometheus (the man of science and technology) with Orpheus (the man who tames nature by means of art) — in fact, of bringing Prometheus back under the guidance of Orpheus. The sole danger for this art, which rejects the experience of nature, is substituting science for nature. The result is the same if the artist, instead of "aping nature" (as they said in the seventeenth century), "apes science." The danger lies in superficial adhesion to a world that is not one's own, in yielding to the blandishments of cybernetics, in being gripped by the coils of mathematics or optics.

In programed art the principle of dynamism is always operative, developing in two directions: the work may be stimulating or kinetic. Kinetic works move by means of some device (and have ancestors in the medieval automata);

stimulating works impose the movement on us, the spectators. For example the works of Gruppo T of Milan and some of Gruppo N of Padua are kinetic; the works of Mari, Castellani, and Alviani of Gruppo N are stimulating.

Bruno Munari, exponent of industrial design, may be regarded as the first to propound programed art in Italy. We have in mind the object *L'ora x* (1945, done recently in fifty copies): transparent colored disks of different sizes turn at different speeds, and something continually new in color and form is born. We have in mind also the "Direct Projections by Polarized Light" (1957), in which he studies the decomposition of light. Today Munari is working in the experimental cinema.

Enzo Mari is closest to Munari. His volume-color researches (begun in 1957) make a three-dimensional complex of Mondrian's space-color relationship. The studies on the relationship between negative and positive suggest a dynamic image. It is a remarkable search, rich in warmth and imagination. *Freedom in Order* is the title of a note of his on aesthetics: a sequence of internally revised programs within which the artist can exercise his freedom — rational freedom (plate 122).

Enrico Castellani comes close to an industrial method with his monochrome "Surfaces." But he suggests a new movement: the canvas is modulated to suggest a three-dimensional space, and the structures in relief take our dynamism for granted. The light falls in a positive or negative way, insuring the mysterious and highly rational rhythm of these surfaces (colorplate 62). Francesco Lo Savio, who died very young, had to work in the confining Roman environment; he too obtained good results in monochrome, and left works of a purist severity.

Getulio Alviani propounds a new material: his aluminum sheets are cut into modular zones and arranged in alternate positions. This creates various possibilities for the reflection of light: the work changes with the spectator's slightest move; the atmosphere enters the picture (plate 125). Waiving any extraneous means, Alviani gives us a new form of illusionism (is the surface wavy or flat?). He does not set forth a closed and perfect image but a value to conquer; not a point of view but the search for a point of view, which, we need hardly say, will never be found — a subtle parable of the instability of the modern world. Alviani has extended his research to the social plane: we think of his wall surface for a kindergarten at Leverkusen and of his fashion textiles.

Programed art demands of the artist something different from Informalism (which was based on individualism); that is why research groups were formed. Industrial methods took the place of artisan methods.

In the field of kinetic art there is Gruppo T, founded in Milan in October, 1959, by Giovanni Anceschi, Davide Boriani (plate 119), Gianni Colombo, and Gabriele De Vecchi — later joined by Grazia Varisco. One of their statements says: "We consider reality a continuous becoming of phenomena that we perceive in change. Once a reality taken in these terms has assumed the position, in man's consciousness (or merely in his intuition), of a fixed and immutable truth, we observe a tendency in the arts to express reality in its terms as becoming."

Anceschi examines the refractions of colored light. Boriani has made a place for himself with his "Magnetic Surfaces," in which iron dust is set in motion by invisible rotating magnets, a parable of the composition and decomposition of matter. The latest works are based on the persistence of light on phosphorus; depending on the rates of motion, we get a science-fiction vision, submarine life, or pyrotechnic joy. Colombo studies the problems of light and movement: the stimulus of the psychological reflexes may likewise conceal anguish. De Vecchi presents "radarscopes" with a curious inversion: the rotating solid element is a thin plate of transparent glass, the atmospheric element a metal plate. After all, if it is true that nothing comes from nothing, it is also true that movement can suggest the weight of a light material. Varisco produces optical games that have the infallible precision of a nightmare. Although the effect may be free and fanciful, the will to programing is obvious in all these works. What is more, they can be produced and reproduced with the certainty of industrial methods: they are not copies but authentic works, just as much as the first one made.

Gruppo N, founded in 1959 in Padua by Biasi, Chiggio, Costa, Landi, and Massironi, is now breaking up. The method of study is collective, but the practical and theoretical experiments differ. The results are very artful. Giovanni Antonio Costa's *Visione Dinamica* is one of the most important works. On a dark rhomboidal surface a set of thin white plastic strips is placed radially and twisted in such a way that, as we change our position, the black surface underneath appears to change. The effect is radiant, since the impression of the twisted strips on our eyes varies (plate 121). Other works take advantage of the principles of motion with which Vasarely has experimented, but with new effects of refraction and interference of light.

In the Neo-Concrete framework (in this connection Argan used the term "Gestaltic art" to link Neo-Concrete Art with programed art) we remember Gruppo I, founded in Rome in 1962 but no longer in existence. We note Uncini, who forces cement into regular metallic recesses, Achille Pace, with

his white labyrinthine lines on a black background (plate 126), and Pasquale Santoro (painter, engraver, and sculptor), who seeks a concrete definition of space (plate 123). Also in Rome, in the field of programed art, there are Sperimentale P (Drei, Guerrieri) and Gruppo Operativo R. Pizzo and Di Luciano have separated from the latter; they work with scientific methods, always starting from problems in mathematical logic and ending in works of "optical" substance, a series of perceived mathematical phenomena.

In Milan we note Agostino Bonalumi; in Genoa, the Tempo 3 group; in Leghorn, Gruppo Atoma; in Rimini, Gruppo V. More or less apart are certain researches (like those of Angelo Savelli, Antonio Virduzzo, 63-year-old Antonio Calderara — plate 120 —, and young Marcolino Gandini in Rome), aimed at bringing a rejuvenated *esprit de finesse* into geometry.

The New Objectivity (symbol and reality)

The artists who look to the symbol, to the object, to reality succeed in saying something new by means of research on two planes, language and contents.

On the linguistic level, many of these researches are related, in literature, to the aims of the Gruppo 63 and the *novissimi* ("newest") poets (Balestrini, Giuliani, Pagliarani, Porta Sanguineti). In fact, the typical qualities of the modern poet, as stated by Giuliani, can very well be applied to these painters: discontinuity of the imaginative process, violence done to signs, coexistence of various orders of discourse, decomposition of the syntactic structure, harshness of the meter. Often the will to form is expressed by means of disconnected fragments arbitrarily juxtaposed, in the spirit of collage, with the haphazardness of a newspaper page. The forms of nature are distorted, not by lack of understanding but in a desire for total possession. Frequently, the figurative language is combined with calligraphy, memory is intertwined with narration. The means are renovated; in addition to the manipulation of already existing objects, there are insertions, imprints, and imitations.

But there is also the wish to renovate the vision of the world, to structure an earthly mythology, but one that is not personal or egoistic, one that is not merely the superfluous and pseudoromantic expression of the artist's ego (or, rather, of the Freudian id) but makes the effort to penetrate into the world of others (Jung's collective unconscious). The aim is not a sterile situation but the search *within themselves* of universal destinies.

What is their relationship with the Pop and new Dada currents? In the

best of them, their adaptation to the American trends is critical, not that of blind followers. It is impossible to reject the new tools developed across the Atlantic (films, billboards, comics, advertising); it is almost always possible to avoid having these tools turn into the "goal" of the artist's own expression.

In Milan we have Aricò, Del Pezzo, Adami, the late Romagnoni, and Baj. Rodolfo Aricò depicts the changing of existential time. The image does not arrive at definition on the canvas; it is not an abstract form, and not an object, but remains in a limbo (plate 128). It may help us to understand this vision when we read a book like Robbe-Grillet's *Istantanée:* a slow narration without time, story, or characters. The subject is only illusorily concrete; man entire does not exist, since he is fragmented into an infinity of particular observations.

The late Giuseppe Romagnoni had come to an interesting narrative painting by way of the technique of photomontage and the association of ideas. There is a new vision of space, totally engulfed by characters and actions. It is possible that he wanted to show that space does not exist, and gives us a painstaking exorcism of it.

Lucio del Pezzo has been living in Milan since 1960, but prior to that had founded Gruppo 58 in Naples. His first works were Dadaist in tone, but in the process of fastening the objects on the canvas there comes, in addition, the memory of the magic of Naples. His most recent works manifest a new purity, metaphysical in tone but with critical intent (colorplate 65). His consoles, set against backgrounds that are often monochromatic, with Art Nouveau decorations, bear toys, maps, and ex-votos. It is a subtle reference to memory, to a past that is at once historical and autobiographical.

Valerio Adami began in the orbit of Matta and then found a language in the world of comic strips. His relationship to reality is mingled with autobiography, and perhaps these two factors derive from the feeling for the "story." Adami looks at reality from behind a veil of irony, as he looks at himself (a psychoanalytic interpretation would explain many of his obsessions). His space is the space of dreams, made of impossible agglomerations of possible things. Freud's great discovery was the importance of infant life, which mortgages man's entire life. And Adami chooses the cartoon just because it enables him to discharge his anxieties, recovering the lost time of infancy. But this search for the past is much more dramatic than comic (plate 129).

In Rome, Mimmo Rotella is a true precursor of the New Realism. He began to exhibit his "torn posters" as early as 1954. "Tearing the posters down from the walls is the only recourse, the only protest against a society

that has lost its taste for change and shocking transformations If I had the strength of Samson, I would paste the Piazza di Spagna over This is research, research is concerned not with aesthetics but with the unforeseen, the temper of the material itself." In 1960, Rotella joined Restany's New Realism. It is remarkable that the torn-poster technique should have made it possible for Rotella to enroll in two movements as different as Informalism (the posters being used as pure material) and the New Realism (when the picture of the poster regains its importance). His home is the city street, his themes everyday images. Since 1963, Rotella has been experimenting with the new technique of photo reportage on canvas (colorplate 64).

Mario Schifano succeeds in making the Pop world Italian, going back to Futurism, particularly to Giacomo Balla. His 1963 paintings appear in the form of reportages: the landscapes of advertising, the image of Leonardo, the sun, events. Today, the link between nature and picture is no longer made through the mass medium, for Schifano refuses to engage in the easy activity of the reporter — he constructs a new reality. He does not accept the world passively but chooses its most interesting aspects; he does not aim at completeness but at the particular; he works in depth rather than breadth (colorplate 65). Today, his pictures are more complicated, fuller; they embody humanity and geometry. Schifano, haunted by the fear of being too late, wants to say everything. We might perhaps define him as a "figurative Informalist."

Franco Angeli starts directly with political symbols (the swastika, the Capitoline she-wolf, the Cross, the dollar, the papal keys), but his symbols are always related because he always finds them within the human sphere. The symbols of power, painted in strong timbres, are later veiled by a colored cloth (a filter as it were) that lets the image show through only in part. The painter's desire to eviscerate the symbol, after having labored to isolate it, is fully justified, because the symbols of violence and domination should be exiled to a region of dissolution. Then, as the images arise behind the cloth, the cloth takes on the function of a scrim — it is no longer the support of the painting but is itself a symbol, a symbol of matter impeding a pictorial vision. And it is important that the image coexists with the symbol, the allegory with the narration (plate 130).

Tano Festa relates to metaphysics, Constructivism, and Dadaism. The spaces, empty at first, fill up with figures from the news and from history (pictures of women, works by Michelangelo); this is logical because the documentary is the first step of a director. His latest pictures are veritable short subjects (plate 131).

Also in the younger generation, Mario Ceroli began his object-sculpture by presenting images of the city; today, he tells complete stories (plate 124). It is a subjective hypothesis within an objectivity chosen as a point of understanding with the spectator (but "humor" in the manner of Tilson turns into drama). Cesare Tacchi, on the other hand, uses the techniques of the tapestry worker, with extremely polished images: the flowered background evokes the image of Canova's Paolina Borghese on the divan, or a friend in an armchair. It is a conscious exaltation of matter.

Other artists in Rome who should be mentioned are Claudio Cintoli, Renato Mambor, Sergio Lombardo, Laura Grisi, and Giosetta Fioroni.

For the last few years, Naples has been making its contribution to the new climate of objectivity. After Renato Barisani, we recall the Gruppo 58, organized by Luigi Castellano (Biasi, Del Pezzo, Di Bello, Fergola, Luca, and Persico), which soon tied up with the "nuclear-art" group of Milan. The works tend toward collages, generally in the line of Dadaism, with a marked popular feeling. The best of them manifest joy; others are aligned with Surrealism.

Michelangelo Pistoletto works in Turin; his painting is dramatic, reflecting an anxiety that is more physical than metaphysical. His intention is "To bring my two images closer together: the one my mirror shows and the one I imagine." Figures taken from photographic enlargements are pasted on a mirror-bright sheet of steel. We are surprised to find, reflected within the picture, our own image. Space, says the painter, is something that is always tangible and at the same time always new, impossible to fix (plate 132).

This is the direction — the new structure to be given to space — in which the trends of the youngest artists are moving: programed art and new objective art. The path of their experiments is broader than ever.

The Art of Spain from 1945 to 1965

By Alexandre Cirici-Pellicer

The Years of Individual Revolt

The complete interruption of all creative artistic movements by the Civil War created a vacuum that continued to 1946, in which the only artists of importance were those who were abroad. In architecture, J. L. Sert in the United States and Antonio Bonet in Argentina represented a continuation of the rationalism of the thirties; in Mexico, Candela carried out very bold experiments with the use of concrete in prestressed vaults. In painting there were Picasso in France; Miró in France and the United States; and Dali in America. There were also the attractive stage sets of Antoni Clavé and the illustrator Emilio Gran Sala, both in Paris. Also in Paris were Francisco Borés, with his flat, muted compositions; Oscar Dominguez, a pioneer and survivor of Surrealism; Pedro Flores, who gave a tapestrylike tone to his complicated compositions; and the sculptor Apelles Fenosa, sensitive and nervous to the point of flamboyance.

The first attempt at revival inside Spain came in 1946. A book on Picasso was published in Barcelona, and in a modest neighborhood center the Catalan Surrealist poet J. V. Foix gave a show of four young people: the painters Pere Tort, August Puig, and Joan Ponç, and lastly the sculptor Francesc Boadella. At that time, Tort and Puig were fascinated by a primitivist urge and a desire for organization of the flat surface, Boadella by exteriorization of the structure, Ponç by the fierce expression of an aggressive desire made of symbols and dreams, originating somewhere between magic and the surreal.

The appeal to individualist revolt launched by this exhibition was a starting point that was carried forward by the ephemeral, diabolic journal *Algol* and finally by the magazine *Dau al Set* ("Seven-Spot Die," in Catalan), chiefly inspired by the poet Joan Brossa and reflecting the existentialist position of the young philosopher Arnau Puig. The format of the magazine, which appeared in 1948, was designed, very imaginatively, by Joan Josep Tharrats, who took care of printing it, making up for the lack of resources by ingenious

graphic procedures. A Surrealist aura surrounded the entire thing, expressing a desire to proclaim the contempt of the young for the false world around them. The illustrations of Joan Ponç, Antoni Tàpies, and Modest Cuixart brought these painters before the public. Tharrats was only to become a painter later, about 1950.

In 1948, the Salon d'Octubre opened in Barcelona. There all the young artists became acquainted with one another, in a unanimous rejection of academicism by way of the most diverse trends that could be derived from the prewar avant-garde, although the lack of communication with the outside world left them all in an atmosphere very much of the days of Picasso and Matisse.

Saragossa was the scene of an unexpected gesture toward living art in the form of the Pórtico group of Santiago Lagunas, Laguardia, and Fermin Aguayo, who became known in Madrid by means of the first abstract show in Spain, at the Galeria Buchholz. In 1949, Navarro Ramon of Valencia also came out as an abstractionist, as did Eusebio Sempere in 1950 at the Sala Mateu in Valencia. The creation of Club 49 in Barcelona in 1949 provided demanding and effective support by connoisseurs and critics for all the creative researches of Catalan visual art.

In 1951, the official policy toward art changed. Since the end of the war, there had been expositions and awards only for the emptiest conventionalism, just as in architecture it was impossible to get a project accepted legally unless it was academic or neopopulist. But in 1951 the General Architectural Bureau accepted modern architecture as valid, under the pressure of such organizations as Group R of Barcelona, which rallied to the standard of organic architecture, supported by the ideas Frank Lloyd Wright and the Italian school, especially Bruno Zevi. J. M. Sostres, a theorist of architecture, was the great driving force of this movement, whose most significant figure was Antonio Coderch, winner of the Grand Prix at the Milan Triennale in 1951.

In painting as in sculpture, the new line, while reserving honors in Spain for the conventional, accepted innovating art for the international expositions. At the time, the state even organized the first Hispano-American Art Biennial, at which could be seen the abstract works of the Galician Manuel Mampaso, the Catalan Enric Planasdurá, and the Majorcan Juli Ramis, surrounded by a great wave of vague disoriented Expressionism, which still represented youth's nonconformity.

The position of the abstractionists was the point of attack of this young dynamism. It was affirmed in 1953 when the International University of

Santander organized a two-week session devoted to abstract art, under the direction of Fernandez Del Amo, director of the new Museum of Contemporary Art in Madrid, with an exhibition organized by Manuel Sanchez Camargo, the assistant director. This show brought together works of the Saragossa group and the Canary Islands group (encouraged by the critic Eduardo Westerdahl) with the still very young painter Manolo Millarès, the Madrid painters, Mampaso and Luque, and those from Barcelona, like Planasdurá and Jordi Mercadé.

The importance of the Santander sessions was that they brought together the hitherto isolated artists of the different groups, and that the presence of Devoto brought to bear the influence of the Argentine movement of Concretism.

In 1954, through the influence of the Basque sculptor Jorge de Oteiza, something new took place in the appearance in Cordova of the Grupo Espacio, out of which later came Equipo 57. This abstract group has concentrated on working in teams and on the problems of a geometrical Constructivism, with explorations of materials and industrial processes.

On the eve of 1955, one would have said that this sort of purist geometrical abstraction had the last word. This was less obvious in sculpture, where Angel Ferrant in Madrid, De Oteiza in the Basque country, and Eudald Serra in Catalonia represented both fidelity to the avant-garde and a feeling for organic forms and for the movement of mobiles and changing ensembles.

Dau al Set, Salon d'Octubre, Pórtico, Club 49, Group R and Grupo Espacio channeled this factor of individual revolt and gave it meaning. Their promoters were mainly Brossa, Victor Maria d'Ymbert, Lagunas, Joan Prats, Oriol Bohigas, and De Oteiza respectively.

The Rise of Informalism

Nineteen fifty-five is a very important year in the evolution of Spanish painting: that is the year when the personality of Antoni Tàpies, fully formed, appeared, when this painter went off from the trend, more or less linked to a belated Surrealism, that was characteristic of the group of *Dau al Set,* to establish himself as a painter of subjectivity. He did so while adopting a very austere manner of working, employing very dull opaque materials, with great thickness, sometimes to the point of bas-relief, in somber tones — ochers, ivories, chocolates, a garnet red with very little brilliance, or rare

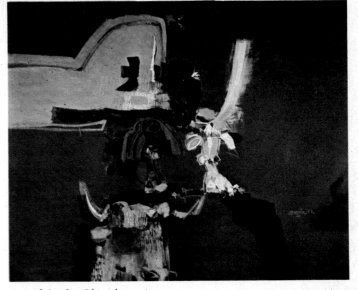

94 Alejandro Obregón 1963

95 Jesús Soto 1963

96 Antonio Berni 1962

97 Marta Minujín 1964

98 Jannis Spiropoulos 1963 99 Constantin Xenakis 1961

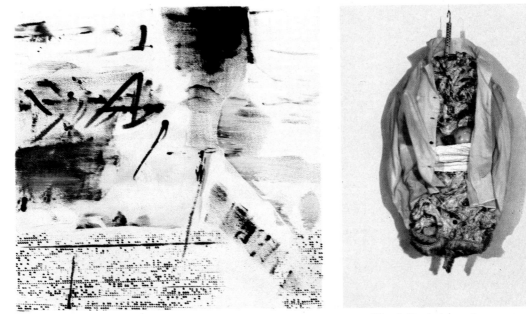

100 J. Molfesis 1964 101 Vlassis Kaniaris 1964

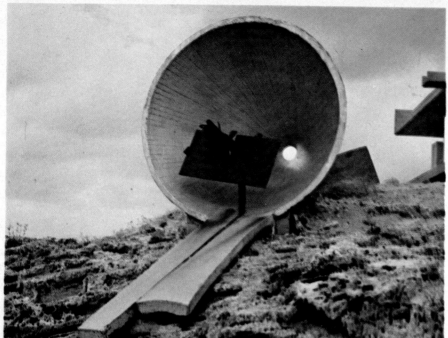

102 Ygael Tumarkin 1963–64

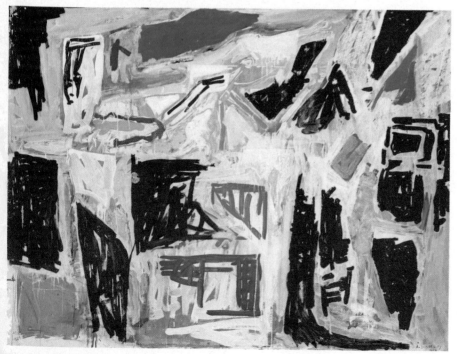

Joseph Zaritsky 1954

104　Jerzy Tchórzewski　1964

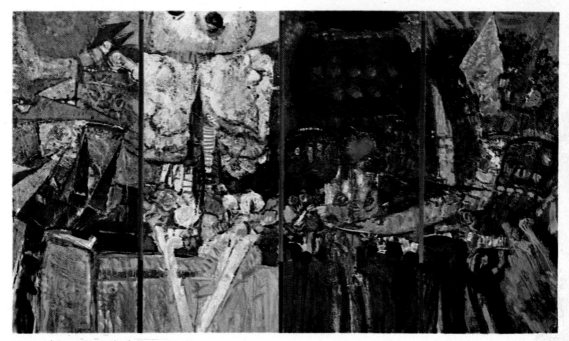

105　Aleksander Kobzdej　1964–65

106 Tadeusz Kantor 1965

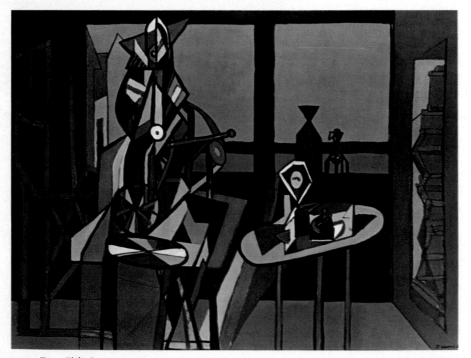

107 František Gross 1962

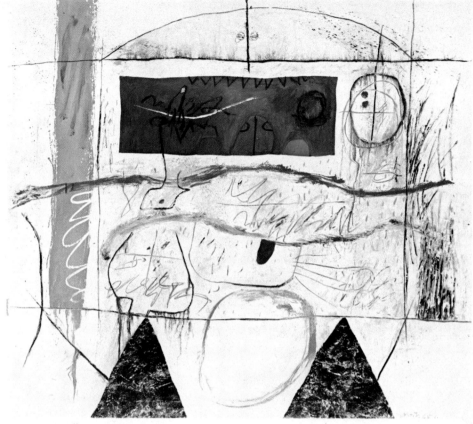

108 Jan Kotík 1965

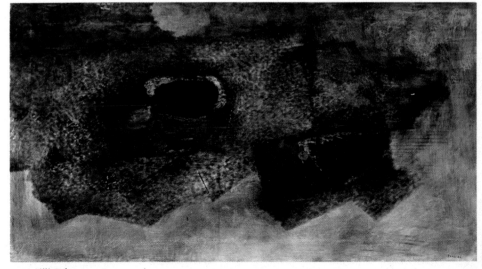

109 Jiří John 1964

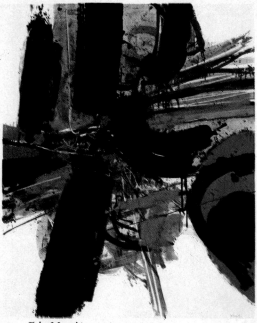

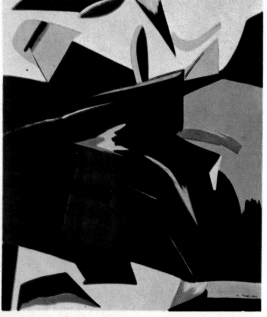

110 Edo Murtić 1965

112 Stojan Ćelić 1962

111 Janez Bernik 1964

purples, sometimes ultramarines, equally mat in tonality, almost powdery.

Since that time, his subjects have been matter humbly presented, sometimes pointed up with stigmata, traces, cuts, swellings, depressions, marks, dots, and seeds. Often the material is of the lowliest: gray cardboard torn, sewed, under glass, spotted, or rubbed. His work as a whole suggests closed objects: doors, closets, windows, drawers, tunics, or covered and upholstered chairs.

In its imposing simplicity and monumental demeanor, his style did not take form at once. At first, it was almost Informalist texture painting, inserted into what Michel Tapié called "the other art." Later, it became purer and purer, tragic, grand, desolate, and at the same time of a great purity of conception and exigent taste (colorplate 67). In 1956, this new Tàpies became well known and had an enormous impact on the youth of Spain, at that time grouped especially in the Association des Artistes Actuels in Barcelona.

After Tàpies came Modest Cuixart, who gave the painting of material a brilliant aspect, not only by means of radiant arabesques and high Baroque impastos but also with sumptuous silvers and golds achieved through the use of metal powders.

In 1950, Joan Josep Tharrats began painting unreal, highly metaphysical landscapes; in 1956, he went into Abstract Expressionism. His impetuous, passionate, explosive style is manifested in a richly colorful Tachism, with a very luxurious arabesque of small spots, subject to large neutral backgrounds (plate 134).

Joan Vilacasas abandoned his intimate and tender figurative lyricism for exquisite mottling that suggests "hare's-fur" Chinese porcelain, and later what he calls "planimetries," arabesques in tinted materials, like maps of an imaginary world. Carles Planell at first went into the purest of Tachisms, with which he soon mixed spatial experiments, in sets of holes, a romantic modification of the ideas of Lucio Fontana. Romà Vallès concentrated particularly on entirely flat painting, without the visible relief of material of all the other painters cited (plate 137). He showed his sensibility in tinting procedures — in particular black and white, sometimes grayish white, even white on white — whose vibration produces a kind of trompe-l'oeil, as if the paintings were objects in relief, after the manner of K. R. H. Sonderborg, and often as if they were vast desert or polar panoramas.

Jordi Curós (born in Olot) abandoned his emphasized realism, sometimes suggesting a Fauve Picasso, for a harsh-substanced Informalism with a density like that of a brick wall. Hernández Pijuan seems to give a tragic version of this Informalism. His sculptural subjects, even when abstract, almost

always in black and white, are reminiscent of fearful Crucifixions in the violence and pain they evoke. Eduard Alcoy likes to express himself in an arid porous material, suggesting bone, old wood, or cork. Enric Planasdurá has given up his geometrical abstraction for the stream of color, à la Pollock. Albert Ràfols Casamada left his Villonlike post-Cubism for a very sober and harmonious Informal arabesque (plate 133). Alfons Mier is obsessed by the counterpoint of high impastos and objects entirely in the round, superposed on organic forms. Josep Guinovart gave up his neorealist social painting for an Informalism that mixes the values of the material with those of color and a powerful high relief.

An important agent for the Madrid center is the Academia Breve de Crítica de Arte, presided over and dominated by Eugenio d'Ors, who has imposed, in the face of official academicism, an eclecticism that has room for any trend aiming at renewal. From this circle emerged Rafael Zabaleta, who has expressed his passionate, even heated, Expressionism by plastic methods learned from post-Cubism. This painting was the most advanced in Madrid, along with that of the School of Madrid, which was sometimes akin to the Italian painters of the Fascist era, despite a popular desire not to fall into the monumental but to get closer to the humblest aspects of the people's way of life.

A more exigent position, aiming at joining the most creative prewar movements, was held by the School of Altamira, which united painters like Mathias Goeritz, Willi Baumeister, and Joan Miró, sculptors like Angel Ferrant, architects like Alberto Sartoris and Luis Felipe Vivanco, and critics like Eduardo Westerdahl, Ricardo Gullón, and José Hierro.

Mention must be made of the group of the Galeria Buchholz, in Madrid, with Carlos Pascual de Lara, a product of the Italianizing group à la Massimo Campigli; Pablo Palazuelo; and Carlos Ferreira, the Synthetist sculptor, who goes to the brink of an organic abstraction.

The first powerfully creative movement of the Madrid center comparable to the *Dau al Set* group in Barcelona was the El Paso group, with the painters Manolo Millarès, Luis Feito, Rafael Canogar, and Antonio Saura and the writers Manuel Conde and José Ayllón. The group was formed in 1957, and in 1958 was joined by the sculptor Martin Chirino and the painters Manuel Viola and Manuel de Rivera. This group made many public appearances and gave shows until 1960, and evoked a long series of demonstrations throughout Spain that cansed a decisive change in the mentality of the young.

Manolo Millarès, who had begun in the furrow of a magical post-Surrealism, akin to Picasso and primitive art, abandoned the representational at this time

and went to creations in material, particularly rough textiles with drawn threads, swelled by dramatic spotted and wrinkled material accretions. The browns, blacks, blood reds, and white lines of the material give his pictures an increasingly tragic sense, as if of images of torture (colorplate 70).

Luis Feito created a less material, more visual, painting. With clouds and soft vague transitions, on backgrounds almost invariably gray, his spots, often black, resemble mysterious appearances, as if they had been placed at different distances in space. These vaporous worlds are inhabited by some ochers, some pinks, some grayish blues (plate 138).

Rafael Canogar, however, represents a third trend: not material and vision but gesture and calligraphy. His thick impasto in severe colors — brown, black, rarely white, more often gray — is worked over spiritedly in hatched lines, in violent, tangled, and complicated but never minuscule arabesques, always passionate and in Baroque accumulation at off-balance points (colorplate 66).

Antonio Saura, who in adolescence had been a Surrealist dreamer, somewhat like Matta, found his idiom in the most passionate and stormy of painting in black and gray on white. Like a De Kooning or even an Appel, with some confusion and even cruelty, his first paintings already suggest the world of half-monsters that was to appear in his latest painting, an image of sorrow and revolt with a marked social intention (plate 139).

Influential were the El Paso group and the Art Autre exhibition that in Madrid and Barcelona showed the work of Appel, Camille Bryen, Alberto Burri, Dubuffet, Hisao Domoto, De Kooning, Jean Fautrier, René Guiette, Philippe Hosiasson, Toshimitsu Imai, Georges Mathieu, Pollock, Jean-Paul Riopelle, Jaroslaw Serpan, Mark Tobey, and Wols.

Among the members of the Madrid group who went into Informalism are Luis Saez, a painter of material and of gesture; Lucio Muñoz, a narrative painter of high impastos with austere colors; Juana Concepción Francés, a painter of dynamism; Vicente Vela, a painter of stigmatic material, with wounds, wrinkles, scratches, scrapings, and worn surfaces testifying to the very process of its elaboration, who has worked toward increasing visualization, with effects of space and light; Manuel Viola, who likewise went from a painting of action to painting the values of light and shade (plate 135); and Antonio Suarez, whose impastos, sometimes resembling those of Fautrier, assume an organic, even visceral, meaning.

To find a creative trend in Valencia comparable to the appearance of *Dau al Set* in Barcelona (1948) and El Paso in Madrid (1957) we must go to the Constructivist Grupo Parpalló, to which the work of the critic Aguilera Cerni

is closely allied; the group Rotgle Obert of Benet and Borillo (1959); and, since 1958, the Art Actuel de la Méditerranée movement, the moving spirit of which was Joan Portolés.

The painter who represented the break with the academic past was Manuel Gil, who began in 1949 with a Nabi inwardness and went on to Expressionism in 1950 and, in 1955, to the creation of the strange invented characters which he called "Koo," the beginnings of a sort of magicism. Gil, who died in 1957 at the age of thirty-seven, opened the way for the young movement of Valencia, whose first important personality was Salvador Soria. Soria has worked out a scholarly cuisine as a painter of material, enriched with the drama of tracks and stigmata of complex flux — cuts, mendings — all organized by simple Constructive rhythms but often complicated by a spatial doctrine that delights in pierced surfaces (colorplate 69).

Mention should be made of the foreign painters who have lived in Spain and have become active members of the centers of Madrid or Barcelona. In Madrid there is the Greek Dimitri Perdikides, an Informalist who gives delicate and sensitive life to a flat, highly organized, almost Pompeian composition imbued with half-visualized classical idioms. In Barcelona there is the German Will Faber, who incorporates real elements, such as numbers, letters, and the rhythms of punched computer cards, on a background of highly sensitive and colorful exhalations; the American Norman Narotzky, who presents fragments of nudes through his almost imperceptible nuances; and the Ecuadorian Enrique Tábara, whose compositions in pure material come close to a world of signs, akin to certain magic arts.

In the international group of Ibiza is the German Erwin Bechtold, an exquisite creator of arabesques of spots and wrinkles, romantic counterpoints of browns and whites, smoothness and swelling, before he went over the simplest sort of organic arabesque.

Nineteen fifty-seven is the great year of Informalism; it is also the great year for its opposite, the tendency that has been called "Constructivist," "neo-Gestalt," or "normative." It was at this time that the Grupo Espacio split and the Grupo 57, dedicated to research in this domain, with collective work an essential feature, was set up in Cordova. This group included Angel Duart, Augustín Ibarrola, José Duarte, Juan Serrano, and Juan Cuenca.

The Galician José María de Labra has worked in a parallel direction since that period. Up to 1958, he was a geometrical painter, and since 1959 he has done painting and sculpture while searching for forms on the basis of such physical data as the mechanical logic of stresses or the chromatic effects ob-

tained by the changing illumination of colored glass. His experiments with wire networks have something in common with the work of the specialist in wire cloth, the Andalusian Manuel de Rivera.

Pablo Palazuelo, a Madrileño, has concentrated on flat studies of great simplicity, surfaces of solid color forming spots with organic contours. The Catalan Joan Claret has for a long time been producing flat compositions in which the lines bound intertwined surfaces of simple design, partly overlapping, with effects of transparency, all in grisaille (plate 136).

The most well-rounded of the Constructivist painters is Alicante-born Eusebio Sempere, an abstractionist since 1949. Since 1955, his essential contribution has been his rhythmic compositions, very expert and often complex, frequently dominated by closely woven hatching and parallel lines of light and shade. Another creation of his are the pierced paintings, or reliefs, on several planes, with changing electric lighting inside, periodically producing different compositions (colorplate 71).

The Basque Nestor Basterrechea has also made Constructivist experiments, on the borderline between painting and sculpture, in incrusted bas-reliefs of a sensitized neoplasticism, sometimes animated by calligraphy.

The Escuela de Altamira, El Paso, the Association des Artistes Actuels, the Grupo Parpalló, the Art Actuel de la Méditerranée, and the Grupo 57 have been the most vigorous collective centers of the various aspects of the movement for innovation between 1955 and 1960, promoted essentially by Westerdahl, Saura, Cirici, Cerni, Portolés, and Duart. In addition to these groups, mention should also be made of the effect of the ephemeral Museum of Contemporary Art in Barcelona, which worked very intensively from 1960 to 1963.

Tangentially, we may speak of the isolated work of some representational artists, such as the hieratic primitive Joan Brotat in Catalonia; José Lapayese of Madrid, a composer of flat still lifes, almost in the manner of Ben Nicholson but very rich in material; and the naïve painters Jaime Burguillos of Seville and Rivera Bagur of Majorca.

Recent Sculpture

After the loss of Angel Ferrant, the veteran sculptor of the Madrid center has been the Aragonese Pablo Serrano, whose brutal constructions in violently welded steel have a dramatic feeling in which texture is of great importance

(plate 140). Ramon Lapayese of Madrid works in metal and has developed from an Expressionism in the manner of Lynn Chadwick toward a feeling for the rhythmical textural motif like that of Pomodoro.

The Basque Eduardo Chillida is the most precise and incisive of these practitioners of metallic expression, with a world of pointed forms, resembling the steel implements of peasants, that has austerity and even cruelty in its bareness and violence (plate 141).

Martin Chirino, from the Canary Islands, a protégé of Ferrant, also works in metal. He specializes in linear open forms that define directions in space. Plácido Fleitas, another sculptor from the Canaries, expresses himself in stone pieces that are compact in volume, organic and full in turgescent form, and often pierced through with equally organic holes.

In Valencia is Andreu Alfaro, who works primarily by cutting out and twisting the metal sheet with great formal economy, precision, and perfect industrial finish (plate 142). His problems are at once those of space, neo-Gestalt, and monumental expression of ideas.

The veteran Catalan sculptor is Eudald Serra, who fashions organic forms suggesting those of Miró. The first of the young men who came after him was Josep María Subirachs, who combines an interest in mechanical, structural, and functional problems of pressures and tensions with a romantic love for textures with many imprints and even a dressing of color (plate 143). Moisès Villèlia, who likes to use light materials, such as reed, is an inexhaustibly creative sculptor, who creates objects (often mobiles) entirely without precedent, with highly varied structures that show respect for the material and love of the craft, patience and shrewdnesss. His latest sculptures are made up of machine-worked pieces of wood that can be freely manipulated in an unprescribed manner (plate 144).

Marcel Martí works all the veins of today's problems. Jaume Cubells sands and burns wood to the point of giving it scenically poetic degraded forms that evoke age-old erosions. He also creates hollow forms resembling animal skeletons.

A special place should be reserved among the younger sculptors for Xavier Corberó, who has been working for some time in Informalism, devoting himself especially to incrusted metal reliefs; the incisions, nails, rods, and surface treatment evoke the quality and accidental features of the human body and its most intimate folds. This romantic phase was followed by a rigorous one of amazing technical precision and a very free play of geometric forms, transparent materials, and infinitely varied possibilities of montage, like those he obtains

by the action of intermittent electromagnets on steel balls set between glass surfaces, giving them very lively random movements (plate 145).

Within the Constructivist trend, the most important work continues to be done by Equipo 57, devoted to normative sculpture, with collective work, scientific and technical research, and a willful interpretation of method. Their sculptures in plastic and wire are highly systematized derivations from the work of Antoine Pevsner, Naum Gabo, and Victor Vasarely. Today the group consists of the Andalusian Juan Cuenca, Angel Duart of Extremadura, the Cordovans José Duarte and Juan Serrano, and the Basque Augustín Ibarrola. Related to them is the work of the Castilian Francisco Sobrino (plate 146), one of the founders of the Groupe de Recherche Art Visuel in Paris.

The Rise of the New Realism

The work of the painters whose development lies within Informalism was done in general between 1960 and 1965, but many of these artists went on to join the trend started by young people who first came before the public between the ages of eighteen and twenty-eight, virtually every one of whom is in one of the various currents grouped under the New Realism.

The starting point may be set at 1956, when the painters Tàpies and Cuixart, the sculptor Subirachs, the photographer Domés, and the poet Brossa, in the windows of the Gales store in Barcelona, created an unexpected sculptural world out of scrap iron, a broken-down violin, chairs with the bottoms out, clay figures of saints, an old umbrella, and pictures of Hoovervilles.

In 1960, the Gallots group of Sabadell (including Slepian, Morvay, Duque, Angle, Balsach, Bermúdez, and Borrell), in a public action, working on the sidewalks of public places under the eyes of movie and television cameras, undertook genuine happenings and did paintings by using hens dipped in dyes as living brushes, before the use of women by Yves Klein. In 1963, at the May Salon of the A.A.A. in Barcelona, there were walls with inscriptions by Julián Pacheco (plate 148), not only as images of the poorest neighborhoods but also with a powerful political and social content. At the same salon were the collages of Joaquim Sarriera, the elements of which were his own pictures; and, in the works of Pere Pagès, the use of photography in painting was seen.

In the same year, at Banyoles (near Gerona), a show by Jordi Gimferrer, Antoni Mercader, and the painter and sculptor Lluís Güell presented the use of industrial and fetishistic objects.

At the March Salon of Valencia in 1964 were a number of works belonging to the same movement. Rafael Armengol, Manuel Boix, and Arturo Heras first appeared there. Later there were one-man shows with works combining photographic images with textures, in the manner of Rauschenberg, with elements of assemblage and of boxes containing objects, in the manner of Del Pezzo. Andreu Cillero, a former Expressionist (plate 147), showed collages of industrial objects there, and Alcón used radiography.

A month later, in Barcelona, the Machines group appeared with the enigmatic boxes and windows of Joan Escribà; Antoni Muntades, who coldly incorporates objects of the mechanical world; and the inspired Jordi Galí, who, while working in the direction of the torn posters of Hains or some of Rauschenberg's textures with photos, arrived at a very personal world, extremely lyrical, expert, incisive, with economy of means but rich imagination (colorplate 68).

Albert Porta, with his collages of old sentimental photographs; Manuel Salamanca, with his paintings like the walls of a hovel; Angel Jové of Lerida, with his broken-down and worn-out room walls; and finally Josep Villaubí, with his tragic, even macabre, collages, complete the list of the New Realism of 1964. To it have rallied previously Informalist painters such as Albert Ràfols Casamada, Romà Vallès, and Alfons Mier.

The Prix Granollers given to Jordi Galí in 1964 and the First Medal given to Rafael Solbes at the National Exposition of Alicante in 1965 confirmed the predominance of this new current among the young artists of Catalonia and Valencia, a current that goes beyond purely aesthetic experience in the work of two Valencian painters tending strongly toward social protest: Solbes, a painter of very sarcastic pictures criticizing officials and the wealthy, and Manuel Valdés, who uses Informalism as a mordant for his pointed collages. The work of Carlos Mensa of Barcelona, somewhere between Pop Art and Expressionism, is close to the art of these Valencians.

Solbes and Valdés, with Anzo, Marí, Martí, and Toledo, have created the Estampa Popular group of workers in black and white in Valencia for the purpose, as their theoretician Tomàs Llorens relates, of working for the people, helping them realize their living conditions, and refusing to take the way of evasion, not forgetting, for the sake of imaginary satisfactions, the fight for the construction of a just society.

Outside of Catalonia and Valencia the only figures we can cite in this trend, which often represents an ideological side of Pop Art, are Rafael Canogar, who has given up Informalism for pictures of human alienation in contemporary life;

Antonio Ximenes, whose paintings, incorporating photographs and objects in the manner of Tom Wesselmann, deride the values and ideals of comfort of middle-class life; and Eduardo Sanz of Santander, whose broken mirrors remind us of those of Enrico Baj. Alongside the work of these artists should perhaps go the work of Eduardo Arroyo of Madrid, who paints grotesque pictures of military men, ecclesiastics, toreros, bureaucrats, and bourgeois in a style resembling the naïve pictures at a country fair.

Some young Expressionists have affinities with the work of these painters, such as José Ortega, who expresses himself with violent gestures in a style akin to those of De Kooning and Appel, and Ricardo Zamorano of Valencia, who works in a pre-Informalist style.

In the Estampa Popular movement of central Spain, mention should be made of the epic chiaroscuro work of Agustín Ibarrola, already referred to as a member of Equipo 57; the more graphic production of Francisco Alvarez; and the incisive, mordant style of Manuel Calvo of Asturias.

This trend, whose most important practitioners have been Galí and Solbes, is not the only one at work among the young artists. The Constructivist trend triggered by the Cordova groups is being continued by the present Equipo 57, and has found new practitioners in Calvo, whose pure and often rhythmic researches are like those of Vasarely, and the Catalan Josep Llucià, who creates very pure monochromatic rhythms on metal-coated paper.

The Netherlands

By R. W. D. Oxenaar

At the big general shows, such as the biennials in Venice, São Paulo, and Paris, or the Documenta in Kassel, one keeps seeing how hard it still is for the national to combine with the international. Although art is increasingly, and with great idealism, proclaimed as a universal language, the national dialects have not lost anything of their importance; all too often, in fact, the unknown or alien aspects of the national tends to impede our evaluations. People tend, now perhaps more than ever, to evaluate the pattern of culture in a country by the number of internationally known figures and trends there, even though the "Esperantists" form only the top of the iceberg. This international visibility often does in fact and with justice presuppose a content, operating on the national level below the waterline, that can be good and in some cases better.

A book that tries to give a survey of the situation in many countries is therefore faced with a dilemma in description that becomes all the more inhibiting in small countries where the international waterline is usually high.

What became visible in the Netherlands above the line in the period of modern art can be listed quickly: Van Gogh, Mondrian, and Appel. If we go into more detail, we can add Jongkind, Van Dongen, the De Stijl group, Corneille, Bram van Velde, De Kooning, and perhaps a few figures out of the CoBrA group. All these artists were entirely or partly expatriates; major Netherlanders often felt the need to become citizens of Europe, and now of the world, in order to get an adequate sounding board.

All those named are painters. The Netherlands was never especially a country of sculptors. Perhaps the spatial ordering of the landscape does not produce a compulsive drive to three-dimensional adventure; and the country has little stone and wood, the classic materials of sculpture. The long-established democratic and Puritan attitudes of Hollanders certainly promoted anti-monumental tendencies. After a slow development in the prewar years, how-

ever, sculpture has had an unprecedented flowering in the Netherlands in the last twenty years, and such names as Wessel Couzijn, Carel Visser, Andre Volten, Jaap Mooy, and the Japanese-American Hollander Shinkichi Tajiri have had international resonance.

In the last ten years, the waterline has sunk very satisfactorily, and throughout the visual arts there are more internationally conspicuous Netherlanders than ever before. But it is true that there is as yet no visible peak, no powerful attractive force, in the generation that followed Appel.

The general pattern of the visual arts in the Netherlands, as in the past, follows the major trends abroad, with the customary lag of several years during which we accumulate a stock of theories. Yet typical national impulses are at work internally, nourishing, deepening, and guiding.

Although Van Gogh is still admired, especially by the younger artists, his influence is no longer direct. Nonetheless, he may be mentioned here as a starting point, in that his work is the first and purest embodiment of the synthesis of southern and northern Expressionism that has become a national characteristic of Dutch painting and sculpture. The Netherlander yearns for the south, but his work has a northern ring. The Fauves were admired here, but the German Expressionists had influence.

Between the two rivers of this Expressionism, with an admixture of Cubist water that helped clarify things, the Stijl group remained an isolated element. Mondrian never formed a school in his own country; only in the past few years has there been anything like a solid step in this direction.

Dada and Surrealism never really had a chance here. The revolution of about 1910 was little noticed. What is more, the subtle paradoxes of Dada and the mystical absurdity of Surrealism do not fit Dutch soil. Any watering-down of reality is not well received.

And so the art of the Netherlands between 1920 and 1945 could fall back on, or withdraw into, the national idioms of Expressionism and realism, with its best exponents, still fully valid, Herman Kruyder (1881-1935), who wandered between Beckmann and Macke but also was colored by a lyrically grotesque peasant infatuation, and Charley Toorop (1891-1955), whose veristic urge sometimes brought him close to both the abstract and the surreal. Although the letdown after the war may seem to have been severe and the immediate past appear to have given few points of attachment for a younger generation, there are two figures who clearly bridge over the war years, partly because the prewar work of both only became really known after the war.

H. N. Werkman (1882-1945), the Groningen painter and printmaker who

was shot by the Germans just before the end of the war, was, as a painter, an apparently naïve Expressionist, strongly influenced by the Germans, with traits reminiscent of Nolde and Kirchner. In his drawings, however, which became very popular after the war, Dadaist and Constructivist principles had been developed in a very personal manner since the twenties. The originality of his vision; the power of his compositions, vivid, even monumental, despite their smallness; the strong, primary rhythm, sometimes based on simple repetition, of his form and color; and the use of ready-made material from the type case — all these make his work completely contemporary even today.

The painter Piet Ouborg (1893-1954) matured almost unnoticed during the thirties in the distant cultural solitude of the prewar Dutch East Indies, to become almost the only important Surrealist of the Netherlands. Influences from Ernst, Tanguy, Dali, and Magritte, operating indirectly through literature, gradually led him to a style all his own: impressively realistic in spatial quality and in detail but with a somber shagginess in the presentation of his prehistoric landscapes, often reminiscent of Hieronymus Bosch, inhabited by still lifes of conglomerates of cultural flotsam.

In 1938, Ouborg returned to the Netherlands. During the war, he evolved, to a great extent on the basis of his many years of contact with Oriental culture, into a vivid, spontaneous, freely Expressionistic and entirely abstract painter; his drawings had already at an early date arrived at a purely automatic calligraphy that now brings to mind the work of Henri Michaux.

This describes the change after 1945 to the overwhelming predominance of an abstraction tinged, in its demonstrably continuous course, by Dada, Surrealism, and Expressionism. But the young people of the postwar period did not find their way along these narrow roads. After five years of being out of contact, they looked outward and found support in Picasso, Miró, Klee, and above all in like-minded young artists abroad.

In a still hesitant search, the attempt was made in 1946 to bring the existing progressive forces together by means of some group shows, finally under the name "Vrij Beelden" ("Free Creativity"). In this way a loose assemblage was made of post-Cubism, Surrealist trends, a whiff of the geometrical abstract, and a solid injection of the École de Paris, chiefly Léon Gischia, Maurice Estève, André Marchand, and Alfred Manessier.

A year later, the young artists formed a closer union, and in 1948 Appel, Corneille, and Constant (C. A. Nieuwenhuis) presented themselves as the Experimental Group, joined by Anton Rooskens, Eugène Brands, and Theo Wolvecamp.

Later in the same year, in Paris, at the instigation of Christian Dotremont and Asger Jorn, these Netherlanders formed the international CoBrA group, of which such figures as Pierre Alechinsky, Doucet, Carl Henning Pedersen, and Jean Atlan soon became members. In the years since then, CoBrA has become so well known a part of the history of art that its initial phase need not be gone over once again here.

In 1949, in the second and last number of *Reflex,* the "Journal of the Experimental Group in Holland," Constant wrote:

> The Experimental Group takes the position that improvisation is an essential precondition of vital art, and therefore it rejects any a priori principle of composition. Although our work is not abstract, we refuse to accept imitation, in any sense whatsoever, as in conflict with this improvisational character. Our work is thus like a stream that has no beginning and no end, and leads us through every region of the subconscious, ever revealing to us images hitherto unknown.

This already states all the factors that have now long been consolidated into a principle of style: improvisation as characteristic of vitality; the undogmatic attitude toward the representational or the abstract; the somewhat Surrealist undertone; the intention of seeking out the origin of creative imagination, for which primitive man, children, and animals became the symbols; and the nonconformist urge to action, uninhibited by any tradition, by which attention was called to the ritual of the act of painting and to painting as a matter of paint, of matter.

Even though the Dutch center of this new informal Expressionism was shifted to Paris in 1950 when Appel and Corneille moved there, these principles of style remained extremely fruitful for Holland, so that until almost 1960 CoBrA, as the international contribution of the Netherlands after the war, set the tone for the more strictly local development as well.

The members of CoBrA very soon diverged, each taking his own road to embodiment of the principles the members had formulated in common. In this process, Appel remained the strongest figure of the group and the most typical representative of the new ideals of form and content.

Despite the nature of his talent, which seems more and more to develop in passionate broad treatment, Appel remains a "classical" painter, approaching pure abstraction in a fluctuating process, sometimes interrupted by series of impressive portraits and nudes, yet never surrendering to Action Painting or

material painting. His recent brief flirtation with Pop Art proved to be an aberration from which he soon recovered. The summer divertimento of gigantic tree-trunk sculpture, which has been a frequent aspect of his work in recent years, is attractive mainly through his uninhibited use of a bright polychrome, for which so many "genuine" sculptors can only hesitantly yearn. His work is not so much deep as broadly heroic, vitally effervescent, an exultant glorification of pure painting (colorplate 72). This puts him in the position, for Holland, of the Jan Sluyters of the postwar generation; it also says how deeply he is rooted in the tradition of a Dutch Expressionism despite his international manner.

It is a rejuvenated Expressionism that has found many adherents, especially in Amsterdam, who are gradually taking on clearer forms after the passing of the CoBrA tempest. Such painters as Ger Lataster, Jef Diederen, Pieter Defesche, Jan Sierhuis, Roelof Frankot, Jan Stekelenburg, Pierre van Soest, and Lai Molin evolved from beginnings in moderate representationalism toward a free abstract calligraphy and a strongly emotional use of color. In large works that are still gaining in spaciousness and gesture, Lataster comes closest to pure Action Painting, while Diederen found a style of his own in a monumental rhythm of large flat spots of color, whose constellation retains a suggestion of landscape.

A great surprise after the war was the much older painter Gerrit Benner, who had developed in the quiet solitude of distant Friesland into a very typical Netherlands Expressionist, with figures, cows, and birds in his landscapes. His simple but taut forms, extremely rough treatment of the paint, and unrepressed expressiveness of color have something of the childlike, primitive, and utterly primeval that was felt in the CoBrA climate to be characteristic. In a fertile interaction of influences, he has remained the most indigenous of painters, with a vision entirely his own, despite CoBrA relationships. Another older painter, J. G. Hansen (1899-1960) of Groningen, who belonged to the group around Werkman, acquired an airy, sharp, pithy, improvisational style, with occasional effects related to Action Painting, that give him a special place within this framework.

Wil Bouthoorn of The Hague remained a figure apart in the Expressionist camp. With a strong, introverted temperament and great tenacity, he achieved, in the dangerous no-man's land between representation and abstraction (plate 149), a characteristic form and color of his own, in which the equilibrium behind the contemporary tormented presentation sometimes recalls Franz Marc or the early Kandinsky.

In a wider cultural union, the Experimental Group formed an almost unique merger of ideals with the generation of Dutch poets known as the 5-tigers ("Fiftiers"). Unquestionably the major figure of this group is the poet Lucebert, who as a draftsman belonged to the original Experimental Group but has developed on a broad scale in painting only in the last five years. His work is, after Appel's, the clearest presentation of the CoBrA principles. By virtue of his twofold gift, his work shows more completely than that of anyone else the fantasy world of legend and fairy tale, of humor and drama, of children and kobolds, beasts and birds (colorplate 74), forming a highly individual folklore closely linked with the CoBrA's original image. His work does not have the broad action and robustness of an Appel but in compensation possesses a sensitive refinement of calligraphy and a more introvert color that give ingratiating life to his much more illustrational content. As a draftsman, graphic artist, and painter, and as the author of a number of recent translations, he is one of Holland's most prominent artists on the international scene.

Although this brief survey does not permit consideration of graphic art, mention may be made here of Anton Heyboer, whose remarkable, almost ritual use of words and pictures in his huge color prints evokes, in a very personal idiom, a world related to that of Lucebert.

Corneille has not been drawn into this Expressionist perspective. His work has always tended more in the Klee-Miró direction, and in his later years in Paris he became more and more definitely a French painter, without any direct connection with specifically Dutch tradition. He is Braque to Appel's Picasso, enriching, deepening, and refining a style and set of motifs already discovered. His free landscapelike abstractions, his geologies of sun and moon, in which a complicated but firm and vivid structure of formations is coupled with a gentle, somewhat muted but very richly variegated poetry of color, represent a level of *belle peinture* in the best sense of the phrase and not merely the external meaning: it is a level that is most unusual for a Netherlander (colorplate 76).

This becomes apparent when he is compared with such a figure as Jaap Nanninga, more or less akin in attitude but much more Dutch, who in the years just before his sudden death in 1962 developed into a highly sensitive, stylized, but inwardly taut painter, for the most part making small abstract oils and gouaches, often with landscapelike motifs or moods. Nanninga shares with Corneille, in contrast to Appel, an inclination toward inward-directed poetry, toward something of the nature of chamber music; but the more northern drive of Nanninga departs from the French brightness of Corneille to seek a mystery

in the misty fusing of forms, and his palette is based chiefly on a melancholy consonance of old whites with grayish blues and greens. He remained a solitary figure in the Netherlands, but the only one who in this much more psychic genre was able to conquer a place of his own alongside the Expressionist clamor (colorplate 73). Willem Hussem, an older abstract painter, moves in a frontier region between north and south. In his best work he finds a synthesis between a broadly spatial, direct, tense gesture and a sensitive, refined treatment of color and material, giving rise to a certain relationship with Hans Hartung, likewise involved between north and south.

Although the germs of Action Painting and material painting are already latent in the early work of Appel, he never became a Pollock or a Dubuffet but kept the middle course. Pure Action Painting would be splendidly represented in the Netherlands if De Kooning could still be called a Hollander; but that would be as unrealistic as extraditing the brothers Bram and Geer van Velde, who obviously belong to the School of Paris. Traces of Action Painting are also to be found in Lataster's unbridled movement, in Hussem's macrocalligraphy, and, up to a few years ago, in the explosiveness of Kees van Bohemen.

Since 1963, Van Bohemen has been painting large stirring abstract nudes (plate 150) in a strictly limited, almost Spanish, range of color — white, blue, brown, black, and sometimes a bit of pink — which have made him one of the national and international sensations of recent years, especially because of the very convincing symbiosis of new figuration and abstraction that he has developed.

In the late fifties, Jaap Wagemaker became Holland's best representative of material painting. In scarcely eight years, he has produced a body of work that impressively attests his vision: "I try to have the painting arise out of the material. Differences of materials and surfaces, along with color, are the structural elements in my paintings." Forming his quite old or quite young "landscapes" out of heavy cementlike pastes, usually in earth pigments, he increasingly employs ready-made materials, such as scraps of wood and iron, slate and shells, which, in combination with the suggestion of a desolate vacant space, evoke, almost surrealistically, the atmosphere of an archeological find or, more menacingly, the remains of a culture destroyed in a conflagration (colorplate 75). His highly individual form and content put him quite on the level of such figures as Tàpies, Burri, Millarès, and Dubuffet.

A material painter of entirely different caliber is Bram Bogart, who worked in Paris at first and is now settled in Brussels. After a long preliminary stage

113 Willi Baumeister 1955

114 Theodor Werner 1964

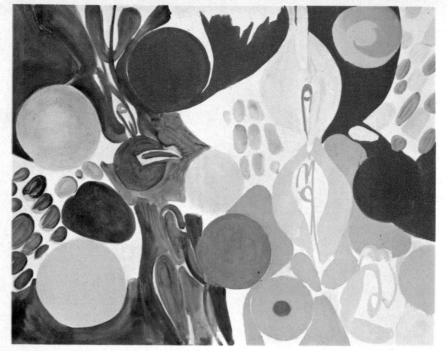

115 Ernst Wilhelm Nay 1965

116 Fritz Winter 1964

117 Max Bill 1964

118 Georg Karl Pfahler 1964

119 Hundertwasser 1960

dolf Hausner 1956

122 Emil Schumacher 1965

121 Bernard Schultze 1965

123 Otto Piene 1963–64

124 Arnold Leissler 1963

125 Rainer Küchenmeister 1963

126 Markus Prachensky 1964–65

127 Walther Stöhrer 1965

128 Horst Antes 1964–65

129 Peter Schubert 1965

130 Friedrich Meckseper 1964

131 Richard Oelze 1960

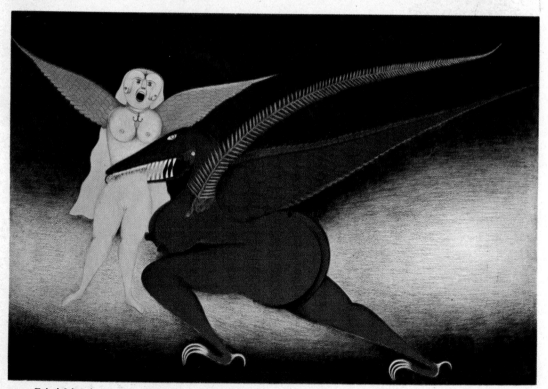

132 Friedrich Schröder-Sonnenstern 1960

in Action Painting and Tachism, he has come lately to a personal rigorous approach to the material principle. The paint is plastered on in gigantic broad, thick, and heavy bands of bright, strongly contrasting colors, as if to make an Informal Mondrian. Here, along with color and structure, an essential role is played by the rhythm of volumes and masses, thereby making the material itself the content, the meaning, of the painting.

The wave of New Realism that has gone out over the world has aroused new interest in the Netherlands in a number of realistic painters who, each in his distinctive way, kept an old tradition alive even through the years of abstraction that were so lean for them.

R. J. Drayer, an older painter from The Hague, evolved very consistently from a prewar magic realism to a bright and luministic but flat, geometrically determined realism, whose choice of subjects often makes it appear to be connected with Pop Art, for instance the work of the American Allan d'Arcangelo.

Co Westerik, a younger man from The Hague, came from a great admiration for the Flemish and Italian primitives to a penetrating, detailed realism, depicting little contingencies of human existence by means of a combination of humor, drama, protest, poetry, and dream (plate 151). He now appears to be a descendant of such English painters as David Hockney and Allen Jones.

Friso ten Holt is one of the few who came to a very individual idiom on the basis of a thoroughgoing Cubism in figure and landscape.

In the younger generation, seeking more direct connection with things abroad, are Aat Verhoog, who combines a biting, in some ways Surrealist, figuration with a more material style of painting, and Joop van Meel and Jan van den Broek, both of whom, in large figurative pieces, attest the deep impression that Francis Bacon has made everywhere in recent years.

The environment of Bacon, and of Graham Sutherland too, is the milieu for the work of Martin Engelman. He has lived in Paris since 1948 and some years ago came out suddenly as a gripping Surrealist, recalling not only Bacon but also Victor Brauner, but creating a world of anguish of his own, in terms of a warm palette, a free style verging on *belle peinture*, and a tempestuous poetic faculty (plate 153).

In the abstract sector as well, the last five years have seen a number of younger artists emerge more clearly as personalities. Jan van Eyk works in Brabant, in the south, on a series of large, solidly built canvases, roughly painted in dark colors. In The Hague, Gerard Verdijk has departed vigorously

from a more or less Tachist past and is now working in a manner whose implication of rapid motion in space (plate 152) sometimes suggests Sonderborg, although by the use of luminous paints he achieves a darting light effect, a color relationship with traffic lights, that borders on Pop Art. Jacqueline de Jong, now working in Paris and editor of the noteworthy magazine *The Situationist Times,* should also be mentioned here, even though by rights she belongs in the Expressionist camp. Joost van Roojen is one of the few younger artists whose work often is hard-edge, although in smaller works he can come to Kleelike, though always geometrical, configurations.

As we have said, geometrical abstraction was never popular in the Netherlands, despite Mondrian. Perhaps the only one still working consistently in this direction is the architect and theoretician Joost Baljeu. Since 1955, he has been designing strictly proportioned wooden constructions in which visual form is given to problems of time and space, on a system that is chiefly reminiscent of the principles of Theo van Doesburg. Baljeu is the founder (1958) and editor of the magazine *Structure.* A younger man who has been attracting attention recently in the same domain is Ad Dekkers.

Pop Art and Op Art, or rather the New Realism and the new tendencies, have few followers in the Netherlands, despite a number of large and sensational international shows. Apparently, the reasons for this are the same as for the limited success of Dada and Surrealism here. The vulgarization of urban culture in Holland, moreover, is not of a nature to give rise easily to a Pop reaction, and, as we have said, playing with realities is seldom well understood here, still less practiced. The New Realist trend in the broadest sense is represented by only a few figures here, most of whom came to it by way of an Informal and/or Tachist past.

Woody van Amen of Rotterdam, who was in the United States in 1961-62, in his bright, intricate, often mobile "Apparatuses" of readymades, gives a show of a kind of Luna Park material, with an internal rational organization that gives it deeper, poignant, and terrifying aspects (plate 154).

The cult of the absurd gains a further symbolic perspective in the dead-pan frauds that Pieter Engels (EPO shows, Engels Products, sales promotions) perpetrates in the guise of repairs to such things as a kitchen chair, a mirror, a screen, or a piece of garden furniture. Here the fantasy is more limited, but there is a Constructivist principle in this work that is highly promising.

Reality is undermined again, in a different way, in the work of Wim T. Schippers, who calls himself "adynamic." The soft and loathsome *Lilac Chair* blown up out of all human proportion, set up for him this summer in Amster-

dam's Vondel Park (plate 156) is spatially and symbolically an ineluctable monument, a throne for a monstrous Ubu Roi that concentrates the crudeness of an entire epoch.

Jan Henderikse, now working in Curaçao, belonged to the Informal Group and the Nul Group and is busy now mainly with more or less serial assemblages (plate 155) in the nature of Fernandez Arman's work. It is characteristic of practically all representatives of Pop and Op that group work, public demonstrations, pamphlets, and other forms of public relations are an essential aspect of their activity.

This has long been true for Engels and Schippers; for Willem de Ridder, the Netherlands representative of the New York Fluxus Group, it is part of a program. By means of concerts, and by means of the products put out by what is called the "European Mail Order House," a literary, musical, and visual attack is made against the false front of reality, on principles that may be described in brief as an embodiment in practice of the ideas of Marcel Duchamp.

Also active in the region of the New Realism and Pop Art are Rik van Bentum, Frank Gribling, R. Lucassen, and Jacob Zekveld.

More realistic than Op, more technical and doctrinal than Pop, the Zero principle moves in the atmosphere of both. In the Netherlands this trend is represented by the small but active Nul Group, including Henk Peeters (plate 157), J. J. Schoonhoven (plate 159), and Armando (plate 158). The group is closely related to the German Zero Group of Otto Piene, Heinz Mack, and Günther Uecker. Their principles, in their own words, involve the creation of "thoughts in common that inspire almost anonymous works." They produce "visual information"; they try to contact the other by means of a "play of visibilities" that is as neutral as possible and allows every freedom. With sculptor Herman de Vries of Arnhem, the group has published the magazine *Nul* since 1961, but in 1965 the magazine merged with the new semiliterary magazine *De Nieuwe Stijl* ("The New Style"), while De Vries publishes the magazine *Integration* by himself.

The only painter operating in the sphere of pure Op Art, and then more or less in the wake of Victor Vasarely, is Peter Struycken (Fig. 1), a young, promising, and very productive painter who starts from the mathematical theory of the relations between form and color and tries to arrive at laws that could form the basis for a kind of prefabrication of imaginative elements.

Sculpture in the Netherlands developed in a different way from painting after the war. Those in the generation of Appel remained involved for a

Fig. 1 Peter Struycken
Natural Movement 1964

longer time in the prewar tradition, which further was much more strongly transmitted by still living older people, such as Raedecker, Krop, and Bronner, as well as by some figures of an intermediate generation: Wezelaar, Esser, Andriessen, and Charlotte van Pallandt.

Supported by the great demand for war monuments, which in general undoubtedly helped sculpture in the Netherlands get on its feet after the war, the tradition of realistic naturalism was able to hold its ground into the fifties.

The breakthrough came in 1950-51 with works, often denounced as designs too extreme for monuments, by Willem Reijers, Carel Kneulman, and Wessel Couzijn. They tried to rise from the statue to the sign, and seek liberation in an abstracting Expressionism that leaves room for open and closed forms, for a dynamic play of space and time, for a magically determined world of the imagination only symbolically related to actuality. Reijers unfortunately died too young, but with his 1946 monument to those shot at Zijpersluis, he remains the first of the younger generation to come to a convincing new vision. By way of a freer Expressionistic period, Kneulman evolved toward a more enclosed structure and an organic form reminiscent of Laurens. Couzijn became artistically the richest and most complete representative of Abstract Expressionism. His work is the embodiment, improvised yet compelled to coagulation, of a dramatic sense of life. For primary dynamics, he is the

sculptural counterpart of Appel. But in Couzijn the cry for freedom is more poignant, the escape from the chains of passion more painful. He does not have Appel's childlike cheerfulness, and his imagination does not bring forth a magical world of fabulous animals but is rather occupied with the abstractions of power and force, of growth and decay in nature. His greatest work is the gigantic bronze *Corporate Entity* (plate 164) for the entrance hall of the Unilever Office Building in Amsterdam, finished in 1962.

Also active in this direction are Ben Guntenaar and Hans Verhulst of Amsterdam; Gust Romijn of Rotterdam, who works mainly in steel; Piet Slegers of Arnhem, who works in rhythmic abstractions; Jan Pieters of Rotterdam; and the playfully fantastic Aart van den IJssel of The Hague. The imaginative world of CoBrA was kept up most clearly, perhaps, in the childlike but aggressive primeval beings of Lotti (van der Gaag); the large steel montages of Jaap Mooy (plate 160), assembled out of scrap iron and readymades, recall this world. Along with Couzijn, Mooy is at the moment one of the best representatives of a language of form, and of a region of the imagination whose choice of subject, vegetationlike, animallike, or anthropomorphically defined signs, and refinements of surface treatment and detail relate to Shinkichi Tajiri. Tajiri's work has been influential in the Netherlands since he settled here in 1956. He is now working on a series of large, strongly erotic male and female symbols (plate 161), one of which could be seen at the last Documenta.

Although it is true, for sculpture as for painting, that the total aspect is still dominated by variations on Expressionism, an important counterbalance has been present in the more Constructivist sector since the middle fifties. Constant, a founder of CoBrA, soon went from painting to sculpture and developed into an original representative of neo-Constructivism. His experiments in space with metal and plexiglass show a relationship to the work of Naum Gabo. After taking part for some years in the movement of the situationists in Paris, he is now totally devoted to his ideal town-planning project of New Babylon (plate 162).

The sculptors Carel Visser and André Volten came, more or less in the tracks of the Stijl Group, to purely Constructivist principles, which they embody mainly in steel. Visser comes, by way of a thoroughgoing, almost Mondrianlike system of horizontal and vertical geometrical volumes (plate 165), an extreme restriction of differences of form, and especially an interest in the serial, to strongly rhythmical compositions that bring him close to some aspects of Op Art. Volten is freer and richer in his motifs, and his work is

directed more toward industry and integration with architecture. However, in him too, in a number of recent very large monumental works, aspects come to the fore that in a way recall Zoltan Kemeny, for example, even though the works are freestanding (plate 163).

Tajiri, Couzijn, Visser, Volten, and Mooy may well be called the most important Netherlands sculptors at present.

New characteristics are already appearing in the youngest generation: the wood reliefs of Mark Brusse, recently polychrome as well, which tend toward the New Realism by virtue of their furniture fragments, mobile and displace-able parts, and use of readymades as junctions (plate 166); the somewhat Arplike experiments in polyester by H. S. Loekenoogen; the loosely inter-locking, smooth, massive forms of Jos Wong; the wood sculptures of Leo de Vries; the many steel sculptures of Ad Molendijk; the bronzes of Cornelius Rogge; and the geometrical forms of Adriaan Engelman. In the figurative sector as well, a new generation has something to say, with such figures as Nic Jonk, Arthur Spronken, and Gooitzen de Jong.

The panorama of the visual arts in the Netherlands is richly varied, more perhaps than ever before. Despite the increasing Europeanization of so many artists and their openness to international currents, a typically Dutch individuality is retained that gives its taste to the work of this country between two rivers.

Scandinavia and Finland

By Pontus K. G. Hultén

Because of their geographical position, the Scandinavian countries are often treated as a unit. This is unfortunate, at least with respect to art history. Scandinavian artists have drawn their inspiration from abroad much more than from each other, and each country has established its own connections with international art. At the same time, the national characteristics are very clearly discernible. This leads us to treat each country separately.

DENMARK

Great earnestness — intense concern with the actual situation, not only in art but in political and human matters in general — marks modern Danish art. At times, this earnestness may seem naïve; at others, it bursts the forms of what can be expressed artistically.

As early as the beginning of the 1930s, the ideas and work of Kandinsky, Klee, Miró, and Picasso had been assimilated in Denmark and had become an independent language in the hands of such painters as Richard Mortensen and Efler Bille. Very expressive pictures, taking Danish folk art as their starting point, were done at the end of the 1930s by Egill Jacobsen. Such gifted and original sculptors as Heerup (plate 169), Tommesen, and Robert Jacobsen came to the fore; painters like Svavar Gudnasson, Carl Henning Pedersen, and Asger Jorn joined the groups of young rebels and pioneers.

This magical-Expressionist pictorial sensibility was further developed after the war. Various artists looked at the existing world and society with freshly critical and probing eyes. They reflected a new spiritual situation. The leading artists in this group found their way to Paris toward the end of the 1940s, and remained more or less permanently settled there. This led to a lively dialogue between Danish art and the international situation in Paris.

The influential CoBrA group was formed by Christian Dotrement, Karel Appel, Constant, Corneille, and Jorn in 1948. Jorn had studied in Paris with Léger and Le Corbusier before the war. During the war, he secretly published a periodical. His strong commitment to existence has taken many forms over the years. In his writings on philosophy and art history he has made an independent and individual fusion of the heritage of Munch, Strindberg, Kierkegaard, and Hans Christian Andersen. He has signed innumerable appeals — against the papacy, against the atom bomb, on different political questions of the day. His art, which includes painting, drawing, ceramics, and textiles, is only a fraction of his omnivorous activity. Jorn is no conspirator, no specialist, but a man who thinks for himself and does not accept any traditional limits to the expression of his personality.

Jorn intends at any cost to cut away the mask of convention and good taste that surrounds our society and to bring to light instead the terrible, passionate world that lies underneath it. His paintings and etchings are a sort of peephole opening on a world where chaotic and fearful forces rule. It is not a question of reverting to representation but of evoking from reality the recognizable symbols that are the vehicles of expression. Jorn's pictorial language, with its grotesque fantastic creations, brings up to date a primeval Nordic tradition of cultist and ritual signs first encountered in rock carvings. In all their chaotic darkness, Jorn's paintings, like his writings, show flashes of a total vision that is both terrible and imposing (colorplate 77).

During the 1930s, Richard Mortensen had an important role as the introducer of international abstract art in Denmark and as one of the founders of the vital Linien group of artists. As early as 1931, he had been impressed by the art of Kandinsky and, with the exception of a short period of Surrealism inspired by Dali and Tanguy, has remained true to geometrical-abstract painting. But it is a geometry with an internal tension. Mortensen handles line masterfully; he is a remarkable colorist; what is essential for him is the thing expressed. With Nordic directness he seeks to combine spontaneous expression with carefully thought-out structure; his aim is to weld thought and imagination into a unity. He moved to Paris after World War II, and his art developed under the influence of the French craving for clear thought and form. In recent years, he has formulated the wealth of his imagination with ever increasing clarity and awareness. His brush draws lines and flying rhythms that build a new and striking jazz. Thanks to his graphic sensitivity, Mortensen has been able to impart an element of spontaneous life, generosity, and freedom into even his most rigorously simple compositions (plate 167).

Mortensen has been in a phase of new development for some time. This is partly a consequence of his temperament, which oscillates between poles of hope and despair, optimism and depression, or, on the artistic plane, Constructivism and continuity against revolt and destructiveness. To some extent, his latest phase contradicts the notion that an artist should create in a single manner. As always, his art is eminently a reflection of the spiritual climate in which he works. More than most, Mortensen tries to communicate in his art. In his latest work he seems to have enlisted among the constructive forces of existence. The nihilist waits with his head averted.

Carl Henning Pedersen has remained within the CoBrA group. He paints a fantastic world of suns, horses, palaces, evil dwarfs, fair princesses, and wan ghosts (plate 171). His color is sometimes flaming in ecstasy, sometimes as glittering as a Nordic winter night, but it can also be refinedly ascetic in gray, black, and white. It is a lyric sort of painting that perhaps best corresponds to the conventional notions of Nordic creativity. Such, too, is the author's profession of faith concerning the sun:

> I seek to seize the flames of fire and get them to flare on my
> rectangular canvas. I seek to burn with fire, to be like the sun —
> I seek to seize the sun and hold it to me when I am painting. And
> I seek to use the sun's rays and get each and every one to fuse in
> my picture. I seek to hold the sun, so that the day will never
> vanish.

Robert Jacobsen's first sculptures, in wood, were abstract. During the war, he created a series of fabulous animals in stone. It was only in Paris after the war, as one of the group centered around the Galerie Denise René, that he found the artistic material that fits him best, iron. In iron he could continue the experiments with space and pierced-through forms that he had begun in stone. Iron gives him the opportunity of combining tension and dynamics with a constructive idea. Iron seems to be the ideal material for him, and seldom have an artist and a material come together so congenially. Iron does not permit any softness, any cheap effects. If it is handled well, its character is integrity and strength. Jacobsen's black welded metal plates have a virility and vitality unrivaled in abstract art. His sculptures are not elegant; they still show traces of the artist's labor, which, with the heaviness of the material, give it tangibility and directness. No perfect harmony is sought; one is always coming across unexpected angles, exciting structures. In these purely abstract

solutions of spatial and planar problems there is an overpowering strength that seems almost magical and is a direct expression of Jacobsen's own nature. In 1966, Jacobsen was given an award at the XXXIII Biennale.

In his "Dolls" series, which for now is a closed chapter, but one which went far to make Jacobsen famous, the artist found a frolicsome outlet for his fantasy and demoniacal emotion. The materials — bicycle wheels, chains, old wrenches — came from dump heaps. They are welded together and colorfully retain their impudence and spontaneity. Jacobsen grasps the unexpected connection, lets the whim assume a monumental form, and welds the moment firmly into these "collage sculptures." Out of the used manufacturers' products he creates a complete organism with a life of its own. The multifarious parts have entered a new unity. Furthermore, the material acquires new qualities in addition to its own when he hollows it, bores holes in it, twists it, combines, breaks up, smooths over, polishes, forges, and welds. No colors are added, but the various treatments give the surface color and caprice. The ensemble becomes a human figure that expresses the entire gamut: joy, complacency, pompousness, haughtiness, and sometimes terror. The sculptures are carica- tures, fetishes, saga kings, and totem poles. They are imbued with infernal jesting. The elegance of the satire lies in its sure touch and strikes one like a hammer blow (plate 170).

Albert Mertz has not only an etymological connection with Schwitters (inventor of Merz). Like him, he has worked in many media: films, mobiles, photocollage, photograms, painting, and linoleum cuts. At the same time, he is a contemporary representative of the tradition in Danish art that was marked by Eckersberg and Lundström. He selects out of actuality the bits he puts together with shocking effect. His environment is lower-middle-class Copenhagen, and he combines themes from it — beer-truck drivers, station masters with their whistless — into a unity in which there reigns a frightening stillness (plate 168), like that of De Chirico's street scenes. Terror prevails in the midst of the idyl. Toward the middle fifties, when Mertz was working chiefly with linoleum cuts, everything in his world, including people, was reduced to signs and hieroglyphics. His color became dry and chilly. But, with brighter colors, life, fantasy, and poetry enter his pictures, which begin to move in new rhythms. His drawing carries its suggestiveness further and becomes magical. After a period of Expressionistic experiment, in which his pictorial world stiffened, the earthy-animal element reasserted itself, under a universal star of eternity and crystalline clarity. But something has changed. Line and space perspective are heavily laden with menace and terror. Hands

are raised as warning signals of sudden dread. Mertz says that his pictures act as signboards; they are not lacking in definition. In contemporary Danish art Mertz has a place apart, suspicious of avant-gardism, at the same time attracted by the New Realism. He may be called the first Pop Artist in Danish art, but above all he is the administrator of his own inheritance of suggestion and magic.

NORWAY

Norwegian art was for a long time confined, as it were, by its peaks, overshadowed by such portents as Munch and Vigeland. Orientation in this direction had been strong since the days of the Fresco Group. As early as the 1930s, Norway had produced monumental social art, whose heroes were fishermen, farmers, workers, and spiritual leaders. It was only with considerable difficulty that Norwegian artists succeeded in freeing themselves from this tradition.

Large monumental projects have continued to be of importance. The City Hall and Government Building in Oslo are examples.

In later years, the artistic situation in Norway has changed essentially. The social call to action has been carried out and has died away. For today's artists the task is to vindicate the individual against collectivity and standardization. The nationalism — the attitude of reserve toward international influences — that has long marked Norwegian art is beginning to slacken, although there is nothing to parallel the lively communication that has existed between, for example, Danish art and Paris since the war. To the extent that Norwegian art has sought points of connection abroad, it was to German Expressionism. It is significant that the German immigrant Rolf Nesch settled in Norway in 1933. Around him some young Norwegian painters formed an experimental group that sought to expand the expressive possibilities of art by working with new materials.

Nesch began with drawings but went over to graphics, working directly on the plate. He introduced extraneous materials on metal, stone, glass, and wood, etc., combining them into a kind of mosaic. These he called "material pictures." His Norwegian colleagues Olav Strömme and Sigurd Winge experiment with plaster and cement, which they carve and paint. While going further and further away from actuality in design, form, and color, they come closer and closer to actuality in the materials.

Among the artists who continued the traditions of the 1930s, a non-figurative school grew up after the war. The paintings of Gunnar S. Gundersen, one of the founders of the Taerningen ("Cube") group in 1956, contain fragments of recognizable objects, but the ensemble is abstract. The result is painting of great clarity and purity, with pure colors and forms, logically thought through and strongly rhythmical. Something of the same ideal is present in Odd Tandberg. Like Gundersen, he has been much in demand for projects of spatial decoration (plate 172). For example, in the new Govern-

ment Building in Oslo he has decorated a number of wall panels in sand-blasted concrete, with colored cement mixed with natural stone.

Also abstract and nonliterary are Ludvig Eikaas's decorations. In a factory staircase, he allows the architecture of the staircase to echo in the decoration, forming a variation on the theme of the staircase itself. In recent years, however, he has exhibited a kind of return to representation. He now practices an "abstract Impressionism" in which fragments of actuality are resolved into their pictorial elements and then combined, with color predominating.

Inger Sitter and Carl Nesjar began as realists, with tight drawing and composition and Spartan coloring. The motifs that they made their own in these works — heavy rocky islands against the calm surface of the sea, the pale play of color among the sea spray, the white snow and the black rock masses, or the closed blocks of houses in the city contrasting with the treetops in the air — are still present in their latest paintings, but as the mood, character, and ground tone for abstract painting. Inger Sitter, who studied with André Lhote, cooperated in decorating the Government Building and later also became interested in collage (plate 174). She is also active in graphics.

In the course of long stays abroad, and in collaboration with Picasso, among others, and the Swedish artist Siri Derkert, Nesjar worked out a new material, sandblasted concrete, which opens new and rich perspectives for decorative projects. It is a new way of looking at the problem of decorative art; the decoration rises to a level with the architectural (plate 173). Nesjar has also worked with experimental photographs and films, including abstract photographs with natural forms. His paintings and concrete reliefs are characterized by powerful spiritual articulation and great imagination.

Knut Rumohr, best known for his drawings, creates an abstract Expressionism that leaves conscious life in the background to allow uncontrolled emotional impulses to guide his creativity.

Jacob Weidemann — who represented Norway in the XXXIII Biennale in Venice, 1966 — has expressed himself abstractly at some times and naturalistically at others. His gouaches and watercolors attest a lyrical feeling for nature and a musical feeling for color that seem to be a congenial expression of his personality. The same quality is also reflected in his work in large forms, from oil paintings to such decorative projects as the murals in the Hydro Building in Oslo. Nature continues to inspire him; his pictures are abstract recompositions of the most palpable sense impressions — not specifically Norwegian, but intimate experiences af autumn forests, moss, rock, bark, heather, and pine. The heavy impasto of his oils has an element of the romantic, some-

thing corresponding to the variegated coloration of the scene in nature that he is representing. In this work he carries on an old tradition in Norwegian art, that of the naturalists of the 1880s und the neo-Romantics of the 1890s, even though his form of expression is entirely different (colorplate 78).

Arnald Haukeland worked for a long time in the sculptural tradition of Maillol and Bourdelle. His free-standing statues and other monuments (at Sandvika, for instance) are marked by powerful plastic form in which robust strength is overdimensioned. A trip to Greece in 1960 brought him into contact with the world of classic beauty and entailed on his part an almost painful settling of accounts with his previous way of seeing. He realized that the classic ideal had its limitations in time and space. When he went on to the Venice Biennale the same year, he was confronted, almost to the point of shock, with contemporary international art. During the months that followed, he feverishly created sculptures that could be regarded as a sample card of almost all the modern styles. This crisis signified the final liberation of his own style. Whereas he had previously allowed the setting, the architecture, to determine his sculpture, his work is now more independent. In order to give his idea as clear a form as possible, his latest sculptures develop large convex and concave metal plates. Smooth curves meet in sharp edges, knife-sharp arcs cut through space. These sculptures breathe movement, tension, and dissonance (plate 175). Haukeland is continuing his experimentation with greater openness and security.

SWEDEN

Whereas in Finland the decorative arts and architecture dominate visual art, in Sweden the visual arts dominate. Sweden's artistic life is very active; foreign influences are received and stimulate the nation's painting and sculpture, which in turn inspire architecture and the decorative arts.

The postwar period brought a revolution in the artistic life of Sweden. Stimulated by the radical new signs of the times, the young generation of artists began to develop seriously into nonrepresentational constructive experiments. Sculptor Arne Jones and painter Lennart Rodhe, with other leading Concretists, continue to play an important role as artists and as teachers in the Stockholm Academy of Art. Olle Baertling, the most uncompromising of the Concretists, carried the heritage of Mondrian and Malevich further, with great consistency, in rigorous geometrical compositions of brilliant color.

Dominant in Swedish art, however, is a romantic, lyrical Expressionism whose basic theses have changed little in the last thirty to forty years. Lage Lindell has a place apart, in a way within this tradition and in a way quite independent. His starting point was Cubism and the abstract art of the period between the two world wars. His first paintings, done in 1947, represented figures on a stage, children playing on the beach, *commedia-dell'arte* motifs in stylized Cubist manner. But like others of his generation, Rodhe and Olofsson, he much later began a nonfigurative art that has expressiveness, feeling, and fullness of fancy. A new starting point for him was formed by landscape — the island landscape of Ven and the park landscape at Haga outside Stockholm. There he found his elements of form, often oval and curvilinear. The landscape of Gotland was a further stimulus to his imagination, inspiring him to a darker and more dramatic painting. At the beginning of the sixties, his work culminated in clear, concise black-and-white compositions, with powerful forms. They are abstract but lead the spectator to interpret into them tragic and comic figures in vigorous actions. By means of these figure fragments we experience a world view of great complexity and powerful tensions (plate 177).

Torsten Renqvist's first exhibition was interpreted as a protest against the abstract art of the forties. The conclusion was hasty. Renqvist has been affected by different influences from most Swedish artists. He has lived in Denmark and England for long periods. The conceptual world of Palmer, Blake, Sutherland, and Nash has meant a great deal to him. His drawings represent everyday things, preferably those that are worn, scrapped, dilapi-

dated: second-hand radios, withered leaves. Charged with energy and aggressiveness, they become symbols of freedom and independence. A trip to the Lofoten Islands in 1955 brought about a change in Renqvist's themes. There he encountered a desolate, stern, cold landscape that inspired him to pictures of bare grandeur. But this flight from civilization to solitude and the void does not mean that the artist's commitment in his time has diminished. The Hungarian catastrophe gave rise to a series of graphic works, impressions of conflict and chaos.

Renqvist's art has always had two sides, one oriented toward the daylight, the other toward night and darkness. But in his latest works he seems to be looking inward and finding himself. He has found a new world of themes in the region around the Enare marsh in Finland. This river landscape of mist and vapor enables him to express his visions of loneliness, desolation, and silence, of death and rebirth (plate 178).

During the last decade, attention has been drawn to some young artists not belonging to any special group and not having any program in common. They are interested in international art in a way previously unknown in Sweden. In a way, this new art constitutes a return to Expressionism. Man and his condition are central once again.

Torsten Andersson, now a young professor at the Academy of Art, comes from the country in southern Sweden. His art combines a strong feeling for nature, acquired in his youth, with strong structure, powerful and committed, of a kind that has been rare in Sweden since 1910. Earnest, humorless, he came to the capital in the 1950s and became acquainted with the art of Vasarely and Dewasne, and regarded his task as being to master their international formal language. It was a strict and necessary schooling, against which the artist gradually revolted. His gods, birds, and springs are powerful expressions of solitude, seeking, and despair. In his last phase we see a greatly changed kind of painting. The fear and anxiety of his childhood find expression, but the artist is prepared to leave this sort of romanticism and return to actuality. In a stately sequence of pictures he looks in a new way at the landscape of his childhood in Skåne. His very latest work, shown at the Venice Biennale in 1964, seems to lead in another direction, once more regarding man in fear and isolation. Many of his latest works are three-dimensional constructions of wood and cloth (colorplate 79).

Fundamental traits of Andersson's artistic personality are his honesty and his dread of stagnating. When he has solidly reached a position, he is already prepared to go beyond it. As an artist he moves between loneliness and

community, between feeling and intellect, between formal rigor and individual sensibility. The remarkable thing is that both trends are present in his work at the same time. Carl Fredrik Hill, the Swedish artist, and Fernand Léger have influenced him most. Thus his nature and his art unite brutality and tenderness, love and terror, intuition and intellect. He says of his paintings: "My pictures, at their best, express a defiant objectivity: they weep silently."

Öyvind Fahlström and Carl Fredrik Reuterswärd have points in common; both express themselves in post-Surrealist symbols, both are fascinated by signs and letters, and both are poets and writers as well as artists. But they are also very different. With almost manic persistence Fahlström performs the task he has set himself. He moves in a world of his own which he develops out of himself, and into which his paintings come more or less by chance. He devotes endless labor to them. Each sign, form, and symbol is placed with the precision of a scientist. Form and color are put down in mutual connection; the relations have exact significance, and the artist explains them in extensive commentaries. They are as exact, impenetrable, and incomprehensible to the uninitiated as an article on atomic physics.

In recent years, Fahlström has lived in New York for long periods and been influenced by American Pop Art and its brutal and vulgar comic-strip-inspired forms. He has applied this style in India inks that simulate a collage of thousands of bits from newspaper pictures. They are broken up and then reproduced on canvas — a job that is said to take months (colorplate 80). Apparently Fahlström is attracted also by the uncompromising moralism of the Pop world.

A striking mixture of pictorial, literary, and mythological elements distinguish Fahlström's art. He engages the media of modern science, politics and journalism in his art and employs them in his most recent work, as for example in *Dr. Schweitzer's Last Mission*. Segments of this picture hang free in space and, as in some of his earlier two-dimensional pictures, may be fastened to each other with magnets. Painting has abandoned its place on the wall and becomes also theater, a game, and psycho-drama. This work when exhibited at the XXXIII Biennale aroused immense interest from the public as well as the art critics.

Reuterswärd is a master in arranging short circuits and setting intellectual traps. Painting is only one facet of his talent. He also writes poetry, creates happenings, and designs theater décor. He aims at giving a critical picture of the times, standing things on their heads. His critical commentary is not negative; he wants to use these absurdities to attain an affirmation. This is

the case when he cuts up the word list of the Swedish Academy and bakes a loaf out of the ground-up bits. Reuterswärd gives an answer in everything he does. Sometimes with a malicious smile, often elegantly and tenderly ironic, he comments on the upper-middle-class environment he comes from and the artist's world he lives in. With his disrespectful caprices and unexpected turns, he achieves what he aims at: the spectator feels shocked and troubled yet realizes that there is a meaning in what seems most meaningless. Reuterswärd's elegance and poetical instinct never betray him. His paintings tend more and more toward calligraphy; his color is clear and metallic, sometimes sparkling like precious stones (colorplate 81).

During the past few years he has withdrawn from public life so that he might deepen and develop his artistic vision and self-critical acumen. However, in 1965 he was appointed a professor at the Royal Swedish Academy of Art, the youngest man ever to have been named to such a post. During the same year he also completed his most ambitious project to date: the settings for the opera *Herr von Hancken.*

Martin Holmgren's revolt is of a different kind. In his field, sculpture, he looks for a counterpart to the new French novels of Butor and Robbe-Grillet. For him the world is not full of symbols, nor is it absurd. It *is,* and just for that account deserves our interest.

Holmgren's first work was representational: ballet subjects that showed a strong interest in movement. Later he developed a formal language that was starker, and more powerful. A trip to France in 1952 gave him many themes that show man in terror and confusion but also in revolt: acrobats, motorcyclists, and toreadors are some of his heroes. After returning to Sweden, he sought to maintain contact with France. His commitment to his time is strong. The flood in Holland, the Hungarian catastrophe, inspired him to protesting commentaries. He uses the idioms he found in France to examine and to present in an ever new naked light man and his situation in a dynamic world (plate 179).

Elis Eriksson too began as a representational sculptor, but after experimenting with more conventional abstraction worked his way through to a highly personal form of sculptural expression. He made reliefs with powerfully rough-hewn and painted pieces of wood that had the same freshness as driftwood. In 1962 he introduced a type of collage, painstakingly worked boxes with all sorts of instructions, indications, and so forth, designed to send the spectator in all directions (plate 176). These wood sculptures were all written over with the obscenities of everyday life, a colorful language of which

Eriksson is a past master. The wood is now supplemented with new material — plaster and tinfoil for instance — but these latest creations show the same fresh sponteneity in the choice of idiom and give a picture of an artist who is fascinated by the capacity of words and material for autonomous expression. His directness is as irresistible as Pollock's; his works are not visions but the products of painstaking labor. They are born in cooperation with the material, within — and outside of — the framework of its possibilities. Eriksson's technical skill, rich imagination, and impudent freedom from restraint give him every opportunity to express his powerful artistic personality.

Per Olof Ultvedt began at the Academy of Art in 1945 as a painter. His way to sculpture led through drawings and films. In 1958, he built his first great wooden mechanism, the first in a series of "animated mobiles." Movement, or rather movements, driven by one or more motors, is the element that holds the sculpture together and gives it a unique personality. Since 1958, Ultvedt has made a large number of these mechanisms, which have been seen in Stockholm galleries, at exhibitions of kinetic art in the Stedelijk Museum in Amsterdam and the Moderna Museet in Stockholm, at the Venice Biennale, and elsewhere. Ultvedt also works with various kinds of labyrinths. All these labyrinths, puzzles, and such inveigle the spectator into a quest in which he must invest energy but is rewarded with surprises.

Ultvedt did his most carefully worked-out piece in 1964, in collaboration with the art critic Ulf Linde. It was *The Face of a Newspaper,* commissioned for the anniversary of a large daily paper. In this "moving collage" the two artists in various ways individualized the machines and apparatuses that are used to put out a newspaper, such as cameras, printing presses, teleprinters, and typewriters. Each lived its own life: voices called vainly into the telephone, pop music played when the keys of the typewriter were pressed, intricate assemblages of letters were made and wiped out. At the same time, the pieces of the powerful collage — vigorously painted in black and white — made a living picture of *The Face of a Newspaper.*

In spring, 1965 (plate 180), the powerfully dimensioned *Hommage à Christoffer Polhem,* was shown in an outdoor sculpture exhibition in Amsterdam's Vondel Park. His latest work, *Hon* ("She"), a giant sculpture of a woman, was made in collaboration with Niki de Saint-Phalle and Jean Tinguely in 1966. Ultvedt has animated the interior of this work with several kinetic sculptures, such as *The Man in the TV Chair, The Broken Clavicle,* etc.

Ultvedt is now working on several monumental tasks; among them a curtain for the Swedish Pavilion at the world's fair in Montreal in 1967.

FINLAND

In Finland, too, national Romanticism had a strong hold on art for a long time; this is readily understandable if we think of the country's political background. Sibelius's compositions had their counterpart in Aksel Gallén-Kallela's illustrations for the Finnish national epic, *Kalevala*. Helene Schjerf-beck and Ellen Therleff were the first representatives of abstract art, while their contemporaries Tyko Sallinen and Marcus Collin devoted themselves to a social, realistic art.

Finnish architecture and decorative arts developed with a far greater freedom and independence and from the international point of view dominate the artistic scene in Finland. The first to begin to free themselves from the dominance of national Romanticism and Expressionism was a devoted group of a few Concretists after World War II. A breakthrough on a broad front came only toward the end of the 1950s, when Finnish artists began to make contact with international art trends. Above all they turned to Italy, which is also one of the principal countries in European industrial design. These Informalists were greeted like a breath of fresh air in an art climate that had been confined and stagnant. There was, however, a lurking danger. These free formal experiments sometimes produced results that were all too easily obtained. The forms had no accurate backing; the game remained all too superficial.

In 1961, an exposition of contemporary French, Spanish, and Italian art was held in Helsinki: Art 1961 Helsinki. It not only showed that Informalism had reached the general public but also brought about a new orientation and strengthening of Finnish art. Much of the superficial aspect fell away or was rethought. Some artists, who had not considered Informalism their natural means of expression, ventured on new ways. Those who remained inside Informalism carried on with greater intensity and commitment. In this way Art 1961 Helsinki signified a consolidation and a new starting point for Finnish art. Without forming a unified group, many of the new artists got together and exhibited under the name of "Martians."

The new young generation, those still in their mid-thirties, won their first recognition toward the end of the 1950s. It is significant that this should have happened to painters Esko Tirronen and Ahti Lavonen and sculptors Kain Tapper and Laila Pullinen in connection with their entries at the Venice Biennale. With the same intensity, originality, and determination as the Finnish designers, these young sculptors seek to find something new. They do unflag-

ging explorations of materials and techniques. But the earlier, strictly nonrepresentational sculptures were followed by a new figurative tendency with a very natural feeling. Older art, and especially the Baroque, seems to have been a source of inspiration.

Tapper, with a background of training in industrial design, has won the greatest international renown with his forceful integrity. His bas-relief for an altar (plate 181) was the first abstract work to find a place in a church in Finland, where church architecture had been radical to an extreme. Harry Kirijärvi handles stone with remarkable sensitivity and imaginative power. Pullinen experiments with combinations of unusual materials — bronze and black granite, bronze and ebony, marble — in her sculptures of actors, authors, and angels (plate 183). Tirronen is another leading representative of Finnish Abstract Expressionism. Lavonen's painting, with its lyrical serenity, shows another aspect of the Finnish national character (plate 182).

Belgium

By Jean Dypréau

If the appearance of new trends in contemporary painting, and especially the vogue of Pop Art since 1962, has dictated a revision of the judgments of criticism as to the influence of certain Dadaist or Surrealist painters, it is chiefly Marcel Duchamp and our countryman René Magritte who have gained well-earned notoriety from these changes in orientation.

Magritte's situation in the present context is rather paradoxical. Whereas Duchamp likes to see the restored interest in him and the admiration he receives from the younger generation, Magritte is reluctant to accept the laurels, which he regards as suspect, and says he is ready to file suit for disavowal of paternity.

Magritte's work arouses enthusiasm and followers not only in England and America (where Jim Dine and James Rosenquist claim kinship with him) but also in Germany (where Klapheck, with a respectful sense of humor, reverses the procedure) and even in France, for so long inhospitable to his work (despite the fact that André Breton has found in it "mystery in full daylight," adding that it had supported the movement since 1929). If we honor Magritte here, it is not only because he is so much in the limelight today but because in recent years he has continued increasingly to enrich the Surrealist universe with an innumerable series of images that restore to us, with increased efficacy, a "description of inspired thought," as he says, that will make possible "the advent of visible poetry" (colorplate 82).

The actions of this painter may be described, as Breton puts it, as "nonautomatic" and "fully thought out"; the work of Paul Delvaux, on the other hand, shows no compunction regarding the unconscious and dreams. The painter accepts being "possessed" by the eagerly denuded creatures that haunt his pictures; he takes part in these ceremonies of night lights (lamps, moons, braziers); he means to be a witness of these promenades on the outskirts of the city (even where one begins to have doubts as to the time and place of our life), to witness the farewells and returns, to overhear the tender Sapphic dialogues.

Here the railroad stations set disconcerting intineraries before us; shadows grow out of a light from the north; unquiet cities recall the great disorders of universal consciousness.

These two major painters lacked recognition on the international scene for a long time and even in their own country have only recently received the position they were entitled to. However, by 1945, (which will serve as our starting point for a brief survey of our painting and sculpture down to 1960), they had already established themselves as great masters, in full possession of their vocabulary, aware of their originality and the breadth of their creative power.

But Surrealism fell out of fashion after the war. The long break from 1940 to 1945 favored the return to that form of abstraction of which Mondrian and Malevich had been the protagonists thirty years earlier. Perhaps the ruin and disorder that the war produced led artists to lose interest in the concrete representation of a world whose cruelty and absurdity offended their sensibility. Geometric abstraction allowed them to assert their desire for a discipline of the spirit, for an architectural order, while prolonging the ascetic spirit that events had imposed on them.

The abstract purism whose catechism was to be laid down by Degand was intransigently defended by the Art Abstrait group, whose leader may be said to have been Jo Delahaut. He was the first, after a short Expressionist period, to formulate, in an optical system apparently close to that of Auguste Herbin but actually more intellectualized, the first propositions of the second abstract generation.

On the other hand, it is hard to find a common denominator among the members of the group that called itself Jeune Peinture Belge and appeared in Belgium as early as 1945 and abroad in 1946. Its objective seems to have been to promote a certain orientation toward abstraction without anathematizing representation, so long as it was liberated from imagery and anecdotes. Rik Slabbinck, a painter who was to remain faithful to that kind of representation, was a member of the initial group. The members of the group had different, sometimes contrary, temperaments, and although for a short period some of them were under the dominance of the School of Paris in general and Jean Bazaine in particular, they soon departed from it and strove to assert the originality of their national temperament.

Before World War I, that temperament had flowered, chiefly in Flanders, in Expressionism. James Ensor, the infant prodigy of Expressionism, soon invented a script of such freedom that it foreshadowed abstract lyricism; and a

transposition of his demons and masks is to be found in most of the painters of the CoBrA group that was to be clothed with such authority by the young Pierre Alechinsky. Constant Permeke, too, had given Expressionism a freedom of script that put it on the road to abstraction. Brusselmans had tried (sometimes successfully) to reconcile his lyricism with formal demands that were close to geometry. Fritz Van den Berge had adapted the Surrealist universe to his own expressive needs. Gustave de Smedt had brought a naïve and joyfully bold accent to the movement.

It can be said that Expressionism in Flanders and Surrealism in the Walloon country soon put an end to the inclinations toward abstraction of such artists as Victor Servranckx, Georges Vantongerloo, Jozef Peeters, Paul Joostens (plate 184), Pierre-Louis Flouquet, Félix De Boeck, Karel Maes, Joseph Lacasse, Marthe Donas, Jean-Jacques Gaillard, and Closon, only a few of whom can claim a body of truly and continually abstract work.

After 1954, the Expressionist tradition was to find new ferment in abstract lyricism and a representationalism so freely elaborated that it permits the spectator to take a double view, deformation of the human figure or transposition of the landscape. Lyric abstraction was to try to break the virtual monopoly of geometrical art, forcing it to make efforts at renewal, at least two of which led to the sprouting of new groups: that of movement and that of optical researches.

Returning to 1945 and the first manifestations of the Jeune Peinture Belge, its leaders may be listed as Louis Van Lint, Anne Bonnet, Marc Mendelson, and Gaston Bertrand. Other painters, like Antoine Mortier, took part in some of their activities but were soon to go their own ways, to the point of no longer having anything in common with the initial group. As we have said, the group did not lay claim to any well-defined doctrine. These painters were at first figurative but soon underwent the decisive shock of an important exposition, Jeune Peinture Française, at the Palais des Arts in Brussels, 1947.

Van Lint can boast of a body of work that is patiently elaborated and at the same time explores, sometimes as a pathfinder, the various domains of abstraction, especially, since 1949, the trend that, halfway from representation, was to take the name "CoBrA." Anne Bonnet, who died too young, left us a homogeneous body of work of an intimate poetry and an assured technical mastery. Mendelson unhesitatingly shows the variety of his vocabulary, which ranges from a highly constructed art to Matterism, and his ability to adapt to the requirements of architecture. Bertrand already had asserted his originality in his extremely uncluttered portraits, which were followed by rigorous compositions

that are humanized by sensibility and tenderness. His spaces lead to serene meditation and to a masterfully guided voyage in the realm of the imaginary.

Among those who, while taking part in some activities of the group, soon chose solitary paths are Luc Peire, who has settled in France and there continues a body of work that makes its effects by geometrical parallelism; Jan Cox, professor at Boston University, whom we shall discuss again at the end of this essay in order to show his contribution to the new metamorphoses of Surrealism; and, above all, Antoine Mortier, the most genuine temperament of his generation.

Mortier is the worthy successor of our great Expressionists. He is unafraid of the representational universe, in which virtually all his compositions find their expressive power and emotional solidity. He has a feeling for large-scale architectonics, violent chiaroscuro, and soberly dramatic scripts, but also for the most subtle of poetry, tender effusions of matter, and the exciting meeting of two colors. Before or at the same time as the American Franz Kline, he gave Abstract Expressionism its most convincing image (plate 197).

The Art Abstrait group was founded only in 1952, but, as we have said, most of its members at that moment had a body of work in the process of full evolution. We have mentioned Jo Delahaut, whose first abstract canvas was painted in 1945. Jan Burssens (who was soon to go in the direction of Expressionism), Pol Bury (who gave up easel painting in 1952 to work out his mobile planes), Carrey, Jean Milo, Collignon, Plomteux, Jean Rets, and Jan Saverys have considerable pictorial experience behind them. In 1954, Bury, Delahaut, Elno, and the critic Séaux published a manifesto titled *Spatialism,* the main interest of which lies in that it already contains some of the premises for the imperatives that today are those of what are called visual-research groups, and even of those who have given a new meaning to objects:

> Forms should be freed, be animated, and be registered in every material. Movement in its diversity and in all its applications should give the work of art a new energy.
> The frontiers between major and minor arts are meaningless. Objects can be real substrates of plastic expression just as much as a painting or a piece of sculpture can.
> *Spatialism* makes use of all the discoveries of science and industry, and from them derives new sources of inspiration. . . .

It is hard to draw a precise boundary between the art that has been described as constructed and the art to which, often arbitrarily, the names "Informalism,"

"Tachism," "Action Painting," and "art of the sign" have been given. It is true nonetheless that about 1955 a change took place that had been prepared by precursors and that deprived Constructivist art not only of what had been at first a veritable monopoly but also of its popularity with art lovers. The new generation asserts its faith in lyric abstraction and proclaims the benefits of a liberation of form.

Despite its confused nature, CoBrA had already suggested what the resources of a new Expressionism could be. But it was only with the first productions, in 1955, of a modest art center, Taptoe, that the full scope of the movement could be realized. In it, alongside Jorn and Bay, Maurice de Wyckaert, Serge Vandercam, Hugo Claus, and the sculptors Reinhoud and Roel D'Haese showed us works of seductive violence.

Vandercam came late to painting, but his first steps were tremendous. He had tried surprising abstract experiments in photography, but discovered with a sort of frenzy the ways and means that pictorial creation offered him. His first canvases sometimes make us think of a volcanic eruption of many-colored lavas, but also of secret anatomies. Then came his "blue period": the night becomes peopled with forms that evoke an Orient that is not at all literary, a Turkey that leaves Pierre Loti in his Golden Horn and takes up the rude, raucous clamor of Cappadocia, the war dances, the telluric architecture, the stony uncertain roads. Little by little, the landscape possesses him; tender pinks and unexpected greens make him teeter in the imaginary.

Then the plant world seems to rule his actions; naturally, instinctively, the signs become images; branches intertwine; tree trunks rise up out of which an unexpected springtime sprouts suddenly. His script likewise evokes the high plateaus of the Ardennes, the arid, desert, strange mossy hollows, with their twisted bushes of mingled mist and nightmare.

Finally, a trip to Denmark leads him to discover the Tollund man (an ancient Dane found preserved in a peat bog), in whom the painter sees the martyred defendant who in turn accuses his torturer, an inhuman, criminal society. Vandercam's work becomes more and more somber, his vision more tragic. Mortally wounded beings try desperately to keep their human appearance. Then the painter feels a need to search the wound, which he evokes by crushing multiple superposed sheets of paper, a new technique that he is still exploring. That is the point he has reached today, but his felicity in expression may coincide tomorrow with a new felicity in life (plate 188).

Classically trained, an admirer of Matisse, Cézanne, and Braque, whose rhythms he began by transposing into a highly elaborate abstraction, but one

that sometimes had its own invention and freedom, Englebert Van Anderlecht found his true path in an Expressionism that was very close to that of Vandercam in spirit but very different in technique.

More resolutely Informal than Vandercam, less concerned with keeping contact with reality, he gives us, in a hundred canvases that might be compared to pages of a newspaper, blazing images, dramatic in their brevity, whose perfection is equal to their tragic lucidity, the sign of a man who had already felt the breath of death: cries of revolt, brief excesses of the happiness of forgetfulness, and sometimes, welling up, a pantheism at once modern and archaic. Here the painter identifies himself with his action, embodies himself in a sign, loses and finds himself in his effort.

Such is the drama that they evoke, but often the joy of life, the desire to live are so strong, so sharp, that we retain only their brilliant necessity, their iridescent aspect of precious stones, their play of light, their many-colored flames, and all their imaginable flowerings. We even forget the technical invention, the sureness of hand that shows the living memory of the school exercises from which this symphony sprang, unfinished but irreplaceable (colorplate 86).

Fifteen years ago, Pol Mara invited us to a new embarkation for Cythera. The creatures that we rediscovered there, those men and women with lunar faces, those familiar fabulous horses, those birds in search of an amorous fowler, seemed to be inventing a landscape. They banished us from a daily anecdotal reality before going on to abstract themselves in the projection of their forms. Thus, subtly and insensibly, the painter carried us away in his colored whirls, forcing us to lose our footing. Ten years later, the Greek orders imposed new structures again on Mara. The verticality of the columns, the architecture of the temples, the geography of the isthmuses disciplined our view while a demanding light selected its colors and accentuated the contrasts (colorplate 85).

In recent years, still another metamorphosis has occurred, which we shall discuss in making an inventory of the latest news. Virtually the same thing happened to Drybergh, Burssens, and Bert de Leeuw, who all went from lyric abstraction to what must be called a new or post-abstract representation, despite the anathemas launched by many critics against these terms. Alain Robbe-Grillet likes to say, when people talk to him about the "new novel," that novels worth the name have always been new. The same thing could be said of representation. From this point of view, certainly, the representationalism of Cézanne or Matisse would likewise have to be called new. Perhaps the phrase "post-abstract representation" may be the least objectionable one to describe a representation that has profited by nonrepresentational experiments and techniques.

Maurice Wyckaert was one of the first to become aware of this. As early as 1959, he clearly showed his intention of renouncing all the imperatives of abstractionism so as to enrich the landscape with his violent chromatic oppositions (colorplate 83). In the process he proved himself to be one of our most gifted colorists. Jan Burssens, the Ghent painter, started from geometrical abstraction and soon gave free rein to a lyricism under the control of secure craftsmanship (plate 187).

The painting of Roger Dudant, standing apart from Expressionism, has always been true to the representationalist world, but his sobriety, formal rigor, his concern in sacrificing the anecdote to the state of mind, and graphic virtuosity endow him with incontestable modernity. The industrial landscape of the Walloon country has found in him the voice of its harsh poetry.

Bert de Leeuw put before us another aspect of lyrical abstraction, one that created a new word, "Matterism." One of the founders of a short-lived but extremely active group, Hessenhuis 58, he won attention and a prize at the First Biennial of Young Painting in Paris. He too in recent reliefs inhabited with imprints and petrified human forms has shown his intention of rallying to a new realism (plate 191).

J. M. Londot, of Namur, is a Matterist too, and although abstract compositions can be seen in his painting, they very often suggest blast furnaces and what we should call, with Jean Dubuffet, "texturologies." Guy Mees with his laces and André Bogart with his spindles show us that it is only a step from Matterism to the assemblage art that in the last few years has furthered the revival of relief.

Here we must mention a painter born at Delft but living in Belgium and a participant for years in what a Swiss curator has called the "new Flemish experiments." Bram Bogart started as a figurative painter inspired by the vigorous compositions of Constant Permeke. While still very young, be went through just about a complete cycle of abstract experiments and finally, in 1953, discovered the subject matter that was to permit him an absolutely original form of expression. But it would be unfair to regard him as a pioneer only from this point of view. As early as 1948, he had painted a series of canvases in which signs were of decisive importance. Few painters of his generation have had his ability to introduce continual variations into his explorations while remaining true to a style and script that are always the faithful reflection of a temperament and a sensibility. In him the greatest possible freedom of action is always joined with a profound need for order and rigor, the worthy climax of which today are his enormous solar blazons. He also makes us realize what

abstraction has to gain by taking root in the textures of reality and elemental rhythms (colorplate 84).

René Guiette and Marc Mendelson likewise have used Matterism to revive their inspiration.

Geometric abstraction has not been swept away by the flood of lyrical abstraction and the revival of representationalism. Many artists have stubbornly continued to do their work, sometimes seeking new ways that could reconcile their needs for experimentation and for rigorous forms. Guy Vanden-branden is an exemplary case of this uncompromising attitude, joining to fidelity to a discipline a will to renewal, especially by way of relief and bringing out the value of the object. The geometrical revival seems to tempt Mark Verstockt and Richard Lucas as well. Dan Van Severen tries, by means of monochrome variations, to convert us to a meditational painting that is close in spirit to Rothko's work but is tied to the almost obsessional image of the Cross. Jef Verheyen should perhaps be regarded as the best-known representative of monochrome painting, however, and of what some have called "magism." His originality and poetic power cannot be denied.

At the recent San Marino Biennale, Argan was the spirited defender of the visual-research groups and won the prize jury over to his point of view. The first two prizes went to the Zero group of Dusseldorf and the N group of Milan. There are no research groups in Belgium, but there are some isolated artists who did not wait for the success of Op Art in America to go ahead with what may be considered a metamorphosis of geometrical abstraction: Wybrand, Ganzevoort, and especially Leblanc embody this tendency with indisputable authority.

Pol Bury, whose work is on the planes of both visual research and movement, has won an international reputation by long and patient research conducted with an inexhaustible inventiveness, a sense of humor, a rare manual dexterity, and a sensibility that was uncomfortable with geometrical austerity.

Before leaving painting, we must take a look at those in our country who have made use of the advertising techniques made popular by Pop Art or have tried, like Rauschenberg with his "combine-paintings," to incorporate ordinary objects into their canvases and to recall the permanence of a school of painting that is Surrealist in spirit; and it is time, too, to mention some artists who have found international recognition in the School of Paris.

In the last few years, Pol Mara, whose abstract experiments we mentioned above, has incorporated human figures taken from advertisements, magazines, and movies into his canvases and silkscreen paintings.

The images of Hugo Claus and the "objects" of Marcel Broothaers likewise meet the needs of a new popular art, from which the manner of Marcel Maeyer, despite its unaccustomed character, is not too far removed.

The procedures of Roger Raveel are perhaps even more unusual. When he incorporates various objects, even a pigeon or hen, in flesh, feathers, and bones, into a painting, his aim is to establish a direct, immediate bond between painting and the world around us. Whereas some American painters have sought to increase the strangeness of their painting by adding objects to it, Raveel is trying to convert us by poetical evidence (plate 189).

The paintings of Octave Landuyt and Jan Cox are related to Surrealism, at least in their sources, even if both painters are too much in the service of internal requirements to conform to any orthodoxy. Landuyt's anguish often goes beyond the individual level to rise to the social plane and let us see what "images" the destructive madness of men could reduce us to (plate 195). Technical perfection and refinement of the material make this body of work still more tragically effective. Cox's work leads us to the delights of the imaginary, to the concretization of myths, or to that explication of man that a portrait can be (plate 196).

Around Jacques Lacomblez, whose talent matured early, there have gathered some painters and sculptors who do not wish to depart from a Surrealist discipline. Two of them, Remo Martini and Kamiel Van Breedam, successfully practice assemblage.

For some years, Mesens, a writer of the Surrealist group, has been doing exercises in assemblage and collage. Recently his friends have realized that what they took for a brilliant pastime had become works of astonishing plastic success, impressive for humor and poetry (plate 185). It is to be expected that Mesens will soon have the position he deserves.

Many Belgian artists have won a worldwide reputation in the School of Paris. If we have not analyzed their work here, it is because they must be listed in a different chapter. It will be useful, however, to recall that Henri Michaux, one of the greatest contemporary poets, it also one of the boldest prospectors in the plastic realm. Pierre Alechinsky (plate 186) has had his name alongside those of Asger Jorn, Karel Appel, and Corneille in many international expositions. Raoul Ubac has given slate its patent of nobility. There are also Willy Anthoons, whom we shall mention first in this brief survey of our sculpture, and Reinhoud, who has only recently settled in France, but whose position there is already enviable.

But it is no longer necessary for our artists to expatriate themselves to win

international recognition. Roel D'Haese, who has only left the suburbs of Brussels to settle near the North Sea, has seen his name cited alongside those of the greatest sculptors of his generation.

When his *Prodigal Son* was shown at the Salon de Mai in 1960, I predicted that it would take on the status of a symbol. I believe that if the terms "New Realism" or "post-abstract representationalism" have any meaning, it must relate to this deformation, to this disfigurement that is a refiguring. It should likewise be kept in mind that while D'Haese was running the risk of a return to representation, he was regarded by all the critics as an Informalist who was fully the master of his equipment.

After the techniques of forged steel and lost-wax casting, he wanted to try wood, which he mastered with the same ease. It is the same love of risks and difficulties that recently made him do an astonishing equestrian statue, *Le Chant de Mal* ("The Song of Evil"). D'Haese is also a draftsman whose virtuosity equals his inventiveness. Like his senior, Lismonde, he finds in this technique a major means of expression (plate 190).

Pierre Caille has been able to use ceramics to give free rein to a sometimes unbridled imagination but also to a feeling for the unusual and mysterious that gives his work a very personal accent. The ceramics of Carmen Dionyse and Olivier Strebelle are also related to sculpture. Recently Strebelle has taken to the lost-wax technique.

While Franz Lamberechts explores the resources of polyester, Marcel Arnould uses varied materials to enrich the magic of his threatening forms. Jacques Moeschal's researches are oriented toward the unity of sculpture and architecture that tomorrow's cities will embody. Among those who work in stone and respect the purity of forms are André Willequet, Jan Dries, and Gérard Holmens.

Without giving a complete list, we have tried to give some points of orientation, some instances of the diversity of temperaments and tendencies. Among the youngest sculptors we must cite Jean-Paul Laenen, Koenraad, and Félix Roulin, whose maturity is now beyond question.

To the renewal of relief I have mentioned are linked three names whose prestige has been confirmed by recent international shows: Pol Bury, Vic Gentils, and Paul Van Hoeydonck. Their procedures are most dissimilar and their only common denominator is quality and originality. Moreover, it would be unfair to limit their contribution to relief alone: each has gone firmly and with perfect ease into sculpture itself.

We do not have time here to mark the stages that separate Bury's "Multiplanes" from his "Punctuations," and the latter from his most recent sculp-

tures. His "Punctuations" still give us a spectacle; his "Entities" invite us to meditation. The sculptor has created, if not movement giving the illusion of immobility, at least an equivocal movement that seems to question itself. He compels us to associate movement with duration. His erectable, retractable, or vibratory rods seem to answer the deep needs of an organism. Their growth or "wilting" seems to contradict the mechanism that makes them move. In him humor is more than a ritual game of the spirit; it is a means of fathoming mystery, or at least of becoming its accomplice (plate 193).

It would be unfair to consider Van Hoeydonck's work only in its latest spectacular developments. It should be remembered that his plexiglass reliefs were already akin to the works of visual research: they entrapped light in order better to entrap our view. Today, therefore, every stage of his evolution takes on unsuspected significance. With him we always feel that we are on the heels of the future (plate 192).

As for Gentils, he seems to have brought the art of assemblage to its highest refinement and complete efficacy. And if the word "magic" had not been sullied by so many impotent sorcerers, that is the word we should use to describe Gentils' power of giving life to the inanimate (plate 194).

Japan

By Yoshiaki Tono

Several years ago, when the Swiss sculptor Jean Tinguely came to Tokyo to hold a one-man show, he started to work on a huge piece of construction — provisionally called "Tradition-Destroying Machine" — which he never completed. He had conceived the idea before he came to Japan: a huge "rococo-like" structure — an assemblage of wheels from discarded scooters and other broken-down machine parts, vibrating and generating tremendous noise — that would crush traditional earthen teapots at the rate of several a minute. These bits of "tradition" scattered on the floor would be swept up by a contemplative old man — like the *okina* (old man) in the traditional *no* play. The finished work was to have been his *Homage to Tokyo,* equivalent to his *Homage to New York.*

After experimenting with a number of sketches, and searching for machine parts and teapots, he realized that his idea was outdated and abandoned the huge work. On one of the sketches he wrote: *"Tokyo: l'idée fixe, ratée — remâchée — de travers. Genre 1914-18."* And in an interview he said: "The Tokyo I had in mind was the Japan of tradition. But as soon as I arrived, I saw that to make a machine destroy traditional teapots was an outdated symbolism. It has no bearing on any of the problems of today's Japan. It belongs in a past from which the Japanese have freed themselves. I want to produce a work that is concerned with the *future* of Japan."

Without doubt, Tinguely was correct. When I was in France, I often heard people use the phrase "as far away as Japan" or, ironically, "Distance creates mystery." We are amused to find that many foreigners still see our mysterious ex-Empire as a museum in which Fujiyama, *ukiyo-e* (old woodcuts), stone gardens, calligraphy, and Zen Buddhism (shall we add transistor radios and electric-eye cameras?) are beautifully displayed. Frankly, we feel as perplexed and overwhelmed as children who are made to listen to stories about the deeds of their great-grandfathers. But we, the Japanese of today, are not the blear-eyed, bowing custodians of that old, mythical museum.

Foreign visitors are often disappointed when they see Japanese contemporary paintings, because they are no different from those found in New York or Paris. The visitors' thirst for the exotic is quenched only when they come across some calligraphy-like works of the softly colored and hazily formed abstract paintings that are dim and indistinct as the dusk on a sleepy spring day. Such Japonesque painting, however, whether produced consciously or not, is a kind of retrogressive art, grown under glass, an attempt to carry over into the present the remnants of a past that should have died out completely. It could be called an affectation of colorless descendants who have buried their own personalities under the legacy and legend of a mighty grandfather.

Among those tourists in search of the past, Tinguely was one of the few who discover the real Tokyo, the great metropolis with a population of ten million, full of frenzy and clamor, and he decided to be "concerned with the *future* of Japan." It should be obvious that tradition is not the object of a treasure hunt, to be dug out of the sands of the past. Tradition must be in our blood, an integral part of each of us.

After the Meiji Restoration in 1868, Japanese society had to catch up rapidly — in less than a hundred years — with what the West had accomplished in five centuries. Consequently, the art of this country has sometimes been called transplanted art or colonial art. The artists of Japan had to learn and to assimilate European modernism as quickly as possible, first Impressionism, Cézanne, Van Gogh, then Fauvism, Cubism, Matisse, Picasso, Futurism, Dada, Surrealism, and Constructivism. The only exceptions are probably Yasuo Kuniyoshi, who added a bit of Oriental finesse to the American scene, and Tsugouhara Foujita, who became a member of the School of Paris. Hardly had Japanese modernists started to make various styles of their own when the storm of World War II burst upon the seedling of modern art with explosive fury.

A fortunate few refugees like Kenzo Okada and Koumi Sugai were probably the first Japanese artists to become known in the West after the war. Both had left a still chaotic Japan (Okada in 1950, Sugai in 1952) for New York and Paris, respectively, where they distinguished themselves. It is interesting to note that, in foreign lands, they began to reveal the poetry of Japan in their art. The works of Sugai are full of exquisite images of Oriental fables or hieroglyphic characters that were made, with tenacious yet pliant will, to look like abstract forms. Even in his recent works, which are much simpler and more abstract, it is easy to feel the sense of Oriental humor

with its gentle smile. In the works of Okada, the traditional "ready-made" images — the roof of a shrine, a fan, a stone garden — appear vaguely, like hazy scenes seen through a heavy mist.

Among other artists living in Europe and the United States, Yozo Hamaguchi, Key Sato, Hisao Domoto, Toshimitsu Imai, Akira Kito, Josaku Maeda (plate 199), Yase Tabuchi (Paris), Minoru Kawabata, Gen Inokuma (New York), Kenjiro Azuma, and Nobuya Abe (Italy) should be mentioned.

Let us turn to the artists who live and work in Japan today. It took the modern Japanese artists at least ten years after the end of World War II to become familiar with all the new international movements. During the first half of the 1950s, the influence of European existentialism was very strong. This was reflected in a hybrid of Surrealism and Social Realism that we called the School of Grotesque Art. In search of freedom and equality, in opposition to the many official artists' associations where the jury and guild system rules, but eager to show their works, the young artists started around 1949 to exhibit in two independent exhibitions: the Yomiuri Indépendent and the Nihon Indépendent. The School of Grotesque Art came to the fore during the early years of these two exhibitions. The Yomiuri Indépendent, especially, became a center for young artists; the Nihon Indépendent has always been tied to left-wing propaganda. Grotesque Art grew out of an extreme social situation. After defeat in a war that had destroyed all existing values and conditions, despair, confusion, and distrust were everywhere. In this nihilistic atmosphere, artists like Masao Tsuruoka, Taro Okamoto, and Jiro Oyamada — followed by the younger artists Bushiro Mohri, Kojin Toneyama, and Tatsuo Ikeda (Fig. 2) — expressed their wrath and hollow laughter by populating their canvases with a zoo of grotesque and fantastic creatures. One of the youngest painters of this school, On Kawara, made his debut around 1952, at the age of twenty, with his fantastic works *Events in Storage, Yellow Race,* and *Bathroom* (plate 198), which made him the first important art figure of the new postwar generation.

In his works one seems to see the aftermath of a murder committed in a locked room, with distorted corpses writhing in a curiously warped spatial setting. This vision, however, is not a merely literal reflection of confusion or despair for the human state. It is, rather, his expression of the human figure as a castoff ruined object found among the postwar ruins.

Kawara's drawings and canvases seem to shine with an inspiration that transforms human beings into inanimate flotsam. They echo the triumphant song of the phoenix that rose from the ashes of Hiroshima. His later works

are an experimental series: "Original Printed Paintings," in a technique by which he was able to transfer an original painting numerous times but with variations in each printing (a method and concept similar to Jean Fautrier's "Originaux Multiples" series).

In 1958, Kawara went to Mexico, where he made a study of the local architecture. Since then, he has divided his time between New York and Paris.

In the first half of the 1950s, another movement was started in Osaka. Some twenty young artists gathered around the prewar vanguard painter Jiro Yoshihara and formed the Gutai Group. During the first years, they staged happenings, outdoors or on a stage, to demonstrate that art can spring from chaos and chance. They had not lost their sense of innocent "fun." Atsuko Tanaka draped innumerable pieces of pink and yellow cloth in a pine forest near the sea and let them flutter in the wind like big banners. Sadamasa Motonaga hung vinyl bags filled with liquids in many bright colors from a ceiling so that they shone like a cluster of giant drops suspended in mid-air. Kazuo Shiraga mixed clay with water, then jumped into it, leaving traces of his action in the mud. Saburo Murakami used a large piece of gold foil as a wall and hurled himself through it, leaving the jagged mark of a man's figure. Another example was a white vinyl cloth spread out in a forest for about a hundred years to collect footprints. These experiments, which at first seem Dadaist, liberated Japanese art from the narrow conventions of two-dimensional painting. Dramatizing spontaneous encounters between human actions and objects in simple settings, they were symbolic of growth and death in nature. Needless to say, this anti-art-like movement did not last long. But when Michel Tapié, the originator of the term "Art Informel," came to Japan in 1957, he praised the group highly. When he undertook to support them in the international market, the artists of the group began to return to two-dimensional painting, an ironical development.

Two outstanding members of the Gutai Group, Tanaka and Motonaga, deserve further discussion. After her already mentioned display of colored cloth in the forest, Miss Tanaka hung bells throughout an exhibition hall and made them ring one after another. Another time, she decorated panels and stage costumes, as well as huge dolls, with wildly blinking, extravagantly colored electric bulbs. In 1958, she started to work on canvas, painting circles with brilliantly colored enamel paints. The groups or circles, which gave the impression of dancers in movement, were inspired by the preliminary sketches she had made for her arrangements of electric bulbs. These paintings emanate a pure lyricism, filled with a deep and delicate sensibility (colorplate 87).

They call to mind the concept of a *mandala,* which the sages of the ancient Orient saw in the universe.

By pouring a fluid enamel paint and letting it drip wildly all over his canvas, Motonaga creates richly colored shapes that look like nuclear clouds. Their explosive spontaneity seems to break man's fixed vision, though Motonaga's ambiguous images remain at the threshold of reality. His fluid forms, charged with bright colors and explosive laughter, recall the art of the Momoyama period (plate 200).

The exhibition International Art Today, sponsored by Japan's biggest newspaper, *Asahi Shimbun,* and held in Tokyo in a department store in 1956, gave Japanese artists the first chance since the war to have direct contact with the international world. (In a way, this big exhibition can be compared to New York's Armory Show of 1913.) Jean Fautrier's "Otages" and Dubuffet's "Corps de Dames" series and Wols's paintings seemed to share with the

Fig. 2
Tatsuo Ikeda
b. 1934 in Manchuria,
China. Lives in
New York
Size Is Size. 1963.
Etching. 14 x 13"

Japanese artists the impact of the supreme tragedy of Hiroshima. In the Action Painting of Pollock and De Kooning, an intense anti-European attitude seemed to be even more significant than their introspective self-expression. The Japanese artists shared the conviction that the orderliness and harmony of the happy prewar European modernism had been destroyed forever, and that painting had been reduced to the bare essentials; the very existence of human beings was in question.

The first pioneers of postwar abstract painting were artists like Takeo Yamaguchi, Yoshishige Saito, and Toshinobu Onosato — all born between 1900 and 1910. Before the war, they had been influenced by European modernism, but the experience of war and of the postwar period had profoundly changed their outlook. As their new, individual styles matured in the second half of the 1950s, Japanese abstract painting achieved a new status.

Yamaguchi, whose prewar years had passed under the influence of Zadkine and Léger in Paris, began to paint rigid forms that look like simplified Japanese characters. He plasters plywood boards with mustard-yellow or black paint, using a big palette knife, giving his work a vast spaciouness reminiscent of the monotonous open spaces of continental China, where he had spent the war years. More recently, he has simplified color and form to triangles and squares, and his paintings appear at first glance to be merely layers upon layers of paint (plate 204). His work resembles the crude yet powerful prayer of a farmer — a farmer who loves to till the soil.

Since his first one-man show at the Tokyo Gallery in 1958, Saito has become the most prominent figure in Japanese abstract art. His international fame has been increased by many prizes, among them the Grand Prix at the Tokyo Biennale, the prize of the Association International des Critiques d'Art, and the International Painting Prize at the São Paulo Biennale. He has also attracted attention at the Venice Biennale and the Carnegie International Exhibition. Saito has made contemporary Japanese art internationally known. He became first known around 1956 with his "Oni" ("Demon") series, which used illusory images of ancient Japanese demons. In recent years, however, his works are almost pure abstractions. He rarely uses canvas but prefers plywood, working on it with an electric drill that leaves scars of lines and dots, which he fills in with monochrome blue, red, green, or yellow paint. He dislikes canvas and brushes because they make the expression of emotion appear too easy and too smooth. The plywood board offers strong resistance, which he conquers by engraving his forms with the drill in a zigzag manner, like lightning flashing in the dark. Although a mysterious emotion shows

through the entanglement of sensitive color and graffiti-like lines and dots, one must not overlook the dislike of easygoing self-expression that lies behind it (colorplate 89). Saito states: "Determination and chance, love and hostility are overlapped on both surfaces of the plywood board; in a moment they become frozen and petrified I am the recorder of the dead to whom I had given life."

The lines of the drill that go out of control reveal the voice of the "other," which destroys Saito's conventional ego. In the 1930s, Saito painted trashy images, such as street posters and kettles à la Pop Art, and constructed mobiles that look like pinball machines. These antipictorial works were, of course, completely ignored at the time. Today, this antipictorial attitude still dominates even his pictorial expression. And his most recent works, which are Constructivist, prove how he hates to repeat himself. Once again, Saito has begun to let down his admirers by abandoning a style they had grown used to.

Another pioneer of abstract painting, Toshinobu Onosato, is obsessed with circles. He returned home in 1949 after five years as a prisoner of war in Siberia. For a time, his work forcefully expressed emotion through Expressionism. The circular forms began to appear in 1955. At first, he arranged freehand circles in irregular patterns, but gradually he developed a unique style wherein precise geometric circles are divided by tiny mosaic squares (colorplate 91). The feverish human emotion was gradually eliminated. Like the mosaic artists of old, he repeats nonindividualistic circles and squares. "By repeating the same thing every day," Onosato says, "I discover how much I change every day." Thus he buries his ego in a sumptuous sham of anonymous forms and primary colors. "Here, time is arrested into a rare crystallization The artist's involvement with pulsating life has been suspended and frozen into a single pose and attitude. Effortlessly, the scene chants a serene and tranquil melody," wrote the critic Shuzo Takiguchi in the catalogue for Onosato's show at the Miami Gallery in 1962.

A group of much younger artists, born in the 1930s or later, is rightly called the postwar generation because it saw the war with the innocent eyes of children. An urban designer, born in 1931, wrote in his diary: "During the war, I ran and played under the incendiary bombs with the naïveté of a child." An artist, born in 1935, wrote: "I was a grammar-school boy during the war. For me, the empty cages of the zoo were a cheerful playground; the bits of broken bottles and burned machines in the ruins of Tokyo were my toys. The incendiary bombs looked like beautiful fireworks that left me in

a state of ecstasy." This generation grew up on the burnt and destroyed land. It did not feel the destruction and death of the established values as a tragedy. Its *tabula rasa* was created by lightning that flashed for an instant over Hiroshima. The members of this generation are optimists in that they do not consider any form of destruction a tragedy but rather a starting point, a rebirth. At the same time, they are nihilists because they do not believe that any established order can be permanent.

In the Yomiuri Indépendent Exhibition of 1958, another group of young artists initiated a movement called Neo-Dada Organizers (no connection with the Neo-Dada movement in New York) by advocating a kind of junk art and demonstrations of destructive actions. The halls of the exhibition looked like junkyards full of broken beer bottles, discarded cars, old shoes, rusty cans, pieces of old wood and bamboo, and automobile scraps. All this brought back the smell of the smoke over Tokyo fifteen years earlier. These artists, whose first toys had been melted glass bottles found in the debris after the fires, discarded canvas and oil paint as materials for the conventional expression of beauty; all this broken junk was a much more direct and natural material for the expression of their emotions. One could sense an immediate and forceful feeling for the objects from ruins. Despite the apparent similarity, this is entirely different from the *papiers collés* of the Cubists or the collages and ready-made objects of the Dadaists and Surrealists in Europe and America, whose aim was to discover new materials for aesthetic uses. The urban designer Arata Isozaki, at the time advocate of this movement and later an outstanding student of Kenzo Tange, who is the originator of the daring concept of the "Invisible City," wrote: "The ruins are the symbol of our future city; the future city *is* ruins. Our present-day city lives for a short time, emanates energy, and again turns into ruins."

The Neo-Dada Organizers, like all such movements, died quickly because of its intense and explosive nature. A few of its members survived the movement and set out on a lonely path. One of the outstanding figures is Shusaku Arakawa. In 1960, he started to produce odd-looking sculptures, made of wads of cotton hardened with cement, which he enclosed in coffinlike boxes. These sculptures, which looked like mummies, shocked the audience because they were ferocious materializations of the sickened unconscious mind of contemporary man. After inflicting this intense shock on the Japanese public, Arakawa left for New York in 1961, where he continues to work. In his latest work, a series called "Diagrams," he has turned to a two-dimensional medium. He places everyday objects — such as combs, egg beaters, coat hangers, gloves,

and umbrellas — on a canvas and blows paint on them with an airbrush. This leaves the silhouettes of the objects on the canvas — fixed shadows of prosaic objects, like a reflection of their existence in the four-dimensional world. Although one can see the influence of Marcel Duchamp's *Tu m'*, Arawaka, with the penetrating eyes of the dead, makes a phantom of the outer world. His shadows of objects force us to think of the silhouette of a human body stained on the marble wall of a bank in Hiroshima by the flash of the atom bomb (colorplate 90).

Another important member of the Neo-Dada Organizers is Tomio Miki. In 1962, he began a series of ears made of aluminum pieces. The ears, which range from lifesize to one that is approximately 6 feet high and weighs 490 pounds, are reminiscent of Hieronymus Bosch's colossal ear tortured by the music of hell in his *Garden of Delights*, or the detached ears of Miminashi Hoichi, the Buddhist lute player who performed for the amusement of the ghosts of samurai, who finally tore off his ears when he refused to play for them any more. Miki's ears, which suggest human profiles, seem to refuse sound, to reject the easygoing communication of today, and stand rigidly as metaphysical "objects" (plate 201).

If Arawaka and Miki can be considered artists of detachment and death, other members of the post-Hiroshima generation still manage to maintain a sense of humor. Shijiro Okamoto's sharp line and vivid colors suggest abstract cartoons (plate 202), while Mokuma Kikuhata builds brightly colored targets and roulette wheels out of wood or cast-metal objects (colorplate 88). Yukihisa Isobe (plate 203), a chic *enfant terrible* of the Japanese art world, piles up wooden boxes that can be rearranged at the spectator's will. Some of the boxes contain beautiful children's toys, and sometimes the lids, which can be opened, are decorated with huge silkscreen reproductions of paintings by such old masters as Korin and Sotatsu.

Other independent young artists of the post-Hiroshima generation are Keiji Usami (plate 206), who has a fine sense of spatial tension and minute color differentiation; Mitsuo Kano (plate 205), once a gifted etcher, who makes exquisite zinc reliefs derived from the plates for the etchings; and Masuo Ikeda, another outstanding etcher, who engraves his copperplates with lonely, desperate, yet humorous human figures.

With the appearance of the younger generation, contemporary Japanese art has begun to take a unique place in the international art world. These young artists are shattering the image of the Orient that has existed among Westerners since Marco Polo.

237

South American Art Today

By Jorge Romero Brest

It might be supposed that the originality of the art of South America today is derived from the relationship to the natural environment in which the people live, to the patterns of action that circumstances impose on them, or to the ideas, feelings, and desires that arise in the community; but there is nothing to justify such a supposition, at least in categorical terms. Nature was discovered unseasonably, with a borrowed perspective, and plays a minor role; the patterns of action are not differentiated enough to interest artists, or are stereotyped when they are differentiated; and neither the ideas nor the feelings and desires have deep roots in reality. Would the originality then spring from relationship to the past? We learn from the past that forms have always varied because of primarily political influences that operate in waves of opposite directions and superpose, thereby preventing integration into a line of evolution. As a result, each epoch found its own art, and the art of today depends very little on that of yesterday. This does not mean that there is a similar disparity between the forms of the various regions, as might have been expected in a huge underpopulated continent with poor communications; on the contrary, it imposes unity, even in mistakes; it is as if common origin had assured a common destiny.

There is no doubt that the conquistadors began a superposition of cultures in a state of clumsy ignorance of the indigenous forms of expression, trying to get the Indians to imitate the forms of the conquerors' homelands, Spain and Portugal. But also the hybrid nature of the forms of this kind that they introduced, and others that were accepted later, led to a second- or third-hand European art that was incapable of any fecund action on minds in this distant region of the world. And since all these countries had been kept in a wretched state of political, economic, and social underdevelopment, who could engage in art except the minorities of Europeans and Europeanizing Americans? How were they to discover the well of existence with the poor instruments at their disposal? Even today, it is only a few young men in the big cities who are

barely beginning to perceive this well, without the artists of the other cities being able to profit by that experience, because of the narrow conditions of provincial life.

Nonetheless, I think it is of value to indicate the historical strata to which the forms belong whose perpetuation has been sought in our century, originating the ideas that give life to the American tradition.

First, the thousand-year-old culture of the Incas, the center of which was Peru, with ramifications as far as Ecuador and Colombia in one direction and Bolivia and northeast Argentina in the other. There were also the less important centers founded by the Guarani Indians in Paraguay and the Argentine province of Misiones, the Araucanians in Southern Chile, and the unidentified inhabitants of Easter Island. From these are derived the forms that some people take as models, relying on the undoubted fact that they are of historical value but neglecting the equally undoubted fact that they are alien to us. As for the African Negroes introduced into Brazil, the influence has been less harmful in every way, although it too had its victims.

Then came the colonial culture in the Baroque mode, Portuguese in Brazil and Spanish in the other countries, producing paintings, stucco figures, carvings in wood and stone, and furniture, made by the Indians with incredible skill, assimilating the message of Jesus as if to think that this was the right road to awaken them. Although urged to create by copying European prints, they did not act freely, and the first possibility of inherent expression failed. Is this understood by those who are acting today to bring these forms into life? They are unwilling even to realize that oblivion has covered them for more than a century.

Finally came the naturalistic and romantic folklore culture of the nineteenth century, which produced a maximum of disorientation in creativity, not only because of the existential poverty of the contents but also because the forms corresponded to the way of seeing things of the Europeans — French, German, English, Italian — who initiated artistic activity in South America, in wide-eyed surprise at the colonial reality and adapting to it the forms they had learned in their own countries. It was thus a vision of the picturesque, which the natives accepted for want of artistic experience and which they later practiced, studying at the same academies as the Europeans; but it was far from the unique vision that was imagined then and for so long.

From all of this we can see that if a false note is heard in South American art since the conquest, it is because over these four centuries the obstacles to creation grew and became more diverse, and the inferiority complex was

formed that prevented the most gifted artists from doing major work. Is there freedom of action now? Has the complex disappeared? Undoubtedly the situation is changing; a freer spirit prevailed at the Second American Biennial of Art in Cordoba, Argentina, in 1964; but the old ideas persist, often covertly, and the new ideas are not always received with discretion and responsibility.

The life that continued with a slow rhythm in each country after independence did not favor the flowering of modern art at the turn of the present century. Although there were solid painters and sculptors who followed the officially authorized bourgeois line of expression, who measured the real scope of Impressionism and the great masters who followed it? Martín Malharro in Argentina, Juan Francisco Gonzáles in Chile, Andrés de Santamaría in Colombia, Armando Reverón in Venezuela? Only partly, without altogether abandoning their old positions. Nonetheless, the last two deserve special mention, since, when "there was nothing to predict the existence of that magical sensibility called Reverón," as Clara Sujo says, Reverón cultivated a kind of Impressionism, less subject to the technique than to the spirit, with refinement and maturity, and since Santamaría was "the only American of his time whose passion is concentrated exclusively in the chromatic material and whose rage for coloring and mistreating forms borders on the earnest rages of European Expressionism," as Marta Traba has written.

But the ferment was working, and toward the 1920s rebellious dissidence began in the countries that had no thousand-year-old tradition: articles in the magazine *Martín Fierro,* and Alfredo Guttero's First Salon of New Art in Buenos Aires; the Week of Modern Art under the inspiration of Paulo Prado and the works of Mario de Andrade in São Paulo; the mass sojourns of Chilean artists in Europe carried out by a farseeing cabinet minister; the arrival of Joaquín Torres-García in Montevideo a little later. It was rebelliousness that did not, to be sure, signify the installation of authentically modern art but showed signs of breaking with the naturalistic and folkloristic past, ushering in the transitional stage.

Then, on the fringes of these confused movements, appeared the artists who started the turn toward the modern; none were openly aggressive, all were to some extent respectful of tradition. They were the Uruguayan painters Pedro Figari, Joaquín Torres-García, and, to a lesser degree, Rafael Barradas; the Argentines Emilio Pettoruti and Lino Enea Spilimbergo; the Russian Lasar Segall, naturalized in Brazil; the Brazilians Anita Malfatti and Tarsila do Amaral; and with the Argentine sculptor Pablo Curatella Manes. Battling valiantly with the envi-

ronment after having been in Europe, each of them gave artistic creation a status it had never had before, one that even the elites of South America were slow to recognize.

Although a Gallicized man of the world, Figari saw, with remarkable penetration, the picturesque traditional actions of the Negro and the peasant on the Río de la Plata and used these themes to create a body of painting that was modern without intending to be, splendid and full of light and irony, eminently folklorist without committing the sin of naturalism (plate 207). A more conscious champion was Torres-García, a friend of Mondrian's, who combined the severity of neoplasticism with the romantic goodheartedness of a palette of grays, and frankly employed simple native signs to give his art an American basis and therefore, hopefully, eternal validity, and lost nothing thereby; on the contrary, one would say that the dogma, however perilous for others, was marvelously balanced in him (plate 209).

Pettoruti's path was different. He was an intelligent man who lived through the Futurist revolution without committing himself and then became acquainted with the Cubists, making the composition dynamic and progressively eliminating the empirical contents of the forms, perfecting his mastery in a quest for a security that was alien to both (plate 208); now, living in Paris, he is immune to the contagion of the movements of youth, after having been so young himself in his youth. Spilimbergo was a painter of human figures who introduced the modern spirit rather than modern forms, as far as the public of Buenos Aires would accept it, and they did accept him without delay. Meanwhile, Manes was rising in Paris, moving cautiously after his apprenticeship in Bourdelle's studio and later practicing a dynamic Cubism that did not exclude the human figure; finally, installed in Buenos Aires, he sculpted abstract works of obstinate rigor (plate 215).

The situation of modern art was confused everywhere, and most of all in Brazil, because of the inexhaustible freshness of the Negro music, singing, and dance, which attracted many painters. None of them succeeded, but by means of these kinds of folkloric forms and those imported from an Expressionist Europe some sounded the modern note, at the same time asserting Brazilianism as an artistic dogma; in particular, this was true of Segall, who was integrated into the society of São Paulo and there did noteworthy work (plate 210). It was figurative, naturally, and not very modern, as was the work of Candido Portinari, an inland Brazilian titan who sometimes surpassed the facile folklorism of the others by virtue of his passion, making use of the experience of Picasso and the Mexican muralists (plate 211). Meanwhile, Do Amaral, who is still

working, made a happy marriage of Brazilian themes (both native and Negro) with the rigid objectivism of Léger.

The first authentically modern position in South America was taken by the Argentine painters, followers of Max Bill and Georges Vantongerloo, who called themselves "Concrete" in the 1940s, certainly because they dared go all the way with the experience of European art. The Americans had to learn as much as they could in Europe, and learning meant doing it well. That was the view of Tarsila do Amaral when, on returning from a trip to Europe, she advised her compatriots to do a period of "compulsory military service in Cubism."

The Concrete movement may not seem to have been very fruitful, for Tomás Maldonado, the leader of the movement, went into the theory and teaching of design (today he is rector of the Hochschule für Gestaltung in Ulm, Germany), Lidy Prati gave up exhibiting, Ennio Iommi and Claudio Girola preferred to perfect their craft, and Alfredo Hlito (who has been living in Mexico for some years) confined his imagination. But all we need to realize the fertility of the group, apart from the solid work of each of its members, is to reflect that among them was José Antonio Fernández Muro, one of the peaks of contemporary South American art and winner of the first prize at the Hispano-American Biennial of 1963.

In Brazil, on the other hand, there was no comparable outbreak of Concrete art. Of those who remained in the country, the only outstanding ones were Iván Serpa for some years; Lygia Clark, with her sculptures in brass, pieces that can be folded like Froebelian toys; and more recently Ruben Valentim, whose works have Afro-Bahian roots. Among the deserters are the painter Vieira da Silva, and Almir Mavignier, whose paintings are measured to the point of exasperation.

Less orthodox was the Madí group in Buenos Aires, headed by Carmelo Arden Quin, searchers for a new pattern of picture. The group soon broke up, except for Gyula Kosice, who kept working hard and created "hydraulic sculpture," interesting objects of metal and plastics in to which he introduces water as an element of instability, very much in keeping with the exigencies of the time.

Alejandro Otero of Venezuela, oriented toward a curious color dynamics, with rigid structures in parallel zones bounding the color, attracted attention some years ago with his Color-rhythms. Similar attention is aroused today by the compositions of another Venezuelan, Gerd Leufert, who juxtaposes large pseudo-geometrical areas in broad rhythm, with clearly treated tints. The recent

white reliefs of the Colombian Eduardo Ramírez Villamizar also attest a strongly creative imagination.

The geometrical spirit has gained new strength in recent years, with Argentine painters like Eduardo MacEntyre, who no longer think of the picture as a play of positions among simple elements, giving space the power of poetical suggestion that the Concretists aimed at, but as an unfolding of complex elements that confer on space a power of musical suggestion. This is still more the case with those working in Paris, some forming part of the Groupe de Recherche d'Art Visuelle (Julio Le Parc — plate 213 — Horacio García Rossi, and Francisco Sobrino), others outside it (Martha Boto, Gregorio Vardánega, and Hugo Demarco). Employing various materials, they can be said to use intervals of light, giving space a power of existential suggestion. Akin to them, but in another manner, the Brazilian Abraham Palatnik makes boxes containing mobile elements, which produce multiple forms by plays of light on a ground-glass screen.

Still related to the geometrical artists is Jesús Soto of Venezuela, one of the most important artists of South America, and first-prize winner of the second Bienal Americana de Arte in 1964. He is the "inventor of a subtle calligraphy of wires rising from the background of painted wood of each painting, with the refinement of the Japanese, or compositions with simple geometrical planes contrasting in space at a distance from the background," as I have written on another occasion (colorplate 95). There is Cruz-Diez, another Venezuelan, who paints forms, which change with the position of the viewer, in the interstices produced by little planes parallel and perpendicular to the background of the picture. There are also two Argentines and a Brazilian, all living in Paris: Luis Tomasell, who makes reliefs with polyhedral bodies attached by a vertex to the background of the picture; Marino Di Teana (born in Italy), who erects monumental steel sculptures; and Sergio de Camergo, with his reliefs in plaster and wood. In Buenos Aires, Victor Magariños makes lean but organic forms with a vigorously colored line; however, he is also emerging as a luminist.

This South American preference for geometry is noteworthy, especially considering how the artists are. The situation is not so strange or incongruous as it may seem, however, since these paradigmatic forms correspond to the embarrassing pedagogy of those who are afraid of their own anger.

When the first São Paulo Bienal took place in 1951, the figurative and abstract artists still coexisted peacefully in these lands. I will mention, later on, those I consider the most important. First I should like to point out that both the figurative and abstract artists were victims, since they had to establish

modern art at a time when minorities were unprepared and they themselves had not overcome their secular inhibition. I believe that the only reason the Concretists seemed so advanced fifteen years ago was that they were the least repressed at that time.

I shall pay special attention to militants who have produced work of international value. Among the Argentine painters are Juan del Prete, who always experimented, and with *brio,* anticipating forms in every field; Raquel Forner and Héctor Basaldúa, who still fluctuate between figurative and abstract but manage to progress; Horacio Butler and Raúl Soldi, stubbornly figurative; and the unclassifiable Juan Batle Planas, a repentant Surrealist. Among the sculptors are Alicia Pérez Penalba, who lives in Paris and is victorious everywhere, making forms that are abstract in their lack of empirical content but naturalistic in the manner in which they exist in space (plate 216); Líbero Badíi of Italian descent, who lives in Buenos Aires, a representationalist of great nobility, abstract so far as a sculptor can be who still uses the old materials; and Noemí Gerstein, more absolutely abstract. Two workers in black and white are Fernando López Anaya, with high mastery, and Américo Balan (born in Russia), with his rigorous anti-rhetorical conception.

In Brazil the abstract painters had to face up to the glory of the nation, Alfredo Volpi, who is still doing representational painting by way of abstraction (as José Augusto Franca has said) to keep the original power of the synthetic structures that he paints — façades of houses, walls, doors, windows — in which space is absolute. Thus it is only in the present decade that abstract artists of substance are to be found, with the sole exception of Faiga Ostrower, a splendid worker in black and white. Arnaldo Pedroso d'Horta and Marcelo Grassman, draftsmen, and Bruno Giorgi, a sculptor, are the leading strongly figurative artists.

Three other sculptors of this generation are outstanding: Marina Núñez del Prado of Bolivia, who vivifies ancient native figures with modern spirit, the work characterized by smooth surfaces, sharp edges, and hard dynamic patterns; Eduardo Yepes, a Uruguayan born in Spain, a firm constructor of figures and therefore obstinate toward the lightness of the materials suitable for abstract forms; and the Chilean Lily Garafulic, of Yugoslavian ancestry, an excellent carver and modeler, who does not let herself be overwhelmed by modernity but accepts it slowly. These artists are lovers of the material, and for that reason have not been able to adopt the creative behavior corresponding to their vital development.

Among the Chilean painters of the same epoch is the bright figure of Matta — who lives for the most part abroad, in the United States and Europe, and who has become the most prominent South American artist (plate 212). And with good reason, since there might be argument whether to locate his works inside or outside the bounds of abstract Surrealism, but there can be no doubt as to the freshness and richness of his imagination in the search of forms for psychic processes. He is a creator of worlds, a member of a genus of whom few are left, and has recently caused a stir with works inspired by the Cuban revolution. Linked with him are Nemesio Antúnez and Enrique Zañartu, both living in Chile, both evoking nature and life, despite their laborious researches into the unconscious.

The question of abstract art is difficult in general because of the vagueness of the term, which is used to designate forms that are taken to have no empirical content or an esoteric existential content, both of which are false meanings. But a still harder question is its development in South America, for because of its delayed development as compared with its development in Europe, it not only merges with representational art but also with Informalism.

In Argentina, however, there is abstract art in the European manner. Once Antonio Sibellino made a relief and Juan del Prete a picture, both absolutely abstract, many painters and workers in black and white took up this possibility of form. Some outstanding figures later were José Antonio Fernández Muro, Clorindo Testa, Sarah Grilo, Kasuya Sakai, and Miguel Ocampo, whose works were exhibited with resounding effect at the National Museum of Fine Arts in Buenos Aires in 1960. At the time, I said of Muro that if he were not a painter, geometry would have destroyed his art, but that he overcame the possibility because he was one; he lives in New York now, and finds continually better solutions (colorplate 93). Of Testa I said that his painting is embryonic, and that he needed only chalk whites, grayish blacks, and blackish grays to have his forms retain seismic mystery, despite a certain latent geometrical severity; at the present time, they are clearer and more structural, and thereby mysterious in the highest degree (plate 214). As for Grilo and Sakai, who live in New York, they have perfected the practice of the abstract: the former by definitively eliminating the Cubist forms that had been an obsession with her, the latter by rendering more expressive the structures that he creates with juxtaposed chromatic zones. I add to the group a single, not too typical, Informalist, Mari Pucciarelli, who lives in Rome and is engaged in perpetuating a "polymaterial" form of expression, undoubtedly of high quality but already antiquated, and two workers in black and white, very distinctive in character: Luis Seoane,

vaguely representational and a vigorous constructer, and Mabel Rublí, abstract and refinedly environmental.

Of the Brazilians, only Antonio Bandeira can be considered abstract. The others make forays into Informalism: Iberé Camargo, a former representation-alist now dominated by the strange fascination of losing himself in the entrails of the earth, as Mario Pedrosa has written; Frans Krajcberg, born in Poland, who has been engaging in curious experiments: chalk rubbings on Japan paper over bas-reliefs and natural rocks, woodcuts that retain the traces of the tool, and compositions with rocks on earth-tone backgrounds (plate 218); Manabú Mabe, with a sure, slightly deliquescent taste for color and diffuse composition; and Flabio Shiro, who is Japanese, Brazilian, and French and whose work evokes the fascinating Amazon jungle and its monsters.

The other countries too have painters who vacillate. In Chile the two who stand out are abstract: José Balmes, a lyricist seriously concerned with the material, and Eduardo Bonatti. In Colombia, Alejandro Obregón and Wilhelm Wiedermann (born in Germany) are abstract. The first is sensitive, as the critics of a former day demanded, by virtue of the color range that he obtains with his impasto (colorplate 94), but not imaginative, as the critics of today demand. The Venezuelans — Mercedes Pardo, Humberto Jaimes Sánchez, Elsa Gramko, and J. M. Cruxent — are more advanced, passing from one tendency to an-other without making full use of their splendid gifts. The same occurs in Peru, with Fernando Szyszlo and Carlos Aitor Castillo (both abstract) and Arturo Kubotta (Informal), and in Uruguay with José Gamarra, a promising talent despite the primitive signs he uses (plate 217), and Nelson Ramos, an excellent beginner. There are few sculptors, but two living in Paris and one in Rome deserve to be better known: the Argentine Leonardo Delfino, the Brazilian Sonia Ebling, and the Peruvian Joaquín Roca-Rey.

Except for the painting of those mentioned, and not of all of these, one gets a feeling of weariness when faced with the painting of the other abstractionists and Informalists and goes through the same ritual in judging it as they un-doubtedly did in making it: as if the pictures were ends, objects without a destiny, not even that of being ornaments, and not means of being free. The disease is endemic but becomes graver in these countries because very often the creator is the sport of the wind that is blowing, without being able to avoid it.

Here, as everywhere, we have been talking of a return to representation, a great sophistry, for although a new approach to the human figure may be observed, there is not by any means a return to that which has been, and also because an essential change has taken place in the plastic structures; but, sophism

or not, it remains a problem. A satisfactory solution, however, has been given by four Argentine painters recently praised by John Canaday, who considers them the probable founders of the "School of Buenos Aires." This may be so, or exaggerated, or it may not be so; time will tell. But they must be given credit for putting themselves at least on a level with Europe. The artists are Rómulo Macció (now living in Paris), Luis Felipe Noé (who has just been in New York for a year), Jorge de la Vega, and Ernesto Deira, members of the group that did so well at the exposition of the National Museum of Fine Arts, Buenos Aires, in 1962. To these should be added Antonio Seguí (also living in Paris), because of a certain thematic affinity. All except Seguí are connected with Informalism, although they prefer to call themselves "neofigurative."

Outstanding in the group are Macció and Noé, who won the International Prize and the National Prize of the Instituto Torcuato di Tella respectively, in 1963, but all of them are important. Macció is a strange painter of space (even though he seems to be figurative); the forms act dialectically to destroy their fixedness, each picture presenting an image beyond "nothing" in a present, of amazing temporal energy, that lacks a past and a future (colorplate 92). Noé is more tragic, attracted by life in its aspects as space made time rather than by the time that is its origin, as foreign to good taste as can be, tremendously authentic in his enthusiastic way of working (plate 221). This is the converse of the gifted Seguí, who surprises us with the most varied resources, producing a painting which we cannot say is "modern" or "ancient" but is always of the first quality (plate 220), just as De la Vega surprises us with his "collage painting" of forms that are graceful yet solid, always providing a droll spectacle (plate 219), and Deira, who, with his painting more and more delineated, even with wires, gives a magical conception of life. Apart from them, the only ones I find interesting are the Brazilian painter Iván Serpa, and Jorge Piqueras, a Peruvian living in Paris; the former, after steeling himself in Concretism, is a dramatic neofiguratist, and the latter has well-marked Surrealist accents.

Other notable painters, fully in the field of representation, are María Luisa Pacheco, a Bolivian living in New York, who abrades native themes until she obtains abstract expressions (plate 222); the Chilean Ernesto Barreda, with representations of houses, interiors, and utensils, obsessive by dint of being accurate; the "primitive" Brazilian Djanira, whose exotic pictures have a rare quality of enchantment through the felicity they arouse; and above all, Fernando Botero of Colombia, a creator of ridiculous figures with a rare sense of humor, wavering gigantic images that are greatly appreciated in his own country and the United States (plate 223).

Leaving out Lucio Fontana (although he was born and got his early education in Argentina) who is too big to fit in here, the picture is completed by the young men and women in Buenos Aires who make "objects" out of the most diverse materials. They create "puppets" that invade space instead of occupying it dictatorially as sculptures do. It is a curious version of the temporality that is lived through without most of us knowing it. This undoubtedly does away with the picture and, ultimately, the work of art as a symbol of eternity, but replaces it with something provisionally "real."

This issue received some notoriety when Pierre Restany, Clement Greenberg, and I gave the Torcuato di Tella Institute National Prize for 1964 to Marta Minujín, the chief advocate of this "puppetism," and set up a special prize for Emilio Renart, who in a way goes along with her. Miss Minujín makes increasingly large forms with mattress ticking painted in strong colors and stuffed with wool, and hangs them in the air (colorplate 97); or she uses them to create absurd structures, figurative or nonfigurative but with equal force, in order to bury those who make pictures. Renart makes monsters out of less perishable materials, erotic forms that are manifested in their form, not their workmanship, and cause scandal or charm, depending on the viewer. Also noteworthy are Rubén Santantonín, with hanging dynamic abstract forms; Delia Puzzovio, who uses plaster casts, placing them among broken objects, paper, and pieces of junk and creating strange little wagons and funeral wreaths; and Pablo Suárez, with human figures in the round made of wallpaper, having a burden of tragic irony, if not of cruel desperation.

The youth of this movement makes it all the more surprising that Antonio Berni participates in it. He is a mature neorealist Argentine painter who, after having made portraits and revolutionary scenes wholesale for decades, did an about-face. He started to tell the life story of characters he had invented, using collages and black-and-whites of marked modern descent, without thereby betraying his principles, since the spirit of popular passion persists, documenting poverty but now sublimated into artistic forms (colorplate 96). The jury of the Venice Biennale awarded him one of its grand prizes in 1962.

Modern art began to exist in South America when its practitioners understood the meaning of life in the cities of Europe and the United States, and it will exist definitively when they discover the original source of existence in our cities. Pierre Restany, speaking of the New Realism and "urban folklore," undoubtedly with reference to this new way of bringing the content of the artistic image into focus, put his finger on the sore spot of the South Americans:

what is at issue is to make present ways of life — that is, those of the city — once more active in the imagination, so that artistic forms may take on the only valid note.

The question is complex because there are social classes, and above all specifically determined groups within those classes. There are classes in art as well, depending on the people to whom it is addressed — indigenists and folklorists, naturalists and romantics, workers and intellectuals, and so forth — each group with its art, its galleries, and its critics. I do not refer to the painters and sculptors of these groups because I adopt a point of view different from any of them. Or, rather, because I take all of them into account in basing my criteria on free creation.

Although the contrary is asserted in certain leftish circles, the art to whose South American manifestations I have referred is not the art of one social class. On the contrary, it describes the ambiguous action of the majorities and the minorities in the only form possible, without engaging itself in them, as driving toward liberty. How else are we to justify the new esteem of geometry, which gives architectural and urbanistic solutions for the majorities, and the simultaneous esteem of intuition, in pictorial and sculptural solutions for the minorities? We need only dismiss ideas to realize that the art of both groups is governed by the same ontological necessity of placing oneself in the truth, which can never have a definitive form if it is to be truth.

I do not believe that South Americans understand this theoretical position. Sociologists and psychologists, politicians and professors in particular, all of them practitioners of ideologies, are far below the artists. But the movements of the youth justify our being more optimistic today than yesterday. Not that it is important to cast the horoscope of what the forms of the future will be. They will be what they should be in view of the circumstances. What is important is the attitude, the new active intention of all, whether conscious or unconscious.

Greece: An Approach to Contemporary Art

By Dimitris A. Fatouros

On the analysis of present-day art

There are special difficulties attendant in analyzing contemporary art. Personal biases are always present, and to a certain extent they are unavoidable in analyses of today's conditions and actions.

There are also difficulties arising out of the kind of artistic life, the artistic nature, of a period. I shall, of course, try to avoid a conventional analysis of today's art in Greece. I would like to give an objective, and, as far as possible, fruitful approach at the same time. Accordingly, less attention will be given to artists who do not contribute to solving the problem of the change of style, for all that they do honest work and have artistic abilities (not merely skill and dexterity). Before we can become acquainted with present tendencies in the art of a country — in this case, Greece — we must look at the situation of international art and the way things stand in Greece with respect to the general prerequisites of art. These brief remarks are not a digression. They are among the main elements for grasping the subject, and out of them the criteria for judgment will be obtained. Despite the sweeping nature and the difficulty of the task, we must undertake a very general survey of the present movement of artistic ideas on the international plane.

Some years ago, it would have been very simple to achieve an ordering of artistic ideas, if only a conventional one. On the one hand the great current of the abstract (geometrical or nongeometrical) artist, on the other the more or less representational. The most vital and creative artists obviously belonged to the first group. We must observe that we can not force social realism into either of the two currents; it is a sterile mode of expression, anticreative and inhuman, which for the most part does not belong to the basic forms of visual art. But what is the situation today? It is very hard to make distinctions and to generalize, but it seems clear that the object, movement, the industrial "fact," and the problem "man" are treated emphatically. On these lines, we may distinguish six basic characteristics of today's art:

1. The object. It can exist in and of itself, as a whole or as a part of a whole, or as an attached element, and by itself or forming part of a whole in which it is repeated (a table that appears as a table or can exist "opposite" itself).
2. Movement. As a positive and creative element, it usually appears in works with geometrical forms.
3. Objects or situations that become symbols of the industrial environment and industrialized life are themes for representation.
4. Human figures reappear, either on an ironic, caricatural, often tragic plane, or on an Expressionistic plane that is the best-known category of the New Realism.
5. Abstract and Informal art in the strict sense is not so widespread. These two modes, however, are the starting point for a calligraphy, and their techniques and principles assist all the trends mentioned above.
6. Space, whether directly and geometrically defined by the tendencies of neo-Informal art, or indirectly, as a fundamental theme for all creative tendencies. Restless meticulousness marks the enterprises that relate to an attempt at a new ordering of the human milieu. Here the researches of contemporary art may be linked with those of contemporary architecture.

There is one more general theme: The subjects of art and the spread of its ideas have now reached a point of great complexity and astonishing rapidity. Shows are moved from one country to another; there is a multiple nexus of government expositions and shows by private groups and individuals. Presentation outside the boundaries of each nation has become much easier, so that the criterion for the recognition of an artist has changed. There is also an enormous number of publications, from the most luxurious to the most paltry. A sort of artbook industry has taken root, which is filled out with pseudo-monographs and simple photograph collections. There are also many criticisms in newspapers and magazines, along with brief dissertations in exposition catalogues. Such activity in theory and art criticism is undoubtedly useful but also dangerous, since often it is nothing more than pseudo-analysis and repetition of critical phrases. It is harder for us to study, define, and order in the midst of this feverish activity. Finally, special care is required when we seek genuine artistic expression. Possibly the artist is employing a certain technique (Tachism, for instance) and by means of it only seems to be doing new work. Even though it is known that technical tricks are not enough to bring about a new order in the mode of expression, they often produce confusion. We can see this confirmed in virtually all of figurative technique, where the irony or caricature is often

nothing other than a slightly tragic Expressionism. For some nations, including Greece, this is a special problem. These are the nations that have inherited pregnant characteristic art forms from their history. Here tradition, which is determined by the credo of the artist or is a historical fact, plays a special role in the evolution of art.

Greek art today

Greek art is undoubtedly on the upgrade today. The awarding of the Unesco Prize at the 1960 Venice Biennale to the painter Yannis Spyropoulos may be taken as a visible sign of this. The years since then have been extraordinarily fruitful. Before we go on to learn of artistic activity in these years, however, it will be useful to survey the Greek situation, so far as art and the general artistic movement in the country are concerned.

After World War II, Greek art and the formation of the younger artists were decisively influenced by the generation that had grown up between the wars. At the end of that period and for the first years after World War II, the painters Ghika, Engonopoulos, Moralis, Tsaroukhis, and Dhiamandopoulos embodied the character of the epoch. Ghika, who has been living in London and Paris for five or six years, has been the most important pathfinder, with his deep philosophical views, a post-Cubist style, and echoes of Oriental art. Engonopoulos works in a purely Surrealist style; he is also a prominent Surrealist poet. Tsaroukhis and Moralis, each having a large number of disciples (in addition, Moralis is a professor at the School of Fine Arts in Athens), worked in the manner of the great painters of the period between the wars, perhaps more like Matisse and Braque than like Picasso, while experimenting in Greek painting style as it appears in vase painting and in Byzantine and folk art. This tradition was studied eagerly by the versatile architect Pikionis and the painter Kontoghlou. All these men represented the basis of Greek art in the first postwar years. Their influence has declined since about 1960, which was the beginning of a completely modern period of Greek art.

Alekos Kondopoulos, a painter with academic experience and theoretical endowment, has since 1949 undertaken to create a movement toward abstraction, toward a mainly metageometrical painting. Besides the important figure of Spyropoulos, who gained recognition for Informal painting in Greece, the decisive factors for the development of present-day Greek art were the artists already outside Greece when the war ended.

Some of them already had reputations when they left. A few (for example, the painter Yannis Gaitis) had tried, even before they left Greece, to search out new possibilities of expression. These artists, now thirty-five to fifty years old, either returned for good or have gone back and forth since 1960. They spend a large part of the year, perhaps most of it, in Greece, set up studios, and organize groups of artists. By communicating something of the life of the great centers, but also gaining by contact with Greek reality, with the actuality of the landscape, the sun, the people, and memory, they create a truly fertile movement.

Here we must mention a number of Greeks, most of them living in Paris and not exhibiting regularly in Greece or taking any great part in Greek artistic life. Among them are some of the best-known names of modern art. I am thinking of Prassinos, who is perhaps more French than Greek, the sculptor Takis, and the painters Vyzandios, Karakhalios, Vafiadis, and Angelopoulos in Paris, and Kardamatis in Venice. In the United States, older painters like Xeron and the late Baziotes and younger ones like Chryssa occupy a position of genuine importance but no longer have any connection with the Greek scene.

Critics, some more and some less influential, have been of decisive service and today still make their contribution to the development of Greek art. In addition, an especially important role is played by Zygos ("Balance"), the oldest gallery in Athens (which closed in 1965), and its magazine of the same name, now the only one in Greece for the visual arts. Of interesting effectiveness was (1960-64) the work of the newer Athens gallery Nees Morfes ("New Forms"), which for some time also published a magazine with the same title; and the art society Techni ("Art") in Salonica, whose exhibition hall, discussions, and lectures helped activate modern artistic expression in Greece. Mention should be made of the work of a vital young painter, Leonidhas Christakis, who organized the first show of Greek abstract art in 1958, and the intelligent and creative output of Argyrakis, an artist primarily active as a caricaturist. Athens and Salonica, the great urban and artistic centers of Greece, have other noteworthy galleries, such as the Merlin Gallery, the Hilton and Astor galleries in Athens, and the exposition hall of the Doxiadis Technical Office.

There are two other factors that aided in forming present-day Greek art: the frequent shows abroad in the last five years of artists from Greece, with government and private assistance, and the participation of Greek critics and theoreticians in international bodies. Of those living abroad permanently, we

must mention Tony Spiteris in Paris, the general secretary of the AICA, and Sotiris Messinis in Venice.

For the last three years, the Greek section of the AICA, with the financial aid of the Keranis tobacco company, has been awarding an annual prize in sculpture or painting. This prize, although it has not yet won the prominence it deserves, is thus far the only one in Greece.

Greece's poetry, novels, and music have have played a role in the development of Greek art. Chiefly poets, but novelists too, did yeoman service in forming the spiritual space that is necessary for art. Many of them wrote art criticism (Empirikos and Elytis for example), while others were active in painting as proficiently as in literature (Engonopoulos and Pendzikis).

There are some negative factors: There is no museum of modern art in Greece (a National Gallery is now being built in Athens that will represent contemporary art as well); there are no systematic art publications; there is no serious art trade; and the professional position of artists is very difficult.

We find the power of innovation and the ability to apply modern art forms in the Greek artists who in their own way follow the major currents of their time, and in the few who with varying degrees of force create art that really embodies modern truth (as a rule, we call this art pioneer work, and not simply modern art).

Of the older painters mentioned above, Ghika has worked outside Greece in recent years, on a series of works (which he has not shown in Greece) in which the geometrical elements are diminishing and persist only as symbols. At the same time, a spectral school of painting has developed that lays more emphasis on the fantastic character of the pictures. Moralis has done a number of large decorations for buildings in the last five years; most of the pioneer artists have no opportunity to experiment and apply their work in architecture. Within the tradition of representational art, and in a clearly neoclassical or neo-Byzantine style, Spiros Vasiliou, an astoundingly skillful painter, and two professors at the School of Fine Arts in Athens, Nikolaou and Mavroidhis, constitute an active group in modern Greek art life. The very young artists, Fasianos, Mytaras, and Kypraios, are working chiefly in this manner; they are talented painters, and their acquaintance with abstract and Informal art is obvious. The sculptor Kapralos and his pupil Klouvatos have done work based on Greek sculpture, while Yannis Pappas (professor at the School of Fine Arts in Athens) works in a purely academic manner.

Among the graphic artists, the older figures Vaso Katraki (with "heroic"

tendencies in her lithographs) and Tasos and the younger Siotropou work purely representationally. Ventouras, a sensitive artist, keeps only the recollection of the thing seen; Piladhakis, a young painter and graphic artist, abandons the object and composes with lines, points, and surfaces, suggesting cross sections of plants, trees, or marine depths.

Of the four young painters who are today the most characteristic New Realists, three (Gaitis, Maltezos and Touyas) come directly from Informalism. The human figure appears caricaturally in all three, especially in Gaitis, who retains some of the quality of children's drawing and bases his compositions on cinematic principles. The fourth, Karas, had really never abandoned representational pictures. His work has a genuine pictorial capacity and approaches Expressionism.

The largest group among modern painters works in various aspects of Informalism. Spyropoulos is undoubtedly the most mature of these. In his latest works, which are very dark, the image is built up out of earth colors and suggestions of geometric line formation (colorplate 98). It is especially characteristic of his work that it keeps the aesthetics of the colors and forms of the Greek scene. The older Lefakis (professor of painting at the School of Architecture of the University of Salonica) creates often strongly colored works, with a high quality of technique which gives his excellent Informal works an Expressionistic attitude (plate 225).

Younger painters are already producing mature work. Perdhikidhis, who lives in Spain, creates expressive pictures that are tonally extremely soft and into which he introduces traces of calligraphy. Piladhakis, whom we have already seen as a graphic artist, does painting that is methodical yet vital. The younger artists Dekoulakos, Stefopolous, and Paniáras work in almost the same manner; the older Zongolopoulou uses color qualities distributed pointillistically. Their work always relates to some pictorial impression that in the last analysis is religious. Peculiarly Expressionistic is the work of Pierrakos, a painter who has lived in Paris for years. A creator of earnestly abstract landscapes, he has also done a number of excellent drawings.

The painting of Svoronos (in Salonica) shows an impressive geometrical conception of drawing. After a period of Tachism, Marthas (who died in 1965) ended his career with works of purely geometrical expression with triangular forms. A very methodical and serious painter, C. Xenakis is one of those who are making long-range experiments on the pictorial problem with well-thought-out and intense work (colorplate 99).

The work of Molfésis, one of the most intelligent of the painters, who has

been living in Paris for a long time, is an authentic expression of painting based on direct and dynamic brushwork as well as on "toning" of the surface (colorplate 100). From it we get a clear idea of feeling for the pictorial act; a sort of communication goes out from the restless, nervous forms that move over the painting's surface. A still younger man, Kondos, works in a microscopic script that suggests drawing. Tsoklis is on a road that leads to an ironic Surrealism. Similarities are to be found in Kondaxakis in Salonica. Nicholas Georgiadis, an artist living in London, has been especially successful as a painter for the theater and has made a name for himself on the stages of England and Germany. His painting sensitively combines collage with fragmentary geometrical elements (plate 224).

A number of younger painters have completely given up conventional painting and aim at incorporation of objects into the painting. Nikos Sakhinis, who lives in Salonica, uses pieces of junk, which he glues on the painting and composes with great sensitivity. Even the harshest and most unpoetic of objects take on a pictorial sense and alter their meaning. Untiringly and systematically, Sakhinis investigates his means and expressive capacities; he is one of the foremost contemporary Greek artists. Logothetis (in Salonica) uses sheet metal; Archelaou (in Athens) works with drilled wood. Pavlos, who lives in Paris, has been engaged in collage technique and makes relief pictures. Nikos Kesanlis has worked in the same direction in Paris with great success. For some time, Danil and Vlassis Caniaris have been searching in Paris for an art that is no longer painting and still not sculpture. Danil uses cardboard boxes and forms a sort of theater space for a scenic theme. Caniaris, one of the most introspective Greek artists, uses rags, scarecrows, and garments; he is trying to make a way of life out of an aesthetic sensibility (colorplate 101). Tragic experiences are honestly expressed and give the work dignity.

The artists we have mentioned (and beginning with Molfesis, all of them are young or all but) have a number of traits in common. They are restless but not hasty or superficial, persistent but not unboundedly fanatical, and often experiment more on themselves than on their work. They have all produced more or less mature works.

Nothing in Greek art corresponds basically to Expressionism. This can be seen from the fact that Busianis (a painter who has made a name in German Expressionism) has not produced any disciples in Greece, despite the high quality of his work and the strength of his personality. In addition to the sculptor Lameras, we find the marks of an Expressionistic attitude in Arlioti. In sculpture, the older figures — Aperghis, Zongolopoulous, Coulentianos (plate 226)

and Loukopoulos — retain fruitful youthful dynamics. Aperghis uses thin metal rods; Zongolopoulous is characterized by a prismatic composition tending toward symbolism.

Philolaos, who after years in Paris is once more taking part in Greek art life, often uses everyday objects as his material, and is experimenting with the transformation of matter and objects into the "mythical." In another direction, Spiteris is making works that achieve a kind of monumentality without being bombastic. Usually by expressive treatment of stone, Sklavos's works retain an archaic simplicity and communicate a feeling of heavy calm. Mylona succeeds in defining a plastic space by the way she stresses movement of planes.

I fear that this presentation has taken the form of a list of names. Perhaps it is because a number of artists, although not on the highest level, should be mentioned because they contribute to the climate of Greek art. And as for the young artists, they at least bring promise for the future in many ways. Many of the artists have been mentioned to give an objective picture. I have not entirely suppressed my own bias toward those tendencies and characteristics I regard as the most creative in contemporary art. But in any event I have tried not to limit the circle too much to demonstrate what possibilities have been tried and what the outlook is for the future.

Finally, the young Theodoros is at present the most powerfully promising young sculptor in Greece (he was awarded the Prix Rodin at the 1965 Paris Biennal). His work is well thought out and has a searching quality.

Israeli Art Today

By Yona Fischer

The contemporary situation of art in Israel is characterized not so much by the battle between diverse schools as by the role, always more considerable, of the young generation. When we speak of a young Israeli generation, we do not necessarily mean young artists but rather those who have contributed to the break with the earlier mentality, with the tradition that said there was or was not a properly Israeli art.

Let us briefly summarize the past:

1. The activity of the first painters in Palestine coincides with the first waves of Zionist immigration (about 1906-18): the founding of a typically provincial school having as masters artists working in a conception close to Jugendstil or in a naturalist tradition.

2. A first generation of painters of a partly local education, having undergone the double influence of Cézanne and the "Jewish" Expressionism of the School of Paris (1920-23).

3. A post-Expressionist movement born of the massive immigration from Central Europe (Steinhardt, a member of the Berlin Sturm group; Ascheim, a pupil of Otto Müller; Ardon, a student of Klee, Kandinsky, and Johannes Itten at the Bauhaus — 1933-40).

4. The first consciously modern movement with the founding in 1948 of the New Horizons group, which brought together the veteran landscape artists Zaritsky, Streichmann, and Sematsky (who gradually passed to abstraction) and the younger artists.

5. In the fifties, two major tendencies:

a) that of Ardon's students in Jerusalem, more Expressionist and interested in formal problems, either in abstraction (Arikha) or in a sort of new representationalism (Tamir, Bezem); and

b) that of the followers of Zaritsky within and outside the New Horizons group, who developed a free, improvised abstraction, closer to that of the American Abstract Expressionism. These two groups constitute an intermediary generation between the old generation of landscape artists and contemporary trends.

The school of Palestine (the state of Israel was created in 1948) always made a parent figure of the School of Paris (Soutine and Chagall on the one hand, Rouault on the other). It practically ignored all preoccupation with a purely formal order, which explains the absence of abstract art before 1950 and, even today, of geometric art, of the New Realism, of Pop and Op Art — styles with which, however, the Israelis are acquainted.

After 1948, practical problems were first avoided, then favored; then they began to mark the development of an Israeli way of life and of Israeli art. The massive immigration (Israel doubled its population in ten years) posed demographic and cultural problems. Arid towns without any unity but the repetition of materials, untiringly repeated plans formulated to remedy the most urgent needs, mushroomed over the countryside. Ten years later, a new Israeli landscape already existed: the Orient was no more than a memory.

Lyric and Expressionist abstraction, long Zaritsky's province, had voiced its numerous possibilities. It is not surprising that the new way of life — the new landscape and perhaps a certain disillusion — provoked the arrival of sculpture and of an artistic movement leading from easel painting to an art capable of adaptation to extrapictorial functions.

If sculpture did not exist previously except in some rare artists, it assumed prime importance thanks to Ytshak Dantziger, Yehiel Shemi, Shamai Haber, and Ygael Tumarkin.

Now about fifty years old, Dantziger is in himself a summary of the development of Israeli sculpture. Some thirty years ago, he worked on a torso representing Nimrod, the Biblical hero, with features indicating a yearning toward the archaic. Ten years ago, he worked on the construction of a metal monument at the Yad Lebanim Memorial in Holon, which can today be seen to belong in the Israeli abstract movement. Since then, he has wanted to submit form to the service of an idea, to make it play a symbolic role in the landscape (plate 227). He made plans for gardens and imaginary water conduits for the endless desert space of the Negev. A monument in stone and iron that he and Haber created for the new Israel Museum in Jerusalem interprets the idea of static and dynamic objects scattered at random in the gesture of a sower.

Haber and Shemi (the former working in Paris, the latter at the Kabri Kibbutz in Galilee) also think mainly about the Israeli landscape, Haber in the assembling of monumental stones (the atomic-research center at Newe-Rubin), Shemi with iron scrap that he opposes to the geometric and utilitarian aspect of the local urbanism (plate 228). Their work transcends human scale to join that of infinite horizons.

With Tumarkin the idea of a sculpture-monument becomes defined. Sculptor, painter, and theater designer (he has worked notably at the Brecht Theater in East Berlin), Tumarkin creates monuments destined for a rigid landscape or a public building. His monuments express the meeting of such elements as sun and shade, wind, sea, and rock (colorplate 102). Their form, in reinforced concrete, is on the whole geometric: it shelters the most clashing elements — vegetal, symbolic, or purely constructive — in iron and polyester (sculptures at the Israel Museum, monuments at the Yad Mordechai Museum, in Atlit, and so forth).

The other young sculptors are preoccupied with projects having a more or less direct rapport with urbanism (Buki Schwarts: the fountain-observation point at Elath; Marc Scheps: "Burned Bark" and "Espace de Rêve" [plate 229] series, projects for a three-dimensional city, shown at the Galerie "J" in Paris).

We have said that Israeli painting has tended in recent years to upset the conventional notions of easel painting. Zaritsky (colorplate 103) and Ardon (plate 230) remain the uncontested masters of Israeli painting, so diverse are their paths; their activity, however, goes beyond the limits of this summary. Another painter, Arieh Aroch — a former member of New Horizons — exerted an influence no doubt less spectacular than the two masters but just as important on the young painters. Aroch tried to re-create an image derived from a half-popular, half-childish imagery, based on graffiti, collage, assemblage, photographs, and the free use of pencil — an abstract language as to form, a concrete and nostalgically rich language as to content.

We find the same invention, the same freedom, in Léa Nikel, in the drawings of Aviva Uri, and, pushed even further, in the very young Raffi Lavie. Lavie passed close to Informalism, but his principal concern is the "writing" of the painting, which he wants to be as spontaneous as that of a child (plate 231).

The evolution summarized here has been encouraged by the construction of the Hebrew University City in Jerusalem (ceramic murals by Kahana), of large hotels (Hazaz's wall at the Tel Aviv Sheraton, Siona Shimshi's batik wall at the Tel Aviv Hilton), and of museums (Palombo's iron gates for the Yad Vashem Memorial in Jerusalem, Haber and Dantziger's joint sculpture and Tumarkin's steel monument at the Israel Museum, which opened in May, 1965). Some important shows originating abroad have also helped increase the public's and the artists' knowledge of contemporary art (the Picasso retrospective at the Tel Aviv Museum, the Klee exhibit at the Israel Museum). If happenings, poster art, and Op are not practiced in Israel (the internationally renowned Agam, who lives in Paris, is the only one who works in this direction), the

avant-garde, contact with which was formerly sought abroad, is established even here. Aika Brown, who died in 1964 at the age of twenty-seven, worked in a spirit close to the French New Realism (painting-reliefs with dolls — plate 232); an exhibition of the new 10+ Group at the Artists' Pavilion in Tel Aviv showed for the first time sculptures, paintings, photographs, and optical games — an exhibition in the course of which a collective painting was executed in public, short films by young Israeli movie makers were shown, and electronic music was performed.

Polish Art Today

By Mieczyslaw Porebski

The processes manifest at present in Polish art have long been implicit, but it is only recently that they have become clearly visible. The year 1959 may well be taken as the turning point. In that year, Polish art achieved a number of successes abroad; here we may confine ourselves to mentioning the award to Aleksander Kobzdej at the São Paulo Biennial or the prize won by Jan Lebensztejn at the Biennial of the Young in Paris. Prior to these successes, the work of Tadeusz Kantor had won general interest and recognition. Memories were also aroused of the evolution of the Polish avant-garde between the wars. It was introduced between 1917 and 1922 by the Formists, further defined in 1924 by the Constructivist-Suprematist group associated with the magazine *Blok*, to which Wladyslaw Strzemiński (the creator of Unism) and Henryk Stażewski belonged, and later continued by the Cracow Group that came into being in the thirties and found its fullest expression in the mature work of Maria Jarema.

This may have served to define the place of Polish art in the stream of tendencies at the time. But the "discovery" of contemporary modern Polish art also had certain darker aspects, both external and internal. Externally, the essential traits of Polish visual art were most often reduced to what had been known and accepted elsewhere, not subjected to penetrating analysis. Since the standards applied to Polish art served primarily to discover things that had already been discerned in the art of other countries, this could only have its effect on the internal situation of our artistic life as well. There appeared a widespread tendency to make superficial imitations of what was most modern in others: Action Painting, a cult of the self-organizing pictorial material, spontaneous expressive means that were neither intellectually nor formally controlled. In addition, there was a feeling for visual sensualism that found fertile soil in the tradition of the post-Impressionist coloration that is so deeply rooted in our country. The situation first emerged fully at the Third Exposition of Modern Art in Warsaw, September, 1959.

This situation, however, was not influential in the choice of works to represent Polish art at the Confrontations show organized in the Krzywe Kolo Gallery in Warsaw on the occasion of the AICA Congress. It should be noted that this state of affairs had already given rise to warning voices on the part of our critics. In 1957, I had pointed out myself that sooner or later the art of the early fifties, "impulsive, morally sensitive and uncompromising as it is, and concrete in its sources of inspiration, single-minded in content, inclining toward egocentrism and primitive schematism," would have to give way to an energized reflection, to the gradual regeneration of the inspirational and intellectual factors, as well as to the increasing absorption the diversified experimentation that was going on. In connection with the 1959 show, KTT, the chronicler of *Nowa Kultura*, remarked:

> The magic of modern technique, by now conventionalized and in any case not hard to master, is beginning to fail, and once more artists, as in the beginning of painting, are divided not into the "old" and the "new" but into those who express nothing and those who have something to communicate, into the bold and the timid — in a word, into the clever and the stupid.

The unswerving desire for the maturing need of such a new orientation and revision of the results already achieved, and of a revaluation of currently accepted criteria, was emphatically expressed in the Metaphors show in Sopot and Warsaw 1962. In the intention of the organizers of the show, that watchword "metaphor" was not meant to point toward poetic eccentricity in artistic creation but rather to provide an emphasis on the effort, to reveal the expression of the tension between the image and the context outside it. The idea was that this type of transcendence in painting should contrast with the immanent conception of autonomous form, in which the relationship to reality is limited to the purely sentient emotional reaction. Metaphor in painting should go beyond this superficial level of consciousness and permit the emergence of that "iconosphere" that constitutes the characteristic environment of modern man.

Since that time the new artistic situation, both in Poland and elsewhere, has clarified to an extent that makes it possible to venture a much fuller description. One requirement is that analysis should not be replaced by the hasty comparisons of phenomena on the basis of superficial and often mis-

leading analogies. The attempt may of course be made to show that Polish art today, like that of other lands, has its Pop Art and Op Art, its neo-Dadaism and neofigurativism, just as eight or ten years ago the discovery was made that it had its own geometrical abstraction, lyrical abstraction, Surrealism, and Tachism. Instead, it would be more accurate to try to point out what factors create a peculiar artistic atmosphere in Poland, and in what way this atmosphere influences the interplay of forces and tendencies in our painting, sculpture, and other visual arts.

There is no doubt that the dynamics of Polish art life are dependent upon all the changes in the socio-economic structure of our country. The intensive industrialization and urbanization, bringing about resultant changes in habits and standards of living; the ever greater part played by the media of mass communication in integrating social life; the formation of a mass culture in the modern sense of the term — all these demand a new type of professional artist. His special qualifications find application in industrial design as well as in the organization of the visual iconosphere of large groups of people by means of printing and the graphic arts, exposition and fair architecture, and stage sets in the theater, movies, and television. The days when the Polish poster or Polish exposition technique was an independent enclave of a specific *art pour l'art* are beginning to fade, and the initiators of the well-known Polish achievements in this field, such as H. Tomaszewski and J. Mroszczak, try to impart to their students and successors not only their own inventiveness but also practical, rational methods of analysis and programing of visual mass effects.

In this way the professional artists gains new fields of activity and a new position in society; on the other hand, painting, sculpture, and the graphic arts increasingly lose their professional character, becoming a kind of exceptional dedication, most often combined with teaching, and paid more in prestige and personal status than in money.

Such a conception of the artist's function may well have its basis in the tradition of Polish Romanticism, in which the poet, composer, or painter was viewed by the public as the principal bearer of the nation's creative power and aspirations. Today's situation differs from that of the nineteenth century in that its key problem is far more universal than the conservation and development of the national consciousness. What is involved is the elaboration of a model of our own, or a style of our own, that participates in everything that modern civilization brings with it: the discovery of visual equivalents for the people's technological, philosophical, and moral horizons, the decipherment

of their myths, and the overcoming of the dead points of "petty stabilization" on the one hand and of psychic disintegration and alienation on the other.

In this way an art arises that is more and more marked by a particular intellectual distance to the object, or a cause of artistic stimulus, by the multiplicity of meanings and breadth of perspectives. These perspectives may be various perspectives; they may lead into the past as well as into the future, may be directed at man and his experiences as well as at whole civilizations and their images.

As an example of this we may take the work of Jerzy Nowosielski (plate 236), who aims more and more vigorously at restoring the long-lost formal and rather doctrinal traditions of the ancient and medieval icons. In the painted structures of Tadeusz Brzozowski (plate 233), broken down into their individual fibers, we recognize an artful paraphrase of the mystic Pietàs and Man of Sorrows of the late Middle Ages. But in neither case do we have an arbitrary decision. The cultural sphere with which Nowosielski and Brzozowski are linked arises out of the special position of the Polish cultural domain, which is open alike to the traditions of the Latin and German West and to those of the Slavic and Greek East.

Aleksander Kobzdej ties up consistently with traditions that are closer to us, which treat the picture as a physical object producing its effect by the beauty of its material structure (colorplate 105). For Tadeusz Kantor, too, the painter's art is above all a living seismograph, showing the shifts of an exciting play of situations conducted by the modern artist with the creative possibilities that have been opened to him (colorplate 106). Mikulski directs his attention to the stereotypes of modern man and seeks suitable methods for noting, describing, and analyzing them in painting (plate 234).

All these painters belong to the generation that entered its period of mature creativity in the last few years, after carving out its own ideological and artistic profile and drawing its own conclusion from the trends and influences that were decisive for its formation: from the theories of abstract rigorism, the battle for the pictorial completeness of the picture, and the Surrealists' demonstration of the right to intellectual freedom. This generation, which formed during the war and developed slowly and not without hindrances and temporary obstacles, has been less productive in the realm of sculpture but has produced some first-rate graphic artists, such as Wójtowicz, J. Panek, and J. Kraupe-Swiderska.

Alongside this generation, a slightly younger one that has grown up since the war is assuming an increasingly prominent place in present-day art. Its

members are helping to create a new professional status for the artist as an expert in the modern technique of visual information and in the visual forming of our environment. This function absorbs the great majority of the young people who graduate from our art schools every year, but this integrating trend by no means excludes the natural desire to look for a personal and autonomous creative formula. A number of them combine old and new technologies of visual treatment, passing from painting, graphics, and sculpture to photography, movies, television, printing, and the architecture of space, color, and light. W. Borowczyk, J. Lenica, A. Strumillo, and A. Pawlowski have likewise done important work in these fields. Our leading film directors, A. Wajda and W. Has, are both painters by training.

Among the classical techniques, for which new justifications and applications have been found, two or three well-established orientations should be pointed out. One is represented by artists with whom imagination plays the chief role. This factor does not act as an engine of creativity but is itself an object of observations and operations at a distance, as in a modern remote-control apparatus. There is the cool obsession of Jan Lebensztejn (plate 235), much more intentional than impulsive, the consciously controlled explosive fantasy of Jerzy Tchórzewski (colorplate 104), who does not leave the slightest particle of his fluorescent pictorial substance subject to chance. A different kind of creative distance marks the work of Zbigniew Makowski. It has its roots in the intellectual obstinacy with which this painter and poet juggles with mysterious ciphers of symbols, magic signs and tables, poetic glosses and sketches. Here concepts and alphabets, languages and civilizations mingle, and the function of communication exposes its primary hermetic ambiguity and vagueness (plate 237).

The exploration of conscious and unconscious structures of the world of ideas and language that these artists conduct is supplemented by the penetration of pure sense experience of visual space and tensions. The experimental way of Stefan Gierowski (plate 238), Wojciech Fangor (plate 239), and the highly gifted Zbigniew Gostomski (plate 240) has followed this direction. This trend finds stronger and stronger support in a group of young sculptors and architects, all graduates of the Warsaw Academy of Fine Art.

In this brief survey I have of course been able to refer only to a few tendencies, those which seem to me characteristic of the present and full of promise for the future. They appear against a background of sharply differentiated artistic generations, creeds, attitudes, and trends: from naturalism, which still retains its faithful *petit-bourgeois* public, through post-Impressionistic

colorism, which meets the taste of a more demanding circle, to the various species of abstractionism, which finds a fairly limited response. The essential problems of the Polish art of today, however, seem to be born and decided elsewhere, in the extensive region where the most distant creative traditions of our cultural world encounter new potentialities of visual culture for the masses.

Two Generations of Contemporary Czechoslowak Painting

By Jiři Kotalik

Czechoslovak art has a continuous tradition, although one occasionally broken by temporary caesuras, of striving to take an active part in the solution of the general problems of European development. This tradition is expressed in the sequence and work in common of several generations. The first of these aligned itself, around 1900, with Impressionism, Symbolism, and Art Nouveau. The next generation, in the years before World War I, took up and developed the problems of Expressionism and, especially, Cubism. The third generation, which came to maturity between the wars, is marked by the chasm between socially oriented realism and the tendencies toward Surrealism. Some artists of the second and third generations helped define the paths of Czechoslovak art after 1945 by their creative contributions and their teaching; many are still the pace setters and embodiments of the renewed continuity of development. Nonetheless, if I am to present a selection of names in order to sketch the present state of Czechoslovak painting, I shall concentrate on the work of the two most recent generations. I feel that their intentions and results, in the effort to achieve diversity and plurality of methods, richness and polyphony of means of expression, give the most characteristic idea of today's prospects and problems. This concern with diversity corresponds to the essence of modern art, whose course cannot be set forth as a linear sequence and mechanical alternation of artists' views and forms but is rather to be explained by their connection and polarization, interpenetration and resonance. There is a creative dialectic in the interrelationships of the Czech and Slovak cultures, based on many coinciding views but also on evident expressive differentiations. In the work of Czech artists, lyric quality and balance can often be regarded as characteristic, while the contribution of Slovak artists can be seen in the balladlike intonation, frequently rising to the dramatic.

We consider first the generation that came to the fore on the eve of World War II, whose development was interrupted and whose mental state was thrown into turmoil by the years of crisis. They fell into apparently contradic-

tory groups between 1939 and 1948 (Seven in October, Group 42, Group R, and, in Slovakia, the August 29 Group) but were still connected by the common need to react to what was happening and to bring the inner and outer worlds into accord. Within the realistic trend are artists interested in both the world of nature and human events, in the familiar things of daily life. In the foreground of these efforts are the pictorially smooth, spontaneous, yet solidly constructed and colorful pictures of František Jiroudek (plate 241). Simpler in expression are the works of Arnošt Paderlík, accented in a surface solution that still sings the pure notes of Czech folklore. Another solution (today in evident transition into the fantastic) can be recognized in Josef Liesler, with his technically brilliant but internally disunified paintings and graphic works.

The second trend is represented by artists who have been battling for years to express the contradictory and deceptive reality of the modern world by stressing the semantic aspects of the creative idiom. František Gross's sorrow-laden pictures, animated by the sheen of civilizing machinery, bring this out in spatial collisions and in the significant tension of strikingly constructed forms (colorplate 107). Kamil Lhoták sees the world in terms of boyish adventures; his oils and drawings present enchanted chance encounters of things and machines in a bare landscape, in which reality and dream constantly interpenetrate (plate 242). Another viewpoint is represented by the elemental, life-hungry paintings of Karel Souček, which try to express the nervous unrest of the spatial and luminous rhythm of the great city. František Hudeček, in imaginary visions of a city and the universe, and Jan Smetana, in pictorially broader and more color-compact landscapes of the outskirts, have recently been returning to the certainties of their earlier work.

The third tendency, becoming stronger today, conceives the picture as an autonomous structure giving an immediate expression to personal experiences and ideas. In this respect Jan Kotík attains equilibrium between an expressively intuited action and well-considered Constructivity in pictures that are outstanding for the measure and purity of their pictorial means, for their clear, even gay, speech (colorplate 108). The Surrealist experience is still evident in a number of artists: Josef Istler, whose paintings and lithographs have taut, crystalline forms illuminated from within by the strong light of imaginative intuition (plate 243); Václav Tikal, in the significant and expressive contraposition of natural forms to the complicated world of modern technology; and Bohdan Lacina, whose works present calm, exquisite evocations of ideas from the realm of musical and mathematical order. Surrealism is also evident in the complicated oils and drawings of Zdeněk Sklenář, where fantasy plays a

Fig. 3 Vladimír Tesař
b. 1924 in Prague, Czechoslovakia
Lives in Prague
Target. 1965. Colored woodcut
$15^{3}/_{4}$ x $11^{3}/_{4}''$

leading role, fed in part by recollections of Giuseppe Arcimboldo and the bizarre Manneristic milieu at the Prague court of Rudolf II and in part, in the ornamental paraphrase of hieroglyphics, by old Chinese culture. A free combination of imaginative ideas and formal abstraction marks the paintings of Ota Janeček, which develop formal parallels between the organic and inorganic worlds.

Slovak painting of this generation is dominated by the striving for understanding and expression of the time and its events; the dramatic content necessarily includes the problem of man, his character, and his fate. This emerges in the epic mood of the oils and pastels of Ján Želibský, as well as in the compositionally more collected weight of the paintings and drawings of Peter Matejka. More emotional is the creativity of the somewhat younger wave, whose chief representatives are Ladislav Guderna, whose spare, Constructivist, almost statuesque paintings and charcoal drawings aim at a balance between painterlike and plastic values, and Ferdinand Hložník, who creates free transpositions of the picturesque atmosphere of mountain villages of wooden houses (plate 245). Many of the artists are prominent in monumental decorative painting, with

large projects connected with architecture, as in the expressive and intellectually conceived works of Ladislav Gandl.

The new wave is represented by artists who began creative work after World War II. Their first steps were impeded by lapses into treating art as dogma, which were overcome after 1956. Their work therefore had to be all the more collected, and for personal reasons the artists united in a number of creative groups (Trasa, Máj, UB 12, M 57, Etapa, Radar Group D, Crossing, and, in Slovakia, the Mikuláš Galandas Group). By and large their work lacks drama: it is poetic and bright, bold and self-conscious; these artists, at first without direct contact with world developments, found their own way into the problems of modern art and creatively reestablished the continuity of their native tradition.

This generation, too, is marked by visual diversity in the arc between inspiration and artifact, but without any sharp boundaries and harsh transitions. The inner and outer worlds of the artist are no longer merely coordinated but often identified. A mature and purposeful personality is the painter and graphic artist Jiří John. His work is continuous and smooth in its poetic and meditative reworking of natural phenomena — landscapes, rocks, flowers, clouds, water — into symbols concentrated in form and color (colorplate 109). Visually near him is Čestmír Kafka (plate 251), in whose paintings and monotypes, however, prevails a Constructivist emphasis supplemented by a striving for fuller development of the surface structure. The paintings of Bohdan Kopecký have a rougher and more real accent, based on his long residence in the industrial landscape of northern Bohemia; the masses of land and coal are expressed in the dark-blue and opalescent twilights of mellow layers. The paintings of Josef Jíras show pictorial spontaneity, with elastic outlines and smooth patches of color reflecting the expressive unrest of a personal confession.

In the abstract current, some painters aim at clearly defined results; for them the picture is a product of complicated psychic processes and the expression of inner intuition. They use as their springboard many newly adopted Surrealist motifs. Mention should first be made of Mikuláš Medek, whose complex, refined, and symbolically ambiguous paintings are executed in summary forms and magically shining colors, evoked and swallowed up in darkness (plate 246). Milder and more moderate, without any strong effects, are the oil paintings and graphic works of Jiří Balcar, with their fusion of structurally vivid surfaces and calligraphic signs; they are inspired by feelings of confusion and absurdity, and often suggest the tortured world of Franz Kafka. Recently, attempts at a thoroughgoing mathematization and geometri-

zation of creative expression have come to the fore, which Zdeněk Sýkora has taken over into his work without any particular contribution of his own.

In general, the painting of this wave ranges far and wide, for several other visual trends are moving in a similar direction, touching and penetrating one another, whether in the free creative reflection of experiences of nature, as lyrically expressed by Adriena Šimotavá and Oldřich Smutný or abstracted by Vladimír Vašiček and Ladislav Karoušek; or in the striving for spatial and material metaphors of reality, in the balance of objective and subjective points of view, in František Ronovský and Milan Obrátil.

Slovak art of the present is also getting new traits from the youngest generation, whose members are creatively developing many of the themes of the native tradition in a more radical formal idiom. Their views may be characterized by the striving for a dramatic conception of art with a markedly humanist trend yet with a subjective and introspective attitude. This is true especially of Rudolf Krivoš, who concentrates on the creative representation of man and his fate, using a dark, velvety palette (plate 247); Milan Pašteka, who uses drastic, expressively represented forms; and Milan Laluha, whose

Fig. 4 Jaroslav Serych
b. 1928 in Havlíckuv Brod, Czechoslovakia
Lives in Prague
Impression. Mixed media. 21¹/₂ x 36″

paintings, powerful in form and color, faithfully reflect the picturesqueness of Slovak nature. Marian Čunderlík follows Abstract Expressionism, with an open calligraphy and color and a complicated, restless reflection of internal ideas. The paintings and collages of Andrej Barčík show architectonic rigor and measured expression while reflecting the deep experience of old folk myths (plate 244).

Sculpture and Drawing

In plastic art, as in painting, a differentiation in expression may be seen.

The way of the Czech generation born around 1910 is presented in Karel Hladík's solid development of lyrically shaded modeling to tectonically self-enclosed yet always poetically formed figures in wood and stone (plate 250). In Ladislav Zívr's spatially contorted metaphors of forms and ideas (obviously related to Surrealist poetics) and in Vincenc Vingler's mono-thematic restriction to the animal world, the predominant urge is toward a summary lapidary solution of the plastic structure.

Among Slovak sculptors, a prominent place belongs to the work of Jozef Kostka for its soft sensitivity of modeling, in which poetic vision harmonizes with the solid structure of the masses. The scope and intensity of this artist's work can be seen even more clearly today in his strong and free drawings. The center of gravity of the work of Rudolf Pribiš lies in his reliefs, which comprise not only precise medallions but monumental projects, conceived in a sound and clear but sometimes cool composition. Rudolf Uher's sturdily formed sculptures, with their stress on the natural quality of the material and on immediacy of experience, are marked by the bold solution of formal problems, sometimes with a touch of improvisation. A more measured and concentrated effect is produced by the works of Alexander Trizuljak, which aim at structural liberation.

There are many names in the latest wave as well, but the common de-nominator of the rich list of individual forms of manifestation may be taken as the drive toward *directe taille*, the direct working out of an idea in the material, primarily in stone, wood, and steel. In the foreground of the markedly tectonic interest is the firm, sturdy, and communicative creativity of Miloslav Chlupáč. His structurally rigorous and sharp work is marked by the characteristics of sculpture in stone, as are the formally enclosed sculptures of Zdeněk Palcr. In Olbram Zoubek and Eva Kmentová the

Constructivist purpose is escalated into spare, almost ascetic forms, often having the value of verbal signatures. In contrast, Stanislav Kolíbal bases his sculptures on the dynamics of volumes and their external and internal measure.

The other major current in the work of this generation links expressiveness with an ever watchful interest in the human form; the modeling often has psychological concerns. This holds true for Vladimír Janoušek, an intellectual artist with the ability to solve demanding monumental tasks connected with architecture (plate 249). More intimate, and with a more penetrating inward look, is the work of Věra Janoušková, among whose latest works are eloquent metaphors of the grotesque and the tragic. Within the broad limits of this strong current, the striving for the dramatic frequently appears. In Mojmír Proclík it occurs in the spatial forming of the masses; in Zdenka Fibichová it determines the internal cohesion of organically derived forms. Certain expressive aspects also occur in the work of sculptors with an expressly figurative orientation, as in the case of the meditative Stanislav Hanzík and the rougher and more obvious expression of Jiři Bradáček.

Within the third current, marked by a tendency toward imaginative transposition of actuality, Vladimír Proclík obtains notable results; his woodcuts, inventive in form and sometimes comically pointed, are related to the old traditions of popular art and tend to be directed against the dehumanizing mechanization of modern times. Zbyněk Sekal reacts out of similar ideas, but with different methods and results. His sculpture is strongly architectonic, and the idiom of his wood and metal reliefs, linked with elements of an assemblage of complicated and distressing reality, is direct and unmasked; his works voice the feelings of a solitary, sometimes almost anguished, introspection (plate 252). This is also the meaning of the creativity of Karel Nepraš and his intricate, disquieting "glands" of metal objects, metaphors of the *Castle* or other Kafka fantasies. The imaginative orientation of some of the younger generation shows obvious traits of literary inspiration. In part this is also true of the expressively furrowed sculptures and reliefs of Jan Koblasa, which seek to evoke the insistent idiom of magic idols in an interpenetration of sculptural and pictorial principles, but whose intensity sometimes becomes monotony. Pavel Krbálek shows good understanding of the compositional and expressive possibilities of steel in his elemental constructions, which occasionally have a superficial decorative quality. In his harsh effort at rather cold mobile constructions of metals and plastics, Jiří Novák too does not always avoid this danger.

Fig. 5 Albín Brunovsky
b. 1933 in Zohor,
Hungary
Lives in Bratislava,
Czechoslovakia
Exmaster. 1965
Etching. 13 x 19¼″

Among younger Slovak sculptors the most mature personality is Vladimír Konpánek. Constantly inspired by life on the land, he expresses the inner bond of man with nature in clear, comprehensible forms (plate 248). The work of Pavel Tóth and Antonín Čutek is marked by a similar struggle to obtain a stern and sober tectonic order; they are more matter-of-fact in their attitude and more complicated in their composition, often with a hint of decorative stylization. The same danger sometimes affects the thematically assertive spontaneous creativity of Ján Kulich. Jozef Jankovič and Andrej Rudavský bring the tension of new problems into Slovak sculpture; they are two elemental talents, gifted with an impressive mass of inner expressive force, but as yet unconcentrated in their means of formulation.

In graphics the preponderant contribution has been made by Slovak artists, with Vincenc Hložník at their head. This artist's many-sided work expresses the anxieties and hopes of the times he has lived through, with occasional accents of inner pain and contemplative meditation (plate 254). In contrast, the works of Orest Dubay have a calm, terse quality; their flat solutions are in some ways reminiscent of traditional old woodcuts. In Bohemia, too, we find frequent creative evocations of the world of popular art forms: in the drawings of Jiří Trnka, which are foils to his enchanting puppet films; in the work of Antonín Strnadel, which reflects the fantastic tension of folk myth; and in the precise lines of Adolf Zabranský's illustrations. Jiří Kolář is at the boundary between visual art and poetry; his work tests the poetic

possibilities of graphic expression in collages, rollages, montages of letters, and so forth. Although these pieces often seem to be only games, they have a significant drive, often connected with the neglected field of the folklore of the big city.

The younger generation, whose representatives matured over an extended period, has stood for the creative renewal of graphic techniques as a direct medium of personal visions and ideas. A conscious thematic program, but expressed in the language of purely visual metaphors, prevails in the graphic cycles of Vladimír Tesař (Fig. 3), inspired by the links of human fate to the times. In a woodcut technique of more robust structure, and tending more toward the epic, Karl Hruška produces cycles of figures and scenes from Shakespeare along with pictures of sports events. Ladislav Čepelák has for years presented a sober, straightforward orientation in graphically polished landscape drawings. A similar starting point was chosen by Pavel Sukdolák, but today he transforms events in nature into poetic surfaces and formal emblems, in colored etchings full of lyric, purified harmonies (plate 253). The graphic works of Jaroslav Šerých are concerned with the balance between formal dignity and inner content; they too are colored etchings, realized by the fusion and interpenetration of abstract forms with dynamic, even hard, structures (Fig. 4).

In Slovakia the younger generation of graphic artists, for all its individual differentiation, shows a unity in expression — an epic quality, with a picturesque attitude and expression. This can be seen clearly in the technically mature work of Ján Lebis and Viera Gergelová and is also characteristic of the more intimate work of Viera Bombová and the figurative papers of Josef Baláž. The precise forms and expressive suggestion of the graphic work of Albín Brunovský embody principles of Surrealist poetics. Their half-grotesque, half-tragic world is symptomatic of a heightened effort to communicate meaning and to make statement intense — not only in its outward description, but in its inner, highly personal vision (Fig. 5). This is an essential feature of the impressively talented generation of Czechoslovak artists now coming on the scene, searching for the clarity of their way.

Yugoslavia

By Zoran Kržišnik

After the fury of four years of World War II on Yugoslavian soil (which demanded, like a tithe of blood, more than a tenth of the population), and after the first difficult postwar years, when all the strength that could be spared was engaged in the reconstruction of a country that had been literally destroyed — after all this, it was necessary not only to replace that which had been destroyed materially but above all to overcome the extremely bitter emptiness entrenched in the ranks of the generation that should at that time have been at the peak of its work potential and creative force. Around 1950, the nation's artistic life reached a state of normalcy. To the foreign observer of our artistic evolution, and to the native artists who participated in it, it must have seemed even more that we had arrived at a veritable renascence, a regeneration of the whole artistic climate; it must have seemed that in a few years, almost in a few months, we had come further than in the previous ten years. There were many reasons for this, and each has its importance, even if the final result is not their sum but, on the whole, their product. The new generation, which entered the scene all at once, like a solid phalanx, and filled the yawning gap, had arrived at its maturity. These were the artists who were born between 1920 and 1930; but an even younger generation very quickly and impetuously joined them, the generation that is today around thirty years old, which already furnishes most of the exhibitors at national and international shows. The need, according to which art must be engaged in a direct, activist manner, as a fighter for and propagator of progressive convictions, was eliminated; the self-styled "social realism" that in the first postwar years had taken the leadership of art and resolutely, if only transitorily, eliminated all the other attempts at style — or had at least driven them back in a painful defensive — had suddenly become one of many possible artistic conceptions, and the works created in the framework of its hypotheses began to be treated according to the same principles as the works of all the other stylistic currents: that is, according to quality. Moreover, Yugoslavia was by then able to open

more largely to the outside world and had begun to show itself in the international artistic arena: at the beginning still cautiously and clumsily (for the tradition that prevailed and was understood in the arena before the war was feeble in Yugoslavia), and then with the bold rapture of the young. The international exhibitions introduced the first serious confrontations with contemporary creation in the other artistic centers and made it possible for Yugoslavian art to measure its strength. And the result of this measuring was the organization of the International Biennial of Graphic Art in Yugoslavia itself, in Ljubljana, as it was the most convenient place for a huge periodic exposition and at the same time was probably the place where the country's graphic creation was concentrated. Evidently the idea and the organization of such a vast meeting was already part of a further phase of the artistic evolution: the first echo of the sudden feeling of freedom was the enthusiastic adoption of new artistic attainments and manners, a veritable greediness for rapid and direct communication with the creators of foreign artistic centers in their own artistic language. That could not last long. And in truth, as soon as the first wave subsided, the foaming tide cleansed itself and the familiar configurations of submerged areas appeared — or, to drop the metaphor, the Yugoslavian artistic tradition reaffirmed its organizing, formative, and evaluative influence.

Under the term "tradition" in this sense must be included many factors. Above all, the "modernists" very soon had to make room for certain older artists, masters who had their place in European art even before the war, and who now, on the solid foundation of their earlier work, continued to develop their own pictorial manner, sometimes reaching such arrestingly strong and extreme solutions that for several years these older artists retook the lead in the Yugoslavian artistic milieu. These representational artists belonged mainly to two currents — Expressionism and Surrealism — which, in the period between the wars, prevailed in this multiform and diverse country. It is apparently impossible to draw a geographic line of demarcation between the spheres of influence of these two currents; it is admitted, however, that the artistic circle that chose Belgrade as its center inclined above all to Surrealism, and that the most northerly part was on the whole under the influence of Expressionism. And even in the bosom of Expressionism the nonobjective current began to manifest itself. Its first attempts appeared before 1920; now it took a great leap.

A characteristic example of an artist who went from Expressionist beginnings, passing through a brief intermediary realistic period, to the nonobjective, while gaining in quality, is Petar Lubarda. (In this brief summary we can cite

particular artists only as examples, representing characteristics of this or that style, school, or artistic principle. Even a fleeting presentation of all those who deserve attention by virtue of their artistic strength would lead us beyond the permitted framework; on the other hand, a mere list would be meaningless.) A Montenegrin by birth (and a giant by virtue of his artistic scope) Lubarda derives his boundless inspiration from the sun of the country, from the landscape of bare monuments — carved not by man but by nature — and presents us with the magnificence of blocks of stone, of sculptures not finished but only indicated, which excite the imagination to dreams of permanence and eternity. (There is little greenery on the rocky earth of Montenegro, and what there is must fight savagely for its existence. And even an incessant effort squeezes out of this miserly soil only a little more than do several rapid blows, with which one wrenches the necessities from nature. The rest is eked out by conversation, song, and meditation.) Like the Greece of antiquity, Montenegro is a land of elements: its soil could easily have given birth to the doctrine of air, water, earth, and fire, the four basic elements. Here the sea is deeply blue, the color of marble, green and azure; here the sky is as deeply blue; here the land is rocky, burned white in the heat or thrown into eager ecstasy in the rare moments of rain. And here is the fire of the artistic temperament, which consumes that which is created and vomits forth new images, introducing motion into the eternal calm, an ephemeral moment into the secular time of existence. Thus are born paintings that Lubarda calls *Montenegro, Torch, Conflagration, Desert Winds.* It is evident that an art coming from these foundations is monumental and that the canvas only replaces the wall on which it will radiate, or the cliffs destined to carry its ineradicable traces. That is why Lubarda works with large surfaces and sharp accents; that is why he deems white a primordial background material and treats red blots like living springs of vomiting fire, which is from time to time cooled and damped, at other times permitted all its violence and allowed to spread out on almost the whole surface of the canvas. Lubarda's art, although nonrepresentational, remains in motif close to Expressionist allusion, which so far has in no way disappeared from his work. This art is typical of a strong contemporary current.

Another road starting from Expressionism was traversed by Marij Pregelj, of Slovene birth and at present probably the most consistent and systematic representative of the art called thematic, who has shown the advantages — and limitations — of that point of view not only in his paintings and engravings but also in his large mural decorations. He is inspired by a theme, which he tries to surround definitively and to exhaust by an adequate formal treat-

ment. It is essentially a question of a representational art with formally modern permutations, which are characteristics of the most different styles. Pregelj understands painting as a sort of staging of formal knowledge pushed to the limit, and for the aid of that staging he obtains very often surprising and always monumental solutions. For him color signifies proportion; details — even the narrative of the picture — submit to the demands of the total, of the epic meaning. Each detail receives an accent equal to its actual significance, while the composition is one of innumerable possibilities for presenting that theme, and its worth is to the degree of its accomplishment. Pregelj's experience is of a spiritual nature — the response of contemporary man, of the man of intellect, of culture, and of knowledge, to unrestrained forces from the irrational, from nothingness, from the inhuman. (His work is not just a protest but also the creation of positive values, the peopling of the world of the human spirit with new objects of thought and knowledge.) The stiff ritual poses of his figures recall a living Byzantium, although in his work one cannot speak of a traditional incorporation of the Byzantine representational world. It is a question of an adopted kinship, of the conscious use of means that in earlier times spoke of large permanent things, of human existence in a tortured time that endlessly transforms itself. (Besides, the immobility of Pregelj's ritual personages is problematic: the more they digress from the real world of our daily experience and tend to become symbols for him, the more expressive is their capacity for metamorphosis from one symbol to another, from one sign to another.)

Thus we have in passing indicated the second class of tradition that undoubtedly helps form the image of contemporary Yugoslavian artistic creation. Yugoslavia is among other things a treasure house luxuriously rich in medieval frescoes, scattered in the churches and monasteries of Serbia and Macedonia, some of them newly discovered under plaster in mosques, some of them for long centuries the object of pious veneration and of the first artistic discoveries. As do the dark icons, with their dull gold backgrounds, they belong to the heritage — ancient, but never extinguished in Byzantium — that found among the Slavs the freest, most sensitive, and most vital worshipers. But regardless of that, the golden brilliance of the Byzantine mosaics, their noble and restrained coloring, the severe ritual and monumental character of their composition, the unity of conception, and the striking bearing of the figures — all continue to live in the consciousness of the descendants of Byzantium, just as it is possible to find elements and reflections of ancient icons in the works of certain of the most modern artists.

The hundred-year-long Turkish domination in certain regions of Yugoslavia

brought with it particular forms of architecture and a rich Oriental ornamentation; this was united in new, precious combinations with the ornamental motifs that the Slavs still preserved in their primitive native land. The influence of the neighbors to the north and to the west was even stronger. From the north broke the heavy wave of religious art, which tended to refined coloration and emphatic expression, and which blended itself with the Mediterranean culture, which was more concise, less spiritual, stronger in color, more finished in form, with much less atmosphere but with a much gayer outlook on life. An early heir of these two currents is the Surrealist Vladimir Veličković, who in the agony of the twentieth century revives in a surprising manner Michelangelo's, Titian's, and Bosch's expressivity.

The third stratum of tradition is the markedly social art of the thirties, which was on the one hand inspired in such a creative manner by popular art and on the other hand so deeply an influence upon it that in certain unusual works it is difficult to say where the one begins and the other ends. We are thinking here above all of the work of the Zemlja ("Earth") group and its incontestable ideological and artistic leader, the painter Krsto Hegedušić. An organization of progressive, socially committed Zagreb artists, Zemlja was founded in 1929 (the first year of the world economic crisis and also the year when in the Yugoslavia of old the most severe police persecution of progressive forces began) and lasted until 1935, when it was officially banned. The work of the members of Zemlja, with its sanguinary motifs of peasant and proletarian life — violence, persecutions, hangings, and shootings on the one hand and the suffering of the rebels on the other — signified a large mobilization of progressive forces; at the same time, Zemlja also produced several really important artistic works. And Hegedušić, the initiator and secretary of the group, almost simultaneously transmuted the revolutionary traditions and the art of battle in the Croatian campaign, where he sought inspiration of form and content in direct contact with the oppressed peasant; and at the same time, through the organization of the so-called School of Hlebine, he set in motion among the peasants themselves the excellent artistic invention of "primitive" Yugoslavians.

After the war, the rich and extremely interesting art of the primitives acquired a great and deserved popularity through its exhibitions in Yugoslavia and abroad; it is, however, a lateral branch against the mainstream of the evolution of Yugoslavian visual art. But it is impossible, in speaking of contemporary Yugoslavian painting, to bypass the work of Hegedušić himself, whose art from 1929 to the present bears witness to a moving homogeneous vision and, in the use of pictorial means, to an almost equally arresting evolution,

Fig. 6 Miroslav Sutej. b. 1936 in Duga Resa, Yugoslavia. Lives in Zagreb, Yugoslavia
 Emerging Forms 7. 1965. Ink. $19^{3}/_{8} \times 15^{5}/_{8}''$

since in *Water Corpses, Milkmaids, Morning,* and his other recent works he uses the Surrealist discoveries and the newest attainments of abstract art with equal assurance. It is precisely these discoveries that introduced here and there in Hegedušić's new paintings a lightly ironic tone that was not there before, a sort of private game with people and place, a hint of caricature; but in spite of that it remains Hegedušić (who in fact was never a "realist" in the historical sense of the word), a powerful central pillar of the directly socially committed art and an eloquent confirmation of the fact that the weakness of numerous postwar "Surrealists" was not in the doctrine but in their creative ability (plate 255).

If the folklore and primitive art have no direct action on the main evolution of Yugoslavian visual art (evidently the folkloric elements have supplied and are still supplying many artists with well-considered modernist paraphrases), we cannot say the same about the eventful substratum and formal expression of children's drawing (today exploited in the world, according to all reports), that grand stimulant of the artistic *detente.* Inspired by children's drawing and even more by children's sensitivity, an expressive psychologist among Yugoslavian painters, is Gabrijel Stupica, a very subtle artist who as a painter in all his long evolution (from Expressionist beginnings, through a realistic period, up to the present) interested himself above all in man — as a model and even more as a presence in the painting. His inspiration has been in a great measure in the portrait; in passing by way of of the psychological portrait to the "portrait" in the classic sense of the term, where the facial expression and the characteristic gesture are paramount, and where the phenomena and objects of the external world play only a secondary position, he came to a psychological presentation with a choice and a disposition of objects — in the majority even truly "exterior," used as collages — in which only later do several features take a human form and even a resemblance to the model. Particularly illustrative from this point of view are his self-portraits, where the detailed knowledge of the model's spirituality places the appropriate material in the artist's hands — be he working from a perspective chart or on a middle and distant ground, for Stupica's painting also incorporates, in a sovereign manner, the cinematic view (plate 257).

As he is an excellent draftsman, he inevitably achieves the personality of the man or the object in restrained strokes, even when he doesn't seek it but voluntarily leaves the designation and the creation of the "aura" to the personality of the objects: to the parts taken in the mixture of clothing, photographs, buttons, napkins — used "actually" or "figuratively." In the frozen world of his

whites, blues, and pale grays, the black strokes of the contours are like wounds; his dry expressivity betrays in a characteristic manner Stupica's artistic continuity.

Oton Gliha has taken still another road: his beginnings are in the tradition of Cézanne, but his projection soon became flatter and flatter, while the warmth of expression increased and the constructive power of his color became fulfilled and consolidated. His stone walls evoke the dull poverty of the soil of his littoral Carso, the precious arable earth encircled by high restraining walls of stone built as protection against the wind and also because there is no place to remove the stones to. The inspiration is again based on the objective, on the landscape, while the execution shows an unusual veiled variant of Expressionism in colors.

A number of the important postwar realists have now linked their work to their beginnings and to their experiences of many years of creation and, in the presence of impulses that made irruptions in Yugoslavian artistic life, have re-created and are still creating works characterized by the strong individuality and mature mastery of uncommon artists. The youngest, those who were artistically formed only after the war, evidently did not begin with the experiences and the surmounted disappointments of the older generation: they rediscovered the possibilities of painting and hurled themselves into the whirlpool of visual creation in the contemporary world, into its primitively new schools and currents, and also into the vagaries and thoughtlessness of fashion. For certain extremes only time will no doubt have the final word, but it is certain that, particularly in Zagreb, an important group has formed of those adept in the self-styled "new tendencies" of Pop Art, Op Art, and of the international style in sculpture that numbers among its leaders the painter and printmaker Ivan Picelj, until very recently the most conspicuous representative of geometric abstraction — a current indeed little esteemed by Yugoslavian artists. Picelj's paintings and silkscreen prints have extremely pure and disciplined surfaces, in which skillful intertwining creates compositions of an uncustomary care and of an aesthetic effect (plate 262). Next to him, Miroslav Sutej, who also works in silkscreen, seems at present the purest exponent in his milieu of an expressive and almost organic Op Art (Fig. 6).

The persistent seduction of Yugoslavian artists by styles in which sentiment plays a small part or — theoretically — is completely denied, and, to the contrary, their inclination for all that signifies an emphasis of emotional elements, of the state of the soul and of the memory of the artistic vision, cannot be only the result of a momentary state in the evolution of society and the milieu but

must be rooted much more deeply and probably even form the first fruits of the so-called national temperament. It is apparent that with such predispositions the challenge of Pop Art had more effect than the geometric styles, although above all through its "romantic" consideration of the state of the soul. In its framework today Bogdan Meško creates his *Beatles,* his *Memories of Proust,* and his *Sparks of a Happy Satyr* (plate 261) — a rather surprising development for an artist whose point of departure was to some extent close to Hagiwara and his vulnerable warriors. Almost in harmony with the principle whose extremes they touch, the very personal pictorial world of Marko Šuštaršič is also found on the border of Pop Art, although his sources are elsewhere and his path of development straight, to the point where his contact with the tendencies of Pop Art (at least in superficial appearances) seems truly accidental. For form Šuštaršič is inspired by folk art, and for content he is dedicated to the point where the small and the large things of life meet. He is inspired by a sign, a piece of painted wood, on which a conscientious hand has painted that which has roused and internally seized it, while adding to it a series of elements that "have their place" in painting: decorative ornaments, symbolic accents, signs, of which it is impossible to decipher the significance and which tradition has consecrated. (And the coexistence of all that with the village path and the open country behind the sign: a coexistence of painting and nature so close that it is almost impossible to see anything else.) Are there only associations or is there real inspiration in Šuštaršič's painting? We undoubtedly find in it the motifs of popular ornaments, intense colors, the clumsy workmanship of primitive painting, the pictorial surface finished toward the top and side, the self-renewing motif of that surface, of that sign in the painting, so that each figure is arranged within the closed loneliness of his cupboard, like a ship's model in a bottle (plate 263). Is it necessary to emphasize to what extent such an art is a peculiar variant of Surrealism and that Šuštaršič belongs — regardless of the first fleeting impression — to the style that has given, besides Expressionism, terseness and interest. Belgrade is the traditional center of Surrealism, and although for the last decade we have no longer been able to speak of the artistic centers of old — Ljubljana, Belgrade, and Zagreb — as centers of an expressly regional aspect, the artists still join themselves to their geographic position by their inner affinities; it is also true, according to a certain law of reciprocal attraction, that representatives of an allied stylistic idea very often settle in one area. Šuštaršič, the young Štefan Planinc, and the very interesting, literarily inspired master of the interregnum generation, France Mihelič, indeed represent three generations of north Yugoslavian Surrealists.

But quantitatively the incomparably strongest group is that of the Belgrade artists of the same artistic conception, among whom in recent years the monumental Vladimir Veličković distinctly stands out (plate 259). His imagination is stimulated by the reality of Hiroshima, of concentration camps, and of strongly sadistic experiments on men and animals in the name of science. In addition, formally his work seems a spiritual kin of Dürer's Apocalyptic woodcuts, the pitiless etchings of the Dutch naturalists, and Leonardo's anatomy drawings. The penetration into the kernel and essence of things signifies for Veličković the separation of harmonious and favorable fantasies, thereby unveiling the rottenness hidden under the seemingly flourishing flower. He is interested in mortal combat, then in agony and decomposition. Not in death, because death is so definitive and is the possibility of a passage to a new life, but in the fall of something great into the abyss of nothingness and the hopelessness of decay and decline, which in his judgment is the most characteristic essence of all that is earthly. (The actual forms of decay are the basis of his bold visions. There is no way out except in the fact that one is confronted with reality in its most hideous aspect and that one receives it inwardly.)

Next to Veličković, his contemporary Radomir Damnjanović — who skillfully combines the Surrealist tradition with the boldness of Pop Art — is literally a placid artist. Damnjanović is a native of a region where there is a strong Moslem artistic tradition with an extremely developed and expressive ornamentation. The sense of ornament, of its expressive power and exuberant serenity, is apparent in Damnjanović's abstract canvases, in which a sinuous stroke takes the place of an ocean, a truncated pyramid replaces man, dotted lines a sandy beach, circles and half-circles architecture — where an agitated, amusing, multiform world opens before us, the world of youth, a world that only awaits its conqueror. (The language of symbols and ornaments has a particular advantage: it is never possible to solve it completely; with a unique significance, it always contains something original, a bit of mystery. In the clear surfaces and clean lines of Damnjanović's abstractions, that element of mystery is particularly welcome: it gives another dimension to the canvases; it extends their influence into the realm of the spirit.) And Damnjanović is not afraid of emptiness. The vast monochromatic background is as much a part of the painting as the forms that Damnjanović arbitrarily fashions, an integrating part of that world identical with the goal, organized and mastered anew each instant (plate 258).

Miljenko Stančić and Vasilje Jordan, from Zagreb, are excellent representatives of a more moderate and more lyric Surrealist vision, which achieves,

particularly in Stančić, often slyly ironic effects. Different again are the monochrome "abstract landscapes" of Andrej Jemc, from Ljubljana, with their strong Surrealist accents (plate 264).

Also from Ljubljana is Janez Bernik, the representative of the generation of the thirties who has obtained the greatest number of international prizes and national honors. He has, for so young an artist, already covered a very long path of development and given each phase several masterful solutions. From representational beginnings he passed to paintings of mass, which in the last phase were drenched with spirit, at first like a gash or a wound in the primitive magma, then by the separation of darkness and light with the division in two of the paintings or graphics, in which one clearly reads the material half, chaotic, and the spiritual half, structured. The structured spirituality is soon explained by his symbol: the letter (colorplate 111). This testimony of the victory of man's spirit over the mass, of the power of human communication — and with that of the symbol for Man himself — reveals Bernik's intellectual as well as his decorative richness. The coloration is calm to the extreme, the surface rationally divided and as rationally filled; the painter's sensitive impulse remains outside the picture — it is the harbinger of Bernik's neatly aware and controlled creation.

Edo Murtić creates in the grand tradition of Action Painting, although he is perhaps more strictly linked to organic forms (colorplate 110). But he expresses himself in an eminently figurative manner, with a bold use of colors, with a bold and solid composition whose solidity is all the more amazing as Murtić's theme is dynamic in the extreme — his invariable motif bare "creation," conceived as an eruption — an explosion. In the bosom of the primitive theme — black, blue-gray, rusty brown — is born the explosion of colors. They make the background shine — at least on the edge; they extend to the left and right in space; they crystallize in the center. Or they even stop immobile for an instant — an unreal moment, similar to the immobility of a photograph taken in a thousandth of a second. In this congealed explosion the creation of a myriad universes is captured. But this creation has nothing in common with the Biblical one. The systematic sequence is destroyed; time and temporal perspective have not yet been born, all is simultaneous, all is now, at once only an instant and more than eternity: a new glance at Something, born from Nothing. (This creation, which is outside of the organization of time, evidently is nothing but primitive chaos. All is powerful, valuable, and necessary. The spectator has only one choice: to accept this vision in its entirety or to reject it in its entirety.)

Zlatko Prica is an artist endlessly attracted by the organic world. With the

nervous and complicated mentality of today's man, he penetrates the elementary facts of conception, of maturation, of the simple yet mysterious roundness of fruit. While as a colorist he is a product of post-Impressionism, he stopped in passing at the sober coloration of folk art and approached the deceptive simplicity of large surfaces of pure colors. (He likes red, yellow, and blue, the primary colors, which, because of their intensity, their blending, and their coexistence evoke in us the sensation of a much richer spectrum.) Prica, who has entered his current phase showing man as well as "form," is now removed to a distance of observation, where that form also begins to decompose optically, to disintegrate under the influence of secondary elements, so that all that remains is the trace and the presentiment of the body that used to be solid; but the liaison with other bodies, with the surroundings, with "the atmosphere," is clearly visible. In his latest works, the artist is still more detached from his figures and objects; between them and the observer he has erected a translucent wall, divided by a vertical and horizontal grill that recalls a window frame, to the point where the objects and the figure behind them seem to be in a shop window.

In contrast, Stojan Ćelić is a restless seeker, an intellectual with a rich and sensitive substratum, a nervous analyst who endlessly crosses the frontier of abstraction and returns in such a way that his paintings almost always show the traces of the landscape artist's inspiration. His nature demands the testing of two creative possibilities: he penetrates the surfaces and lines of the pulse of life, and he permits the forms of the organic world to congeal in figures and geometric formulas. Ćelić is a distinctive example of the artist who expresses himself in a manner analogous to Bernik's and is yet related to that of other Yugoslavian artists (colorplate 112).

Miodrag Protić is both a painter and writer, and his extraordinary craftsmanship permits him to create refined studies on certain pictorial problems of our time. Recently he plunged into a new pictorial presentation of light — of the source of light in the painting itself, of luminous reflections coming from outside; now that is replaced by meditation on rhythm, color, form, and time. His always calm, tightly composed, and static paintings, with their vertical expressive tendency, are dominated by saturated colors and solid contours, which he packs into a vast expanse of purely pictorial symbolic objectivity — from "the object that signifies the spirit" to "the spirit that is created in the object," or at least in a suitable symbol for it. This art is not exaggeratedly sentimental but is above all contemplative; only in the color does the artist's powerful temperament sometimes flare up, his world of silence and restraint

experiences the sudden and impetuous stresses of a personality that, in spite of all its self-discipline, cannot remove itself from the demands and questions of our aggressive time (plate 260).

If it is characteristic of the present situation of Yugoslavian art that all the contemporary currents and schools prosper and that each has at least one good representative, it is equally significant that the three branches of the visual arts — painting, graphics, and sculpture — also develop rather uniformly. Painting has perhaps a certain priority because of its relatively longer tradition. Sculpture can be said to have a history on the basis of the internationally most illustrious Yugoslavian artist between the wars, the master of the oldest contemporary generation, Ivan Meštrović. But graphics, as the youngest branch, has had in these last years the most rapid development, and it is at present probably the liveliest and most resonant; even more, it offers the most homogeneous national image. Without any doubt a strong impetus for the development of graphics was given by the organization of the International Biennial of Graphic Art, which since 1953 has gathered examples from all over the world; but the idea of such a biennial was evidently unable to be born until the country's creative graphic strength promised to be equal with that of foreign exhibitors. It is understandable that a particularly strong graphic group should have formed in Ljubljana; but there are also distinctive creators in the various techniques throughout other regions, if by "graphic artists" we mean that the medium is for them the only or at least the prime mode of expression, though they may also be painters and sculptors.

All that we have said about the renascence of Yugoslavian art since around 1950 is as significant for sculpture as for painting and graphics. The year 1950 signifies for sculpture perhaps a still more explicit line of demarcation — for a completely external reason: during the first postwar period, sculptors were directed mostly toward the design of monuments; there were so many commissions that the artists were hardly able to fulfill them. But once these demands were satisfied the artists turned to their inner preoccupations.

Since his first works broke through to broad daylight, Dušan Džamonja has been an original creator in iron and wood. The forms of his powerful abstract sculptures, mostly hammered and welded, recall from a distance the figurative and architectural monuments of Islamic art. (Džamonja is always basically true to himself, even though the diversity of his works may be amazing.) To his basic materials, iron and wood, he has also added glass as the fragile heart of his harsh, severe, tortured sculptures. Regardless of the title and the solution in each instance, the sculptures' figurative content and emotional associations

are always the same; it is always a question of torture and suffering and the victory of the tortured over the persecutor, on which Džamonja imposes his form and his principle. From the iron crown of the *Peasant King* to the dolorous embroilment of the human mind, from the cry to the sorrow of the forest of a captive bird forced to an unknown service, the rich nuances of Džamonja's creations have always the same characteristic of the creator: the sovereign force that subordinates the material, the craftsmanship, and the world (plate 265).

Drago Tršar has combined sculpture of mass with the forms of stalactites and stalagmites of his native Carso; the will of the human crowd, of its collective revelation, with the primitive forms of nature, with the obtaining of results common in the union of equivalent masses. The fusion of the collective idea and the material has in his work a special harmony; it carries in it the strength and the capacity to surpass itself, to extract the material from the soil, to give to the idea of the collective an almost musical harmony, the weight of a powerful organ chord (plate 267).

Among the contemporary artists who are adept at Op Art, we must mention the sculptor Vojin Bakić, who has followed a long and lively path and created several important works in each phase of his career. His "luminous forms" and "developed" or "ramified surfaces" are the provisional conclusion of a long evolution, which began to some extent with the examination of volume and surface and the applied study of Rodin and Maillol. The surface remained Bakić's strongest preoccupation at the time of his leaf forms and of the answering echo of glittering surfaces, while the study of volume has led him to a vaster examination of the role and significance of space, of that which unites the shell of the sculpture and also of that which surrounds it, which we sense at first as a void, after which the void is cut by the sculpture with its axes of different sorts and different angles and is thus filled with tension and excitement (plate 266).

Slavko Tihec works in iron and iron wire, suggesting Džamonja's work; but it is precisely the comparison with Džamonja that shows us in a very plastic manner the lyric side of Tihec's world, the almost Japanese finesse and the preciosity of his sculptures, whose inspiration is almost always organic. The large blooms of metallic sunflowers, the umbrella unfurled by a geisha, the luminous circle of the sun — all enliven the dull metallic material and, outside their actual borders, make the surfaces animate the space that surrounds them. Tihec is not part of the young generation, but his "Semaphores," his "Vertical Sculptures," have only recently been organically incorporated into the picture of contemporary Yugoslavian sculpture (plate 268).

If we examine the works and the path traversed by the artists who have been mentioned (and all those of whom we think when speaking of the diverse tastes and styles), the final statement is that Yugoslavian artistic life is at the moment extremely dynamic, in rapid evolution, and for that reason difficult to review. It would hardly be possible to designate one or the other art as dominant, and the same is true of the artistic currents — although for the moment the majority of the artists still tend toward abstraction. The Yugoslavian artists come from all regions of the country and also work in the most diverse areas (very interesting works, for example, are produced by Kondovski and Koneski in Skopje, or Likar in Sarajevo); the artistic centers of earlier days have lost their historical significance, but on the contrary the artists are often intimately linked to the place and region of their birth. And we state also that Yugoslavian art is promptly and conscientiously urbanizing itself — in harmony with the development of the social and economic life — and also that it conscientiously participates in the artistic life of the international scene. Yugoslavian art today has become increasingly international and increasingly objective.

Germany, Austria, and Switzerland

By Will Grohmann

Despite the big biennials in Venice, São Paulo, Tokyo, and Paris, despite the Documenta and other world expositions of visual art, it is difficult (even in Germany) to define the state of creative activity, more difficult than it has been since 1945. For one thing, connections with the thought of the first half of our century has become looser; for another, the bulk of new works and the number of artists have grown to almost limitless proportions. Even if there had been as many painters and sculptors in former years as there are today, the number of them that reached the public was far smaller; even the less gifted now manage to find someone to go to bat for them, especially since the number of galleries has multiplied. It is hard to imagine that there is any place where a genius is working unknown or going down to destruction; the desire of exhibitors, dealers, and art writers to make discoveries is much too great to allow that.

Retrospective connection is weak, especially because 1933 marks a sharp caesura. The pioneers of the twentieth century are a matter of history for the younger generation. Only a few of the great abstractionists and Surrealists still count with them: Picasso, Kandinsky, Mondrian, Brancusi, Klee, Schwitters, and Ernst. They learned about the older artists after 1945 from a few painters and sculptors of the intermediate generation: Willi Baumeister, Theodor Werner, Ernst Wilhelm Nay, Fritz Winters, Hans Hartung, and Hans Uhlmann, who could still profit directly from the breakthrough after 1900. These men are the links between yesterday and today.

But it is not only the harshness of history, or lack of understanding, that separates the young from the old. There is a deeper reason: the world of the young is completely different from the world of the past; the young people's existence is defined by entirely different points of view. The contrast between man and the world has long ceased to exist. The artist has become a part of the new reality, in which he takes an active part and to which the viewer too must adjust if he hopes to recognize his own existence in the work of the artist.

What is involved is much more than a new way of seeing — creations whose

dictatorial forms contribute to defining present actuality. The experiences of artists range far beyond seeing and knowing and beyond previous concepts of space and time; the artist has to deal with a very complicated reality, a field of invisible forces. Relations with science that were initiated in Cubism are growing stronger; there are artists today who appeal to Werner Heisenberg's indeterminacy relation or to the natural philosophy of C. F. von Weizsäcker.

The language of an art of this nature can be only a code, understood only to a limited extent. It is not surprising if society is uncertain and asks whether art, in its highest forms, is not a matter of the past, as Hegel already thought. Is there still a need for it? But as long as artists are born, there will still be art, even when the need for it is first produced by the achievements of artists. Undoubtedly, the second phase of abstract art, which in Germany began after the war, contemporaneously with the first breakthrough of abstraction in France and America, has passed its zenith; the day of its unrivaled dominion is over.

Since the end of the fifties, trends have developed that are far removed from those of the abstractionists and are building, out of the everyday practice of industrial society and its consumption economy, out of the everyday world of facts, banalities, and absurdities, a kind of neorealism or neo-Dadaism. Its land of origin is the United States, but the French Art Brut undoubtedly played a part in the origin of this Pop Art.

For many people, Pop is already out and Op is in. The pace is being stepped up every year, without our seeing where things are going. New materials have emerged out of the new ideas, or new ideas out of the new materials. Artists use metal and glass, wood and plastics, take imprints of objects and seals, and have extended the boundaries of the picture so far that the differences between painting, relief, and sculpture dwindle daily. Freedom seems to have become unbounded, a blessing for the imaginative, a torment for the imitative. The only answer to whether or not the result is still art is that the concept of art is not unchanging, and that we must give the name of art to these diverse forms, whatever their presuppositions. Often, the only difference from an object is that the work of the creative person is under the sign of the spirit.

The Painters

As in other countries, there are still painters and sculptors working in Germany today who are far removed from present problems, such as Werner, Nay, Winter, Uhlmann. If Baumeister had not died, he would have been the most typical representative of this generation, which had the good fortune of start-

ing from fixed bases. In the postwar years they became classics, inasmuch as they had already been working before World War II. Baumeister spoke of a post-Picasso generation. He had studied with Adolf Hölzel in Stuttgart, although without following his theories. Werner came from the same Stuttgart Academy, but from academic teachers of the old school, such as Nay had had in Berlin and Hartung in Dresden. Winter was the only one who studied at the Bauhaus; Uhlmann was self-taught. All of them had as their foundation the inventions and discoveries of the post-1900 pioneers. Like Oskar Schlemmer, the friend of his youth, Baumeister had taken Cubism and Cézanne to his heart; Nay, Expressionism; Hartung, the Blaue Reiter; Winter, Kandinsky and Klee; Uhlmann, Constructivism. All of them had solid ground under their feet and could go along part of the way with their older traveling companions. This was precisely what had disappeared for the younger painters and sculptors who came up in the early fifties; they had learned the craft somewhere or other, usually at one of the many art schools, but made virtually no use of it. Their older colleagues hardly bothered with them; they were concerned with themselves. Baumeister was the only exception. Even before being called to the Stuttgart Academy in 1946, he had devoted himself unselfishly to the new crop. Such painters as Karl Otto Götz were much stimulated by him, and Julius Bissier, only four years younger than he, took counsel with him. At the Academy Baumeister taught the students to have the courage to be free.

These painters are still active; while they hardly determine the work of those who came after them, they do affect the climate in which they create. Willi Baumeister has been dead for more than ten years but is only understood today. His archaizing sand pictures have a richness of structure that brings them directly into the period of material-tinted Tachist pictures, while his growth pictures show the influence of the Far East in calligraphy and image (colorplate 113). The late "Montaru," "Aru," and "Han" series seem to us today to be beyond the Eastern frontier, as if assuming what we dare to dream. Young painters take respectful note that Baumeister had already used much of what they have discovered by way of technical procedures — the application of pastes, the insertion of fibers, the occasional monochrome, and the use of black as a color.

Baumeister's opposite is Theodor Werner, who was quite content to stay in the background, did not care much for shows, and never taught. A Swabian, like Baumeister, he inclined toward the nature philosophy of a Von Schelling: "Nature should be visible spirit, the spirit invisible nature." For a decade, he felt that rhythm holds the world together, but since 1950 he has forged ahead

into the space-time conceptions of an Einstein or a Heisenberg. In his own words, his pictures are becoming "star pictures seen on the great voyage through the spaces of time, constellations that signify this and that, change, dissolve, and form constellations again." His pictorial language encompasses everything, in equilibrium and tension. During the fifties, his pictures became more substantial, by means of calligraphy and by virtue of their treatments and structures, which give the moment duration (colorplate 114).

Winter and Nay are the other pair of opposites. Fritz Winter, a pupil of Kandinsky and Klee, still responds to the visible world, in a poetic language. And, at bottom, the "inward mystic construction" that Franz Marc spoke of still wears its lifelike images, even when they are built up of rough blocks and are free from verifiable models (colorplate 116). Winter has an incomparable gamut of blacks and grays. Ernst Wilhelm Nay is rather a musician than a poet, in love with surfaces and colors as values of Gestalt. For him everything must be in accord, but the perfection of his compositional technique goes over into the contrapuntal, and today into the symphonic. His instrumentation is abundant yet always disciplined; he will make a blue stronger until it floods the whole, or he will put adjoining colors into differentiated dialogue. The reason why for over ten years he worked almost exclusively with circles and is only now getting away from them is that circles, with their multivalency, were the suitable means for him to compose in color, to achieve final freedom and always give it up in order to attain new beginnings (colorplate 115).

Woty Werner, the weaver of pictures, is the only one in Germany who works without preliminary drawings or cartoons and handles her loom as a painter does his brushes and colors (plate 280). Design and execution are one for her. Her color sense never lets her down; her forms emerge surely and naturally from warp and weft.

Julius Bissier, the great solitary, has only become well-known in his old age. We can see in him the link to the Far East. Long before the founding of the Zen Group, to which he belonged, he had been led to the East Asians by Ernst Grosse, the Sinologist of Freiburg, and had found in them a confirmation of his own intentions. The symbol-like forms of his meditative black-and-white wash drawings in ink (Fig. 7) were not unlike the signs of the *I Ching;* only in the middle fifties did Bissier return to color (egg tempera), using it since then with the same sensibility as Klee. If there are any suggestions of the objective, he withdraws them at once, returning to the realm of contemplation and denying the links to German Romanticism as little as did Klee.

It is remarkable how little connection these older figures have with one

Fig. 7 Julius Bissier
b. 1893 in Freiburg, Breisgau. Lives in Hagnau am Bodensee
Giving-Receiving. 1938. $24^3/_4 \times 19^1/_4''$

another, how little they understand one another as painters. Even if we enlarge the frame of reference and consider Josef Fassbender, Fathwinter, or Georg Meistermann, their efforts and achievements still remain at variance. The younger generation was not backed up by any force, as it was in France by Cubism. Expressionism had come to an end in the twenties.

When the younger generation emerged after 1945 (most of them had been in the war), they tried out what was on the table before them, fragments left over from the past. For two or three years, almost all of them painted figuratively though not imitatively, until they got up courage enough for languages of their own. They were helped by what was going on in France, where the Germans Wols and Hartung (Art Informel), along with Jean Fautrier and Jean Dubuffet (Art Brut), gave a powerful impulse to development; and equally helpful were the Americans, who, since the war, headed by Jackson Pollock, had developed a new kind of project (Action Painting). Pollock had become known through the shows that Peggy Guggenheim had arranged in Europe after the war, Wols through the shows at René Drouin's in 1945 and 1947; Drouin also took up Dubuffet and Fautrier. Wols was the uncrowned king, a state of affairs to which his death at the age of thirty-eight contributed.

Wols's dream pictures state the condition of his self-destruction directly; the translucent watercolors, even more than the oil paintings, are built up of the finest of structures, of fibers, feelers, roots, and deceptive colors. Hartung sets down the state of his momentary experiences and excitements, but in a more linear and more active way than Wols; in him too there is nothing intentional. There was a good deal of discussion in Germany on Pollock's techniques (dripping) and Fautrier's pastes. How much young Germans knew at that time from their own observation is hard to say. Travel was difficult after the war, and periodicals were scarce. What was available was a kind of conversation across the frontiers, a kind of rumor, with photographs and occasional catalogues of shows. But apart from all that, the new things were in the air, and experiments were going on everywhere in the same direction.

In 1952, four German painters made a step forward, setting up a show in the Zimmergalerie Franck in Frankfurt am Main that gave rise to much discussion. They were Karl Otto Götz, Otto Greis, Heinz Kreutz, and Bernard Schultze. Their way of painting gained adherents, and all at once people everywhere in Germany were painting in the Tachist manner.

There was a new intensity in the way painters dealt with their materials; a new vehemence in the way they produced a vibrant surface out of painted, spackled, or dropped spots of color; a new diligence in organizing pictures out

Fig. 8 Joseph Fassbender
b. 1903 in Cologne
Lives in Cologne
Aristophanaic
1962. Ink drawing
15³/₄ x 11³/₄". Galerie
der Spiegel, Cologne

of colored structures; a new allover plan in the pictures, showing new divisions
but a uniform attitude in all directions; a new kind of automatism, which to a
great extent excluded the intervention of the painter; new improvisation; new
self-expression; new absolute freedom. At first, there were only a few who
worked in this direction and regarded the new means as an impetus, not a goal.
In them, not in the multitude that flocked around them, the genuineness of the

activity could be traced. As if they had been waiting for it, the secondary talents jumped at the tempting style and often obtained results that concealed the worthlessness of the imitative project. There is nothing easier than following a movement that seems to do away with form. It was almost simpler than making something agreeable out of geometrically based abstraction, instead of forging ahead to new ideas and formulations, as Max Bill did.

Of the four Tachists who exhibited in the Zimmergalerie, Schultze is the most imaginative, Götz the most logical. Schultze began objectively as a student of the realist Jaeckel at the Berlin Academy, turned to Surrealism with most of his generation, and was in the middle of a new start at the time of the show. As early as 1952, he realized the dangers of planning in advance and how easy it is for the work to become the "death mask of the conception," and determined to arrive at his goal in the process of painting and to make matter more precious. If the color does not have enough weight, he reinforces its volume with sand, straw, or whatnot. He allows the work to come into being with all its accidents and incidents but guides it. The most amazing thing is that the macrocosm and the microcosm, even landscape — a river valley from Courbet or a death of Sardanapalus from Delacroix — can be read into his pictures. Nobody can explain where these associations come from; they are as little planned as the cosmic element in Kandinsky. Perhaps it would be more accurate to speak of contacts than of associations. Until these pictures, Schultze was a Tachist like his contemporary friends; what came later develops logically from the initial steps but is not of the same nature. It is, rather, painting that is plastic in space. The dynamics of the creative process explode the surface: the colored substance is supported on a framework of wire, cardboard, and other accessories, which is coated with plastic and synthetic resin; and Schultze now paints on this with the same dedication to the pictorial process as when he remained on the flat (colorplate 121). What comes into being is absurd Rococo, or so at least they thought in Baden-Baden upon entering the two Grotto Rooms; and the colors too sparkle as in the *Embarkation for Cythera,* but the plastic quality is that of the *Wies,* in which sculpture and painting likewise interpenetrate. The color invention is richer than at the beginning of the fifties, when Schultze's watercolors and paintings were close to those of Wols.

Götz diverged from Schultze as early as 1952, as he diverged in 1956 from K. R. H. Sonderborg, with whom he exhibited at the Kestner-Gesellschaft in Hanover. Reference to calligraphy fitted him as little as membership in Tachism in the Zimmergalerie. Götz belonged to the movement only insofar as he relied almost entirely on chance in the painting process. He first sets down a form in

color (the positive), then rips it up with a tool (negative), working with a dry brush on the wet picture. The structures thus formed point in the direction of speed. In 1952, one still was reminded of his Surrealist beginnings during the war, his metamorphoses of insects and birds; the later works suggest swirling and whirling waves and storms. Impetus and movement, color and rhythm coincide, and Götz approaches analogies to natural phenomena as they have never been painted before (plate 271).

Sonderborg and Götz have tempo and dynamics in common, and Sonderborg's titles *Supersonic* and *Nautical* could be the titles of works by Götz as well. But Sonderborg differs in design. His work comes out of a store of energy that has been long accumulating; he deals with marginal human situations. He has collected experiences in the port district of Hamburg, the city of Paris, and in Manhattan, and he is interested in painting a mural for the showroom of a car dealer in Mannheim. Sonderborg works not only with paints and brushes but uses industrial equipment — scrapers, spatulas, and razor blades — and works with them like a mechanic. His pictures are unromantic. From 1953 on, they are like rockets: diagonals burst forth from a whirlwind; from 1958 on, what is essential goes on behind partitions, through cracks in which a glimpse can be had of houses and cities, not people (plate 269). It is enough for him that he himself is in the picture, and probably he looks only for himself in all his pictures: that gives them their authenticity. His drawings go even further in that direction; they are a shorthand that only the initiated can understand.

"Action Painting" is the best way to describe Sonderborg's work; his activity comes from the center and seeks the circumference. This applies to most of his colleagues, to Emil Schumacher, Fred Thieler, Hann Trier, Peter Brüning, the Swiss Vera Haller (plate 311), Ernst Wild, Karl Friedrich Dahmen (plate 313), Gerhard Hoehme, and many another who has gone off to Pop or calligraphy. Grouping is even more difficult in Germany than elsewhere, since individualism is more unbounded here than in France or Italy.

Gerhard Hoehme was unquestionably a Tachist, and viewed externally his pictures still have a Tachist appearance, with their color structures forming a vibrant surface, and their approach to monochromy. In any case, his drive goes inward, and comes to contemplative statements, a *Roman Letter* or a *Necrology*. One feels one can read the pictures, and one can if one is able to extract the text from the structures, series, and rhythms, if one reads the pictures like maps. The poetical flows in Hoehme as the physical does in Götz or the artistic in Schultze. In most of the painters of this generation there appear references to experience and even, as in Hans Platschek, to the portrait *(Portrait of Sonder-*

borg). Representations are, in any case, coded events. The occasions drop away, and only the signs remain. When Hoehme paints "Window Pictures" (1963-64), we see crossbars and mullions, usually displaced and often even boarded up and painted over, but fundamentally they are code signals behind which something is hidden — for example, an *Aurora*. If formerly there were scores with lines and notes, now there are meditative wisdoms (plate 270).

This is not so in Thieler, who uses large and enormous formats to paint reports of situations and marks of position, documentations of his existence. One of his most recent pictures is called *Report of Position, January 1965*. Out of "creative uncertainty," as he calls it, come big canvases, for the most part with an explosive center of gravity from which he carries on his action, violent but civilized. Thieler first attracted attention in 1957 at the Couleur Vivante exhibition in Wiesbaden, and since then he has been successful everywhere, in Venice, São Paulo, Kassel; he is convincing because his reactions, although subjective, are credible and pictorial on a high level (plate 273).

His is a forceful nature compared with that of Hann Trier, his colleague at the Berlin Kunstakademie, who has wittily illustrated some hard texts, including Focillon's *Lob der Hand ("Praise of the Hand")*. There it is held that one does not create with the mind but with the hand and tools, and that is what Trier does too, but nonetheless his philosophy deals with experienced time and the duration space achieved through the presence of the painter. What painters set down betrays their dream wishes and seldom coincides with what they are really doing. Trier paints dancing rhythms, after having been plainer before 1954 and conjuring up a *Fast Road* on the canvas. In 1955, honeycomb forms become decisive for his calligraphy and his later patterns ("knitting"); the ill-disposed got the impression of knitted pictures. The pattern is productive, however, even today, when Trier uses it so freely that in his latest pictures (plate 274) one thinks rather of Kokoschka's *Squall* than of *Music Notes*.

Peter Brüning is related to Trier in the elasticity of his space; indeed, in his action he is the freest of them all. He cultivates expressivity as a musician does his themes, and he further resembles the musician in the way he places the accent on the course of time. His color tracks on white backgrounds are instructions for chamber-music impromptus (plate 272).

In addition to Brüning, the youngest, all these painters, including Emil Schumacher, one of the strongest, were in the exhibition in the Cercle Volney, Paris, 1955, organized by René Drouin. Schumacher attracted attention as early as 1955, but the degree of intensity he would develop was not suspected. From 1960 on, he heightened the level of his treatment of the material and the inten-

sity of his figuration. His paintings are landscape and earth, rocks, and craters, cut through by deep crevasses, but often figurative as well (*White Body*, 1962). Primeval rocks and primeval Gestalt, removed from craftsmanship and memory of humanity. It is impossible to speak of myth-building structural elements, as in Baumeister; Schumacher has no "African Pictures" and no "Gilgamesh" series. He has nothing to do with either myth or history; he is as natural in figures as creation itself (colorplate 122). In this respect Dahmen sometimes approaches him.

Some of the painters who went through the doctrine of Tachism abided by the theory and went no further; others have turned completely away from it. Markus Prachensky, an Austrian, has arrived at a dictatorial action that has the effect of a monumental written character (colorplate 126). In the pictures of his countrymen Wolfgang Hollegha and Josef Mikl we seem to recognize memories of events or things, a figure or a head, but they are rather the need of possessing the world than reality. In a fourth Austrian, Arnulf Rainer, a pattern of veiling has grown out of the Tachist technique. Rainer speaks of "painting over," and overpainting is not by any means occasional with him. The pictures are almost without exception monochromatic, four-fifths veiled over from dark to black, but the Gestalt of the overpainting ends in highly sensitive feelers or nerves that let us surmise the life that goes on behind the pattern. It is the change into the contrary, deliberation and calm taking the place of action; Rainer paints about derangement, contemplation, the great ocean, the great void. In this painter, nonetheless, the creative act remains more essential than the finished picture (plate 301).

Rupprecht Geiger shows many outer similarities to those twenty years younger, and in fact was always active in that direction. But it was not noticed because his color is aggressive and his design Suprematist; occasionally, he is not too far from the square pictures of Casimir Malevich. The similarity is deceptive; what is sublimation in the younger painters is a spiritual manifesto in Geiger. He is closer to the Action Painters than to the monochromatists (plate 314).

Despite their use of completely different materials, such as aluminum, plexiglass, nails, and lampblack, Heinz Mack, Otto Piene, and Günter Uecker, often seem to be closer to the meditative painters — Rainer, for example — than to the kinetic artists. The material chosen is not decisive for the meaning of a design, and although in these three Düsseldorf artists there are slight variations, macrocosmic and microcosmic facts that change with the interaction of the means and the position of the observer, the effect is of being drawn into a

deeper significance. Uecker drives nails into his canvas-covered wooden boards and sprays these "objects" with white (plate 287); he speaks of white structures, of a free articulated space of light, a white world in which we begin to meditate. "The state of whiteness may be understood as a prayer; there may be a spiritual experience in its articulation." Coping with new light-struck structures leads into a new and very human world. Mack (plate 288) develops light reliefs out of reflecting metals and glass. Since 1957, he has been publishing a catalogue magazine, *Zero*, in conjunction with Piene, a fellow student at the Art Academy at Düsseldorf who also studied philosophy at Cologne University. Piene too seeks quiet, "empathy into the rhythm of creation," reflectiveness: not a new realism but the invocation of ideas, a new idealism. He uses smoke and soot in his pictures, fixes them and burns the fixative off, and decides in seconds as to the success or failure. There is kinship with natural processes, in the concentration of the point, the circle — sun, fruit, flower, eye — and finally man. Hence the kinship of his pictures *Fire Flower, Smoke Picture*, and *Eye* (oils and smoke) with the Buddhist *mandala* and the Christian mandorla (colorplate 123). Extensive technical experiments go into the production of the kinds of objects and pictures that Mack, Piene, and Uecker make, but nothing that goes beyond the limits of the mastery of art. What is developed in this direction can constitute an essential enlargement of the concept of art.

A third possibility of statement for the young is arrangement in series. The elements are in sequence without differing essentially from one another in color timbre and outline, but without repeating one other. The process has various techniques and meanings, but the graphic element is a structural factor in all these painters.

Writing in its relationship to the picture was the theme of a noteworthy exhibition in Baden-Baden, Amsterdam, and Berlin. The connection is not new; the exhibition showed the most manifold aspects of the problems and involved, in addition to scriptural painting (Paul Klee), Far Eastern calligraphy, the *poème-object* (Apollinaire, Gaul), visual texts (Ferdinand Kriwet), letter pictures (Grieshaber), and musical graphics (John Cage, Mauricio Kagel). The complex of questions is remarkably comprehensive; we already encounter it in Hoehme, whose pictures are shot through with tracks of writing; and in Sonderborg's drawings. In many cases it can hardly be decided whether the relationships to the theme of writing and image are legitimate. Werner Schreib does not work with letters or words, precisely, but with arrangements of locations for his signs, which approach the order of the alphabet. He uses preformed bits that he presses into the surface of the ground like seals, and by means of

them achieves really archaistic effects; one gets the feeling of an ancient clay tablet (plate 315). Similar impressions are given by the engravings of Rudolf Schoofs, which come straight out of the old manuals, and also in his illustrations of poems of Ingeborg Bachmann, Karl Krolow, and Günter Eich. They are formal Gestalts, as far removed from hieroglyphics as from neolithic rock paintings (Fig. 10). Something else again is Walter Menne, who admired the Oriental calligraphers and their splendid tools but was far too independent to let himself be influenced by their stroke. What he produced were powerful automatistic records of his life, which were anything but occasional verse.

The realm of script painting is extensive, and comprises designs of the most diverse kind — for example, Klee's writing pictures, in which image and writing have interpenetrated, so that the pictures are equally effective from either point of view. The color-screen system supports the meaning of the world, and the letters help in the pictorial invention. Often, however, the writing arises entirely out of the pictorial means, in Klee's "plant writing" as in the fantasy writings of Heinz Trökes. In Carlfriedrich Claus the sphere of this script-imagery reaches a high level in both aspects. Whether a page of this kind is called "Paracelsian Thought Landscape" (*Paracelsische Denklandschaft* — plate 285) or *Beginning of a Letter* (1962-63), the effect of the spontaneously imaged is always attained, no matter how complicated the creative process behind it. This does not hinder Claus from making entirely different things, "Letter Constellations" or "Lettering Fields," arrangements of type, as Ferdinand Kriwet makes in another manner. A precocious talent, Kriwet has since he was nineteen been putting out "visual texts," sheets and disks of type, printed words, and bits of sentences, arranged horizontally and vertically or in circles, meant for the eye, as opposed to texts meant for the ear. We can begin reading anywhere and fill out our reading impressions as we please or as we find it necessary. One asks whether this is graphic art or literature, as one wavers between graphic art and music in Cage and Kagel, although in them unquestionably music is what counts.

Pictures can be made from type alone, as Hap Grieshaber did or as his student Josua Reichert does. Reichert composes with letters and other kinds of type material, in such a way that the intended meaning emerges from the printing just as it does from a written line of verse. In 1963, he received the Youth Art Prize in Baden-Baden for his efforts to revive writing in print. The effect of these pictures in letters is similar to that of the sign pictures of Winfred Gaul, for whether traffic signals (plate 316) or *Four Little Roses* are involved, the nature of Gaul's pictures depends on the timbre of the signals as that of

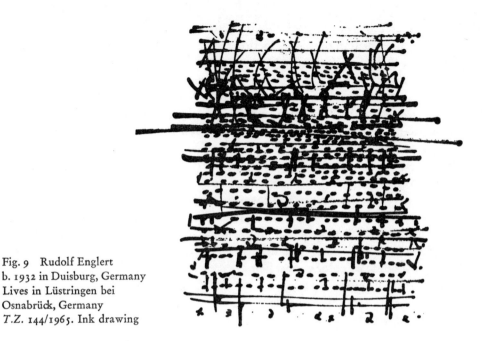

Fig. 9 Rudolf Englert
b. 1932 in Duisburg, Germany
Lives in Lüstringen bei
Osnabrück, Germany
T.Z. 144/1965. Ink drawing

Reichert's pictures depends on the timbre of the letters. Beyond that, the poster-like tendencies of the Pop Artists begin to echo in Gaul.

There has been Pop in Germany too for some years, although on a more modest scale than in America and without any personality as strong as, say, Robert Rauschenberg. It is hard to say whether Pop originated in America or in France. Undoubtedly its ancestors include such Dadaists as Kurt Schwitters and Marcel Duchamp but also the Frenchmen of Art Brut (such as Jean Dubuffet), the Chilean Matta, and of course a Surrealist like Max Ernst. At the very least, they helped supply the spiritual courage to make the leap into the art of the common object.

Pop came a bit late to Germany, and we may concede this all the more frankly in that many of the great moving spirits of contemporary art have been Germans, and the Surrealists stood in the way of Pop Art longer in Germany than anywhere else. We still see in Ernst one of the moving spirits of the younger generation, which works in the direction of dream and actuality, automatism and chance, and has been impressed by his techniques, such as the fraying of structures. Heinz Trökes is still close to Ernst; that he also learned from

Klee enables Trökes to be as mobile in pictorial means as in design, which today moves in the direction of science fiction (plate 279).

Richard Oelze is a Surrealist who came from the Bauhaus, worked in Paris from 1932 to 1936, and then disappeared from view, only reappearing in 1952, in a show in Bremen. He had taken part in Surrealist exhibitions in Paris in 1936 and in New York in 1942, however. Oelze's pictures often remind us of old masters — for example, the *Tree Dream* is reminiscent of Da Vinci's *Virgin of the Rocks;* the shock quality of classical Surrealism has become attenuated in him, and hallucination is repressed by metaphor and metamorphosis. Everything grows and changes, but the structures remain close to landscape und vegetables, even when faces or birds' heads peer out of them (colorplate 131). It is an unreal reality "of other beauty" and of "growing stillness" (as two pictures are titled). All this is only in the language, but the way he communicates his dreams extends to his technique as well. *Monsieur Rosa* (1964) is a whiff of color over a being with human features seen in a vision.

A short time before Oelze's retrospective show in the Kestner Gesellschaft in Hanover, the Viennese Hundertwasser (Friedrich Stowasser) had his first comprehensive German show in the same place. People spoke in both cases of Surrealism, disregarding the age difference; Oelze is nine years younger than Ernst, Hundertwasser twenty-eight years younger than Oelze. A remarkable

Fig. 10 Rudolf Schoofs. b. 1932 in Goch, Germany. *Landscape*. 1963. Drypoint

phenomenon, this overlapping of generations, that is disturbing in other cases as well.

Hundertwasser's style harks back to the Vienna Jugendstil and to Egon Schiele. He has lived in Paris, Normandy, and Venice. There are links to Klee, including the careful technical processes, on which he lays the greatest importance, as can be seen from the data in the catalogue of his works begun in 1954. It can also be seen in his *Thousand Windows*, done in 1962 in Vienna and Venice, with a mixed medium of egg tempera, oil on wrapping paper over jute, and so forth. The pattern of many of his pictures is the spiral, to be read externally as a labyrinth, tree, or sun, internally as "the bloodstream flowing through the body"; is he thinking of the labyrinth of the Minotaur or the spiral nebulae of the universe? Either might be possible with Hundertwasser. His designs are multiple but always recognizable as his, and even his color sense betrays him: his variations of the green-red combination seem inexhaustible (colorplate 119). A *Car with Red Raindrops* is as obviously his as an *Extrovert Window*. In him the fabulous, with its unlogic, plays a role similar to that of metamorphosis in Oelze, and there is always something of magic involved; Hundertwasser is a sorcerer in life as in his work.

The fantastic seems to be at home in Vienna, like Concrete Art in Switzerland. Since early 1965, there has been a traveling exposition, The Vienna School of Fantastic Realism, with paintings by Erich Brauer, Ernst Fuchs, Rudolf Hausner, Wolfgang Hutter, and Anton Lehmden, most of whom come from the painting class of A. P. Gütersloh at the Vienna Academy. They are on very different levels, but common to them all is an interest in the art of the past, which they could study in the Vienna museums, and their leaning toward literature and literary objects. Hausner became known in Germany by way of Documenta II in Kassel and was classified with the Surrealists, as he was some years later by the Galerie Charpentier in Paris. He has some characteristics in common with René Magritte and Victor Brauner, but is more manneristic than they; in general, mannerism enters into this sort of Vienna self-analysis. The *Arche des Odysseus* ("Ship of Odysseus" — colorplate 120) and the "Adam" pictures of the last ten years are self-portraits in which refinement and naïveté are mixed as in the young Otto Dix of 1919-21. Opposite him is Brauer, who took the style of Bruegel the Elder in the Kunsthistorische Museum in Vienna and translated it into a children's-book style, with an abundance of Oriental color (plate 284). With the other painters of the group, including the old-masterlike Ernst Fuchs (plate 283), the movement comes to a halt, and Surrealism becomes drowned in academic reminiscences.

Fig. 11 Walter Menne. b. 1908 in Bad Kreuznach
Lives in Berlin. *Ink Drawing 12*
1966. Ink. $11^5/8$ x $16^3/8''$

There are no similar phenomena in Germany and Switzerland, unless we think of Friedrich Schröder-Sonnenstern (who is to be found mainly in private collections containing Hundertwasser and Oelze), Schiele, and the young Dix. Sonnenstern has only been painting and drawing since 1948 (he was born in 1892), and has great success with his revolutionizing paintings of social criticism and erotic possession. For some he is Germany's greatest living painter, for others a schizophrenic monstrosity. His allegorical and often symbolic designs, with their demonic figures, are disarmingly and quite unimitatively heraldic and in their way the strongest we know. The only question might be whether these monstrous productions of a hallucinatory fancy still belong to Surrealism, since there can be no question of psychic automatism in Sonnenstern (color-plate 132).

Alongside him, the painters inclining to Surrealism give a rather romantic impression — for example, Paul Wunderlich, whose pictures combine aspects of Philipp Otto Runge's work with an urgent, anxious anatomy of men, things, and situations (plate 281). The amazing thing about Wunderlich is the way his masterful craftsmanship enables him to build up, out of the torsos into which he breaks down the world, a magic world that from afar reminds one of Runge (*Aurora-hommage à Runge*) and close up bears the mark of Cain of a menacing

absurdity. Thirty-six-year-old Wilfried Blecher is close to Wunderlich in his inventions of decayed vegetable and human anatomies that look like photocopies with a decorative flair (plate 302). Friedrich Meckseper (colorplate 130) has a harder, more unyielding style, and his early works are imbued with a demonic quality. Horst Janssen is more graphic in his inventions; his ironical drawings might have received their mobility from the early Klee (plate 286). Ursula (Bluhm) goes back to the sources of the movement, to Giuseppe Arcimboldo and the truly naïve. With knotwork and hatching, out of feelers and dusters and fairy-tale characters, not such as have been but should come to be, she makes "Brush Eyeballs" and "Spoon Lanterns." They can give joy but often give fear as well at the tropical luxuriance of her form-finding imagination (plate 282).

All this has nothing to do with Pop Art und yet leads almost imperceptibly to it. *Pop* was the name that the American R. B. Kitaj gave to a picture in 1956, and Lawrence Alloway is said to have used the title of the picture to denote the movement. What has developed in this direction since about 1960 is an art of the big city, of the stereotype world that the consumer comes across at every step. It uses a prefabricated reality and tests what connections can be made within it. The proximity to Dada is rather accidental, even though the Schwitters renascence may have contributed to the new design; after World War II, Schwitters suddenly shot up to the peak of honor, and other Dadaists, such as Jean Arp and Hans Richter, who had meanwhile gone to other styles, also became influential. But Pop is not provocative and hardly antibourgeois but conformist. Even though most visitors to the first Pop shows could not avoid a certain creepy feeling, it was not disagreeable. People were glad that objects were at work in pictures once more; they felt less alienated; they were glad that the picture did not demand, as the *pittura metafisica* did, to be understood in its terrible loneliness. There is a sort of street-fair spirit in Pop Art, if only by the introduction of advertisements, neon signs, and traffic signals; but this atmosphere directly penetrates the void that abstraction, in both its Tachist and geometrical forms, had left in the public. Now at last dialogue was possible again. Important too are the formal aspects that of course are present in Pop.

Since the Germans came rather late to Pop, they were ignored at the international exhibitions. Even the great Pop show that traveled from The Hague to Vienna and Berlin in 1964-65 did not show any Germans, not even Richard Lindner, who emigrated to America in 1930. Yet there are gifted Pop Artists in Germany, such as Wolf Vostell, Gerd Richter, H. P. Alvermann, Konrad

Klapheck, Winfred Gaul, Georg-Karl Pfahler, and Arnold Leissler. They are all quite different from one another and bear little relationship to the Americans.

Vostell has become known for his happenings, which he has set up in Ulm, Wuppertal, Berlin, and New York. They are, as he calls them, "decollage happenings" out of our daily lives, total works of art with the public as performers, subversive disclosures of reality. Decollages are the opposite of collages — that is, they are produced by tearing down posters and other printed matter that has been pasted up. Vostell usually titles his pictures "Decollage Obliteration," since if there are any clearly recognizable photographlike scenes on his poster walls, he goes over them with paint and makes them indistinct to heighten the tension and artistic atmosphere (plate 278). They are creations "out of the repertory," and this repertory is as large as the everyday world, at least as large as man's interest in the world around him. On one picture — almost a phantom — we see Christine Keeler, the head of an astronaut, and a bit of a clipping from the *Kölner Stadtanzeiger* with a report on the Nagold trial. If it were as big as the wall of a house, the passers-by would probably stop and study the story from the fragments. The photographic parts of the picture are introduced by silkscreening, or photographically, or painted, as Gerd Richter does.

The work of Richter suggests enlarged photographs, but he only uses photographs as the occasion or the support of his usually middle-class depictions, a *Family at the Beach* or a portrait of the Documenta leader *Professor Bode*. Richter is from Dresden, and so he knows Eastern-bloc socialist realism. His style has been called capitalist realism, but he says there is no such thing as capitalism or socialism in art. *Pop* would be a better name. The pictures are paintings like any painting; that they are slightly indistinct, out of focus, gives Richter a chance to be more imaginative (plate 277).

Almost every Pop Artist has developed a speciality: Konrad Lueg sports reporting; Herbert Kauffmann the advertising kiosk (plate 318); Konrad Klapheck, a pupil of the pre-Pop Artist Bruno Goller (plate 275) in Düsseldorf, since 1955 the glorification of the typewriter, sewing machine (plate 276), telephone, and water tap. The objects seem to be reproduced exactly, but so greatly enlarged that we are terrified by these domestic objects and seek refuge in the realm of symbols. In Winfred Gaul it is traffic signals or other heraldic everyday matters, which he creates, for they were no more before him in the form in which he paints them than the American flag in the pictures of Jasper Johns. But Gaul's signs are deceptive, no matter how haughty they appear; they point in a

definite direction, to be sure, but one that does not exist. It is a *trompe-l'oeil*, even though "No Trespassing" is posted under it.

Things are quite similar with Georg-Karl Pfahler, except that instead of Gaul's signals he paints imaginary forms, which he calls *Picture of May*, for example. The rectangles of a solid color, rounded at the corners, traversed by simple strips of other colors, seem posterlike at first; but they have titles like *Spirit of Reality*, and when looked at long have a trancelike effect. The viewer gets to meditating although everything is aboveboard, the colors appear solely in their physical beauty, and the approximately geometrical forms are highly precise (colorplate 118). In Pfahler, Pop and Op (optical art) come close together, for he could just as easily go back entirely to optical sensations and their consequences.

This is true of many other painters as well — A. J. Baschlakow (plate 309), for example, or Lothar Quinte in has late period, and certainly Arnold Leissler, who was still painting realistically in 1960 and came, by way of pictures that look like garden plans, to a *Dial* or the *Fluidum eines Möbels* ("*Fluid of a Piece of Furniture*" — colorplate 124). The pictures have the same craftsmanship and simplicity as those of Pfahler and have the same power of generating an afterimage. More or less like the early Dadaists, H. P. Alvermann puts his works together out of the most things, like sinks, clotheshooks, small wagons, musical instruments, and furniture (plate 317). This returns to the familiar couplings of the most diversified things, with the effect of a conscious sham art or an absurd antiart, which becomes art again when it reaches a higher plane. Something similar, expanded into the anecdotal, is to be found in the Austrian Curt Stenvert, although his delight in storytelling is in slight contradiction to the material (plate 322).

Op Art — "the responsive eye," as the Americans say; Concrete Art, as the Swiss call it — was not too much of a surprise to Germans. The Bauhaus had ventured on experiments of this kind in many directions: Kandinsky, Joseph Albers, László Moholy-Nagy, and in Switzerland Max Bill developed the Bauhaus image and theory still further. Op is a matter of abstract designs, usually colored and tending to have motion, developed in the twenties and brought by way of Paris to America by painters like Albers. Today, Albers (who came to America in 1933) is the "grand old man" of the movement there. That Mack, Uecker, and the Swiss Karl Gerstner were invited to the Responsive Eye exhibition at the Museum of Modern Art in 1965 shows that the idea of Op can be taken pretty broadly. The hard-edge show at Denise Renée, Paris, 1964, included the late Jean Arp, Sophie Täuber-Arp, and Richard Lohse from Swit-

zerland (plate 306). Arp said in the catalogue that these pictures are realities, with no significance, no reference in thought, no imitation or description; they allow the elemental and the spontaneous to become active in complete freedom. Today people go still further: they discuss the importance of retinal reactions on colors and forms, study their shifting and deceptive perspectives, call the pictures "generators of reactive perception" (William Seitz). Here too a certain mannerism can be felt.

The younger generation does not show too much interest in Op's possibilities. Max Bill and Richard Lohse are about sixty; Henryk Berlewi, who made experiments in this direction in 1922 in Berlin, is about seventy. But without Bill and Lohse there is much that would not have matured. Bill discovered a kind of painting based on forms of mathematical thought that yet keeps its secret because formula and intuition are in unison. The colors should make the physicist think, since they depart from all norms; they are evident to the art lover, provided he takes the time to clear his color perceptions from what he has learned. Bill is the most inventive of the Concrete artists; his works, which combine outer simplicity with great inner tension, profit from the fact that he is an architect, a sculptor, and a painter and has concerned himself with what is fundamental in the three disciplines (colorplate 117).

Of the younger Swiss painters who share this mental attitude, Gottfried Honegger, Karl Gerstner, and Jean Baier (plate 305), each in his own way, organize sense impressions in harmonic progression. Honegger does this in relief paintings (plate 304) that are close to Ben Nicholson, Gerstner in variations on a mathematical theme (plate 303). Gerstner appeals to the mathematician Andreas Speiser, who has said: "The artist too is not the creator of his works but discovers them, as the mathematician does, in a spiritual God-made world, the only one that is true." The layman has to confine himself to the optical impression and enjoy its perfection. He cannot account for its background any more than he can for the background of any creative performance. A German in this circle is Günther Fruhtrunk, who has been greatly influenced by Jean Arp (plate 307). His titles — *Interference, Metrics of Light,* or *Series and Circle* — indicate the sense of his works, which try "to announce the spiritual structure of the universe and, by means of painting, translate it into the dialectics of chromatic textures" (Carlo Belloli, in a preface).

There remain some young painters, standing apart, whose talent was recognized early. These include above all Horst Antes and Rainer Küchenmeister, both representational. Antes derives from Hap Grieshaber, one might almost think from Max Beckmann if he had not been so long dead. It is the full forms

in a narrow space, the aggressive yet cold colors (the red as well as the blue), the mythologized themes (skulls, cyclops) that point in this direction. One can only think of archaic or chthonian figures (colorplate 128). Every change in Antes has come from within and called for sacrifices, which he has made in order to make further progress. He was discovered by the international public at the third Paris Bienniale de l'Art Jeunesse; Küchenmeister was the discovery of the second one. Küchenmeister calls his strange forms, which are rather against the background than in space, personages or figures. They are mono- lithic, single-toned beings, chronologically even earlier than the chthonian beings of Antes (colorplate 125). Küchenmeister's watercolors and drawings are more eloquent; in them the themes are resolved into nerve lines and tinted surfaces of bodies.

We mention in passing Georg Baselitz, a Saxon like Otto Dix and just as direct in his sensibility, although more involved in his language (plate 320); Heimrad Prem of Munich, with his almost childlike pleasure in storytelling (plate 321); and Uwe Lausen, with his demonic forms. These are new begin- nings, which do not signify, however, that painting has decided to go in that direction. There are other young figures as well, who seem just as promising to us and depart from the representational, including Walter Stöhrer, like Antes a student of Grieshaber's. Stöhrer passionately drives the color impulses over the canvas; at first, one sees only temperament, but as we look more closely, we find, under the pattern, suggestions of representation, from which he had once started (colorplate 127). Have painters become distrustful of pure forms? Are not corporeal beings concealed behind the figurations of Günther Kirch- berger, and landscapes behind the pictures of Peter Schubert (colorplate 129)? Probably not; the contagion of the objective has not gone so far. Schubert speaks of gestures; but do not gestures always contain something of the nature of a Gestalt?

The Sculptors

Sculpture is more conservative than painting. Ever since the Renaissance painting has been quicker to react to changes in the image of reality, as well as to the environment and society. For example, a picture by Masaccio represents a vault structure that was only mastered by architects fifty years later, as has been pointed out by Siegfried Giedion.

Sculpture has become more mobile in the twentieth century. What André

Malraux says in his *Musée Imaginaire de la Sculpture Mondiale* is true, that sculpture around 1900 was a dialogue with the past, but the reproach would no longer hold true for the recent past. The discoveries of Cubism, Constructivism, Futurism, and Surrealism have freed sculpture from its former bonds to figure and proportion, volume and space, and created the prerequisites for what we mean today by sculpture, which sometimes has more relation to current painting than to the sculpture of former times.

The breakthrough after 1900 was accompanied by a revaluation of traditional values. African Negro sculpture and primitive and exotic art were discovered; the archaic was valued more than the classic. The painters were in the lead and tried themselves out in sculpture: Matisse and Derain, Picasso and Braque, Boccioni and Modigliani. They emitted the decisive impulses, more decisive than those from the Brücke painters in Germany. To be sure, prior to them such personalities as Maillol and Rodin in France and Hildebrandt in Germany had revived the feeling for the truth of plastic perception, which had been lost in the nineteenth century, but they ended an epoch rather than opened a new one.

Barlach, Lehmbruck, Scharff, and Marcks have left hardly any imprint on the present generation in Germany. The young sculptors clung to the analysis based on Cubism and Constructivism, to the synthesis of nature and art in Brancusi and Arp, or to the vitality of Henry Moore. The influence of the older men related more to the direction of the path to be taken than to the Gestalt or the details of form. When we see echoes of definite designs — Moore's *Reclining Figure,* for example — we react more negatively than we used to do in the case of similarities or influences. Since 1945, the paramount concern is the design, the individual thought. Not that we look down on technique and perfection, but they are almost taken for granted, and borrowings are of no importance. But where the conception is concerned, we have become quick of eye and make sharp critical distinctions between form and image. In all works, including such as those of Max Bill, we tend to look for the meaning of the whole, for that which holds the world together.

Concerned as we are with the immediate present, we should like to find meaningful divisions. We look for differences based on material, but that does not get us far, since most sculptors use iron, steel, aluminum, scrap, or synthetics; and the ability to handle them, to forge and weld and prepare forms for casting, is as widespread as the woodwork learned in school. If the work is rough, we can always speak of Art Brut, as in painting; and it is often intentionally so. Classification according to design is no less difficult. We always

end by finding that there is a connection between the various conceptions of present-day sculpture. The most diverse works can be recognized as having been made in our time; there must be some such thing as a spirit of the times behind them. It can also be seen in the liking for metal and its use, and in the 'freedom to do as one likes. The shapes often go beyond the rules, beyond balance and logic, into the realm of the incalculable. Of all the prewar approaches, Dada and Surrealism have had the strongest lasting effects, because they tend to go beyond the real in the direction of alchemy, which is the art of making something precious out of something ordinary in some secret way. And the preciousness would not be in the philosophical or aesthetic but in the assertion of the personal, with all its experiments and unreal aims. That at the end of it all something like a unity emerges is no doubt because war and the postwar period forced this generation into a common destiny.

Such distinctions as representational and nonrepresentational are even less important in sculpture than in painting. The few older workers who were still objective have in recent years gone more and more over to the symbolic and allegorical. Bernhard Heiliger, who was close to Moore, has given up relation to the figure in such works as *Flamme* ("*Flame*," 1962 — plate 325), although behind its emotion one can still feel the memory of what man meant for his work. Something metamorphic characterizes most of his works, even when they are as far removed from nature as the relief in the German Embassy in Paris. Karl Hartung is different. In his early works he tended more to Arp than to Moore, and when he approaches the figurative today, the discovery of a pattern urges him away from what is close to nature (plate 323). He is completely unemotional, and rather introverted in his cosmic anxiety. There is not much margin left for sculptors of this trend; departing from the narrow path between nature and imagination leads to banality or bare pattern. Such gifted men as Fritz Koenig preferred to invent new beings (plate 326), group pictures of human beings and animals, or purely symbolic figures (the *Mary Martyr* in Berlin-Plötzensee).

Sculptors are more inclined than painters to a form that can be derived from the human organism. In his later works, Guido Jendritzko comes closer and closer to references to figures. He calls them *Caryatid* or *Watchman*, and that is what they are, at least in their overall attitude. The title *Anthropomorphic* occurs repeatedly with him; the work process usually culminates in the metamorphic; and the terra cottas (*Adaptation*) also point in this direction. In Rolf Szymanski the trend toward the figure arises more out of the experience of his own being. Whatever the sculptures may be called, *Synagogue* (1963) or *Chess*

Pieces, the easy Baroque gesture that they owe to the inner tension of empathy and formal ingenuity refers to the sculptor himself.

Rudolf Hoflehner, an Austrian, works in iron and steel, but in his work technique turns almost into instinct. His metal sculptures remain allied to the figurative, although in a different form from previously. He does no modeling but begins with vertical cylindrical structural elements, which he vigorously perforates and combines, putting the major accent on the growth of the volume. He forms a steel block with a cutting torch and then welds pieces to it to form a Concrete Gestalt. The surfaces are polished or rough, as the design requires; in the end, everything accidental is effaced, but the perfection lies beyond complete craftsmanship (plate 328). "The object is the fascination," Hoflehner says; "it comes out of me, and I become myself."

Steel sculpture exists in Switzerland in Constructivist and other styles. Its protagonist is Robert Müller, a pupil of Germaine Richier's, who has worked almost exclusively in iron and steel since 1951. The form-creating will is unquestionably primary with him; his goal is the object of shell and core, swell and break. Scrap iron is also worked into the piece to enrich the material and the design. Nevertheless, one often traces organic growths behind the welded and forged forms, be they plant, animal, or human; and these are not mere associations. The titles *The Gunner* and *Martyr* (1962), *Cerberus* and *Heart* (1962-64), indicate that Müller, at least after the fact, is aware of what he has created. At first glance, his works seem technological, but they are only so to the extent that identification plays no part during the work process. They are fantastic inventions that are realities from another planet.

Bernhard Luginbühl stays entirely within the domain of pure volume-space relationships. His works enclose space *(Volume)* or evoke it by their outward projected forms *(Space Hook).* The latest works, such as *Grosser Bulldog* (plate 293), combine both in compressed structures that have inward and outward life yet look like robots of an electronic age. Compared to him, his countryman Walter Linck, with his taut and braced springy designs, almost seems a precision toolmaker.

Hans Uhlmann was the originator of iron and steel sculpture in Germany and is still the practitioner of the art with the greatest wealth of ideas. He has long been familiar with the materials and their treatment: wire, sheet metal, rods, and welding, riveting, stamping (plate 291). He has been a student and assistant at the Institute of Technology in Berlin, and during the war went over completely to art. He tested and enhanced his powers in a number of public commissions in Freiburg, Stuttgart, Frankfurt, Bonn, Leverkusen, Hamburg,

and Berlin. The earlier references to birds, insects, and figures have disappeared, and what is left is sculpture in space as the result of mathematical calculation and creative intuition. Significantly, he alters smaller-scale models when he comes to execute them full-scale; the spirit of a design would suffer if he were to multiply the dimensions mechanically. It is almost natural that Gestalt formations, which are in an experiential relation to the world, should occur in him too. Even a Gabo *Spherical Theme* or a Pevsner *Column* is a spatial and corporeal interpretation of a bit of our universe; those who know or those who suspect could translate their conceptions into formulas or into poetical-mythical metaphors. In Uhlmann's steel sculptures, however, in contrast to those of the younger English sculptors, what is involved is not images but bold structurings of space with the help of constructive-sculptural and mathematical-musical inventions. They are "aesthetic imperatives" (Novalis) rather than formed definitions of a condition or a process, thus tending toward architecture and extending it (the steel sculpture in front of a school in Hamburg, 1962, for instance). The drawings are an essential part of Uhlmann's creativity: they go even further in the testing of possibilities than the sculpture.

Although Uhlmann has many students, including painters, at the Berlin Academy, no school has grown up around him: his designs are too strictly conditioned by the combination of mathematical calculation and intuition. But Klaus Ihlenfeld of Berlin, since 1957 living mostly in the United States, and Ursula Sachs, both from Uhlmann's classes, would probably not have developed as successfully as they did without Uhlmann's image to guide them. The teacher-student relationship is much different today from what it used to be; in most cases one would believe, on the basis of the works, that the teacher was someone quite different from the actual master. For example, no one would ever suspect that H. P. Isenrath (plate 333) had been a student of Kricke's.

Norbert Kricke and Brigitte Meier-Denninghoff are a generation younger than Uhlmann and have no doubt been influenced — at least Kricke, who studied in Berlin — by his work. Uhlmann was not yet teaching at the Academy but had been exhibiting regularly at the Rosen Gallery since 1945. At first, like Uhlmann, Kricke made wire sculptures, sometimes in round forms, sometimes angular, with a virtual central point, later organized in tangles. Then, however, more or less at the same time as Meier-Denninghoff, he found an entirely different way, welding thin steel rods of different lengths into planes or letting them swell in the wind like sails or spread out in various directions like birds' wings (plate 331). These are new ideas, whose plastic possibilities Kricke fully worked out. Works like these — the Mannesmann-Plastik and the

one in Reux, Normandy (1961-63) — made Kricke well-known. In these designs the rods are taken out of the plane, curves or sharp bends put into some of them, and the rods made into bundles pointing in various directions, the whole thing swinging freely in space. Like Uhlmann, Kricke is a sculptor for whom the spatial is most important, and he therefore expressly designates his works "space plastics." In contrast, such plane compositions as the relief in the Gelsenkirchen Theater are rather decorative.

Brigitte Meier-Denninghoff began at the Berlin Academy at the end of the war, studied further in Munich, and then worked with Henry Moore and Antoine Pevsner. This gave rise to quite different tendencies, but in the mid-fifties she too went over to the coordination of vertical rods (plate 332); but despite such titles as *Swinging* or *Squall* her work remains more static than Kricke's. This is true of her "Series," of many bent and broken rolling walls, that look like stage scenery or abstract groups, of great beauty und strangeness.

We find steel and iron used quite differently by Friedrich Werthmann and Jochen Hiltmann. Both came from entirely different starting points to spherical forms. Werthmann worked first with strip and rod forms, which he gathered into bundles and shaped and assembled into waving structures or even into spheres surrounding a space. He came there by the serial method — by putting space, rhythm, and structure into a series (plate 334), by transformation and interruption, as he explains. Hiltmann starts with casting steel and swings between directing the process and letting it go its way, for the flow of metal has a will of its own. If a spherical form is to come out of it, decisive action is necessary, and in Hiltmann that comes out of insight into geological processes, not out of awareness of serial laws. And so for the clefts and crevices, the lava or mushroomlike excrescences. No weatherings but formations that have grown from within, with no display side. Allegories? Günter Ferdinand Ris "steps on the man that needs to make an allegory." Ris works his ball-like shapes mainly out of marble.

Steel can also be welded together, as Erich Hauser does, into craggy physiognomies of landscapes or figures, with furrows and crevices that show that the medium-sized objects, for all their monumental appearance, are no monoliths (plate 292).

And metal can also entice to play and movement, like the wire images and metal reliefs that Walter Bodmer of Switzerland has been making for a long time. He is one of the earliest sculptors in wire, and we think of him almost as a classic in the field when compared with, say, Jean Tinguely, a native of Basel and a member of the École de Paris, with his robots and mobile automata.

Usually movement and play go together, as in Harry Kramer (plate 297), whose *"sculptures automobiles"* are wire constructions with a drive mechanism, just like clocks, for which he has a passion, as for all precision instruments. Kramer was trained as a dancer and has carried over some of his dancing gift into his *"automobiles,"* marionettes, and films. His wire sculptures, with their harmonious movements and their sounds like the twittering of birds in cages, are charming. His precision mechanisms have much in common with the subtle inventions of Günther Haese some of whose wire figures are reminiscent of Klee *(Ghost of a Genius,* for example), while others suggest nineteenth-century music boxes (plate 298). *Oasis* (1964) suggests Klee's work between the wars.

Heinz Mack, Otto Piene, and Günther Uecker, whom we have already considered as painters, belong to this trend more in spirit than in practice. Everything they do relates to space and movement, especially as the form is given not by color but by light, even in the colorful Piene. His balls of light for the Düsseldorf Municipal Theater are as much sculptures as the spheres of Werthmann are. Mack's "Light Dynamos" are mobile constructs, sculptures in that the circular mobile aluminum disk, mounted in a housing, leaves changing effects of light and space on the undulating plexiglass plate. Uecker's nail pictures, as plastic structures, already are directly in this milieu; for him, moreover, the white-coated nails on the white-painted sheet of wood are "articulations of a spiritual experience," an analogy to Mallarmé's intention of writing an entire poem only in white. This trio, linked in the Zero group with their spiritual kin — such as Pol Bury, to mention one — is a strongpoint of artistic activism in Germany; this was understood abroad sooner than in its own country. Christian Megert (born in Switzerland) has a legitimate relationship to them; his mirror pictures have "space without end and bounds" as their starting point.

The boundaries between painting and sculpture are flexible. Zoltan Kemeny of Switzerland is regarded by everyone as a sculptor but calls himself a painter. He studied painting and made pictures and collages down to the end of the forties, although already with additions of sand, chiffon, and so forth. He has been making his "Images en relief" since 1945. In 1963, he made a relief 120 meters long for the new Municipal Theater of Frankfurt am Main; in 1964, he won the international prize for sculpture at the Venice Biennale. Using a highly individual montage process, he puts together various parts of metal, aluminum, brass, iron, and, since 1961, copper, often colored by suitable processes. The effect is not one of matter; in *Vitesses Involontaires* (1962 — plate 289) or *Image à Lire* (1963) the immediate statement makes us forget material and technique. Evidently, definite situations or processes are in Kemeny's mind,

whether they take form during the work or come to him in advance. The invention of his manifold structures leads effortlessly not only to aesthetic effects, which change for the spectator as he changes his point of view, but also to contents, such as "breeze" or "emotion." Kemeny calls his relief in the Frankfurt theater a second drama, which supplements the rational architecture with the events of an irrational stage play.

When we add Max Bill, of Winterthur, and the late Alberto Giacometti, born in Stampa, the balance shifts in favor of Switzerland. Despite his French nationality, Jean Arp of Strasbourg felt that he belonged to Switzerland and influenced art from Zurich, Basel, and Locarno just as decisively as art from Paris. Arp and Giacometti had already achieved world fame around 1930, but nobody can deny that the style of Arp's old age and that of Giacometti's maturity are worthy of their bold beginnings and still influence the young.

Max Bill is an exeptional case, in all of contemporary art in general, and in sculpture in particular. He has created works in which the principle of growth and maturing, in Arp's sense, has found personal expression, and works that represent the maximum of mathematical imagination and technical precision, such as the *Construction out of 30 Equal Elements* or the *Endless Loop*. Bill is still working in both these directions, though mathematical intuition is his stronger component. His plastic structures are extremely sober in their means and regularity; although Bill is also an architect and a painter, he gives each discipline its autonomy. He has won recognition for the expression "Concrete Art" (coined in 1930 by Theo van Doesburg) to indicate a nonrepresentational art that is the "expression of the human spirit" and "harmonious measure." The Concrete Art exhibition that he arranged in the Basel Kunsthalle was a turning point in the development of art far beyond the borders of Switzerland. But the viewer must be able to experience the equality of three volumes or the division of a square sheet of brass into spherical shapes.

It is a long way from the Constructivist designs of Robert Müller and the spiritual works of Max Bill to the stonecutter's works of the Swiss Hans Aeschbacher, the Austrian Fritz Wotruba, or the Germans who have formed the Symposion. Perhaps it is a good thing to have this counterweight to the rapid shifts in design. Aeschbacher's sculptures in marble, granite, porphyry, or lava are steles, soaring architectures of great rigor and persuasiveness (plate 327), he titles them "Figures." Wotruba is a disciple of Anton Hanak; since 1945, he has been teaching at the Vienna Academy of Art. He is one of the most successful sculptors; precisely in this age of technological problems, his massive plastic work finds resonance. In his own words, his work has as its

dominant influences "statuary quality, the static, measure, balance, and unity." One often gets the feeling that some of the substance of his figures still has its roots in the quarry, despite the fact that since the fifties Wotruba modulates and differentiates more and more, rounds off the edges and smooths the corners, technically and in conception. Many of his recent works are cast in bronze, some from the outset, others as casts taken from stone statues, as was done at one time with wood statues of Barlach. The procedure is questionable. Strangely enough, the surface of the bronze is rougher and more in movement than that of the stone, as if the hand had been active during the casting. His high reliefs in bronze at the Documenta II aroused well-deserved admiration, yet it would seem to us that his work in stone has a more vigorous life (plate 294).

In Germany the center of stonecutting is the Symposion europäischer Bildhauer ("Symposium of European Sculptors"), which has already exhibited twice in Berlin. Between the Congress Hall and the old Reichstag a number of menhir-like stone colossi were set up, the work of Herbert Baumann, Heinrich Brummak (plate 296), Gerson Fehrenbach, Reinhold Hommes, Utz Kampmann, Roland Göschl and Karl Prantl of Vienna, Josef Wyss of Switzerland, the American Joseph Lonas, and some other foreigners. It was a forest of impressive lofty signs, differentiated from open-air sculpture shows by the obvious affinity of the works and the unity of their conception. Since then, some of the participating sculptors have become known through exhibitions of their own and have shown their individual personalities. Hommes, a student of Karl Hartung's in Berlin, as many of this group have been, has also made bronze sculptures — "Technoid Forms" and "Tectonic Themes" — which do not entirely depart from the sculptor's original concern with stone. Baumann makes "Disks" and "Sun Disks" that have the appearance of millstones with concentric scorings. Kampmann comes close to Pop Art in his latest works and has invented very individual colorfully attractive variations on the cube (plate 329). The sculptors united in the Symposion help each other in their task of setting up a field of modern menhirs everywhere in the world and of tracing a roadway in stone throughout Europe.

It is quite possible for them now and then to use another material as well, such as bronze, for which Otto Herbert Hajek designs his powerful and recently even accessible sculptures. He builds them up out of modeling cement, coats them with wax, and has them cast by the lost-wax process. He has filled major commissions in this way: at the auditorium of the University of Freiburg im Breisgau (1959), the Memorial Hall in Frankfurt-West (1962), and the parvis of the Regina Martyrium cloister in Berlin-Plötzensee (1961-63). From the

outset, Hajek saw his task as a dialogue with space, his path as the further development of the "broken surface" and the "knot in space" to the "space wall" and "stratification of space," the meaning of his work as the overcoming of the contradiction between space and plastic volumes. He seeks to merge them and therefore allows every detail to fuse into the total. The introduction of color and the bands of color marking off the space are bewildering at first, as they expand sculpture to include a considerable portion of the environment; but Hajek's purpose is precisely to make it easier for the viewer to see the spatial plastics within the framework of an intended integration of space. His last works, "Ways of Color" (1964-65), are of wood and steel, about the height of a man. This is a new beginning for Hajek, indicating that he is continuing his task of mastering the environment (plate 295).

The lost-wax technique has also been used occasionally by Gerson Fehrenbach, whom we mentioned as a Symposion sculptor. His knotting together of spatial-plastic elements puts him closer to Hajek than to Karl Hartung, his teacher. Emil Cimiotti also casts by this process, and in his movement and stratification of the hovering volumes is close to his contemporary Hajek. All in all, his works suggest landscapes rather than space nodes (plate 324).

Nele, who first became known with her fantastic gold jewelry at the Stedelijk-Museum in Amsterdam in 1956, was studying with Hans Uhlmann in Berlin at that time; in 1959, she went to Munich, where she came into contact with Hans Platschek and the Spur group. No technical difficulties exist for her; she invents structures as she goes along and gives form to themes of world anguish as well as of burlesque. Her precocity (in 1958 she exhibited a free sculpture at the German Pavilion in the Brussels World's Fair) has not hurt her; she went forward swiftly, and her latest bronzes, evidently cast from steel assemblies, are bold new discoveries (plate 330).

The Spur was founded by Lothar Fischer along with the painters Heimrad, Prem, Sturm, and Zimmer. Fischer was a student of Heinrich Kirchner's and likes to work in clay. Almost all his later work is small terra cottas, looking like things from a prehistoric excavation (*Romeo and Juliet*, 1963). He is a lover of the oldest and most primitive ways in art, but what he does is unmistakably his own, in the spirit of an age that understands the grotesque as well (plate 319).

In general, sculptors have little connection with the experiments of the painters we bring together under the name of Pop. We could sooner think of Pop in relation to Horst Egon Kalinowski (plate 290), but even his earlier stately sarcophagi had no trace of the street-fair atmosphere of the world of consumption, and his recent works, the pictorially highly differentiated "Caisses," pre-

dominantly of wood and leather, seem to have ritual significance. Everything about him is solid and static, more thoughtful than sensational. A comparison with the works of Louise Nevelson is tempting, but it would only show that Kalinowski's mind is of another cast.

Something should be said about the assemblages, which bring together and order carefully chosen objects — pencils, cartridge cases, bits of glass, wood chips, or whatnot. In everyday life these things go almost noticed; by means of their surprising juxtapositions they acquire something of the value of colors. Adolf Karl Luther, who came late to art after passing the examination for assistant judge, is one of the specialists in this field, and his worlds enclosed between two glass plates bring out quite unexpected properties of the materials. For him, as he says, everything in nature is an instrument for receiving light; and he makes the commonplace into "transoptic" actuality.

The diversity of sculpture since 1945 is stupefying, and one design still keeps following another. The process is an eternally fascinating dialogue among the representatives of the younger generation, a dialogue in which many of the older men — Gabo, Pevsner, Schwitters, and Giacometti — take part. The public has got used to the coexistence of such a large number of related and hostile tendencies and drawn its own conclusions. It has become more objective in judging works of art, less dependent on perceptions and feelings, more than ever concentrating on the structures and forms and the identity of the outer and the inner. The public also realizes that the new discoveries and structures meet an essential need in building our existence. Even if not all the works succeed in doing this, many prove that the art of our technological age too contributes to defining our lives and activity, and is the factor of hope in the midst of the many uncertainties in and around us.

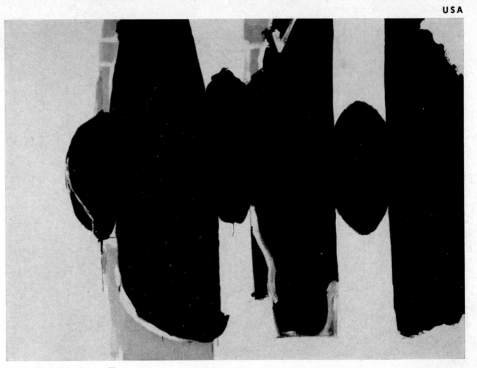

1 Robert Motherwell 1961

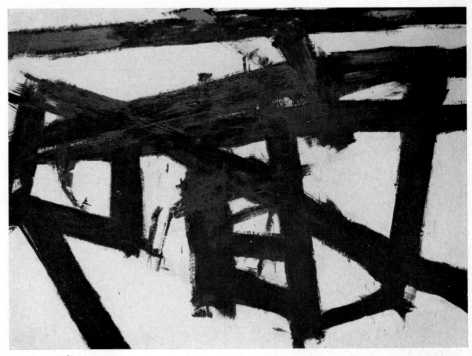

2 Franz Kline 1956

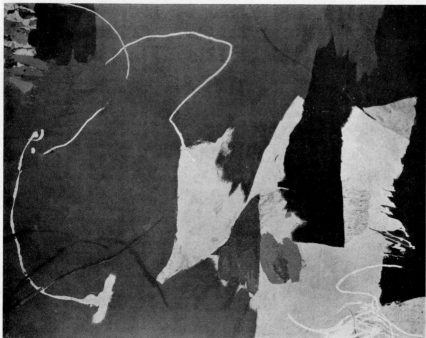

3 James Brooks 1964

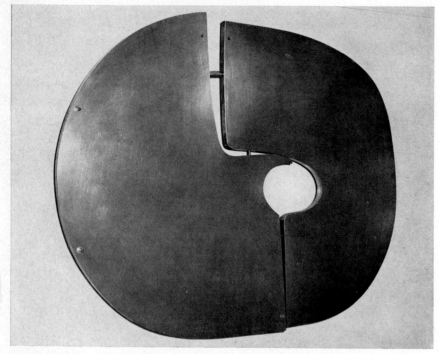

4 Conrad Marca-Relli 1964

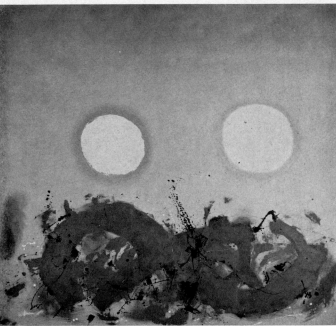

5 Adolph Gottlieb 1962

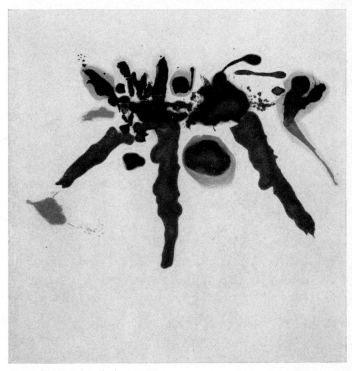

6 Helen Frankenthaler 1962

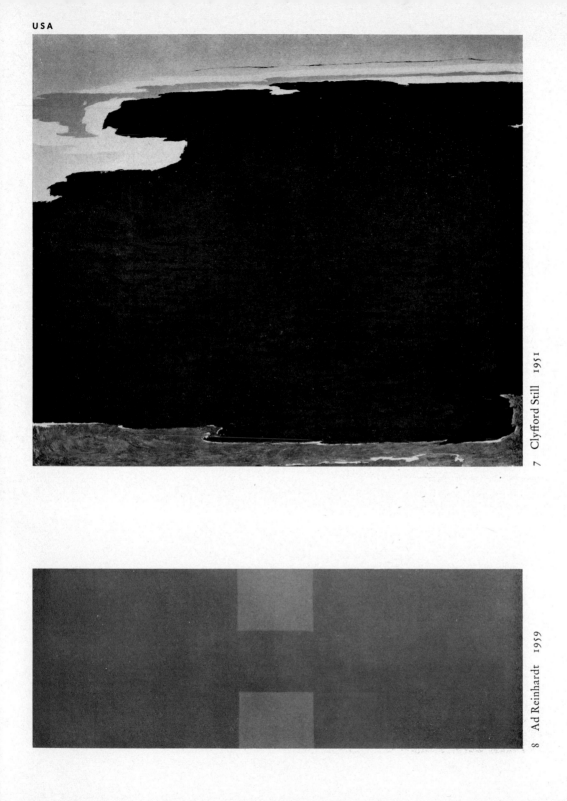

7 Clyfford Still 1951

8 Ad Reinhardt 1959

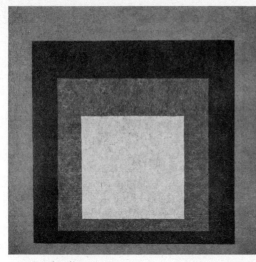

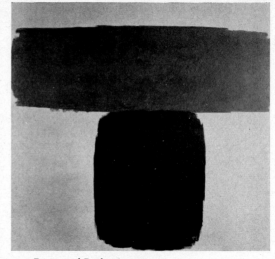

9 Joseph Albers 1958

10 Raymond Parker 1961

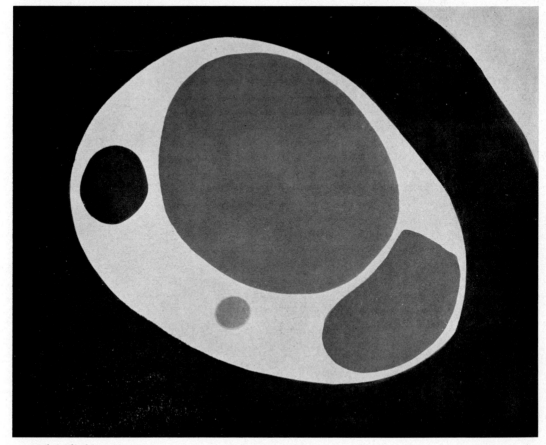

11 Jules Olitski 1963

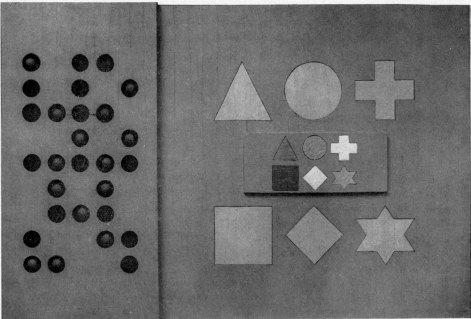

12 George Ortman 1960

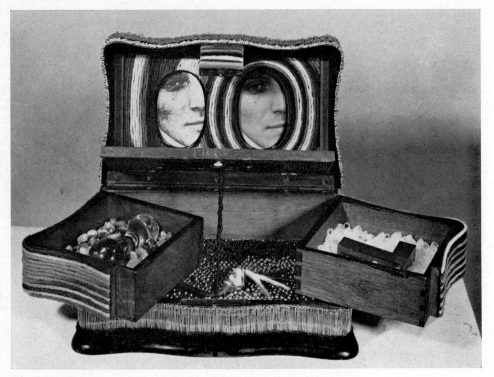

13 Lucas Samaras 1964

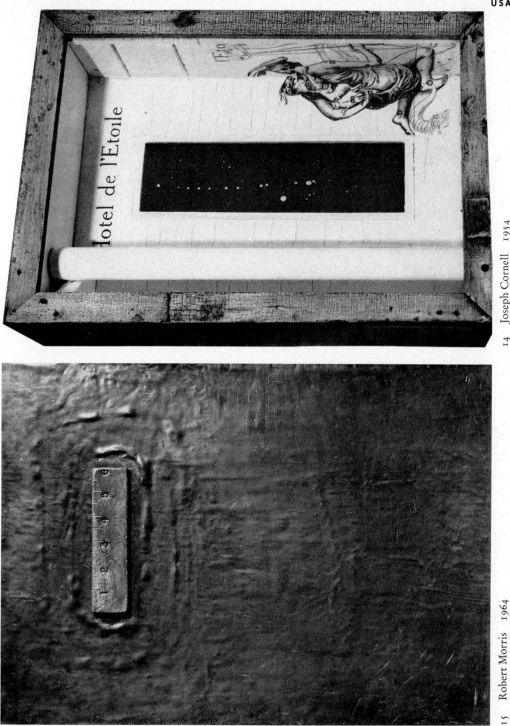

14 Joseph Cornell 1954

15 Robert Morris 1964

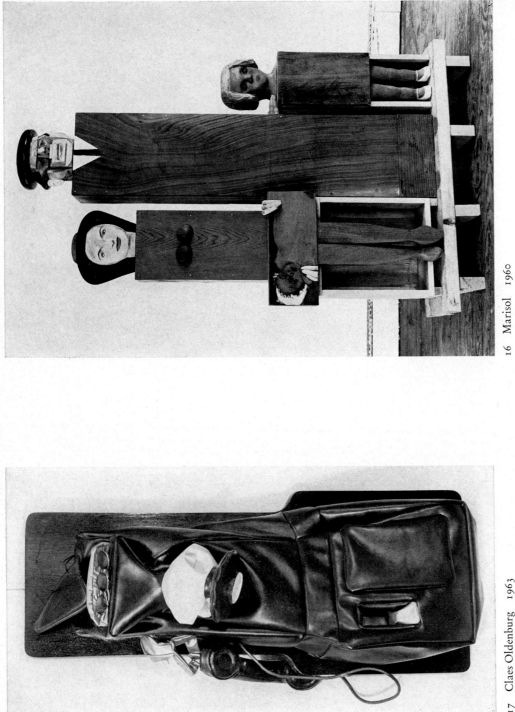

16 Marisol 1960

17 Claes Oldenburg 1963

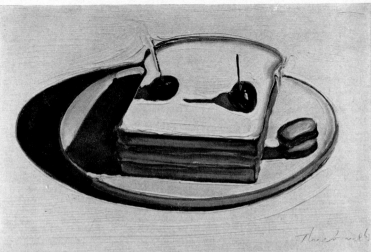

18 Wayne Thiebaud 1963

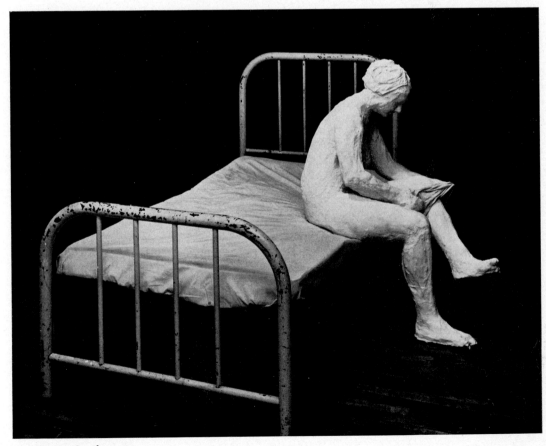

19 George Segal 1963

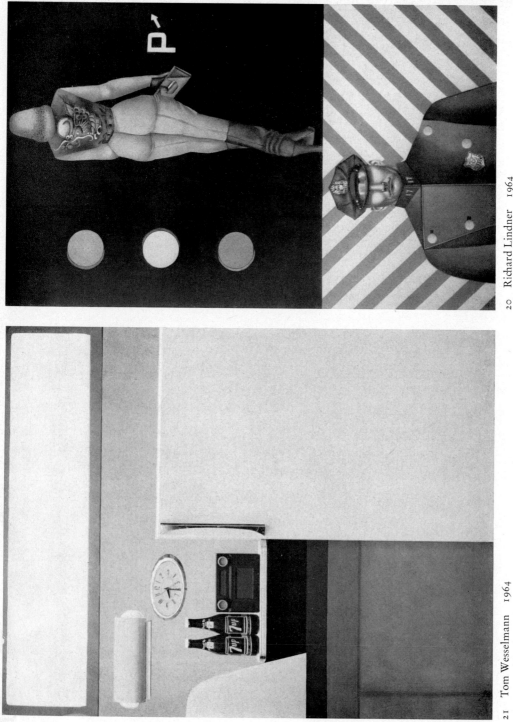

20 Richard Lindner 1964

21 Tom Wesselmann 1964

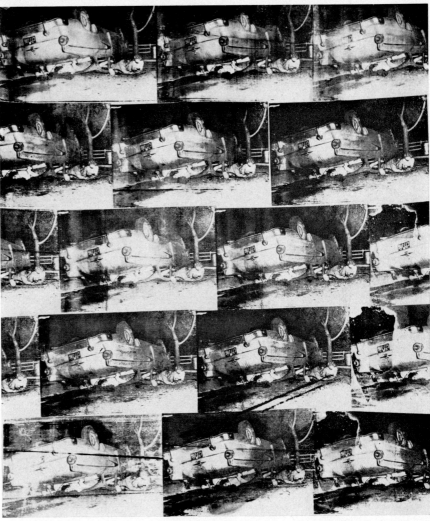

22 Andy Warhol 1963

23 James Rosenquist 1962

24 Robert Indiana 1963

25 Stuart Davis 1957

26 Richard Anuszkiewicz 1964

27 Larry Poons 1963

28 Len Lye 1965

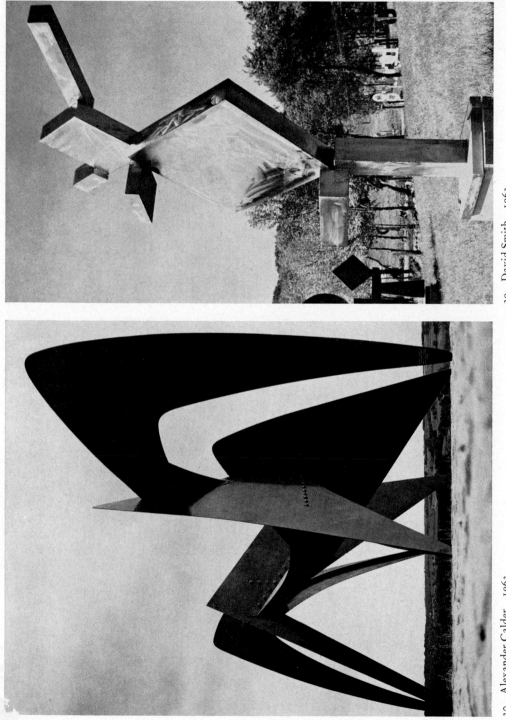

29 David Smith 1963

30 Alexander Calder 1963

31 Reuben Nakian 1963

32 Wilfred Zogbaum 1960

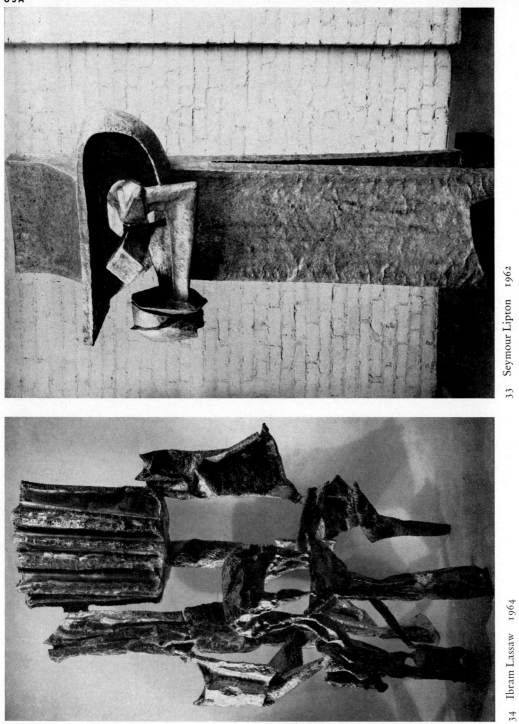

33 Seymour Lipton 1962

34 Ibram Lassaw 1964

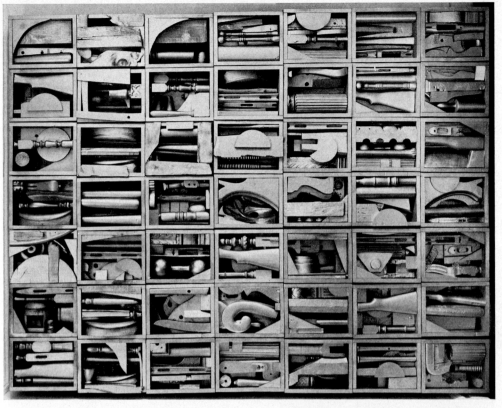

35 Louise Nevelson 1962

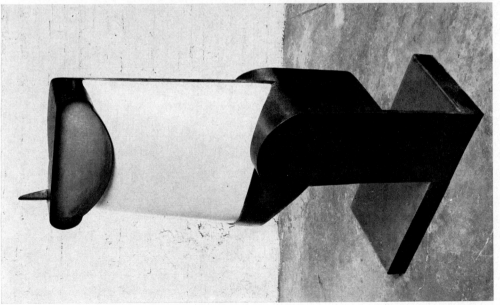

36 Edward Higgins 1963

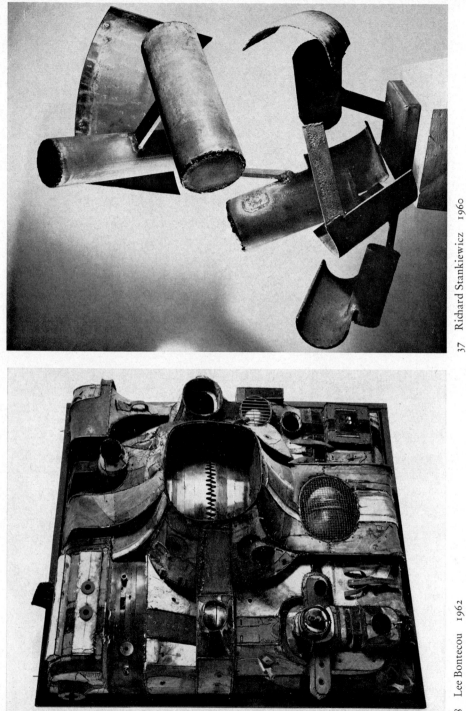

37 Richard Stankiewicz 1960

38 Lee Bontecou 1962

39 John Chamberlain 1964

40 Mark di Suvero 1962

41 Peter Agostini 1963

42 Frank Stella 1964

43 Max Ernst 1964

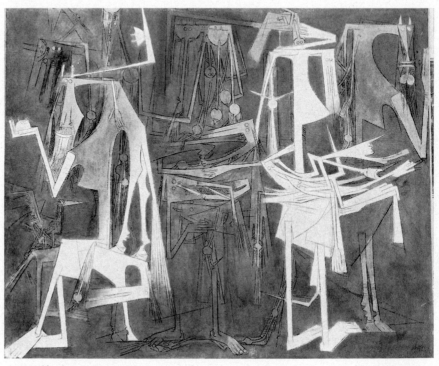

44 Wilfredo Lam 1964

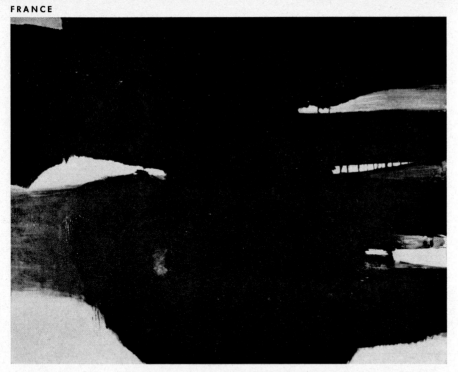

45 Pierre Soulages 1964

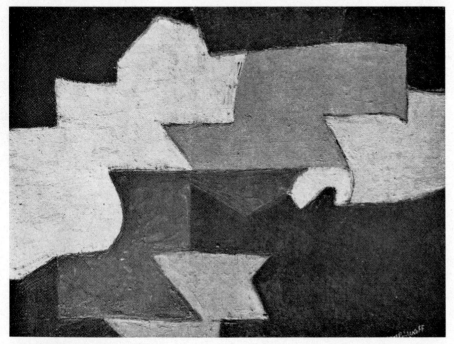

46 Serge Poliakoff 1952

47 Jean Hélion 1958

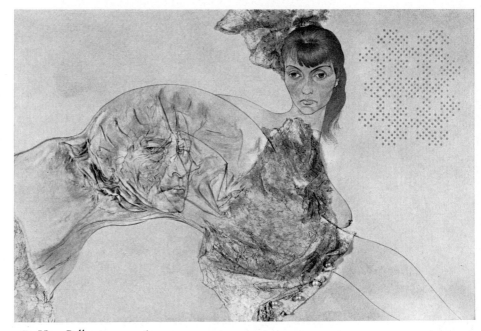

48 Hans Bellmer ca. 1960

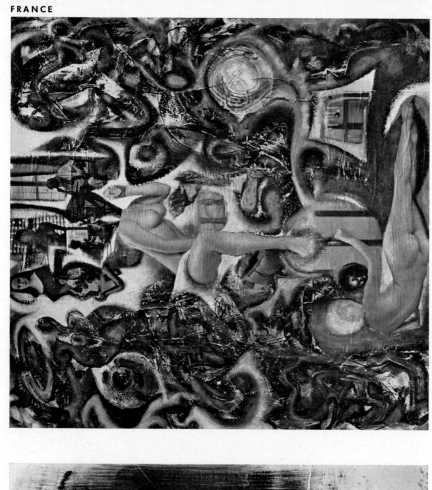

49 Jean-Jacques Lebel 1960

50 Jean Degottex 1964

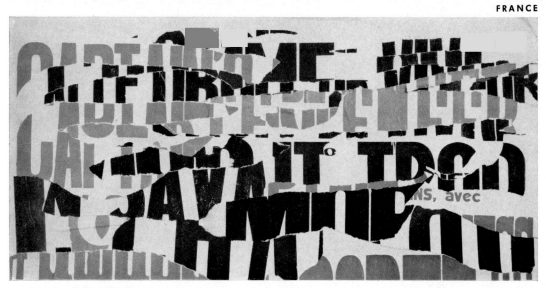

51 Jacques de la Villeglé 1959

52 François Dufrêne 1961

53 Takis 1964

54 Daniel Spoerri 1961

55 Jean Tinguely 1964

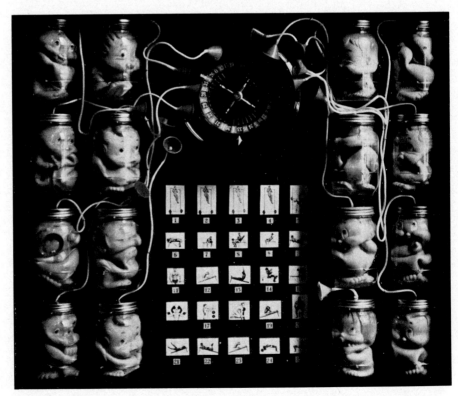

56 Tetsumi Kudo 1962

57 Daniel Pommereulle 1964

58 Jean-Pierre Raynaud 1964

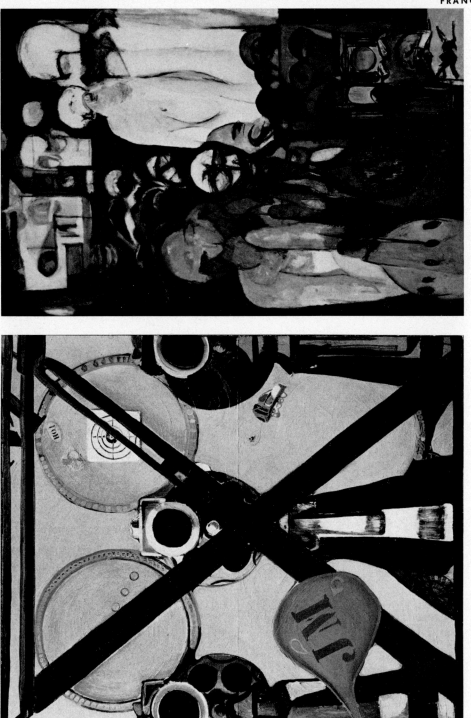

59 Bernard Dufour 1959–60

60 Jacques Monory 1964

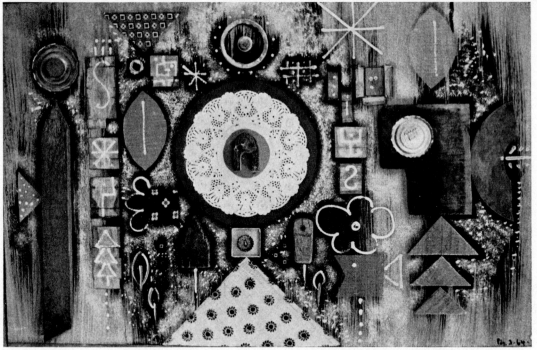

61 Phillip Martin 1964

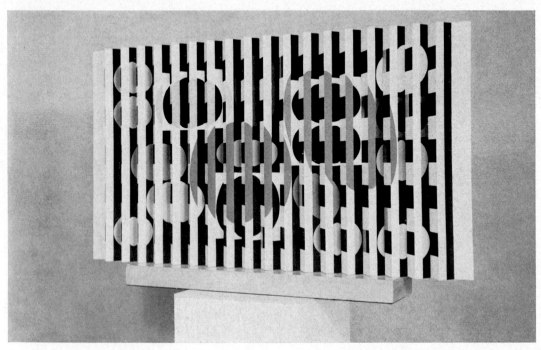

62 Yaacov Agam 1964

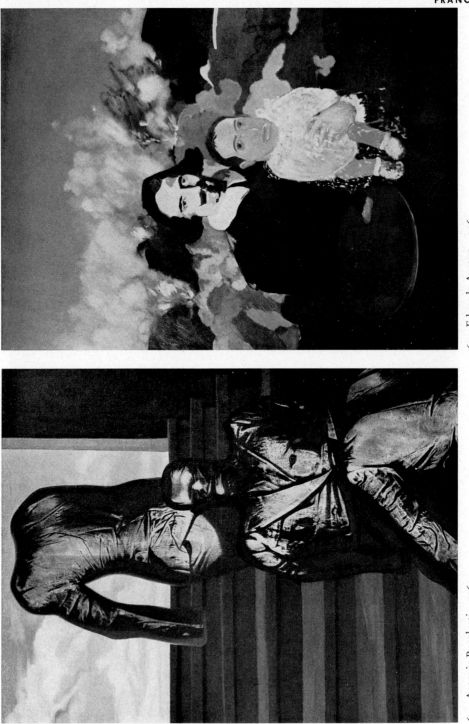

63 Eduardo Arroyo 1964

64 Antonio Recalcati 1964

65 Myriam Bat-Yosef 1964

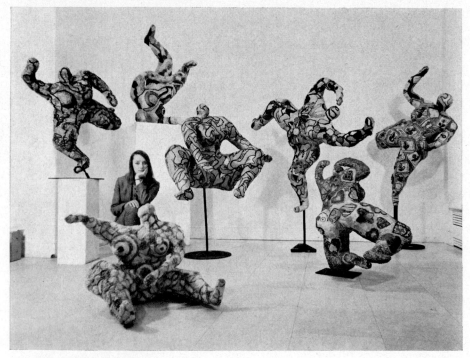

66 Niki de Saint-Phalle 1965

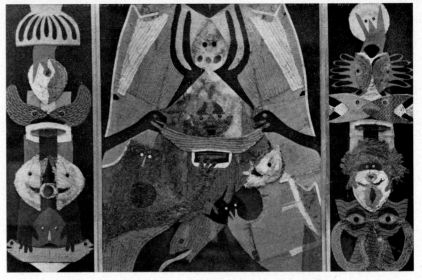

67 Bona 1965

68 Margarita Russo 1965

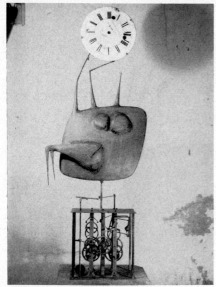

69 Philippe Hiquily 1962

70 Christian d'Orgeix 1965

71 Robert Müller 1963

72 Etienne-Martin 1960

73 Bernard Saby 1965

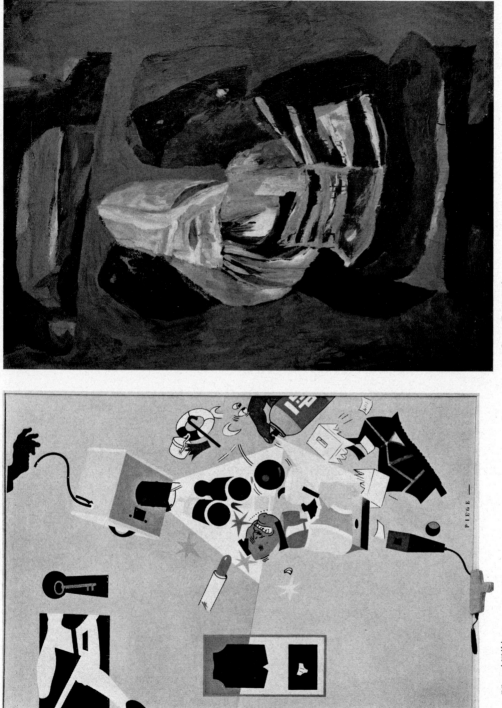

74 Serge Rezvani 1964

75 Hervé Télémaque 1964

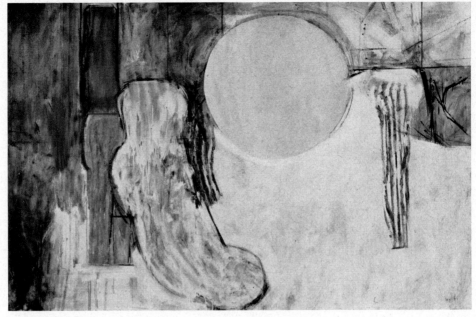

76 Henry Mundy 1962

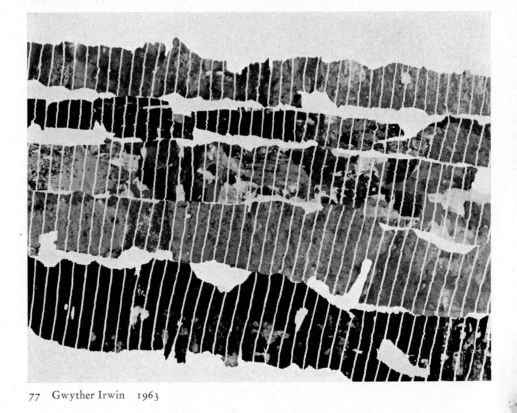

77 Gwyther Irwin 1963

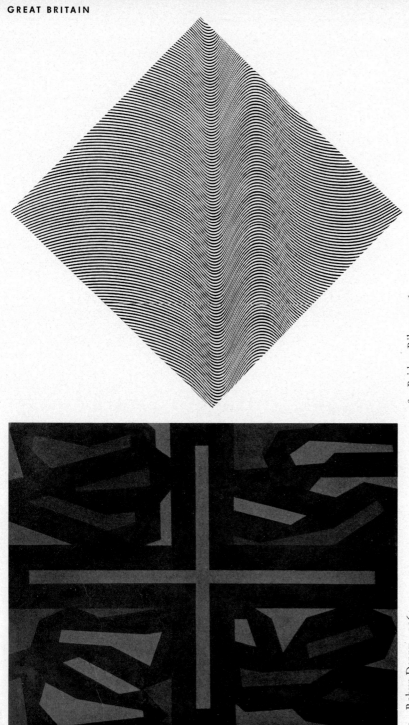

78 Bridget Riley 1964

79 Robyn Denny 1964

80 Gillian Ayres 1964

81 Richard Hamilton 1961–64

82 Ian Stephenson 1963

83 Peter Blake 1961

84 Richard Smith 1963

85 Joe Tilson 1963

86 Allen Jones 1963

87 David Hockney 1963

88 William Turnbull 1957–61

89 Eduardo Paolozzi 1964

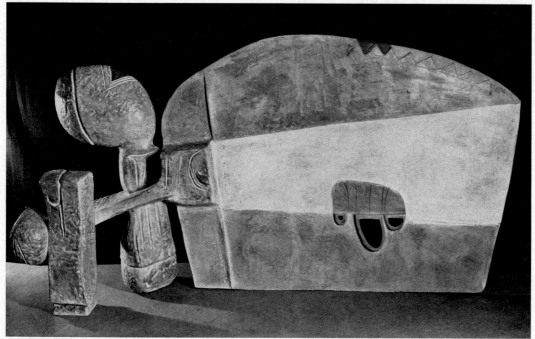

90 Hubert Dalwood 1962

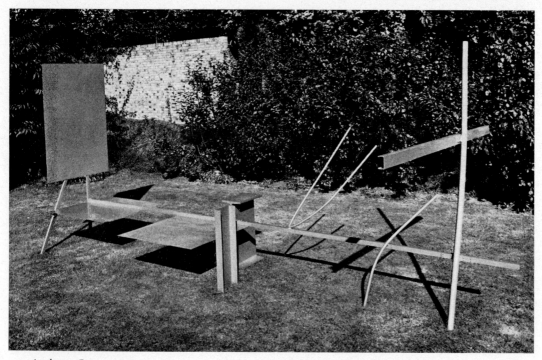

91 Anthony Caro 1962

92 Philip King 1963

93 Patrick Caulfield 1964

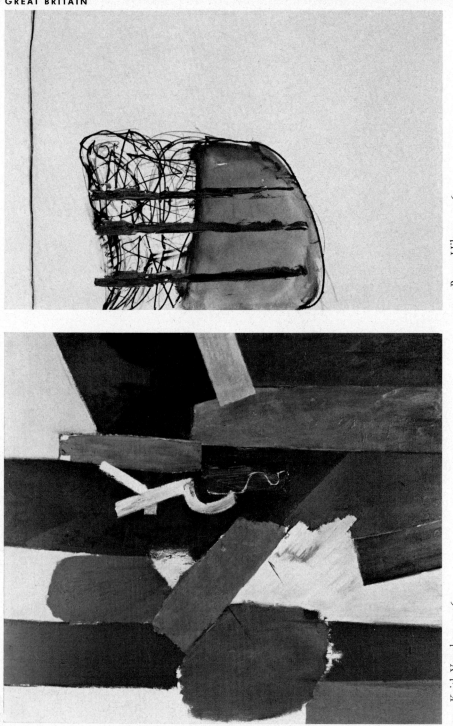

94 Roger Hilton 1960

95 Keith Vaughan 1961

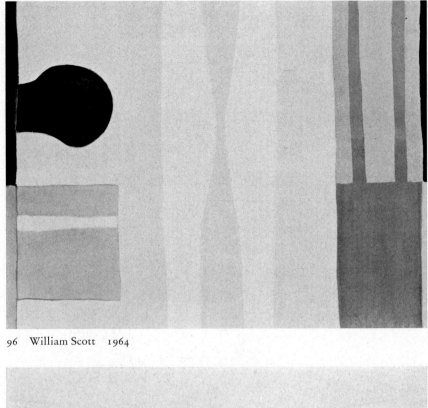

96 William Scott 1964

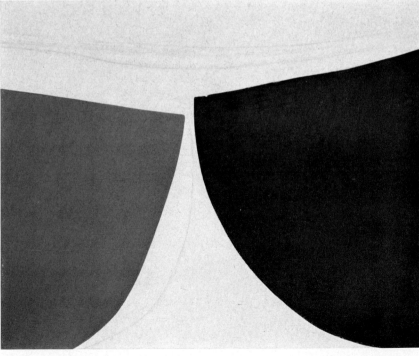

97 Terry Frost 1961

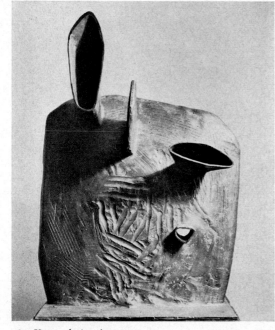

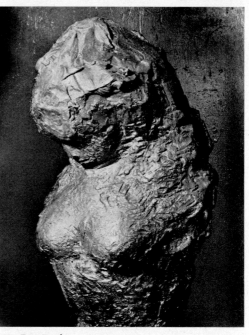

98 Kenneth Armitage 1963

99 Reg Butler 1959–61

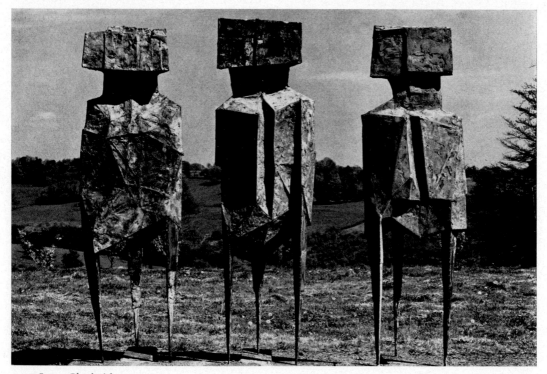

100 Lynn Chadwick 1960

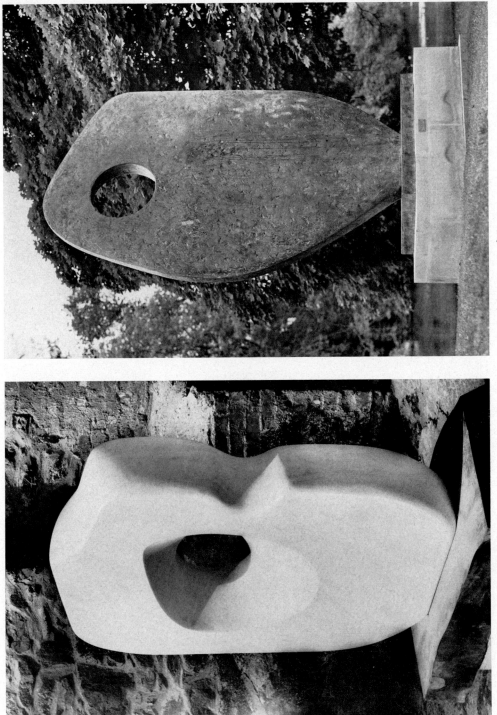

101 Barbara Hepworth 1961–62

102 Barbara Hepworth 1963

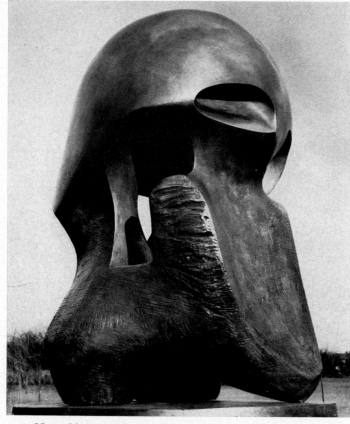

103 Henry Moore 1964

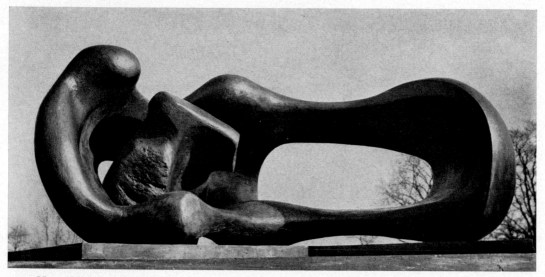

104 Henry Moore 1960—61

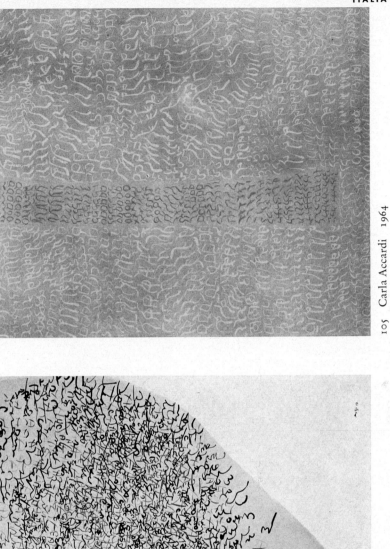

105 Carla Accardi 1964

106 Antonio Sanfilippo 1962

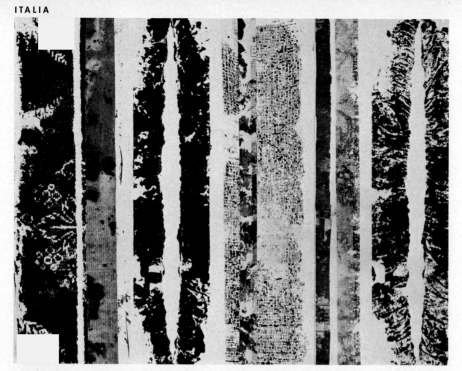

107 Toti Scialoja 1963

108 Sergio Romiti 1961

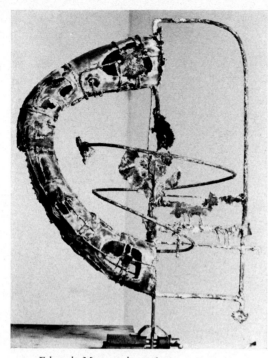

109 Edgardo Mannucci 1964

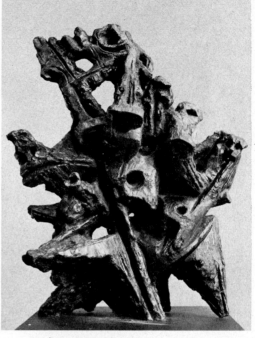

110 Umberto Mastroianni 1961

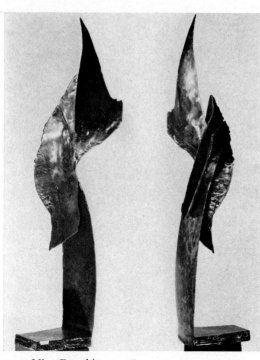

111 Nino Franchina 1963

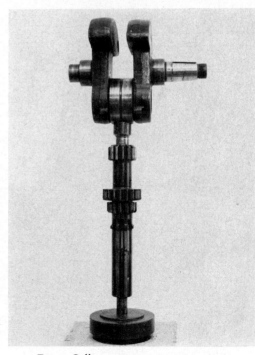

112 Ettore Colla 1961

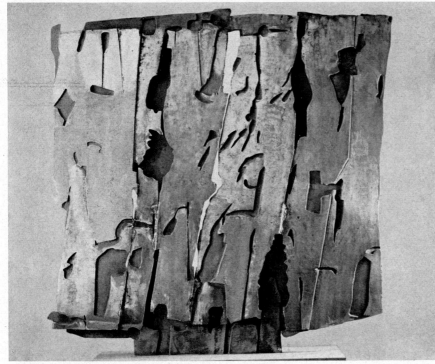

113 Pietro Consagra 1961

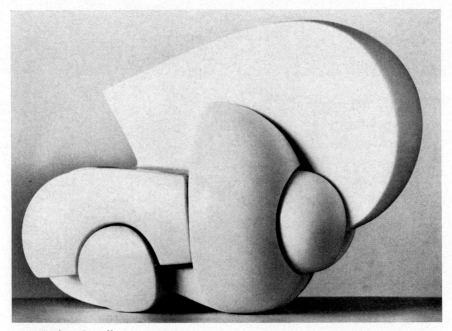

114 Andrea Cascella 1964

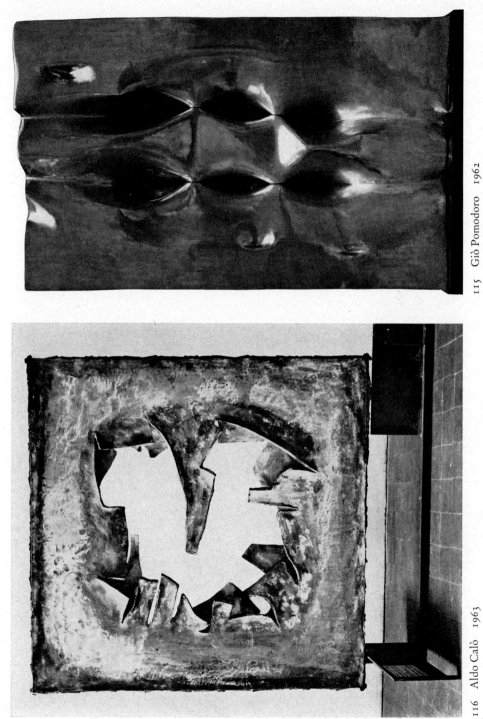

115 Giò Pomodoro 1962

116 Aldo Calò 1963

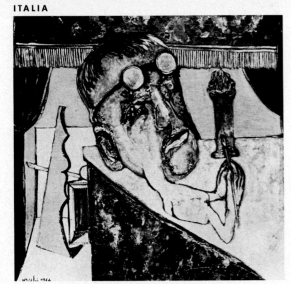

117 Sergio Vacchi 1964

118 Concetto Pozzati 1963–64

119 Davide Boriani 1960

120 Antonio Calderara 1961

121 Giovanni Antonio Costa 1964

122 Enzo Mari 1963

123 Pasquale Santoro 1965 124 Mario Ceroli 1964

125 Getulio Alviani 1964

126 Achille Pace 1964

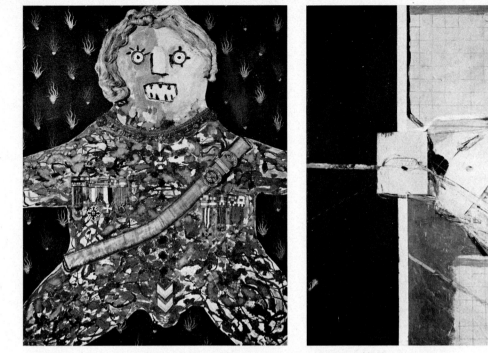

127 Enrico Baj 1961

128 Rodolfo Aricò 1962

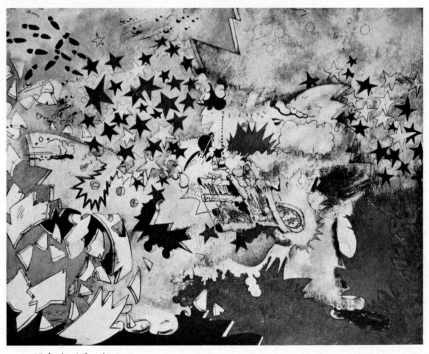

129 Valerio Adami 1963

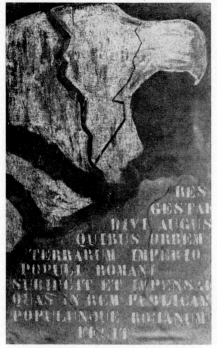

130 Franco Angeli 1964

SOUVENIR OF LONDON

131 Tano Festa 1964

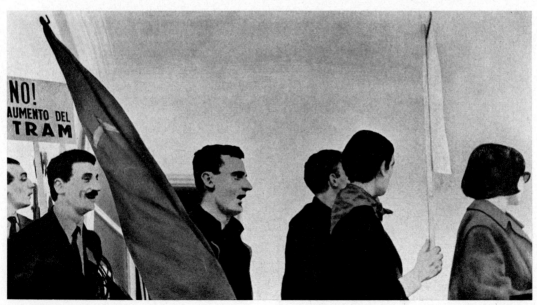

132 Michelangelo Pistoletto 1965

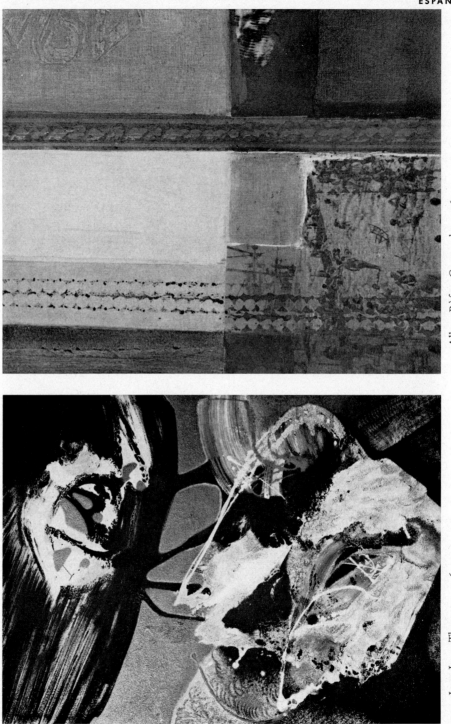

133 Albert Ràfols Casamada 1964

134 Joan Josep Tharrats 1964

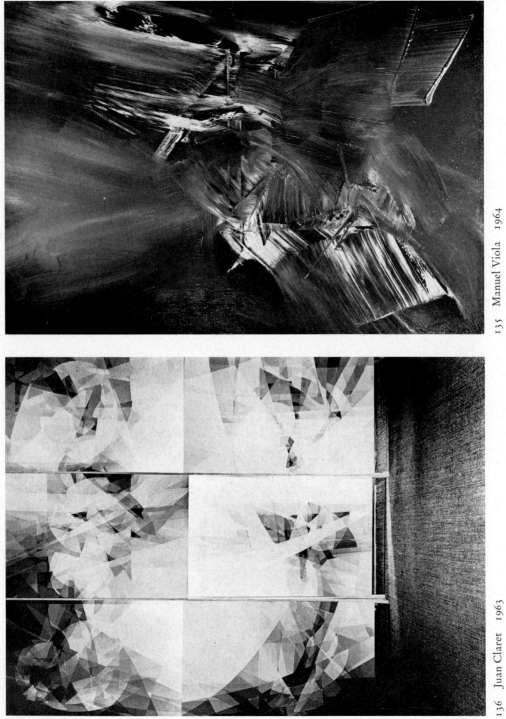

135 Manuel Viola 1964

136 Juan Claret 1963

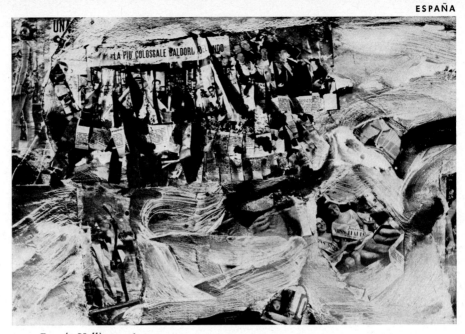

137 Román Vallès 1964

138 Luis Feito 1963

139 Antonio Saura 1963

140 Pablo Serrano 1957

141 Eduardo Chillida

142 Andreu Alfaro 1964

143 Josep Maria Subirachs 1964

144 Moisès Villèlia 1965

145 Xavier Corberó 1965

146 Francisco Sobrino 1963–64

147 Andrés Cillero 1964

148 Julián Pacheco

149 Wil L. Bouthoorn 1964

150 Kees van Bohemen 1964

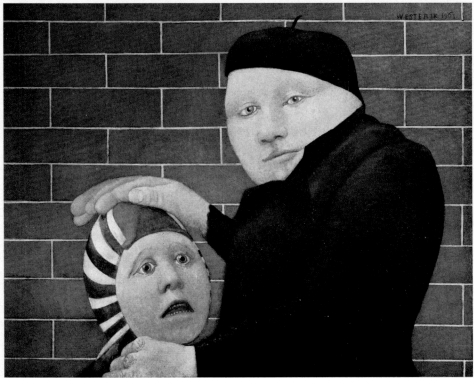

151 Co Westerik 1961

152 Gerard Verdijk 1965

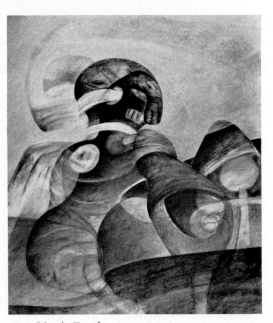

153 Martin Engelman 1964–65

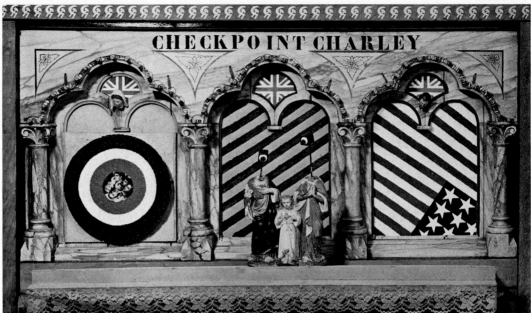

154 Woody van Amen 1965

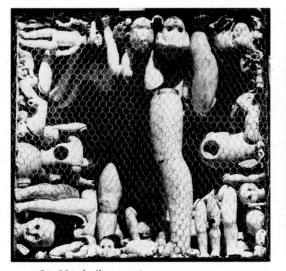

155 Jan Henderikse 1965 156 Wim T. Schippers 1965

157 Henk Peeters 1964–65

158 Armando 1962

159 J. J. Schoonhoven 1964

160 Jaap Mooy 1961

161 Shinkichi Tajiri 1965

162 Constant 1960

163 André Volten 1964

164 Wessel Couzijn 1962

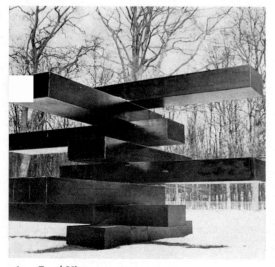

165 Carel Visser 1965

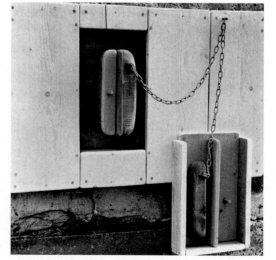

166 Mark Brusse 1965

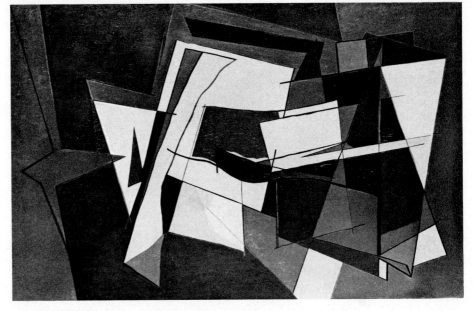

167 Richard Mortensen 1962

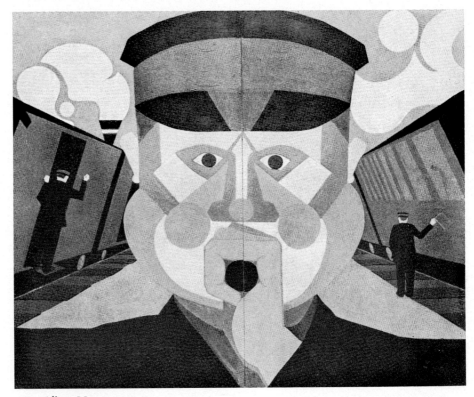

168 Albert Mertz 1952

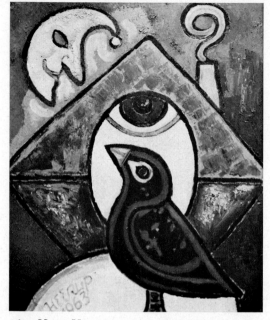

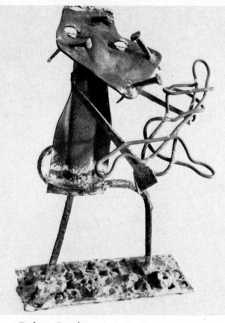

169 Henry Heerup 1963

170 Robert Jacobsen 1959

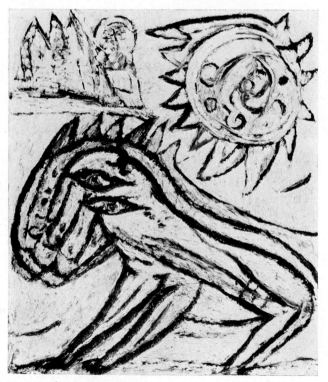

171 Carl Henning Pedersen 1957

172 Odd Tandberg 1962

173 Carl Nesjar 1963

174 Inger Sitter 1964

175 Arnold Haukeland 1960

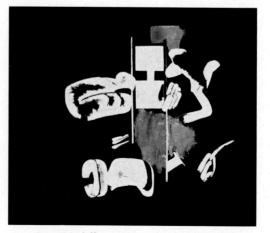

176 Elis Eriksson 1962

177 Lage Lindell 1964

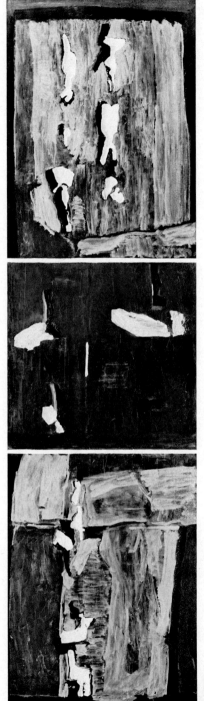

178 Torsten Renqvist 1963

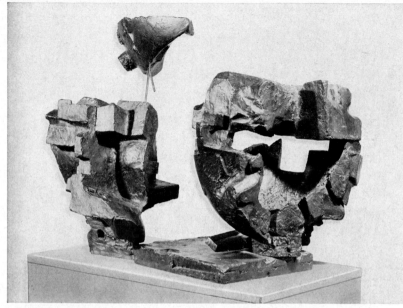

179 Martin Holmgren 1955–60

Per Olof Ultvedt 1965

181 Kain Tapper 1961

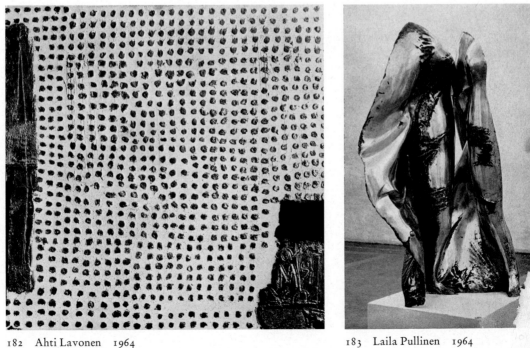

182 Ahti Lavonen 1964

183 Laila Pullinen 1964

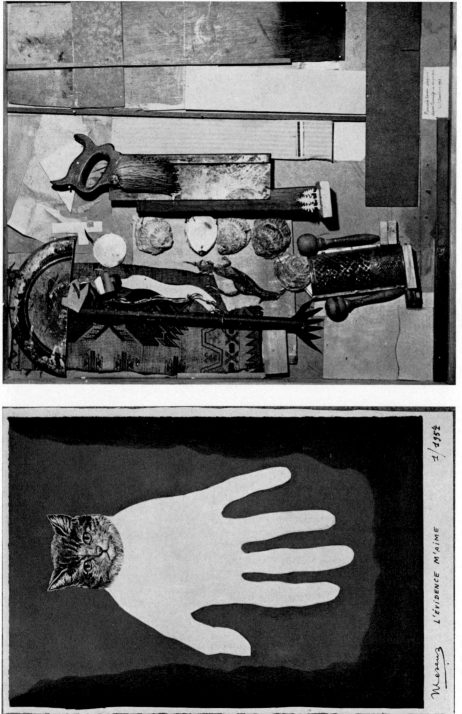

184 Paul Joostens 1958

185 E. L. T. Mesens 1954

186 Pierre Alechinsky 1962

187 Jan Burssens 1963

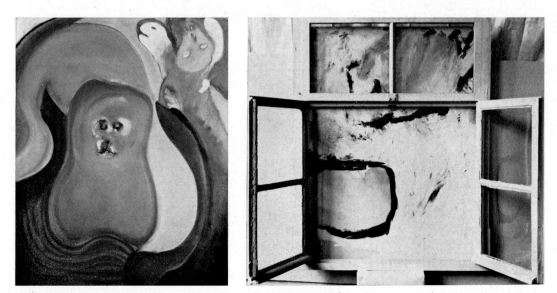

188 Serge Vandercam 1965 189 Roger Raveel 1963

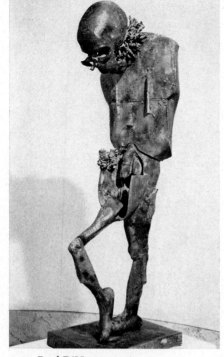

190 Roel D'Haese 1965

191 Bert De Leeuw 1963

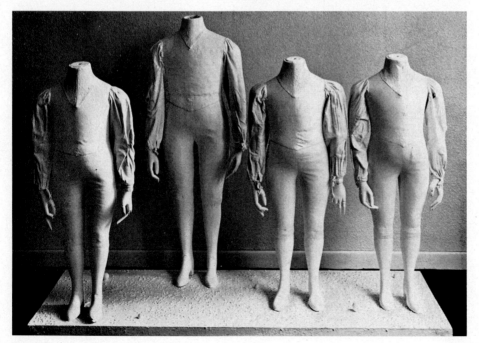

192 Paul Van Hoeydonck 1963

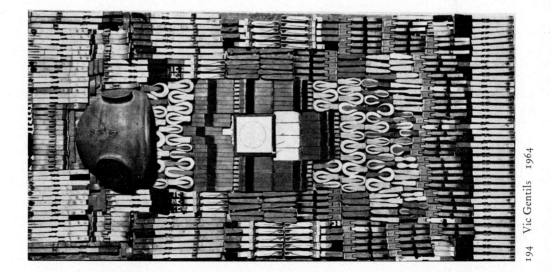

193 Pol Bury 1964

194 Vic Gentils 1964

195 Octave Landuyt 1960

196 Jan Cox 1951

197 Antoine Mortier 1960

198 On Kawara 1953

199 Josaku Maeda 1963

200 Sadamasa Motonoga 1963

201 Tomio Miki 1963

202 Shinjiro Okamoto 1963

203 Yukihisa Isobe 1963

204 Takeo Yamaguchi 1961

205 Mitsuo Kano 1962

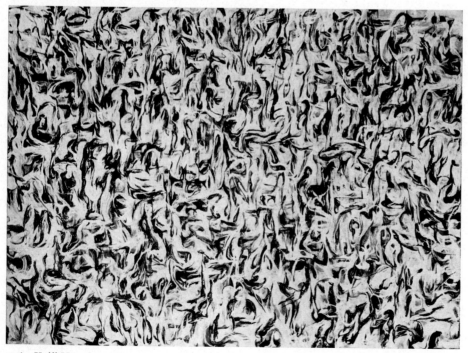

206 Keiji Usami 1962

207 Pedro Figari

208 Emilio Pettoruti 1928

209 Joaquín Torres-García 1931

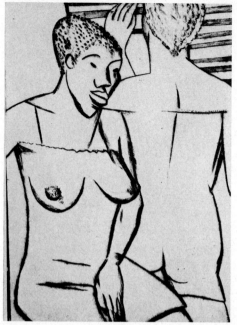

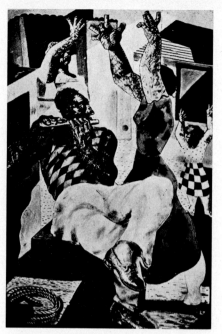

210 Lasar Segall 1928–30

211 Cándido Portinari

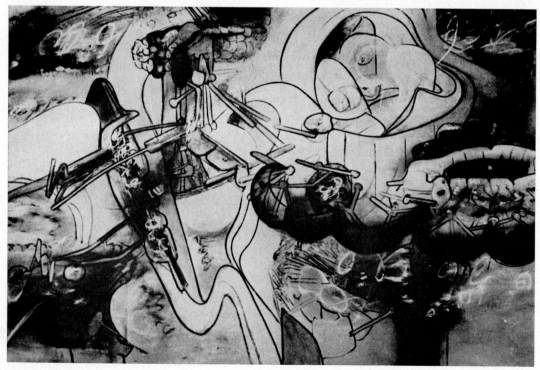

212 Roberto Echaurren Matta 1964

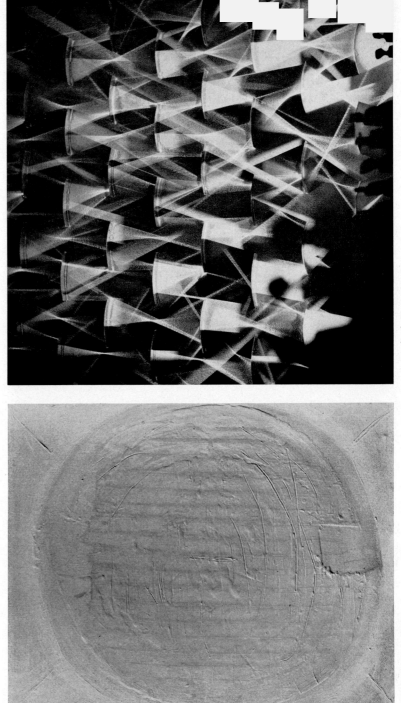

213 Julio le Parc 1963

214 Clorindo Testa 1963

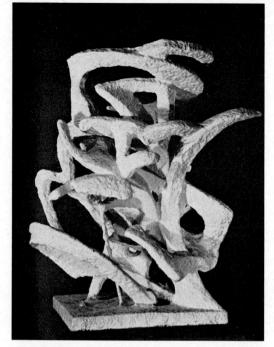

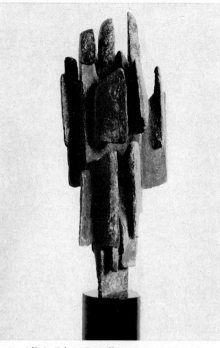

215 Pablo Curatella Manes 1920–26

216 Alicia Pérez Penalba 1961–62

217 José Gamarra 1963

218 Frans Krajcberg 1961

219 Jorge De La Vega

220 Antonio Seguí

221 Luis Felipe Noe 1963

222 Maria Luisa Pacheco 1964

223 Fernando Botero 1963-64

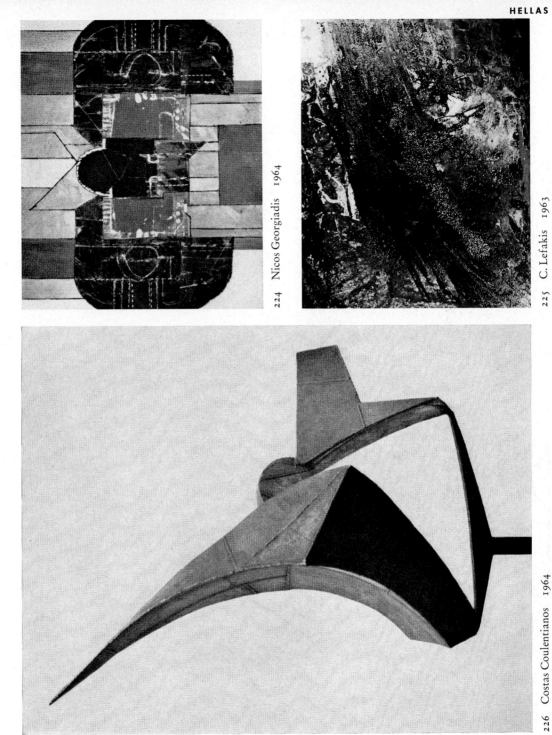

224 Nicos Georgiadis 1964

225 C. Lefakis 1963

226 Costas Coulentianos 1964

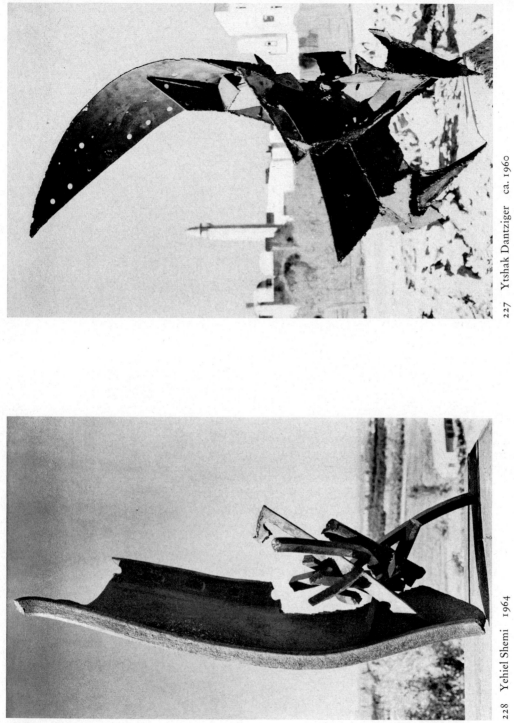

227 Ytshak Dantziger ca. 1960

228 Yehiel Shemi 1964

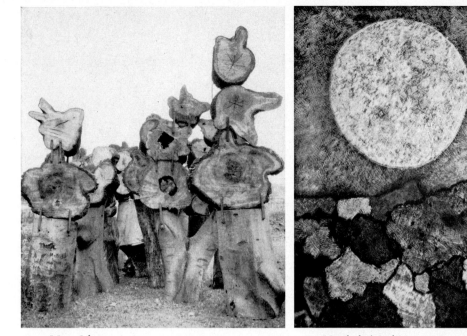

229 Marc Scheps 1963

230 Mordechai Ardon 1962

231 Raffi Lavie 1965

232 Aika Brown 1964

233 Tadeusz Brzozowski 1964

234 Kazimierz Mikulski 1965

235 Jan Lebenstejn 1965

236 Jerzy Nowosielski 1965

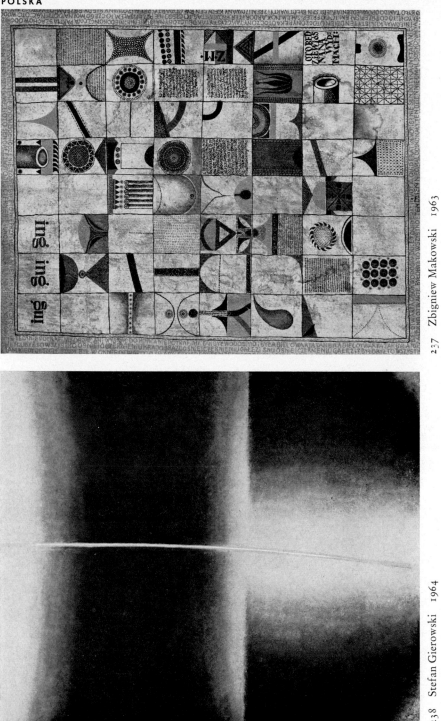

237　Zbigniew Makowski　1963

238　Stefan Gierowski　1964

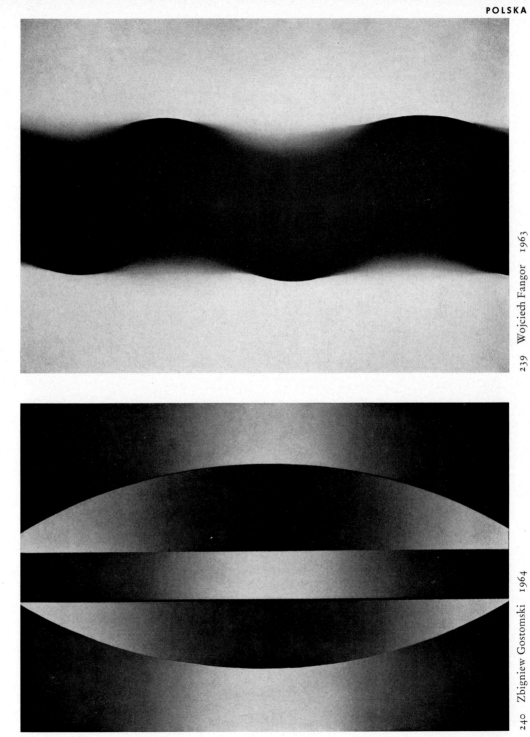

239 Wojciech Fangor 1963

240 Zbigniew Gostomski 1964

241 František Jiroudek 1965

242 Kamil Lhoták 1963

243 Josef Istler 1965

244 Andrej Barčík 1962

245 Ferdinand Hložník 1965

246 Mikuláš Medek 1964

247 Rudolf Krivoš 1963

248 Vladimír Kompánek 1963

249 Vladimír Janoušek 1965

250 Karel Hladík 1962

251 Čestmír Kafka 1961

252 Zbyněk Sekal 1963

253 Pavel Sukdolák

254 Vincent Hložník 1964

255 Krsto Hegedušić 1956

256 Peter Lubarda 1955

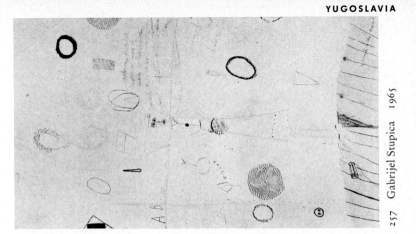

257 Gabrijel Stupica 1965

258 Radomir Damnjanović 1965

259 Vladimir Veličković 1964

260 Miodrag Protić 1965

261 Bogdan Meško 1965

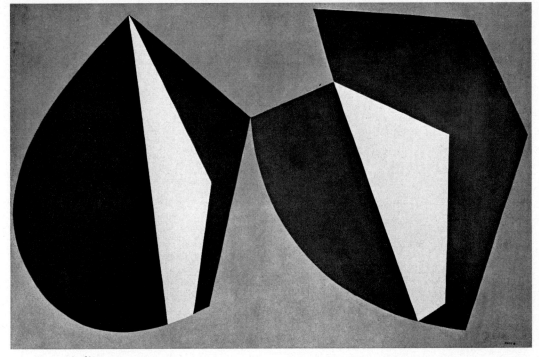

262 Ivan Picelj 1960

263 Marko Šuštaršič 1963

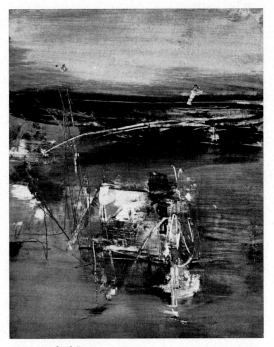

264 Andrej Jemec 1965

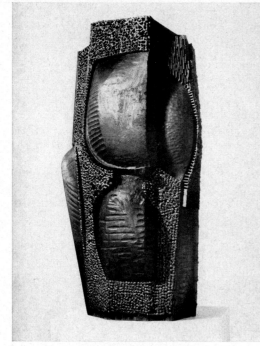

265 Dusan Džamonja 1963

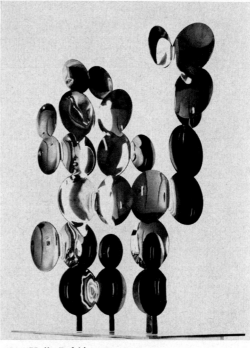

266 Vojin Bakić 1963–64

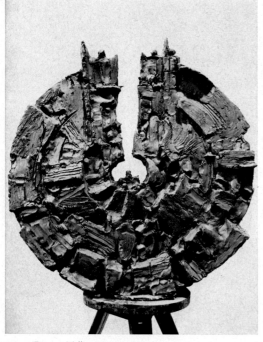

267 Drago Tršar 1965

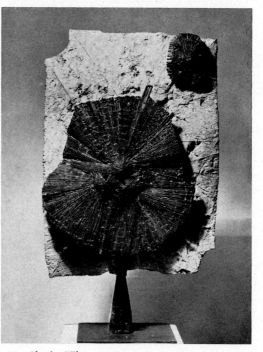

268 Slavko Tihec 1962

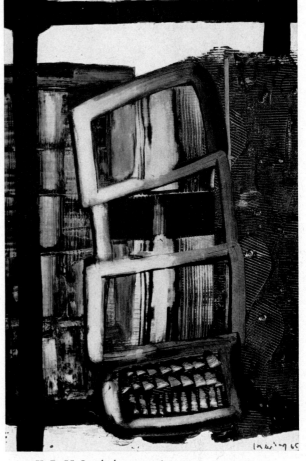

269 K. R. H. Sonderborg 1965

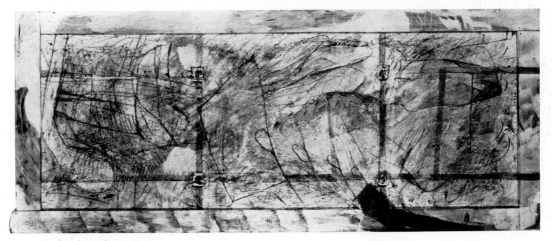

270 Gerhard Hoehme 1964

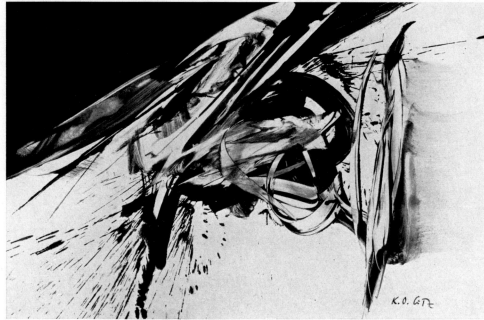

271 Karl Otto Götz 1962

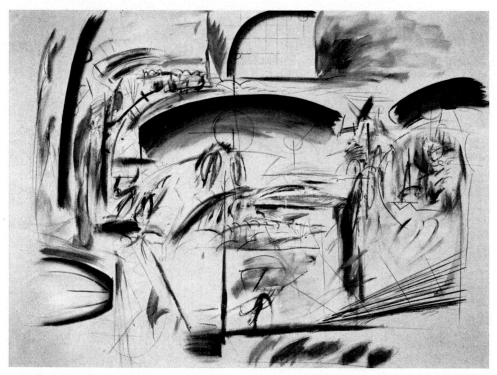

272 Peter Brüning 1964

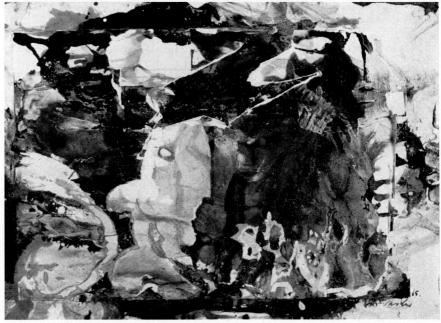

273 Fred Thieler 1965

274 Hann Trier 1965

275 Bruno Goller 1956

276 Konrad Klapheck 1964

277 Gerhard Richter 1964

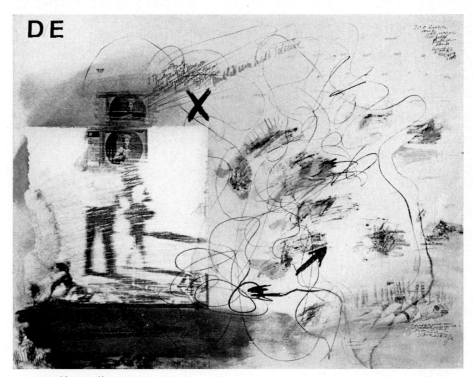

278 Wolf Vostell 1964

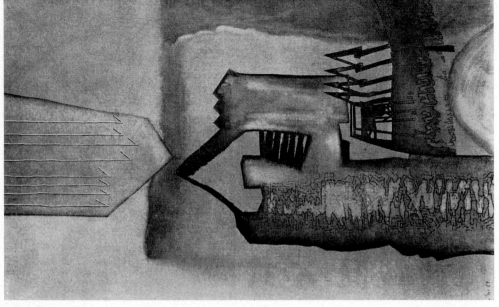

279 Heinz Trökes 1964

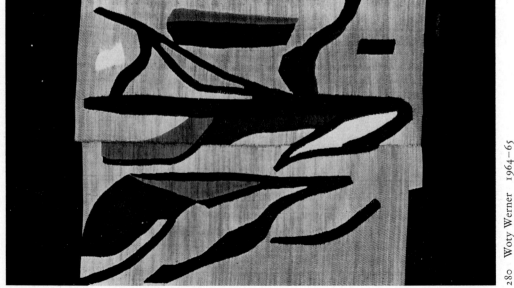

280 Woty Werner 1964–65

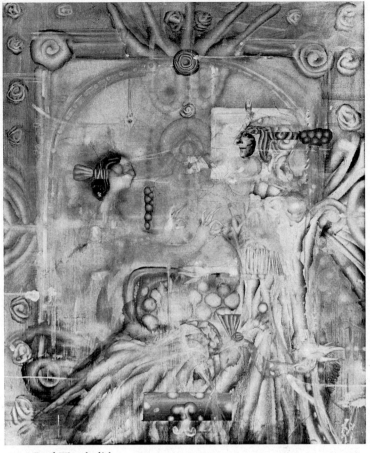

281 Paul Wunderlich 1964

282 Ursula (Bluhm) 1961

283 Ernst Fuchs 1965

284 Erich Brauer 1965

285　Carlfriedrich Claus　1962

286　Horst Janssen　1958

287 Günter Uecker 1964

288 Heinz Mack 1965

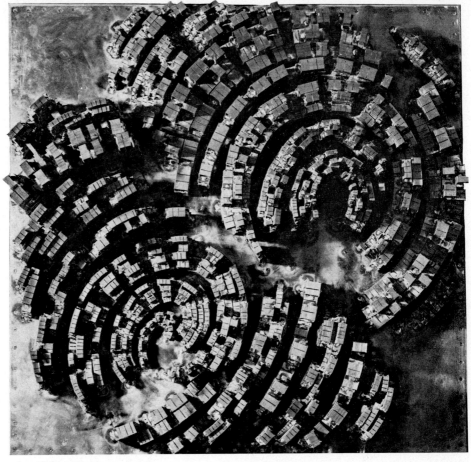

289 Zoltan Kemeny 1962

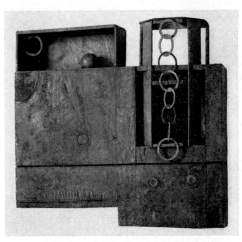

290 Horst Egon Kalinowski 1960—62

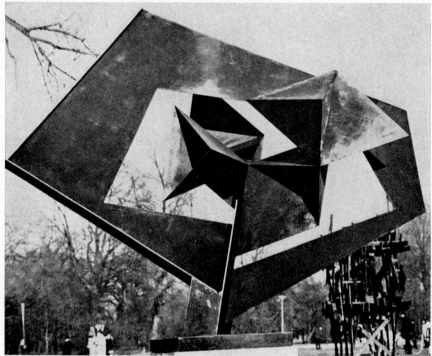

291 Hans Uhlmann 1965

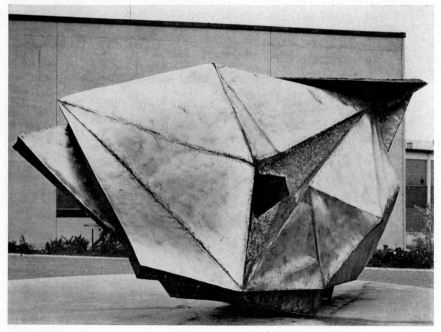

292 Erich Hauser 1964

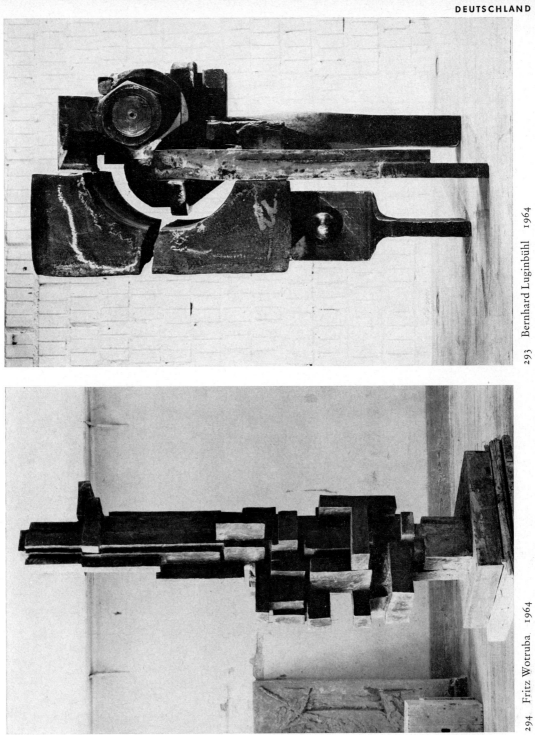

293 Bernhard Luginbühl 1964

294 Fritz Wotruba 1964

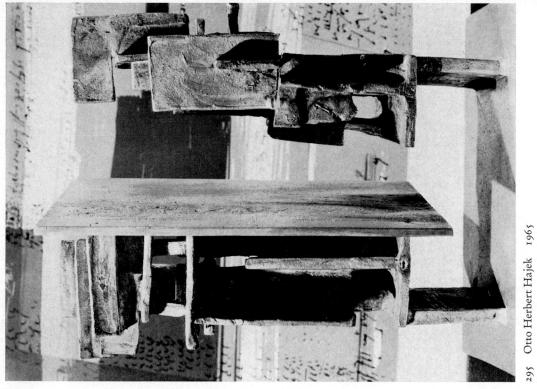

295 Otto Herbert Hajek 1965

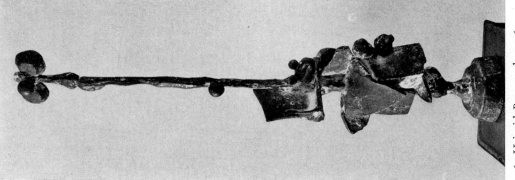

296 Heinrich Brummack 1965

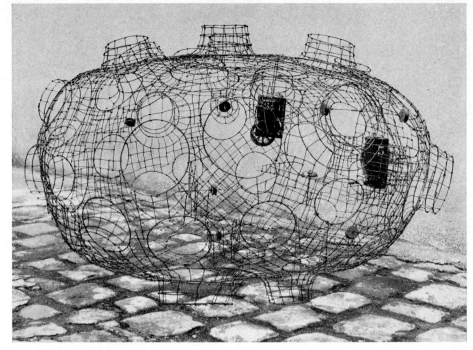

297 Harry Kramer 1962–64

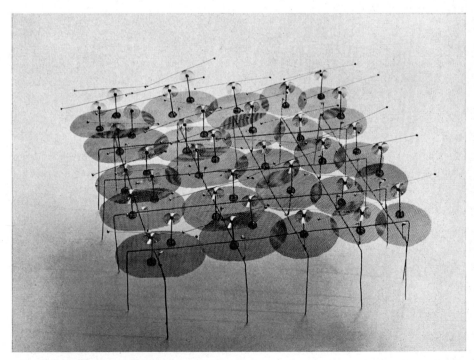

298 Günter Haese 1965

299 Gotthard Graubner 1963–64

300 Bernd Berner 1964

301 Arnulf Rainer 1963

302 Wilfried Blecher 1964

303 Karl Gerstner 1962–64

304 Gottfried Honegger 1963

305 Jean Baier 1965

306 Richard P. Lohse 1956–62–6

307 Günter Fruhtrunk 1962

308 Rolf-Gunter Dienst 1964

309 A. J. Baschlakow 1964

310 Carl-Heinz Kliemann 1964

311 Vera Haller 1964

312 Klaus Jürgen Fischer 1964

313 Karl Friedrich Dahmen 1964

314 Rupprecht Geiger 1961

315 Werner Schreib 1963

316 Winfred Gaul 1964

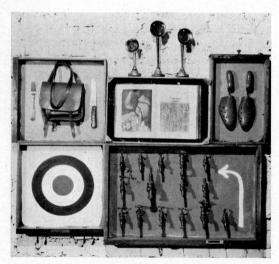

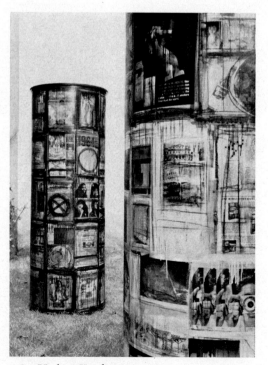

317 H. P. Alvermann 1962

318 Herbert Kaufmann 1964

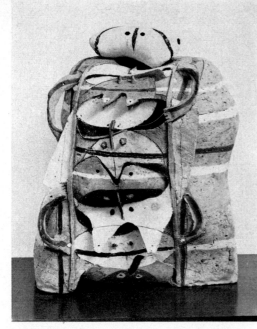

319 Lothar Fischer 1965

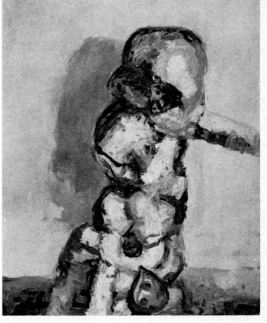

320 Georg Baselitz 1964

321 Heimrad Prem 1965

322 Curt Stenvert 1964

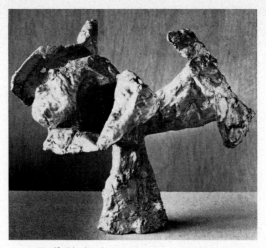

323 Karl Hartung 1963

324 Emil Cimiotti 1964

325 Bernhard Heiliger 1962–63

326 Fritz Koenig 1963

327 Hans Aeschbacher 1964

328 Rudolf Hoflehner 1964

329 Utz Kampmann 1964

330 E. R. Nele 1964

331 Norbert Kricke 1961

332 Brigitte Meier-Denninghoff 1965

333 Paul Isenrath 1962

334 Friederich Werthmann 1963

List of Illustrations

Note: Unless otherwise noted all works are oil on canvas. Measurements are height before width. ■ indicates a colorplate.

■ 11 Robert Rauschenberg
b. 1925 in Port Arthur, Texas. Lives in New York
Windward. 1963. $95^5/8 \times 70''$. Collection Mr. and Mrs. Burton Tremaine, Meriden, Connecticut

■ 12 Larry Rivers
b. 1923 in New York. Lives in Southampton, Long Island
Dutch Masters. 1963. Oil and cardboard on canvas. $67^3/8 \times 46^1/8''$. The Abrams Family Collection, New York

■ 13 Jasper Johns
b. 1930 in Alandale, South Carolina. Lives in New York
Target with Four Faces. 1955. Plaster casts, encaustic, and newspaper on canvas. $30 \times 26''$. The Museum of Modern Art, New York. Gift of Mr. and Mrs. Robert C. Scull, New York

■ 14 Mark Rothko
b. 1903 in Dvinsk, Russia. Lives in New York
Violet Bar. 1957. $69 \times 67''$. Collection Mrs. Harriet Mnuchin, New York

■ 15 Jim Dine
b. 1935 in Cincinnati. Lives in New York
The Studio (Landscape-Painting). 1963. $60 \times 108''$. Sidney Janis Gallery, New York

■ 16 Roy Lichtenstein
b. 1923 in New York. Lives in New York
Blam. 1962. $68 \times 80''$. Collection Richard Brown Baker, New York

United States / black-and-white

1 Robert Motherwell
b. 1915 in Aberdeen, Washington. Lives in New York

Elegy to the Spanish Republic No. 58. 1961. $84 \times 110''$. Rose Art Museum, Brandeis University, Waltham, Massachusetts. Gift of Joachim Jean and Julian J. Aberbach

2 Franz Kline
b. 1910 in Wilkes-Barre, Pennsylvania. d. 1962 in New York
Mahoning. 1956. $80 \times 100''$. The Whitney Museum of American Art, New York

3 James Brooks
b. 1906 in St. Louis, Missouri. Lives in New York, and Montauk, Long Island
Quagett. 1964. Oil and acrylic on canvas. $58 \times 74''$. Kootz Gallery, New York

4 Conrad Marca-Relli
b. 1913 in Boston. Lives in East Hampton, Long Island
Untitled. 1964. Aluminum. $45 \times 56''$. Kootz Gallery, New York

5 Adolph Gottlieb
b. 1903 in New York. Lives in New York
Duet. 1962. $84 \times 89^3/4''$. Atlanta Art Association, Atlanta, Georgia

6 Helen Frankenthaler
b. 1928 in New York. Lives in New York.
Approach. 1962. $82 \times 78''$. The Abrams Family Collection, New York

7 Clyfford Still
b. 1904 in Grandin, North Dakota. Lives in New York
Painting. 1951. $97^1/2 \times 77''$. The Museum of Modern Art, New York

8 Ad Reinhardt
b. 1913 in Buffalo, New York. Lives in New York
Number 10. 1959. $108 \times 40''$. Betty Parsons Gallery, New York

9 Joseph Albers
b. 1888 in Bottrop, Germany. Lives in New Haven, Connecticut
Far Off. 1958. 30×30". Collection Mr. and Mrs. Paul Hirschland, Great Neck, Long Island

10 Raymond Parker
b. 1922 in Beresford, South Dakota. Lives in New York
Untitled. 1961. 68×70". Kootz Gallery, New York

11 Jules Olitski
b. 1922 in Gomel, Russia. Lives in Shaftsbury, Vermont
Yaksi Juice. 1963. Acrylic on canvas. 66×80". Poindexter Gallery, New York

12 George Ortman
b. 1926 in Oakland, California. Lives in New York, and Castine, Maine
The Good Life, or Living by the Rules. 1960. 48×72". Howard Wise Gallery, New York

13 Lucas Samaras
b. 1936 in Macedonia. Lives in New York
Untitled. 1964. Wood box, nails, glass, plastic, assemblage elements. $6^1/4 \times 11 \times 6^1/4$". Collection Mr. and Mrs. Max Wassermann, Newton, Massachusetts

14 Joseph Cornell
b. 1903 in Nyack, New York. Lives in New York
Night Skies: Auriga. 1954. Painted wood construction. $19^1/4 \times 13^1/2 \times 13^1/2$". Collection Mr. and Mrs. A. Bergman, Chicago

15 Robert Morris
b. 1931 in Kansas City, Missouri. Lives in New York
Untitled. 1964. Pencil. $21 \times 15^1/2$". Green Gallery, New York

16 Marisol (Escobar)
b. 1930 in Paris. Lives in New York
Kennedy Family. 1960. Wood and various materials. Height 66". Sidney Janis Gallery, New York

17 Claes Oldenburg
b. 1929 in Stockholm, Sweden. Lives in New York
Soft Telephone. 1963. Vinyl, kapok, cloth, and wood. Height 48". Collection Ben Birillo, New York

18 Wayne Thiebaud
b. 1920 in Mesa, Arizona. Lives in Davis, California
Sandwich. 1963. $8^1/2 \times 11^3/4$". Collection Mr. and Mrs. William H. Copley, New York

19 George Segal
b. 1925 in New York. Lives in North Brunswick, New Jersey
Woman Sitting on a Bed. 1963. Plaster, cloth, and metal. Height 63". Collection Mr. and Mrs. Charles B. Wright, Seattle, Washington

20 Richard Lindner
b. 1901 in Hamburg, Germany. Lives in New York
One Way. 1964. 80×50". Cordier and Ekstrom Gallery, New York

21 Tom Wesselmann
b. 1931 in Cincinnati, Ohio. Lives in New York
Interior, No. 3. 1964. 66×44×3". Green Gallery, New York

22 Andy Warhol
b. 1930 in Philadelphia. Lives in New York
Black and White Disaster No. 4. 1963. 100×28". Leo Castelli Gallery, New York

23 James Rosenquist
b. 1933 in Grand Forks, North Dakota. Lives in New York

Silver Skies. 1962. $17^{1}/_{2} \times 78''$ (3 panels). Collection Mr. and Mrs. Robert C. Scull, New York

24 **Robert Indiana**
b. 1928 in New Castle, Indiana. Lives in New York
Yield Brother, II. 1963. $84^{1}/_{2}''$ square. The Abrams Family Collection, New York

25 **Stuart Davis**
b. 1894 in Philadelphia. d. 1964 in New York
Premiere. 1957. $58 \times 50''$. Los Angeles County Museum

26 **Richard Anuszkiewicz**
b. 1930 in Erie, Pennsylvania. Lives in Port Washington, New York
Complementary Fission. 1964. Liquitex on wood. 48'' square. Collection Albert A. List, New York

27 **Larry Poons**
b. 1937 in Tokyo, Japan. Lives in New York
The Enforcer. 1963. 80'' square. Collection Mr. and Mrs. Robert C. Scull, New York

28 **Len Lye**
b. in Christchurch, New Zealand. Lives in New York
Flip and Two Twisters. 1965. Stainless steel. $94^{1}/_{2} \times 58 \times 156''$. Howard Wise Gallery, New York

29 **David Smith**
b. 1906 in Decatur, Indiana. d. 1965 near Bennington, Vermont
Cubi X. 1963. Steel. Height 108''. Marlborough-Gerson Gallery, New York

30 **Alexander Calder**
b. 1898 in Philadelphia. Lives in Roxbury, Connecticut, and France
Tamanoir. 1963. Painted steel. Height 140''. Perls Gallery, New York

31 **Reuben Nakian**
b. 1896 in New York. Lives in Stamford, Connecticut
Maja. 1963. Plaster model for a bronze. Length 92''. Egan Gallery, New York

32 **Wilfrid Zogbaum**
b. 1915 in Newport, Rhode Island. Lives in East Hampton, New York
Twin Corporal. 1960. Iron and bronze. $31 \times 91^{3}/_{4}''$. Grace Borgenicht Gallery, New York

33 **Seymour Lipton**
b. 1903 in New York. d. 1965 in New York
Defender. 1962. Nickel-silver alloy and bronze. Height $80^{3}/_{4}''$. Marlborough-Gerson Gallery, New York

34 **Ibram Lassaw**
b. 1913 in Alexandria, Egypt. Lives in New York
Cythera. 1964. Copper, nickel-silver alloy, brass, and bronze. Height $90^{1}/_{2}''$. Kootz Gallery, New York

35 **Louise Nevelson**
b. 1890 in Kiev, Russia. Lives in New York
Dawn. 1962. Wood painted with gold. Height $94^{1}/_{2}''$. Pace Gallery, New York

36 **Edward Higgins**
b. 1930 in Gaffney, South Carolina. Lives in Easton, Pennsylvania
Untitled. Stainless steel and plaster. Height 58''. Leo Castelli Gallery, New York

37 **Richard Stankiewicz**
b. 1922 in Philadelphia. Lives in New York
Untitled. 1960. Stainless steel. Height $36^{1}/_{4}''$. Stable Gallery, New York

38 **Lee Bontecou**
b. 1931 in Providence, Rhode Island. Lives in New York
Untitled. 1962. Stainless steel and canvas.

Height 76". Collection Albert A. List, New York

39 John Chamberlain
b. 1927 in Rochester, Indiana. Lives in New York
Madam Moon. 1964. Stainless steel and painted metal. Leo Castelli Gallery, New York

40 Mark di Suvero
b. 1933 in Shanghai, China. Lives in New York
For Giacometti. 1962. Wood and steel. $24 \times 63^{3}/_{4}"$. Wadsworth Atheneum, Hartford, Connecticut

41 Peter Agostini
b. 1913 in New York. Lives in New York
Christmas Package. 1963. Plaster. Height $23^{1}/_{2}"$. Stephen Radich Gallery, New York

42 Frank Stella
b. 1936 in Malden, Massachusetts. Lives in New York
Abajo. 1964. Acrylic on canvas. $89^{3}/_{4} \times 119^{1}/_{2}"$. Leo Castelli Gallery, New York

France / colorplates

■ 17 Matta (Sebastian Antonio Matta)
b. 1912 in Santiago, Chile. Lives in Paris
Les Roses sont belles. 1951. $111 \times 79^{1}/_{2}"$. Private collection

■ 18 Henri Michaux
b. 1899 in Namur, Belgium. Lives in Paris
Gouache. 1960. Gouache on paper. $25^{5}/_{8} \times 19^{5}/_{8}"$. Galerie Point Cardinal, Paris

■ 19 Hans Hartung
b. 1904 in Leipzig, Germany. Lives in Paris
T—1965—E 33. 1965. $60^{5}/_{8} \times 98^{3}/_{8}"$. Galerie de France, Paris

■ 20 André Masson
b. 1896 in Balagny (Oise). Lives in Paris and Aix-en-Provence
La Fin de l'été. 1955. Oil and paper on canvas. $31^{7}/_{8} \times 39^{3}/_{8}"$. Galerie Louise Leiris, Paris

■ 21 Jean Dubuffet
b. 1901 in Le Havre. Live in Paris and Venice
Être et paraître. 1963. $58^{5}/_{8} \times 76^{3}/_{4}"$. Robert Fraser Gallery, London

■ 22 Yves Klein
b. 1928 in Nice. d. 1962 in Paris
Grande empreinte négative positive multiple. 1960. $86^{7}/_{8} \times 156^{1}/_{4}"$. Galerie Alexander Iolas, Paris

■ 23 François Arnal
b. 1924 in La Valette. Lives in Paris
Suggestion Nr. 3: En regardant Velazquez (F). 1963. $51^{1}/_{8} \times 76^{3}/_{4}"$. Private collection, Paris

■ 24 Bernard Réquichot
b. 1929 in Saint-Gilles. d. 1961
Sans. 1961. Collage on wood. $39^{3}/_{8} \times 47^{1}/_{4}"$. Private collection, London

■ 25 Martial Raysse
b. 1936 in Golfe Juan. Lives in Nice and New York
Ciné, peinture et néon. 1964. Fluorescent painting on canvas; various materials. $82^{5}/_{8} \times 51^{1}/_{8}"$. Private collection, The Netherlands

■ 26 Jorge Piqueras
b. 1925 in Lima, Peru. Lives in Paris
Infernis III. 1965. $37^{3}/_{4} \times 31^{1}/_{2}"$. Galerie Karl Flinker, Paris

■ 27 Horst Egon Kalinowski
b. 1914 in Düsseldorf, Germany. Lives in Paris
Ostensoire de la volupté. 1958. $39^{3}/_{8} \times 31^{7}/_{8}"$.

- **28 Raymond Hains**
 b. 1926 in Santerieve. Lives in Paris
 C'est ça le renouveau? From the series "La France déchirée." 1958. Torn poster $19^5/8 \times 29^1/2''$

- **29 Gudmundur Ferró**
 b. 1932 in Olafsvik, Iceland. Lives in Paris
 L'Appétit est un crime. 1963. $78^3/4 \times 118^1/8''$. Collection Delerve, Paris

- **30 Victor Brauner**
 b. 1903 in Piatra-Naemtz, Romania. d. 1966 in Paris
 Rêve. 1964. $35 \times 45^5/8''$. Galerie Alexandre Iolas, Paris

- **31 Fernandez Arman**
 b. 1928 in Nice. Lives in Paris, Nice, and New York
 Quintette à cordes. 1963. Painting and collage on wood. $60^5/8 \times 115^1/4''$. Collection Christian Dotremont, Brussels

- **32 César (Baldaccini)**
 b. 1921 in Marseille. Lives in Paris
 Façade Nr. 1. 1961. Collage with automobile parts. $98^3/8 \times 118^1/8''$. Private collection

- **33 Victor Vasarely**
 b. 1908 in Pécs, Hungary. Lives in Annet-sur-Marne
 Eridan rouge 1957. 1964. $78^3/4 \times 85''$. Collection Mrs. Rautborb, Chicago

- **34 Jean Dewasne**
 b. 1921 in Lille. Lives in Paris
 L'Art de vivre. 1962. Enamel on board. $51^1/8 \times 38^1/8''$. Collection Marcel Stal, Brussels

France / black-and-white

43 **Max Ernst**
b. 1891 in Brühl near Cologne, Germany. Lives in Paris and Huismes (Indre et Loire)

Le Ciel épouse la terre. 1964. $60^5/8 \times 78^3/4$ Galerie Alexandre Iolas, Paris

44 **Wifredo Lam**
b. 1902 in Sàgua, Cuba. Lives in Italy and Paris
Les Enfants sans âme. 1964. $83^1/2 \times 98^3/8''$ Galerie Krugier, Geneva, Switzerland

45 **Pierre Soulages**
b. 1919 in Rodez. Lives in Paris
Peinture 5 Février 64. 1964. $92^1/2 \times 118^1/8''$

46 **Serge Poliakoff**
b. 1906 in Moscow, Russia. Lives in Paris
Composition abstraite. 1952. $18^1/8 \times 24''$. Galerie Springer, Berlin

47 **Jean Hélion**
b. 1904 in Couterne, Normandy. Lives in Paris
Le Brabant. 1958. $59 \times 70^7/8''$. Collection Christian Zervos, Paris

48 **Hans Bellmer**
b. 1902 in Kattowitz, Poland. Lives in Paris
Auto-portrait avec Unica. c. 1960. Mixed media. Galerie Point Cardinal, Paris

49 **Jean-Jacques Lebel**
b. 1936 in Paris. Lives in Paris
Effacement. 1960. Painting and collage on wood. Private collection

50 **Jean Degottex**
b. 1918 in Sathony, Ain. Lives in Paris
Suite rose-noir (XVI). 1964. Oil on paper. $47^1/4 \times 31^1/2''$. Private collection, Brussels

51 **Jacques de la Villeglé**
b. 1926 in Quimper. Lives in Paris
Affiches lacérées le 22 Février 1959, Porte Maillot. 1959. Poster on plywood. $22^7/8 \times 45^5/8''$. Galerie Jacqueline Ranson, Paris

52 François Dufrène
b. 1930 in Paris. Lives in Paris
Labic sur l'ongre. 1961. Back of a poster on paper. $26^3/8 \times 40^1/8''$. Galerie Ad Libitum, Antwerp, Belgium

53 Takis
b. 1925 in Athens, Greece. Lives in Paris
'Télé'-Peinture, Electromagnétique III. 1964. Diameter $35^3/8''$. Galerie Alexandre Iolas, Paris

54 Daniel Spoerri
b. 1930 in Galati, Romania. Lives in Paris
The shower, détrompe-l'oeil. 1961. Object on canvas. Galleria Schwarz, Milan

55 Jean Tinguely
b. 1925 in Basel, Switzerland. Lives in Paris
M. K. III. 1964. Iron machine. $63 \times 82^5/8''$. Museum of Fine Arts, Houston, Texas

56 Tetsumi Kudo
b. 1935 in Osaka, Japan. Lives in Paris
Your Portrait. 1962. Assemblage of objects. $23^1/4 \times 25^5/8''$. Galerie 'Y,' Paris

57 Daniel Pommereulle
b. 1937 in Paris. Lives in Paris
Doux cerveau. 1964. Painted wood and wool. $19^5/8 \times 25^5/8''$. Galerie Jacqueline Ranson, Paris

58 Jean-Pierre Raynaud
b. 1939 in Bar-le-Duc. Lives in Paris
Psycho-objet. 1964. Assemblage of objects. $43^1/4 \times 73^1/4''$. Galerie Jean Larcade, Paris

59 Bernard Dufour
b. 1922 in Paris. Lives in Paris
Ils surgissent. 1959-60. $76^3/4 \times 51^1/8''$. Collection Albert Loeb, New York

60 Jacques Monory
b. 1924 in Paris. Lives in Paris
Regards. $47^1/4 \times 39^3/8''$. Private collection, Paris

61 Phillip Martin
b. 1927 in Essex, England. Lives in Paris and Brussels
Relief No. 3. 1964. Wood, metal, and assorted materials

62 Yaacov Agam
b. 1928 in Palestine. Lives in Paris
Free Standing. 1964. Aluminum painted on both sides. $31^7/8 \times 47^1/4''$. Marlborough-Gerson Gallery, New York

63 Eduardo Arroyo
b. 1937 in Madrid, Spain. Lives in Paris
Velázquez, mon père (Vingt-cinq années de paix). 1964. $57^1/2 \times 44^7/8''$. Collection Meyer, Zurich, Switzerland

64 Antonio Recalcati
b. 1938 in Milan, Italy. Lives in Paris
Sortie. 1964. Private collection, Paris

65 Myriam Bat-Yosef
b. 1931 in Berlin, Germany. Lives in Paris
Le Téléphone des sourds. 1964. Painted object. $6^1/4 \times 8^5/8''$.

66 Niki de Saint-Phalle
b. 1930 in Paris. Lives in Paris
Les Nanas. 1965. Collage, wire, plaster, and cloth. Galerie Alexandre Iolas, Paris

67 Bona
b. 1926 in Rome, Italy. Lives in Paris
Naissances. 1965. $47^1/4 \times 74^3/4''$. Private collection, Paris

68 Margarita Russo
b. 1920 in Munich, Germany. Lives in Paris
Untitled. 1965. Painting and collage. Diameter $66^7/8''$. Collection the artist

69 Philippe Hiquily
b. 1925 in Paris. Lives in Paris
L'Horloge. 1962. Wrought iron. Height
$39^3/8''$. Galerie Karl Flinker, Paris

70 Christian d'Orgeix
b. 1927 in Foix, Ariège. Lives in Paris
La Confidente. 1965. Object. Height $8^5/8''$.
Galerie du Dragon, Paris

71 Robert Müller
b. 1920 in Zurich, Switzerland. Lives in
Paris
L'Archange. 1963. $31^1/2 \times 63 \times 63''$. Galerie
de France, Paris

72 Étienne-Martin
b. 1913 in Loriol. Lives in Paris
Demeure Nr. 3. 1960. Plaster. $98^3/8 \times 196^3/4$
$\times 88^5/8''$. Private collection

73 Bernard Saby
b. 1925 in Paris. Lives in Paris
Gouache. 1965. Gouache on paper. $31^7/8 \times$
$39^3/8''$. Galerie de l'Oeil, Paris

74 Serge Rezvani
b. 1928 in Teheran, Iran. Lives in La Garde
Freinet
Viande à saigner sous le marteau. 1964. $56^3/4$
$\times 45^5/8''$. Private collection, Paris

75 Hervé Télémaque
b. 1937 in Haiti. Lives in Paris
Piège. 1964. $76^3/4 \times 51^1/8''$. Galerie Mathias
Fels, Paris

Great Britain / colorplates

■ 35 Harold Cohen
b. 1928 in London. Lives in London
Pandora. 1964. $102^1/2''$ square. Robert Fra-
ser Gallery, London

■ 36 Bernard Cohen
b. 1933 in London. Lives in London
Floris. 1964. 60″ square. Collection the artist

■ 37 Peter Blake
b. 1932 in Dartford, Kent. Lives in London
Little Lady Luck. 1965. Acrylic and collage
on cardboard. $28^1/2 \times 13^3/4''$. Robert Fraser
Gallery, London

■ 38 R. B. Kitaj
b. 1932 in Ohio. Lives in London
An Early Europe. 1964. $60 \times 84''$. The Ab-
rams Family Collection, New York

■ 39 Antony Donaldson
b. 1939 in Surrey. Lives in London
Zigzag Towards an Aurelia. 1964. Acrylic
on canvas. 66″ square. Rowan Gallery, Lon-
don

■ 40 John Hoyland
b. 1934 in England. Lives in London
17. 5. 64. 1964. Acrylic on canvas. $84 \times$
108″

■ 41 William Tucker
b. 1935 in England
Anabasis I. 1964. Plastic. $59 \times 41''$. Collec-
tion Alan Power, Richmond, Surrey

■ 42 Patrick Heron
b. 1920 in Leeds. Lives in Zennor, St. Ives,
Cornwall
Blue in Blue: with Red and White. 1964.
$60 \times 48''$

■ 43 Ben Nicholson
b. 1894 in Denham, Buckinghamshire. Lives
in Brissago, Switzerland
March 64 (Circle and Venetian Red). 1964.
Relief picture for a free-standing wall. Oil
on fiberboard. $17^1/2 \times 11''$. Collection Dr.
Felicitas Vogler

- 44 Alan Davie
 b. 1920 in Grangemouth, Scotland. Lives in Rush Green, Hertfordshire
 The Golden Drummer Boy No. 2. 1962 68×81½″. Collection Peggy Guggenheim, Venice

- 45 Ivon Hitchens
 b. 1893 in London. Lives in Petworth, Sussex
 Shadows and Weir. 1959. 18×43¼″. Private collection

- 46 Victor Pasmore
 b. 1908 in Chelsam, Surrey. Lives in London
 Blue Development No. 6. 1964. Relief construction. 47¼×20″

- 47 Ceri Richards
 b. 1903 in Dunvant, Swansea, Wales. Lives in London
 La Cathédrale engloutie. 1961. 60″ square. New London Gallery Ltd., London

- 48 Francis Bacon
 b. 1909 in Dublin, Ireland. Lives in London
 Study for Self-Portrait. 1964. 61×55½″. Marlborough Fine Art, Ltd., London

- 49 Graham Sutherland
 b. 1903 in London. Lives in Trottiscliffe, Kent, and Menton, France
 La Fontaine. 1964. 72×56″. Marlborough Fine Art Ltd., London

Great Britain / black-and-white

76 Henry Mundy
b. 1909 in Birkenhead. Lives in London
Grooved. 1962. Oil on wood. 63×96″

77 Gwyther Irwin
b. 1931 in Basingstoke. Lives in London
Quintet. 1963. Paper collage. 48×60″

78 Bridget Riley
b. 1931 in London. Lives in London
Crest. 1964. Rhombus, 64½×64½″. Collection Peter Stuyvesant Foundation, London

79 Robyn Denny
b. 1930 in Abinger, Surrey. Lives in London
Crosspatch. 1964. 60×48″

80 Gillian Ayres
b. 1930 in London. Lives in London
Untitled Painting. 1964. 60″ square

81 Richard Hamilton
b. 1922 in London. Lives in London
Glorious Techniculture. 1961-64. 48″ square

82 Ian Stephenson
b. 1934 in County Durham. Lives in London
Sfumato. 1963. 84″ square

83 Peter Blake
b. 1932 in Dartford, Kent. Lives in London
Self-Portrait. 1961. 69×48″. Robert Fraser Gallery, London

84 Richard Smith
b. 1931 in Letchworth, Hertfordshire. Lives in London
Various Activities. 1963. 54″ square. Collection Peter Stuyvesant Foundation, London

85 Joe Tilson
b. 1928 in London. Lives in London
Nine Elements. 1963. Acrylic on wood relief. 102×71¼″. Marlborough Fine Art Ltd., London

86 Allen Jones
b. 1937 in Southampton. Lives in London
Man and Woman. 1963. 84×71½″

87 David Hockney
b. 1937 in Bradford, Yorkshire. Lives in London

Marriage of Styles II. 1963. 71$^{1}/_{2}$×84″. Collection Contemporary Art Society, London

88 William Turnbull
b. 1922 in Dundee, Scotland. Lives in London
Ulysses. 1957-61. Bronze. Height 50″

89 Eduardo Paolozzi
b. 1924 in Edinburgh. Lives in London
Poem for the Trio MRT. 1964. Aluminum. Height 84$^{1}/_{2}$″. Robert Fraser Gallery, London

90 Hubert Dalwood
b. 1924 in Bristol. Lives in London
Minos. 1962. Aluminum. Height 81″

91 Anthony Caro
b. 1924 in London. Lives in London
Early One Morning. 1962. Steel and aluminum, painted red. Length 243$^{3}/_{4}$″

92 Philip King
b. 1934 in Tunis. Lives in London
Genghis Khan. 1963. Bakelite and fiberglass. 82$^{1}/_{2}$×141$^{3}/_{4}$×82$^{1}/_{2}$″. Collection Peter Stuyvesant Foundation, London

93 Patrick Caulfield
b. 1936 in London. Lives in London
Greece Expiring on the Ruins of Missolonghi. After Delacroix. 1964. 60×48″. Collection Alan Power, London

94 Roger Hilton
b. 1911 in London. Lives in St. Just, Cornwall
Desolate Beach. 1960. 60×39$^{3}/_{4}$″. Collection Calouste Gulbenkian Foundation, London

95 Keith Vaughan
b. 1912 in Selsey Bill, Sussex. Lives in London
Blackmore Church. 1961. 39$^{3}/_{4}$×36″

96 William Scott
b. 1913 in Greenock, Scotland. Lives in London, and Coleford, Somerset
Blue Form on White. 1964. 62$^{1}/_{4}$×94$^{1}/_{2}$″. Collection Peter Stuyvesant Foundation, London

97 Terry Frost
b. 1915 in Leamington Spa. Lives in Banbury, Oxfordshire
Red and Black No. 3. 1961. 50×60″. Collection Peter Stuyvesant Foundation, London

98 Kenneth Armitage
b. 1916 in Leeds. Lives in London
Pandarus V. 1963. Bronze. Height 26$^{1}/_{2}$″

99 Reg Butler
b. 1913 in Buntingford, Bucks. Lives in Berkhamsted, Buckinghamshire
Seated Girl. Detail. 1959-61. Bronze. Height 35″

100 Lynn Chadwick
b. 1914 in London. Lives in Stroud, Gloucestershire
The Watchers. 1960. Bronze. Height 92$^{1}/_{2}$″

101 Barbara Hepworth
b. 1903 in Wakefield, Yorkshire. Lives in St. Ives, Cornwall
Single Form (Memorial). 1961-62. Bronze. Height 122″. Battersea Park, London

102 Barbara Hepworth
Pierced Form. 1963. Greek marble. Height 50$^{1}/_{2}$″

103 Henry Moore
b. 1898 in Castleford, Yorkshire. Lives in Perry Green, Much Hadham, Hertfordshire
Atom Piece. 1964. Bronze. Height 48″

104 Henry Moore
Reclining Mother and Child. 1960-61.

Bronze. $33^{1}/_{4} \times 86^{1}/_{2}''$. Marlborough Fine Art Ltd., London

Italy / colorplates

■ 50 Emilio Vedova
b. 1919 in Venice. Lives in Venice
Plurimi di Berlino. 1964. Mixed media, arranged at will. Marlborough Fine Art Ltd., London

■ 51 Lucio Fontana
b. 1899 in Rosario di Santa Fe, Argentina. Lives in Milan
Concetto Spaziale, La Fine di Dio. 1963. $70^{1}/_{8} \times 43^{3}/_{8}''$. Marlborough Fine Art, Rome

■ 52 Alberto Burri
b. 1915 in Città di Castello. Lives in Rome
Rosso plastica 3. $29^{1}/_{2} \times 39^{3}/_{8}''$. Marlborough Fine Art, Rome

■ 53 Giuseppe Capogrossi
b. 1900 in Rome. Lives in Rome
Superficie 531. 1964. $6^{1}/_{4} \times 9^{1}/_{2}''$. Collection Bracci, Rome

■ 54 Afro (Afro Basaldella)
b. 1912 in Udine. Lives in Rome
Untitled. 1964

■ 55 Giuseppe Santomaso
b. 1907 in Venice. Lives in Venice
Suite Friulana. 1963

■ 56 Piero Dorazio
b. 1927 in Rome. Lives in Rome
Few Roses. 1963. $63^{3}/_{4} \times 51^{1}/_{8}''$. Marlborough Fine Art, Rome

■ 57 Antonio Corpora
b. 1909 in Tunis. Lives in Rome
La dolce vita. 1964. $57^{1}/_{2} \times 44^{7}/_{8}''$

■ 58 Gastone Novelli
b. 1925 in Vienna. Lives in Rome
Histoire de l'oeil. 1963. $53^{1}/_{8}''$ square. Collection Pogliani, Milan

■ 59 Achille Perilli
b. 1927 in Rome. Lives in Rome
Erotica. 1962. Tempera on canvas. $63^{3}/_{4} \times 51^{1}/_{8}''$

■ 60 Arnaldo Pomodoro
b. 1926 in Morciano di Romagna. Lives in Milan
Il grande disco. 1965. Bronze. Diameter $84^{5}/_{8}''$

■ 61 Leoncillo (Leoncillo Leonardi)
b. 1915 in Spoleto. Lives in Rome
San Sebastiano. 1962. $55^{1}/_{8} \times 21^{5}/_{8} \times 11^{3}/_{4}''$. Galleria Odyssia, Rome

■ 62 Enrico Castellani
b. 1930 in Castelmassa. Lives in Milan
Superficie blu. 1963. $57^{1}/_{2} \times 44^{7}/_{8}''$. Galleria Ariete, Milan

■ 63 Mimmo Rotella
b. 1918 in Catanzaro. Lives in Paris
Metro-Goldwyn-Mayer. 1963. Photograph transferred serigraphically to canvas. $35^{7}/_{8} \times 44^{7}/_{8}''$. Galleria La Salita, Rome

■ 64 Mario Schifano
b. in Homs, Libya. Lives in Rome
Smalto su carta. 1963. $63''$ square. Galleria Odyssia, Rome

■ 65 Lucio del Pezo
b. 1933 in Naples. Lives in Milan
Mensola con decorazione romboidale. 1964. $21^{5}/_{8} \times 18^{1}/_{8}''$. Collection Giorgio Marconi, Milan

Italy / black-and-white

105 Carla Accardi
b. 1924 in Trapani. Lives in Rome
Penetrazione. 1964

106 Antonio Sanfilippo
b. 1923 in Partanna. Lives in Rome
Frammenti d'ali. 1962. $86^5/8 \times 74^3/4''$

107 Toti Scialoja
b. 1934 in Rome. Lives in Rome
The Unicorn in Captivity. 1963. Vinavil and collage. $19^5/8 \times 27^5/8''$

108 Sergio Romiti
b. 1928 in Bologna. Lives in Bologna
Untitled. 1961. Collection Tavoni, Bologna

109 Edgardo Mannucci
b. 1904. Lives in Rome
Opera n. 13. 1964. Bronze. $43^1/4 \times 13^3/4 \times 19^5/8''$. Galleria Odyssia, Rome

110 Umberto Mastroianni
b. 1910 in Fontana Liri. Lives in Turin
Personaggio. 1961. $32^1/4 \times 24^3/4 \times 15^3/4''$. Collection Pogliani, Rome

111 Nino Franchina
b. 1912 in Palermo. Lives near Genova
Icaro. 1963. Sheet metal. Height $57^1/8''$. Private collection

112 Ettore Colla
b. 1899 in Parma. Lives in Rome
Dioscuri. 1961. Iron. Height $23^5/8''$. Private collection

113 Pietro Consagra
b. 1920 in Mazarara del Vallo. Lives in Rome
Colloquio libero. 1961. Bronze. $49^5/8 \times 50^3/8''$. Collection the artist

114 Andrea Cascella
b. 1920 in Pescara. Lives in Milan
Un'ora del passato. 1964. Marble

115 Giò Pomodoro
b. 1930 in Orciano di Pesaro. Lives in Milan
Grandi Contatti. 1962. Bronze. $90^1/2 \times 63''$. Private collection

116 Aldo Calò
b. 1910 in San Cesario di Lecce. Lives in Rome
Piastra (Monument to the Liberation of Cuneo). 1963. Bronze. $59''$ square

117 Sergio Vacchi
b. 1925 in Castenaso di Bologna. Lives in Rome
Hommage à Morandi. 1964. $63''$ square

118 Concetto Pozzati
b. 1935 in Padua. Lives in Bologna
Caduta di un Monumento importante. 1963-64. $68^7/8 \times 78^3/4''$. Collection the artist

119 Davide Boriani
b. 1936 in Milan. Lives in Milan
Superficie magnetica. Detail. 1960

120 Antonio Calderara
b. 1903 in Abbiategrasso. Lives in Milan
Piano organizzato, 16. 1961. $16^1/2 \times 19^5/8''$

121 Giovanni Antonio Costa
b. 1935 in Padua. Lives in Padua
Visione dinamica n. 25. 1964. Collection Ted Poland, Boston

122 Enzo Mari
b. 1932 in Novara. Lives in Milan
Struttura d. 724. 1963. Aluminum and plastic. $23^5/8 \times 23^5/8 \times 3^7/8''$. Collection the artist

123 Pasquale Santoro
b. 1933 in Ferrandina. Lives in Rome

Lafcadio. 1965. Wood laths. $43^{1}/_{4} \times 15^{3}/_{4} \times 11^{3}/_{4}''$

124 **Mario Ceroli**
b. 1938 in Castelfrentano. Lives in Rome
Il mister. 1964. $70^{7}/_{8} \times 39^{3}/_{8}''$. Collection Franchetti, Rome

125 **Getulio Alviani**
b. 1939 in Udine. Lives in Milan
Superficie a testura vibratile. 1964. Aluminum. $38^{5}/_{8}''$ square

126 **Achille Pace**
b. 1923 in Termoli. Lives in Rome
Itinerario. 1964

127 **Enrico Baj**
b. 1924 in Milan. Lives in Milan
Generale. 1961. Collage. $57^{1}/_{2} \times 44^{7}/_{8}''$. Galleria Schwarz, Milan

128 **Rodolfo Aricò**
b. 1930 in Milan. Lives in Milan
Qui e ora. 1962. $110^{1}/_{4} \times 78^{3}/_{4}''$

129 **Valerio Adami**
b. 1935 in Bologna. Lives in Arona
Il Giardino del matrimonio. 1963. $80^{3}/_{4} \times 98^{3}/_{8}''$. Collection the artist

130 **Franco Angeli**
b. 1935 in Rome. Lives in Rome
Frammento capitolino. 1964. $39^{3}/_{8} \times 27^{5}/_{8}''$

131 **Tano Festa**
b. 1938 in Rome. Lives in Rome
Souvenir of London. 1964. $70^{7}/_{8} \times 37^{3}/_{4}''$. Galleria Tartaruga, Rome

132 **Michelangelo Pistoletto**
b. 1933 in Biella. Lives in Turin
Coreto. 1965. Collage drawing on reflecting steel plate. $47^{1}/_{4} \times 86^{5}/_{8}''$. Galleria Sperone, Turin

Spain / colorplates

■ 66 **Rafael Canogar**
b. 1934 in Toledo. Lives in Madrid
Four Pictures of an Astronaut. 1960. $78^{3}/_{4} \times 59''$

■ 67 **Antoni Tàpies**
b. 1923 in Barcelona. Lives in Barcelona
Black with red stripe. 1963. $76^{3}/_{4} \times 66^{7}/_{8}''$. Martha Jackson Gallery, New York

■ 68 **Jordi Galì**
b. 1944 in Barcelona. Lives in Barcelona
Peinture collage. 1964. Oil and collage. Collection the artist

■ 69 **Salvador Soria**
b. 1915 in Valencia. Lives in Madrid
Intégration de la destruction. 1963. Iron scraps. $63^{3}/_{4} \times 51^{1}/_{8}''$. Collection the artist

■ 70 **Manolo Millarès**
b. 1926 in Gran Canaria. Lives in Madrid
Homunculus. 1964. Plastic paint on sackcloth. $27^{5}/_{8} \times 39^{3}/_{4}''$. Collection Mr. and Mrs. Pierre Matisse, New York

■ 71 **Eusebio Sempere**
b. 1924 in Alicante. Lives in Madrid
Construction. 1964.

Spain / black-and-white

133 **Albert Ràfols Casamada**
b. 1923 in Barcelona. Lives in Barcelona
August. 1964. Collection the artist

134 **Joan Josep Tharrats**
b. 1918 in Gerona. Lives in Barcelona
Aldebarán. 1964. Mixed media. $51^{1}/_{8} \times 38^{1}/_{8}''$. Galeria Gaspar, Barcelona

135 Manuel Viola
b. 1919 in Saragossa. Lives in Madrid
La chute. 1964

136 Joan Claret
b. 1934 in Barcelona. Lives in Barcelona
Wall Composition. 1963

137 Román Vallès
b. 1923 in Barcelona. Lives in Barcelona
Peinture collage. 1964. $25^5/8 \times 36^1/4''$. Collection the artist

138 Luis Feito
b. 1929 in Madrid. Lives in Madrid
Peinture. 1963. $35^3/8 \times 39^3/8''$

139 Antonio Saura
b. 1930 in Huesca. Lives in Paris and Madrid
Grande Crucifixion rouge et noire. 1963. $76^3/4 \times 96^1/2''$. Galerie Stadler, Paris

140 Pablo Serrano
b. 1910 in Crivillén. Lives in Madrid
Iron composition. 1957

141 Eduardo Chillida
b. 1924 in San Sebastian. Lives in Hernani
Untitled No. 3. N.D. Bronze and wood. Height $28^3/4''$

142 Andreu Alfaro
b. 1929 in Valencia. Lives in Valencia
Celui qui enferme un sourire, celui qui emmure une voix. 1964. Iron. Collection Calpe (Alicante)

143 Josep Maria Subirachs
b. 1927 in Barcelona. Lives in Barcelona
Esquerda. 1964. Bronze and cement. $16^7/8 \times 8^1/4 \times 7^1/8''$. Galerie Huber, Zurich

144 Moisès Villèlia
b. 1928 in Barcelona. Lives in Cabrils (Barcelona)

Sculpture. 1965. Reed and wire. Collection the artist

145 Xavier Corberó
b. 1935 in Barcelona. Lives in Esplugas de Llobregat (Barcelona)
Construction and Motion. 1965. Stainless iron, glass, and bronze. $9^7/8 \times 9^7/8 \times 9^7/8''$. George Staempfli Gallery, New York

146 Francisco Sobrino
b. 1932 in Guadalajara. Lives in Paris
Structure en Plexiglas. 1963-64. $78^3/4 \times 78^3/4 \times 78^3/4''$

147 Andrés Cillero
b. in Valencia. Lives in Valencia
Green and Red. 1964. $39^3/8 \times 29^1/2''$. Collection of the city administration, Melilla

148 Julián Pacheco
b. 1937 in Cuenca. Lives in Paris
Fragment No. 43. N.D. $25^5/8 \times 39^3/8''$

The Netherlands / colorplates

■ 72 Karel Appel
b. 1921 in Amsterdam. Lives in Paris
Woman with Head. 1964. $74^3/4 \times 90^1/2''$. Collection the artist

■ 73 Jaap Nanninga
b. 1904 in Winschoten. d. 1962 in The Hague
Mon-Abri. 1959. $35^3/8 \times 31^1/2''$. Museum, Groningen

■ 74 Lucebert
b. 1924 in Amsterdam. Lives in Bergen
Suzanne. 1965. $78^3/4 \times 55^1/8''$. Collection the artist

■ 75 Jaap Wagemaker
b. 1906 in Haarlem. Lives in Amsterdam
English Red. 1962. Mixed media. $48 \times 39''$. Collection the artist

■ 76 Corneille (Cornélis van Beverloo)
b. 1922 in Liège. Lives in Paris
Eté catalan. 1965. Gouache. $19^5/8 \times 25^5/8''$.
Collection Werner Haftmann, Gmund, Germany

The Netherlands / black-and-white

149 Wil L. Bouthoorn
b. 1916 in The Hague. Lives in The Hague
Painting with Horizontal and Vertical Movement. 1964. Oil on cardboard. $43^1/4 \times 48''$. Gemeentemuseum, The Hague

150 Kees van Bohemen
b. 1928 in The Hague. Lives in The Hague
Drowned Woman. 1964. $51^1/8''$ square. Galerie Delta, Rotterdam

151 Co Westerik
b. 1924 in The Hague. Lives in The Hague
Schoolmaster with Child. 1961. $34^5/8 \times 43^1/4''$.
Collection Frits A. Becht, Loenen a. d. Vecht

152 Gerard Verdijk
b. 1934 in Boxmeer. Lives in The Hague
Where Is the Tiger? 1965. Fluorescent paints and transfer-picture. $59 \times 51^1/8''$. Galerie Orez, The Hague

153 Martin Engelman
b. 1936 in Hoenkoop. Lives in Paris
Urtier. 1964-65. $78^3/4 \times 72^7/8''$. Private collection, England

154 Woody van Amen
b. 1936 in Eindhoven. Lives in Rotterdam
Checkpoint Charley. 1965. Assemblage. $31^1/2 \times 63''$. Collection the City of Rotterdam

155 Jan Henderikse
b. 1937 in Delft. Lives in Curaçao
Box with Puppet Parts. 1965. Wood and puppets. $29^1/2 \times 29^1/2 \times 29^1/2''$. Collection the artist

156 Wim T. Schippers
b. 1942 in Amsterdam. Lives in Amsterdam
Lilac Chair. 1965. Cast concrete. Height $16' 4^7/8''$. Stedelijk Museum, Amsterdam

157 Henk Peeters
b. 1925 in The Hague. Lives in Arnhem
Aquarel. 1964-65. Wood and water-filled plastic bags. $47^1/4 \times 39^3/8''$. Stedelijk Museum, Amsterdam

158 Armando
b. 1929 in Amsterdam. Lives in Amsterdam
Composition with 24 Bolts. 1962. Panel with bolts. $28^3/8 \times 21^1/4''$. Collection the artist

159 J. J. Schoonhoven
b. 1914 in Delft. Lives in Delft
Relief with Squares. 1964. Mixed media. $40^1/2 \times 50''$. Stedelijk van Abbe Museum, Eindhoven

160 Jaap Mooy
b. 1915 in Bergen. Lives in Bergen
Sentinel. 1961. Iron. Height $102^3/8''$. Stedelijk Museum, Amsterdam

161 Shinkichi Tajiri
b. 1923 in Los Angeles. Lives in Baarlo
Made in U.S.A. No. 12. 1965. Bronze. Height $34^5/8''$. Collection Kasteel Scheres, Baarlo

162 Constant
b. 1920 in Amsterdam. Lives in Amsterdam
New Babylon. Model. Concert building for electronic music. 1960. Metal, plexiglass, and wood. $25^5/8 \times 35^3/8''$. Collection the artist

163 André Volten
b. 1925 in Andijk. Lives in Amsterdam
Advertisement Sign. Iron. Height $98^1/2''$.
Shopping center In de Bogaard, Rijswijk

164 Wessel Couzijn
b. 1912 in Amsterdam. Lives in Amsterdam

Corporate Entity. 1962. Bronze. Height 23′, length 46′. Unilever Building, Rotterdam

165 Carel Visser
b. 1928 in Papendrecht. Lives in Amsterdam
8 Beams. 1965. Iron. Lenght 118$^{1}/_{8}$″. Rijksmuseum Kröller-Müller, Otterlo

166 Mark Brusse
b. 1937 in Alkmaar. Lives in Paris
Hommage à Piet Mondrian. 1965. Wood and iron. 43$^{1}/_{4}$×47$^{1}/_{4}$×7$^{7}/_{8}$″. Stedelijk Museum, Amsterdam

Scandinavia and Finland / colorplates

■ 77 Asger Jorn
b. 1914 in Vejrum, Struer, Jutland, Denmark. Lives in Paris and Albisola Mare
In the Wingbeat of the Swans. 1963. 78$^{3}/_{4}$× 118$^{1}/_{8}$″. Galerie van de Loo, Munich, Germany

■ 78 Jacob Weidemann
b. 1923 in Steinkjer, Norway. Lives in Oslo, Norway
Red Autumn Leaf. 1960. Oil on wood. 65$^{3}/_{8}$×79$^{7}/_{8}$″. Moderna Museet, Stockholm, Sweden

■ 79 Torsten Andersson
b. 1926 in Östra Sallerup, Sweden. Lives in Stockholm, Sweden
Källen II. 1962. Oil on canvas and wood in two parts. 27$^{5}/_{8}$× 51$^{1}/_{8}$″, 10$^{5}/_{8}$×34$^{5}/_{8}$″. Moderna Museet, Stockholm

■ 80 Öyvind Fahlström
b. 1928 in São Paulo, Brazil. Lives in New York, and Stockholm, Sweden
Sitzen. 1964. Tempera on paper mounted on canvas. 66$^{1}/_{8}$×78$^{3}/_{4}$″. Moderna Museet, Stockholm

■ 81 Carl Fredrik Reuterswärd
b. 1934 in Stockholm, Sweden. Lives in Stockholm
The Cigar of Eternity. 1960. Lacquer and tempera on canvas. 35×45$^{5}/_{8}$″. Private collection, Paris

Scandinavia and Finland / black-and-white

167 Richard Mortensen
b. 1910 in Stockholm, Sweden. Lives in Copenhagen, Denmark
Dédié à l'Espagne. 1962. 48×74$^{3}/_{4}$″. Collection of the State, Denmark

168 Albert Mertz
b. 1920 in Copenhagen, Denmark. Lives in Menton, France
L'Homme au sifflet. 1952. Oil on plywood. 78$^{3}/_{4}$×88$^{1}/_{8}$″. Private collection

169 Henry Heerup
b. 1907 in Copenhagen, Denmark. Lives in Copenhagen
The Bird and Spring. 1963. Oil on wood. 29$^{1}/_{2}$×23$^{5}/_{8}$″. Gladsaxe Commune, Copenhagen

170 Robert Jacobsen
b. 1912 in Copenhagen, Denmark. Lives in Courtry, par le Pin, Seine et Oise, France
Le crapaud amoureux. 1959. Iron. Height 5$^{3}/_{4}$″. Nationalmuseum, Stockholm

171 Carl Henning Pedersen
b. 1913 in Copenhagen, Denmark. Lives in Copenhagen
Gray Equestrian Picture with Pegasus. 70$^{7}/_{8}$ ×48$^{7}/_{8}$″. Private collection, Denmark

172 Odd Tandberg
b. 1924 in Oslo, Norway. Lives in Akershus, Norway
Free-standing Garden Wall. 1962. Detail.

Terrazzo. Height $78^3/4''$, length 39'. Administration building of Norsk Hydro, Oslo

173 Carl Nesjar
b. 1920 in Larvik, Norway. Lives in Savigny-sur-Orge, Seine et Oise, France
Relief. 1963. Sand blasted onto concrete. Height $86^5/8''$, length 258". Norwegian Pavilion at the International Garden Architecture Exposition, Hamburg

174 Inger Sitter
b. 1929 in Trondheim, Norway. Lives in Savigny-sur-Orge, Seine et Oise, France
White. 1964. Oil and collage. $57^1/2 \times 44^7/8''$. Collection the artist

175 Arnold Haukeland
b. 1920 in Vaerdal, Norway. Lives in Baerum near Oslo, Norway
Dynamik I. 1960. Forged iron. Height $61^3/8''$, length $19^5/8''$, depth $11^3/4''$. Oslo Byes Vel, Oslo

176 Elis Eriksson
b. 1906 in Stockholm, Sweden. Lives in Stockholm
Deetedu. 1962. Wood collage. $31^1/8 \times 40^1/8 \times 3^7/8''$. Private collection

177 Lage Lindell
b. 1920 in Stockholm, Sweden. Lives in Stockholm
Figure Composition. 1964. $66^7/8 \times 78^3/8''$. Moderna Museet, Stockholm

178 Torsten Renqvist
b. 1924 in Ludvika, Sweden. Lives in Stockholm, Sweden
Flodaltare. Triptych. 1963. Oil and tempera. $15^3/4 \times 22''$, $15^3/4''$ square, $15^3/4 \times 22''$. Moderna Museet, Stockholm

179 Martin Holmgren
b. 1921 in Hallnas, Sweden. Lives in Vaxholm, Sweden

Forms Seeking a Common Center. 1955-60. Bronze. $27^5/8 \times 35^3/8''$. Moderna Museet, Stockholm, Sweden

180 Per Olof Ultvedt
b. 1927 in Kemi, Finland. Lives in Stockholm, Sweden
Hommage à Christopher Polhem. 1965. Wood construction. $17'\ 6^1/4'' \times 44'\ 10^5/8''$

181 Kain Tapper
b. 1930 in Saarijärvi, Finland. Lives in Helsinki, Finland
Golgotha. 1961. Wood. $126 \times 161^3/8''$. Parish Church, Orivesi, Finland

182 Ahti Lavonen
b. 1928 in Kaskinen, Finland. Lives in Helsinki, Finland
Composition. 1964. Mixed media. $51^1/8''$ square

183 Laila Pullinen
b. 1933 in Terijoky, Finland (now Russia). Lives in Helsinki, Finland
Primavera II. 1964. Bronze. Height $78^3/4''$. Collection the artist

Belgium / colorplates

■ 82 René Magritte
b. 1898 in Lessines. Lives in Brussels
La Corde sensible. 1955. $44^1/8 \times 57^1/8''$. Collection Lachowsky, Brussels

■ 83 Maurice Wyckaert
b. 1923 in Brussels. Lives in Brussels
Arbres, nuages. 1961. $39^3/8 \times 47^1/4''$. Galerie van de Loo, Munich, Germany

■ 84 Bram Bogart
b. 1921 in Delft, The Netherlands. Lives in Brussels

Gewepend. 1964. Mixed media. $31^{1}/_{2} \times 42^{1}/_{8}''$. Galerie Carrefour, Brussels

■ 85 Pol Mara
b. 1920 in Antwerp. Lives in Antwerp
Le Cycliste. 1965. $76^{3}/_{4} \times 63^{3}/_{4}''$. Private collection

■ 86 Englebert Van Aderlecht
b. 1918 in Brussels. d. 1961 in Brussels
La Nuit fait l'amour. 1959. $66^{7}/_{8} \times 52''$. Private collection

Belgium / black-and-white

184 Paul Joostens
b. 1899 in Antwerp. d. 1960 in Antwerp
Le Paradis terrestre. 1958. Assemblage. $39^{3}/_{8} \times 29^{1}/_{2}''$. Private collection

185 E. L. T. Mesens
b. 1903 in Brussels. Lives in London
L'évidence m'aime. 1954. Collage and china ink. $13 \times 8^{1}/_{4}''$. Collection Marc Hendrickx, Brussels

186 Pierre Alechinsky
b. 1927 in Brussels. Lives in Paris
La Parole est aux enfants. 1962. $38^{1}/_{8} \times 51^{1}/_{8}''$. Collection Sonja Henie and Niels Onstad, Oslo, Norway

187 Jan Burssens
b. 1925 in Mechelen. Lives in Mariakerke near Ghent
The President. 1963. $78^{3}/_{4}''$ square. Private collection

188 Serge Vandercam
b. 1924 in Copenhagen, Denmark. Lives in Bierges-les-Wavre
Les Métamorphoses de l'Iguane. 1965. $63^{3}/_{4} \times 51^{1}/_{8}''$. Galerie Carrefour, Brussels

189 Roger Raveel
b. 1921 in Mechelen. Lives in Mechelen
La Fenêtre. 1963. Wood and glass. $63 \times 48^{3}/_{8}''$. Private collection

190 Roel D'Haese
b. 1921 in Grammont. Lives in Nieuport
The Happy Violin. 1965. Wax. Height $55^{1}/_{8}''$. Galerie van de Loo, Munich, Germany

191 Bert de Leeuw
b. 1926 in Antwerp. Lives in Antwerp
Les Baigneurs de Baden-Baden. 1963. Mixed media. $71^{5}/_{8} \times 60^{1}/_{4}''$. Galerie Krugier, Geneva, Switzerland

192 Paul Van Hoeydonck
b. 1925 in Antwerp. Lives in Antwerp
Spaceboys. 1963. $50^{3}/_{8} \times 37^{3}/_{4} \times 18^{1}/_{2}''$. Galerie Cogeime, Brussels

193 Pol Bury
b. 1922 in Haine St. Pierre. Lives in Paris
23 boules sur 5 plans inclinés. 1964. $^{3}/_{4} \times 27^{5}/_{8} \times 15^{3}/_{4}''$. The Solomon R. Guggenheim Museum, New York

194 Vic Gentils
b. 1919 in Ilfracombe, England. Lives in Antwerp
Chartres. 1964. Assemblage. $70^{7}/_{8} \times 47^{1}/_{4}''$. Collection Vernanneman, Brussels

195 Octave Landuyt
b. 1922 in Ghent. Lives in Ghent
Présence immobile. 1960. $53^{7}/_{8} \times 38^{1}/_{8}''$. Private collection

196 Jan Cox
b. 1919 in The Hague, The Netherlands. Lives in Boston
Le Miroir. 1951. $23^{5}/_{8} \times 31^{1}/_{2}''$. Private collection

197 Antoine Mortier
b. 1908 in Brussels. Lives in Brussels

Le Bandit. 1960. $44^7/_8 \times 63^3/_4''$. Private collection, Brussels

Japan / colorplates

■ 87 Atsuko Tanaka
b. 1932 in Osaka. Lives in Osaka
Painting. 1962. Vinyl color on canvas. $35 \times 29^7/_8''$. Collection Sam Francis, Paris

■ 88 Mokuma Kikuhata
b. 1935 in Fukuoka. Lives in Fukuoka
Untitled. 1963. Paint on wood. $38^1/_8 \times 30^3/_4''$. Minami Gallery, Tokyo

■ 89 Yoshishige Saito
b. 1904 in Tokyo. Lives in Yokohama
Red. 1960. Oil on plywood. $52 \times 78''$. Tokyo Gallery, Tokyo

■ 90 Shusaku Arakawa
b. 1936 in Nagoya. Lives in New York
A Narrow Chimney on a Flight of Stairs without Stairs. 1964. Oil, pen and ink, and collage. $35^7/_8 \times 44^7/_8''$. Dwan Gallery, Los Angeles

■ 91 Toshinobu Onosato
b. 1912 in Iida. Lives in Kiryu
Untitled 100 A. 1964. $51^1/_8 \times 63^3/_4''$. Minami Gallery, Tokyo

Japan / black-and-white

198 On Kawara
b. 1933 in Karya. Lives in New York
Bathroom. 1953. Drawing on paper. $19^5/_8 \times 15^3/_4''$. Collection the artist

199 Josaku Maeda
Birth. 1963. $98^3/_8 \times 78^3/_4''$. Collection Mr and Mrs. Sazo Idemitsu, Tokyo

200 Sadamasa Motonaga
b. 1922 in Iga. Lives in Osaka
Painting. 1963. $51^1/_8 \times 76^3/_4''$. Tokyo Gallery, Tokyo

201 Tomio Miki
b. 1937 in Tokyo. Lives in Tokyo
Ear. 1963. Aluminum. Height $31^1/_2''$. Minami Gallery, Tokyo

202 Shinjiro Okamoto
b. 1933 in Tokyo. Lives in Kamakura
Laughing Landscape. 1963. Watercolor on canvas. $63 \times 44^1/_8''$. Collection Mrs. Robert F. Windfohr, Texas

203 Yukihisa Isobe
b. 1936 in Tokyo. Lives in Tokyo
Untitled. 1963. Plaster on wood. $71^5/_8''$ square. Tokyo Gallery, Tokyo

204 Takeo Yamaguchi
b. 1902 in Seoul, Korea. Lives in Tokyo
Taku. 1961. Oil on wood. $35^7/_8''$ square. The Museum of Modern Art, New York

205 Mitsuo Kano
b. 1933 in Tokyo. Lives in Tokyo
Star-rumination. 1962. Etching. $21^5/_8 \times 16^1/_2''$. Minami Gallery, Tokyo

206 Keiji Usami
b. 1940 in Suita. Lives in Tokyo
Painting No. 2. 1962. $71^5/_8 \times 97^5/_8''$. Collection Tetsusaburo Tanaka, Nagoya

Latin America / colorplates

■ 92 Rómulo Maccíó
b. 1931 in Buenos Aires, Argentina. Lives in Buenos Aires
La Momia. 1963. $66^7/_8 \times 47^1/_4''$. Instituto Torcuato di Tella, Buenos Aires

■ 93 José Antonio Fernández Muro
b. 1920 in Madrid, Spain. Lives in New York
Medalla escarlata. 1963. Oil and mixed media. $49^{1}/_4 \times 47^{1}/_4''$. Gallery Bonino, New York

■ 94 Alejandro Obregón
b. 1920 in Colombia. Lives in Bogotá, Colombia
Torocondor. 1963. $68^{1}/_2 \times 78^{3}/_4''$.

■ 95 Jesús Soto
b. 1923 in Ciudad Bolívar, Venezuela. Lives in Paris
1 azul, 15 negros. 1963. $41''$ square

■ 96 Antonio Berni
b. 1905 in Rosario, Argentina. Lives in Paris and Buenos Aires, Argentina
La Amiga de Ramona. 1962. Oil and collage. $21^{5}/_8 \times 15^{3}/_4''$. Collection Alain Bourbonnais, Paris

■ 97 Marta Minujín
b. 1941 in Buenos Aires, Argentina. Lives in Buenos Aires
Los Acolchados. 1964. Painted ticking and wool. Height $118^{1}/_8''$. Collection the artist

Latin America / black-and-white

207 Pedro Figari
b. 1861 in Montevideo, Uruguay. d. 1938 in Montevideo
El Rericon. N. D. Oil on cardboard. $19^{1}/_4 \times 23^{1}/_4''$. Instituto Torcuato di Tella, Buenos Aires, Argentina

208 Emilio Pettoruti
b. 1892 in La Plata, Argentina. Lives in Paris
Harlequin. 1928. $53^{1}/_8 \times 27^{5}/_8''$. Museo Nacional de Bellas Artes, Buenos Aires, Argentina

209 Joaquín Torres-García
b. 1879 in Montevideo, Uruguay. d. 1949 in Montevideo
Contrasts. 1931. $28^{3}/_4 \times 23^{5}/_8''$. Instituto Torcuato di Tella, Buenos Aires, Argentina

210 Lasar Segall
b. 1891 in Vilna, Russia. d. 1957 in São Paulo, Brazil
Two Forms in Space. From the series "Mangue." 1928-30

211 Candido Portinari
b. 1903 in Brodosqui, Brazil. d. 1963 in Brazil
Morro. N. D. Tempera. $118^{1}/_8 \times 78^{3}/_4''$

212 Matta
(Sebastian Antonio Matta Echaurren)
b. 1912 in Santiago, Chile. Lives in Paris
The Basis of Things. 1964. $78^{3}/_4 \times 118^{1}/_8''$

213 Julio le Parc
b. 1928 in Mendoza, Argentina. Lives in Paris
Continuel-lumière. Architectural design. 1963. $98^{3}/_8 \times 33^{1}/_8 \times 7^{7}/_8''$

214 Clorindo Testa
b. 1923 in Naples, Italy. Lives in Buenos Aires, Argentina
Oval Form. 1963. $39^{3}/_8 \times 31^{1}/_2''$. Galeria Bonino, Buenos Aires, Argentina

215 Pablo Curatella Manes
b. 1891 in La Plata, Argentina. d. 1963 in Buenos Aires, Argentina
Rugby. 1920-26. Plaster. Height $44^{7}/_8''$. Museo Nacional de Bellas Artes, Buenos Aires

216 Alicia Pérez Penalba
b. 1918 in San Pedro, Argentina. Lives in Paris
Incógnita. 1961-62. Bronze. Height $42^{3}/_4''$. Marlborough-Gerson Gallery, New York

217 José Gamarra
b. 1934 in Montevideo, Uruguay. Lives in Paris
Pintura M 63509. 1963

218 Frans Krajcberg
b. 1921 in Brazil. Lives in Paris
Stratus. 1961

219 Jorge de la Vega
b. 1930 in Buenos Aires, Argentina. Lives in Buenos Aires
The Diary of Saint Louverture. N. D. Mixed techniques. $102^{3}/_{8} \times 76^{3}/_{4}''$. Oakland Art Museum, California

220 Antonio Seguí
b. 1934 in Córdoba, Argentina. Lives in Paris
Box with People. N. D. $76^{3}/_{4} \times 51^{1}/_{8}''$

221 Luis Felipe Noé
b. 1933 in Buenos Aires, Argentina. Lives in Buenos Aires
Charisma. 1963. $109^{1}/_{2} \times 77^{1}/_{8}''$. Galeria Bonino, Buenos Aires

222 María Luisa Pacheco
b. 1919 in La Paz, Bolivia. Lives in New York
Tiahuanaco III. 1964. Oil and collage on canvas. $39^{3}/_{8}''$ square. Collection the artist

223 Fernando Botero
b. 1932 in Bogotá, Colombia. Lives in Bogotá
The Studio of Rubens. 1963-64

Greece / colorplates

■ 98 Jannis Spiropoulos
b. 1912 in Pylos. Lives in Athens
An Episode. 1963. $51^{1}/_{8} \times 38^{1}/_{8}''$

■ 99 Constantin Xenakis
b. 1923 in Athens. Lives in Athens
Painting. 1961

■ 100 J. Molfesis
b. 1924 in Athens. Lives in Paris
Untitled. 1964

■ 101 Vlassis Caniaris
b. 1928 in Athens. Lives in Paris
Ni accident, ni drame. 1964

Greece / black-and-white

224 Nicholas Georgíadis
b. 1923 in Athens. Lives in London
Tympanum. 1964. Mixed media. $59^{7}/_{8} \times 72''$. Hamilton Gallery, London

225 C. Lefakis
b. 1906 in Soufli, Thrace. Lives in Thessalonica
Painting. 1963

226 Costas Coulentianos
b. 1918 in Athens. Lives in Paris
Folgore VI. 1964. Iron

Israel / colorplates

■ 102 Ygel Tumarkin
b. 1933 in Dresden, Germany. Lives in Tel Aviv
A Window to the Sea. Beach monument. 1963-64. Concrete and iron. $98^{3}/_{8}'' \times 23'$. Collection Aplit, Israel

■ 103 Joseph Zaritsky
b. 1891 in Borispol, Russia. Lives in Israel
Painting. 1954

Israel / black-and-white

227 Ytshak Dantziger
b. 1916 in Berlin, Germany. Lives in Tel Aviv
The Burning Bush. c. 1960. Iron. Museum of Modern Art, Haifa

228 Yehiel Shemi
b. 1922 in Haifa. Lives in Kibbutz Kabri in Galil Maarabi, Israel
Sculpture. 1964. Iron

229 Marc Scheps
b. 1933. Lives in Paris
Espace de Rêve II. 1963. Wood

230 Mordechai Ardon
b. 1896 in Tuchow, Poland. Lives in Jerusalem
In the Negev. 1962. $36^{1}/_{4} \times 30^{3}/_{4}''$. Collection Mr. and Mrs. Klier, Tel Aviv

231 Raffi Lavie
b. 1937 in Tel Aviv. Lives in Ramat-Gau, Israel
Peinture. 1965. Oil and collage

232 Aika Brown
b. 1937 in Tel Aviv. d. 1964 in France
Picture Relief with Puppets. 1964

Poland / colorplates

■ 104 Jerzy Tchórzewski
b. 1928 in Siedlce. Lives in Warsaw
Signal from the World Space. 1964. $53^{1}/_{8} \times 37^{3}/_{8}''$. Collection Lucano Pomini, Castellanza, Varese, Italy

■ 105 Aleksander Kobzdej
b. 1920 in Olesko. Lives in Warsaw
Christmas Singer (Shepherd — Death —

King — Werewolf). 1964-65. Four sections, each $65 \times 26''$. Collection Berthold Beitz, Essen, Germany

■ 106 Tadeusz Kantor
b. 1915 in Wielopole near Cracow. Lives in Cracow
Urgent. 1965. $46^{1}/_{8} \times 40^{1}/_{8}''$

Poland / black-and-white

233 Tadeusz Brzozowski
b. 1918 in Lvov. Lives in Zakopane
Morning Star. 1964. $42^{7}/_{8} \times 64^{1}/_{8}''$. Collection J. Brzozowksi, Warsaw

234 Kazimierz Mikulski
b. 1918 in Cracow. Lives in Cracow
Woman and Window. 1965. Tempera. $16^{7}/_{8} \times 19^{1}/_{4}''$. Collection the artist

235 Jan Lebensztejn
b. 1930 in Brest Litovsk. Lives in Paris
Vertical Blue. 1965

236 Jerzy Nowosielksi
Marriage Portrait. 1965. $38^{5}/_{8} \times 26^{3}/_{8}''$. Collection the artist

237 Zbigniew Makowski
b. 1928 in Warsaw. Lives in Warsaw
Separated Objects. 1963. $39^{3}/_{8} \times 31^{7}/_{8}''$. The Museum of Modern Art, New York. Gift of Mr. and Mrs. M. A. Lipschultz

238 Stefan Gierowski
b. 1925 in Czestochowa. Lives in Warsaw
Object CLII Intersecting Rings. 1964. $59 \times 49^{1}/_{4}''$. Collection Harry Miller, Pittsburgh

239 Wojciech Fangor
b. 1922
No. 35. 1963. $51^{1}/_{8} \times 38^{1}/_{8}''$

240 Zbigniew Gostomski
b. 1932 in Bydgoszcz. Lives in Warsaw
Optical Counterparts. 1964. Painted relief.
$59 \times 39^{3}/_{8}''$. Collection the artist

Czechoslovakia / colorplates

■ 107 František Gross
b. 1909 in Nová Paka. Lives in Prague
Intérieur. 1962. $48 \times 63^{3}/_{4}''$

■ 108 Jan Kotík
b. 1916 in Turnov. Lives in Prague
Burratino al pincio. 1965. $57^{1}/_{2} \times 63^{3}/_{4}''$

■ 109 Jiří John
b. 1923 in Třešt. Lives in Prague
Water and Earth. 1964. $31^{1}/_{2} \times 57^{1}/_{8}''$

Czechoslovakia / black-and-white

241 František Jiroudek
b. 1914 in Lhota near Semil. Lives in Prague
Drama. 1965. $37^{3}/_{8} \times 59''$

242 Kamil Lhoták
b. 1912 in Prague. Lives in Prague
Landscape with Automobile. 1963. $22^{7}/_{8} \times 35''$

243 Josef Istler
b. 1919 in Prague. Lives in Prague
Picture 3. 1965. $37^{3}/_{8} \times 28^{3}/_{4}''$

244 Andrej Barčík
b. 1928 in Závodie. Lives in Zilina
The Black Moon. 1962. Mixed techniques and collage

245 Ferdinand Hložník
b. 1922 in Svederník. Lives in Bratislava
The Window. 1965. $24 \times 31^{1}/_{2}''$

246 Mikuláš Medek
b. 1926 in Prague. Lives in Prague
162 cm^2 of Fragility. 1964. Oil with enamel.
$63^{3}/_{4} \times 51^{1}/_{8}''$

247 Rudolf Krivoš
b. 1933 in Tisovec. Lives in Bratislava
In the Studio. 1963. Mixed media. $48 \times 31^{7}/_{8}''$

248 Vladimír Konpánek
b. 1927 in Rájek. Lives in Bratislava
Two Village Women. 1963. Bronze

249 Vladimír Janoušek
b. 1922 in Zdírnice. Lives in Prague
Boats. 1965. Polyester. Height $35^{3}/_{8}''$

250 Karel Hladík
b. 1912 in Králová Lhota. Lives in Prague
Reclining Woman. 1962. Wood. $11 \times 26^{3}/_{8}''$

251 Čestmír Kafka
b. 1922 in Jihlava. Lives in Prague
Sea. 1961. $22 \times 29^{7}/_{8}''$

252 Zbyněk Sekal
b. 1923 in Prague. Lives in Prague
End of the Woods. 1963. Wood. $23^{1}/_{2} \times 32^{1}/_{4}''$

253 Pavel Sukdolák
b. 1925 in Humpolec. Lives in Prague
Black and White. N. D. Mixed media.
$20^{7}/_{8} \times 18^{1}/_{2}''$

254 Vincenc Hložník
b. 1922 in Svederník. Lives in Bratislava
From the Cycle "Secrets." 1964. Etching.
$12^{3}/_{8} \times 9^{5}/_{8}''$

Yugoslavia / colorplates

■ 110 Edo Murtić
b. 1921 in Velika Pisanica. Lives in Zagreb
Vertical Conception. 1965

■ 111 Janez Bernik
b. 1933 in Ljubljana. Lives in Ljubljana
The Big Letter. 1964. Oil and tempera

■ 112 Stojan Ćelić
b. 1925 in Bosanski Novi. Lives in Belgrade
Typical Climate. 1962

Yugoslavia / black-and-white

255 Krsto Hegedušić
b. 1901 in Petrinja, Croatia. Lives in Zagreb
Water Corpses. 1956. Tempera and oil on canvas. $41^3/8 \times 52''$. Gallery of Modern Art of the Yugoslavian Academy of the Arts and Sciences, Zagreb

256 Petar Lubarda
b. 1907 in Cetinje. Lives in Belgrade
Motif from Brazil. 1955. $39^3/8 \times 31^1/2''$. Collection the artist

257 Gabrijel Stupica
b. 1913 in Drazgose. Lives in Ljubljana
Flora. 1965. Tempera and collage on canvas. $98 \times 57^7/8''$. Moderna Gallery, Ljubljana

258 Radomir Damnjanović
b. 1936 in Mostar. Lives in Belgrade
Vertical Composition. 1965. Mala Gallery, Ljubljana

259 Vladimir Velićković
b. 1935 in Belgrade. Lives in Belgrade
The Fall. 1964. Oil and tempera. $94^1/2 \times 55^1/8''$

260 Miodrag Protić
b. 1922
Bouquet I. 1965. $31^3/4 \times 39^3/8''$. Moderna Gallery, Ljubljana

261 Bogdan Meško
b. 1936 in Ljubljana. Lives in Ljubljana
Sparks of a Happy Satyr. 1965. Oil and tempera. $35^3/8 \times 43^1/4''$. Moderna Gallery, Ljubljana

262 Ivan Picelj
b. 1924 in Okučani. Lives in Zagreb
Composition XWY-2. 1960. $36^1/4 \times 53^1/2''$. Moderna Gallery, Ljubljana

263 Marko Šuštaršić
b. 1927 in Cerknica. Lives in Ljubljana
Collection of Postcards. 1963. $45^7/8 \times 35''$. Moderna Gallery, Ljubljana

264 Andrej Jemec
b. 1934 in Ljubljana. Lives in Ljubljana
Landscape XXXIV. 1965. $15 \times 11^3/4''$. Moderna Gallery, Ljubljana

265 Dusan Džamonja
b. 1928 in Strumica. Lives in Zagreb
Sculpture. 1963. Height $33^7/8''$. Student Center, Zagreb

266 Vojin Bakić
b. 1915 in Bjelovar. Lives in Zagreb
Reflecting Forms 5. 1963-64. Gallery Suvremene Umjetnosti, Zagreb

267 Drago Tršar
b. 1927 in Planina pri Rakeku. Lives in Ljubljana
The Life of Man III. 1965. Plaster. Moderna Gallery, Ljubljana

268 Slavko Tihec
b. 1928 in Maribor. Lives in Maribor
Vegetative Form III. 1962. Iron and concrete. $38^5/8 \times 21^5/8''$. Moderna Gallery, Ljubljana

Germany, Austria, and Switzerland
colorplates

(All locations in Germany unless otherwise noted)

■ 113 Willi Baumeister
b. 1889 in Stuttgart. d. 1955 in Stuttgart
Euphor I. 1955. Oil on cardboard. $15^3/4 \times 19^7/8''$. Private collection

■ 114 Theodor Werner
b. 1886 in Jettenburg near Tübingen. Lives in Munich
Nr. I/64. 1964. Oil on fiberboard. $28^3/4 \times 35^7/8''$. Collection Professor Sep Ruf, Munich

■ 115 Ernst Wilhelm Nay
b. 1902 in Berlin. Lives in Cologne
Dynamik-Bild. 1965. $63 \times 78^3/4''$. Private collection

■ 116 Fritz Winter
b. 1905 in Altenbögge. Lives in Diessen
Weite Horizontalen. 1964. $59 \times 91^3/8''$. Staatliche Kunstsammlung, Kassel

■ 117 Max Bill
b. 1908 in Winterthur, Switzerland. Lives in Zurich, Switzerland
helligkeit durch kompression. 1964. $55^7/8''$ square. Art International, Lugano, Switzerland

■ 118 Georg Karl Pfahler
b. 1926 in Emetzheim, Weissenburg. Lives in Fellbach near Stuttgart

SP.O.R.İM. 1964. Polymer. $45^1/4 \times 39^3/8''$. Private collection

■ 119 Hundertwasser
b. 1928 in Vienna, Austria. Lives in Venice, Italy, and Paris, France
Soleil et Époque spiraloide de la mer rouge, Nr. 430/1960. 1960. $44^7/8 \times 57^1/2''$. Private collection

■ 120 Rudolf Hausner
b. 1914 in Vienna, Austria. Lives in Vienna
Die Arche des Odysseus. 1956. Tempera and oil on plywood. $43^1/4 \times 59''$. Museum der Stadt Wien

■ 121 Bernard Schultze
b. 1915 in Schneidemühl. Lives in Frankfurt a. M.
Baal-Migof. 1965. Polyester on canvas, wire, textiles, oil. $73^1/4 \times 41''$. Howard Wise Gallery, New York

■ 122 Emil Schumacher
b. 1912 in Hagen. Lives in Hagen
Saraph. 1965. $39^3/8 \times 31^1/2''$. Private collection

■ 123 Otto Piene
b. 1928 in Laasphe, Westphalia. Lives in New York
Rote Nacht — Dunkle Blume. 1963-64. Oil and smoke on burned canvas. $66^7/8 \times 47^1/4''$. Galerie Schmela, Düsseldorf

■ 124 Arnold Leissler
b. 1939 in Hannover. Lives in Hannover
Fluidum eines Möbels. 1963. $49^5/8 \times 36^1/4''$. Collection Heidi and Dieter Brusberg, Hannover

■ 125 Rainer Küchenmeister
b. 1926 in Ahlen, Westphalia. Lives in Paris
Rote Komposition. 1963. Oil on wood. $52 \times 47^1/4''$. Galerie Stangl, Munich

■ 126 Markus Prachensky
b. 1932 in Innsbruck, Austria. Lives in Vienna, Austria, Berlin and Stuttgart
Rot und grüne Fläche — Solitude II. 1964-65. $78^3/4 \times 39^3/8''$. Galerie Schüler, Berlin

■ 127 Walter Stöhrer
b. 1937 in Stuttgart. Lives in Berlin
Nina. 1965. $55^1/8 \times 51^1/8''$. Galerie Schüler, Berlin

■ 128 Horst Antes
b. 1936 in Heppenheim, Bergstrasse. Lives in Karlsruhe
Gelbe Figur mit Vogel. 1964-65. $39^3/8 \times 35^3/8''$. Gimpel and Hanover Gallery, London, England

■ 129 Peter Schubert
b. 1929 in Pirna near Dresden. Lives in Berlin
Savono. 1965. $55^1/8 \times 47^1/4''$. Collection the artist

■ 130 Friedrich Meckseper
b. 1936 in Bremen. Lives in Worpswede
Neun indische Vulkane. 1964. $25^5/8 \times 35^3/8''$. Galerie Brockstedt, Hamburg

■ 131 Richard Oelze
b. 1900 in Magdeburg, Germany. Lives in Rittergut, Posteholz, and Hameln, Land
Epikur. 1960. $31^1/2 \times 39^3/8''$. Private collection

■ 132 Friedrich Schröder-Sonnenstern
b. 1892 in Tilsit (now Sovetsk, Russia). Lives in Berlin
Der Friedenshabicht führt den Friedensengel zum Elysium. 1960. Colored pencil on cardboard. $28 \times 40^1/8''$. Private collection

Germany, Austria, Switzerland
black-and-white

269 K. R. H. Sonderborg
b. 1923 in Sonderborg, Denmark. Lives in Stuttgart and Paris
27. April 65 11.31-12.43. 1965. Oil tempera. $12^3/8 \times 11^3/8''$. Lefebre Gallery, New York

270 Gerhard Hoehme
b. 1920 in Greppin near Dessau. Lives in Düsseldorf and Rome
Tibetanisches Fenster. 1964. Composition board, metal, and wood on canvas. $27^5/8 \times 63''$. Collection the artist

271 Karl Otto Götz
b. 1914 in Aachen. Lives in Düsseldorf
Untitled. 1962. Gouache. $25^5/8 \times 39^3/8''$. Collection the artist

272 Peter Brüning
b. 1929 in Düsseldorf. Lives in Ratingen, Rhineland
Légendes No. 8/64. 1964. $59 \times 78^3/4''$. Galerie Aenne Abels, Cologne

273 Fred Thieler
b. 1916 in Königsberg. Lives in Berlin
Inbild IV/65. 1965. Collage. $29^1/2 \times 39^3/8''$. Collection the artist

274 Hann Trier
b. 1915 in Kaiserswerth. Lives in Berlin
Rocaille. 1965. Egg tempera on canvas. $51^1/8 \times 63^3/4''$. Collection the artist

275 Bruno Goller
b. 1901 in Gummersbach. Lives in Düsseldorf
Zwei Hüte. 1956. $39^3/8 \times 47^1/4''$. Galerie Zwirner, Cologne

276 Konrad Klapheck
b. 1935 in Düsseldorf. Lives in Düsseldorf

Die Intrigantin. 1964. $39^3/8 \times 43^1/4''$. Collection Julien Levy, Bridgeport, Connecticut

277 **Gerd Richter**
b. 1932 in Dresden. Lives in Düsseldorf
Die Sphinx von Gise. 1964. $59 \times 66^7/8''$. Galerie Friedrich, Munich

278 **Wolf Vostell**
b. 1932 in Leverkusen. Lives in Cologne
Aus der Partitur zum Ulmer Happening. 1964. Frottage, smeared chalk, and watercolor on cardboard. $23^5/8 \times 25^5/8''$. Galerie René Block, Berlin

279 **Heinz Trökes**
b. 1913 in Hamborn. Lives in Berlin and Ibiza
Leere Burg. 1964. $62^1/4 \times 40^1/8''$. Collection the artist

280 **Woty Werner**
b. 1903 in Berlin. Lives in Munich
Ouvertüre. 1964-65. Wool tapestry. $124 \times 74^3/4''$. Collection Chancellor Ludwig Erhard, Bonn

281 **Paul Wunderlich**
b. 1927 in Berlin. Lives in Hamburg
Die schöne Ursula. 1964. $63^3/4 \times 52''$. Collection the artist

282 **Ursula (Bluhm)**
b. 1921 in Mittenwald. Lives in Frankfurt a. M.
Aussi une heure du PAN. 1961. $31^7/8 \times 51^1/8''$. Collection Daniel Cordier, Paris

283 **Ernst Fuchs**
b. 1930 in Vienna. Lives in Vienna and Paris
Anti Laokon. 1965. Pencil. $78^3/4 \times 59''$. Collection the artist

284 **Erich Brauer**
b. 1929 in Vienna. Lives in Vienna and Paris

Mit dem schwebenden Knollen. 1965. Watercolor. $9 \times 5^3/8''$. Private collection

285 **Carlfriedrich Claus**
b. 1930 in Annaberg, Erzgebirge. Lives in Annaberg
Paracelsische Denklandschaft. 1962. Pen. $11^1/4 \times 8^1/8''$. Regierungspräsidium Südbaden, Freiburg

286 **Horst Janssen**
b. 1929 in Hamburg. Lives in Hamburg
Akrobaten. 1958. Etching. $23^1/2 \times 15^5/8''$

287 **Günter Uecker**
b. 1930 in Wendorf, Mecklenburg. Lives in Düsseldorf
Weisse Mühle. 1964. Nails on canvas over wood. $6^1/2''$. Howard Wise Gallery, New York

288 **Heinz Mack**
b. 1931 in Lollar, Hessen. Lives in Düsseldorf
Rotor IV: "Silbersonne." 1965. Glass, aluminum, wood, motorized. $22 \times 22 \times 7^7/8''$. Galerie Schmela, Düsseldorf

289 **Zoltan Kemeny**
b. 1907 in Banica, Transylvania. d. 1965 in Zurich, Switzerland
Vitesses Involontaires. 1962. Brass. $39^3/8''$ square. Rijksmuseum Kröller-Müller, Otterlo, The Netherlands

290 **Horst Egon Kalinowski**
b. 1924 in Düsseldorf. Lives in Paris
Diptyque "Plessis-les-Tours." 1960-62. Sculpture-assemblage of wood, leather, and iron. $27^1/8 \times 25^1/4''$. Private collection

291 **Hans Uhlmann**
b. 1900 in Berlin. Lives in Berlin
Amsterdamer Plastik. 1965. Chromium nickel steel. $98^3/8 \times 128 \times 98^3/8''$. Union Boden, Hannover

292 Erich Hauser
b. 1930 in Rietlingen near Tuttlingen. Lives
in Dunningen bei Rottweil
Freiplastik. 1964. Nirosta (stainless) steel.
$236^1/4 \times 118^1/8 \times 78^3/4''$. Raichberg - Mittel-
schule, Stuttgart

293 Bernhard Luginbühl
b. 1929 in Bern, Switzerland. Lives in Bern
Grosser Bulldog. 1964. Iron. Height $29^7/8''$.
Collection the artist

294 Fritz Wotruba
b. 1907 in Vienna. Lives in Vienna
Grosse Skulptur. 1964. Bronze. Height
$120^1/8''$. Marlborough Fine Art Ltd., Lon-
don

295 Otto Herbert Hajek
b. 1927 in Kaltenbach, Czechoslovakia. Lives
in Stuttgart
Plastik 65/32. 1965. Bronze. $8^1/2 \times 6^7/8 \times 4^3/4''$.
Collection the artist

296 Heinrich Brummack
b. 1936 in Treuhofen. Lives in Berlin
Galgenkönig. 1965. Bronze. Height c. $19^1/2''$.
Galerie Schüler, Berlin

297 Harry Kramer
b. 1925 in Lingen. Lives in Paris
Drahtplastik. 1962-64. Knotted iron wire
with a small motor and rubber bands as
drive mechanism. Height c. $35^3/8''$. Galerie
Dieter Brusberg, Hannover

298 Günter Haese
b. 1924 in Kiel. Lives in Düsseldorf
Zephir. 1965. Brass wire. $7^5/8 \times 12^1/4 \times 10''$.
Marlborough Fine Art, Rome

299 Gotthard Graubner
b. 1930 in Erlbach bei Vogtland, Germany.
Lives in Düsseldorf
Grausilberkissen. 1963-64. Oil and canvas

over foam rubber. $11^3/8 \times 10^5/8''$. Collection
the artist

300 Bernd Berner
b. 1930 in Hamburg. Lives in Stuttgart-
Hedelfingen
Flächenraum. 1964. Gouache. $23^5/8 \times 17^3/4''$.
Galerie Brechbühl, Grenchen, Switzerland

301 Arnulf Rainer
b. 1929 in Baden near Vienna. Lives in Ber-
lin and Vienna
Irma la Douce. 1963. $25^3/4 \times 19^7/8''$ Galerie
Springer, Berlin

302 Wilfried Blecher
b. 1930 in Hamborn. Lives in Aich, Stutt-
gart
Zeitspiele. 1964. Mixed media. $27^1/8 \times 20^1/8''$.
Collection the artist

303 Karl Gerstner
b. 1930 in Basel, Switzerland. Lives in Basel
Linsenbild. 1962-64. Plastic lenses and trans-
parent concentric circles. Diameter 28". Al-
bright-Knox Art Gallery, Buffalo, New York

304 Gottfried Honegger
b. 1917 in Zurich, Switzerland. Lives in
Zurich
Tableau-Relief (P.Z. 29). 1963. Oil on plas-
tic. $29^1/2''$ square. Collection Lillian Flors-
heim, Chicago

305 Jean Baier
b. 1932 in Geneva, Switzerland. Lives in
Geneva
Komposition. 1965. Cellulose painting. $35^3/8''$
square. Collection the artist

306 Richard P. Lohse
b. 1902 in Zurich, Switzerland. Lives in
Zurich
*Sixteen Progressive Asymmetrical Color
Groups Within One Symmetrical System.*
1956-66. $37^3/4''$ square. Collection the artist

307 Günter Fruhtrunk
b. 1923 in Munich. Lives in Paris
Hommage à Arp ET II. 1962. Acrylic on
canvas. $51 \times 48^{3}/_{8}''$. Collection Jean Coque-
let, Brussels

308 Rolf-Gunter Dienst
b. 1939 in Kiel. Lives in Baden-Baden
Apropos Eduardo I. 1964. Tempera. $16^{3}/_{4} \times$
$12^{5}/_{8}''$. Collection the artist

309 Alexej Iljitsch Baschlakow
b. 1936 in Haboda, Russia. Lives in Ahlem
near Hannover
Rikon I. 1964. Oil on disc. Diameter $60^{1}/_{4}''$.
Galerie Dieter Brusberg, Hannover

310 Carl-Heinz Kliemann
b. 1924 in Berlin. Lives in Berlin
Olevano I. 1964. Chalk and india ink. $27^{5}/_{8}$
$\times 40^{1}/_{8}''$. Collection of the City of Berlin

311 Vera Haller
b. in Budapest, Hungary. Lives in Lugano,
Switzerland
Tiznit. 1964. $47^{1}/_{4} \times 55^{1}/_{8}''$. Collection the
artist

312 Klaus Jürgen Fischer
b. 1930 in Krefeld. Lives in Baden-Baden
Achteck Grau. 1964. Ink. $39^{3}/_{8}''$ square. Col-
lection the artist

313 Karl Friedrich Dahmen
b. 1917 in Stolberg, Rhineland. Lives in
Stolberg
Ohne Illusion. 1964. Mixed media. $45^{1}/_{4} \times$
$39^{3}/_{8}''$. Lefebre Gallery, New York

314 Rupprecht Geiger
b. 1908 in Munich. Lives in Munich and
Düsseldorf
Gagarin. 1961. $59 \times 55^{1}/_{8}''$. Collection the
artist

315 Werner Schreib
b. 1925 in Berlin. Lives in Frankfurt a. M.
Pétrification sémantique. 1963. Seal ring on
wood board. Collection Baron Marschall von
Bieberstein, Rome

316 Winfred Gaul
b. 1928 in Düsseldorf. Lives in Düsseldorf
and England
"Hände Hoch." 1964. Oil and lacquer on
canvas. $39^{3}/_{8}''$ square. Galerie René Block,
Berlin

317 H. P. Alvermann
b. 1931 in Düsseldorf. Lives in Düsseldorf
Hommage à Düsseldorf. 1962. Mixed media.
$47^{1}/_{4} \times 53^{1}/_{8}''$. Collection Jährling, Wupper-
tal

318 Herbert Kaufmann
b. 1924 in Aachen. Lives in Düsseldorf
Litfass-Säulen. 1964. Columns collage and
oil on plywood construction. Height $67^{3}/_{8}''$,
diameter $24''$. Collection the artist

319 Lothar Fischer
b. 1933 in Gemersheim, Pfalz. Lives in
Munich
El Cid II. 1965. Mixed media. $23^{5}/_{8} \times 17^{3}/_{4}''$.
Galerie van de Loo, Munich

320 Georg Baselitz
b. 1937 in Deutschbaselitz near Kamenz.
Lives in Berlin
Aus der Traum. 1964. $63^{3}/_{4} \times 51^{1}/_{8}''$. Galerie
Michael Werner, Berlin

321 Heimrad Prem
b. 1934 in Roding, Oberpfalz. Lives in
Munich
Er und Sie. Second version. 1965. $39''$
square. Galerie van de Loo, Munich

322 Curt Stenvert
b. 1920 in Vienna. Lives in Vienna

The 38th Human Situation: The Dead Manager Has Bequeathed His Own Gilded Skeleton to His Enchanting Widow. 1964. $61^{3}/_{8} \times 74 \times 21^{5}/_{8}''$

323 Karl Hartung
b. 1908 in Hamburg. Lives in Berlin
Relief. 1963. Bronze. $5^{7}/_{8} \times 7^{1}/_{8}''$. Collection Professor Gonda, Berlin

324 Emil Cimiotti
b. 1927 in Göttingen. Lives in Braunschweig
Untitled. 1964. Bronze. $21^{5}/_{8} \times 21^{5}/_{8} \times 17^{3}/_{4}''$. Collection the artist

325 Bernhard Heiliger
b. 1915 in Stettin. Lives in Berlin
Flamme. 1962-63. Bronze. $252 \times 248''$. Collection of the City of Berlin

326 Fritz Koenig
b. 1924 in Würzburg. Lives in Munich and Ganszberg near Landshut
Domus. 1963. Bronze. Height $17^{1}/_{2}''$. Private collection

327 Hans Aeschbacher
b. 1906 in Zurich, Switzerland. Lives in Russikon, Switzerland
Explorer I. 1964. Marmor Cristallina. $213^{3}/_{8} \times 39 \times 39^{3}/_{4}''$. Swiss National Exhibition, 1964, Lausanne, Switzerland

328 Rudolf Hoflehner
b. 1916 in Linz, Austria. Lives in Vienna and Stuttgart

Figur 86 (middle) and *Figur 85* (right). 1964. Iron. *Figur 86:* height $69^{5}/_{8}''$. *Figur 85:* height $76''$. Gallery Odyssia, New York

329 Utz Kampmann
b. 1935 in Berlin. Lives in Berlin
Farbobjekt 64/15. 1964. Wood. $18^{7}/_{8} \times 18^{7}/_{8} \times 6^{1}/_{4}''$. Collection K. G. Pfahler, Stuttgart
5169 Etienne Anhang O Spalte 122

330 E. R. Nele
b. 1932 in Berlin. Lives in Frankfurt a. M.
Architektur Kopf. 1964. Bronze. $11^{3}/_{4} \times 15^{3}/_{4}''$. Galerie van de Loo, Munich

331 Norbert Kricke
b. 1922 in Düsseldorf. Lives in Düsseldorf
Sculpture spatiale. 1961. Chromium steel. Height $23^{5}/_{8}''$. Galerie Dieter Brusberg, Hannover

332 Brigitte Meier-Denninghoff
b. 1923 in Berlin. Lives in Paris
65/1. 1965. Brass. $27^{5}/_{8} \times 20^{7}/_{8} \times 18^{1}/_{8}''$. Marlborough Fine Art Ltd., London

333 Paul Isenrath
b. 1936 in Mönchengladbach. Lives in Düsseldorf
Plastik. 1962. Bent copper sheet. $6^{7}/_{8} \times 5 \times 4^{3}/_{4}''$. Galerie Thomas, Munich

334 Friedrich Werthmann
b. 1927 in Barmen. Lives in Düsseldorf
Gordischer Knoten. 1963. Tungsten steel. $5 \times 1^{1}/_{8} \times 1^{1}/_{8}''$. Loughborough College, England

Photo Credits

Lüfti Özkök, Älvsjö, Sweden 176
Gemeentemusea, Amsterdam 156, 157, 159, 160
Studio Hartland, Amsterdam 154
Philip Mechanicus, Amsterdam 158
Pearl Perlmutter, Amsterdam 164
Albert Seelen, Amsterdam 150
Bram Wisman, Amsterdam 162
Shunk-Kender, Antwerp 52, 229
Photo F. Tas, Antwerp 191
Jerome Drown, Atlanta, Ga. 5

Tajiri, Baarlo, Netherlands 161
Photo Robert, Barcelona 134
F. Catalá Roca, Barcelona 145
Galerie René Block, Berlin 316
Reinhard Friedrich, Berlin 325
Photo Gnilka, Berlin 274, 301, 323
Jürgen Müller-Schneck, Berlin 278
Hilde Zenker, Berlin 296, 310, 320
Studio Fotofas, Bologna 118
Paul Bijtebier, Brussels 115, 188, 196
G. D. Hackett, Brussels 195
Stout, Brussels 194
Sameer Makarios, Buenos Aires 214
Museo Nacional de Bellas Artes, Buenos Aires 208
E. Regales, Buenos Aires 215

Galerie Aenne Abels, Cologne 272

Hilla Becher, Düsseldorf 271
Inge Goertz-Bauer, Düsseldorf 318
Arno Jansen, Düsseldorf 324
Walter Klein, Düsseldorf 276
Landesbildstelle Rheinland, Düsseldorf 275
Photo Maren, Düsseldorf 334

Reiner Ruthenbeck, Düsseldorf 317
Manfred Tischer, Düsseldorf 308

William Boone Studio, East Hampton, N.Y. 4

Leonardo Bezzola, Flamatt, Germany 293
Franz Rath, Frankfurt am Main 295
Bruno Krupp, Freiburg im Breisgau 292

Photo Claerhout, Ghent 187
David Farrell, Gloucester 89, 100

A. Dingjan, The Hague 151
Marianne Dommisse, The Hague 155
Gemeentemuseum, The Hague 149, 285
Henk van der Vet, The Hague 152
Edgar Lieseberg, Hannover 281
M. Karjanoja, Helsinki 181

Jerezy Borowiec, Krakow 234

K. H. Steppe, Landshut, Germany 326
Mala Galerija, Ljubljana 258
Moderna Galerija, Ljubljana 257, 260-64, 267, 268
Brompton Studio, London 76, 79, 80, 87, 96
Harriet Crowder, London 98
Robert Fraser Gallery, London 83, 93
Kim Lim, London 88, 91
Marlborough Fine Art Ltd., London 85, 95, 294
Morgan-Wells, London 101
Rodney Todd-White, London 90

Bacci Attilio, Milan 127-29
Ugo Mulas, Milan 30, 114
Grete Stern, Montevideo 207

Index

496

Hutter, Wolfgang 307
Huxley, Paul 114

Ibarrola, Augustín 176, 179, 181
Ihlenfeld, Klaus 317
I Jssel, Aart van den 201
Ikeda, Masuo 237
Ikeda, Tatsuo 231, 233 (fig. 2)
Imai, Toshimitsu 175, 231
Indiana, Robert 24, 37, 39, pl. 24
Inlander, Henry 109
Inokuma, Gen 231
Iommi, Ennio 242
Irwin, Gwyther 114, pl. 77
Isenrath, Paul 317, pl. 333
Isobe, Yukihisa 237, pl. 203
Isozaki, Arata 236
Istler, Josef 269, pl. 243
Itten, Johannes 258

Jacobsen, Egill 203
Jacobsen, Robert 203, 205 f., pl. 170
Jaeckel, Willy 299
Janeček, Ota 270
Jankovič, Jozef 275
Janoušek, Vladimir 274, pl. 249
Janoušková, Vera 273
Janssen, Horst 309, pl. 286
Jarema, Maria 262
Jemec, Andrej 287, pl. 264
Jendritzko, Guido 315
Jíras, Josef 271
Jiroudek, František 269, pl. 241
John, Jiří 271, colorpl. 109
Johns, Jasper 31 ff., 40, 45, 57, 62, 85, 310,
 colorpl. 13
Jones, Allen 117 f., 197, pl. 86
Jones, Arne 211
Jong, Gooitzen de 202
Jong, Jacqueline de 198
Jongkind, Johan 182
Jonk, Nic 202
Joostens, Paul 220, pl. 184
Jordan, Vasilje 286
Jorn, Asger 12, 112, 185, 203 f., 222, 226,
 colorpl. 77

Jové, Angel 180
Judd, Donald 57
Jung, C. G. 7, 158

Kafka, Cestmír 271, pl. 251
Kafka, Franz 271, 274
Kagel, Mauricio 303 f.
Kahana 260
Kahnweiler, Daniel-Henry 64
Kalinowski, Horst Egon 85, 90, 322 f., colorpl. 27,
 pl. 290
Kampmann, Utz 321, pl. 329
Kandinsky, Wassily 59 f., 62, 69, 139, 186, 203 f.,
 258, 292, 294 f., 299, 311
Kano, Mitsuo 237, pl. 205
Kanovitz, Howard 40
Kantor, Tadeusz 262, 265, colorpl. 106
Kapralos, C. 254
Kaprow, Allan 30, 34
Karakhalios 253
Karas 255
Kardamatis 253
Karoušek, Ladislav 272
Katraki, Vaso 254
Katz, Alex 40
Kaufmann, Herbert 310, pl. 318
Kawabata, Minoru 231
Kawara, On 231 f., pl. 198
Keeler, Christine 310
Kelly, Ellsworth 23 ff., 39, 43, colorpl. 8
Kemeny, Zoltan 202, 319 f., pl. 289
Kennedy, John F. 63
Kesanlis, Nikos 256
Kierkegaard, Sören 204
Kikuhata, Mokuma 237, colorpl. 88
King, Philip 58, 120, pl. 92
Kinley, Peter 110
Kirchberger, Günther 313
Kirchner, Ernst Ludwig 184
Kirchner, Heinrich 322
Kirijärvi, Harry 217
Kitaj, R. B. 110, 118, 309, colorpl. 38
Kito, Akira 231
Klapheck, Konrad 218, 310, pl. 276
Klee, Paul 7, 59, 184, 187, 203, 258, 260, 292,
 294 f., 319

502

504